Digital Dhataraphy

Greenberg, Steve.
The complete idiot's guide to
digital photography like a pro /

LIKE A MEDRAWN

Fourth Edition

by Steven Greenberg

VICTORVILLE CITY LIBRARY 15011 Circle Dr Victorville, CA 92395 760-245-4222

ALPHA BOOKS

Published by the Penguin Group

Penguin Group (USA) Inc., 375 Hudson Street, New York, New York 10014, U.S.A.

Penguin Group (Canada), 10 Alcorn Avenue, Toronto, Ontario, Canada M4V 3B2 (a division of Pearson Penguin Canada Inc.)

Penguin Books Ltd, 80 Strand, London WC2R 0RL, England

Penguin Ireland, 25 St Stephen's Green, Dublin 2, Ireland (a division of Penguin Books Ltd)

Penguin Group (Australia), 250 Camberwell Road, Camberwell, Victoria 3124, Australia (a division of Pearson Australia Group Pty Ltd)

Penguin Books India Pvt Ltd, 11 Community Centre, Panchsheel Park, New Delhi-110 017, India

Penguin Group (NZ), cnr Airborne and Rosedale Roads, Albany, Auckland 1310, New Zealand (a division of Pearson New Zealand Ltd)

Penguin Books (South Africa) (Pty) Ltd, 24 Sturdee Avenue, Rosebank, Johannesburg 2196, South Africa

Penguin Books Ltd, Registered Offices: 80 Strand, London WC2R 0RL, England

Copyright © 2005 by Steven Greenberg

All rights reserved. No part of this book shall be reproduced, stored in a retrieval system, or transmitted by any means, electronic, mechanical, photocopying, recording, or otherwise, without written permission from the publisher. No patent liability is assumed with respect to the use of the information contained herein. Although every precaution has been taken in the preparation of this book, the publisher and author assume no responsibility for errors or omissions. Neither is any liability assumed for damages resulting from the use of information contained herein. For information, address Alpha Books, 800 East 96th Street, Indianapolis, IN 46240.

THE COMPLETE IDIOT'S GUIDE TO and Design are registered trademarks of Penguin Group (USA) Inc.

International Standard Book Number: 1-59257-434-3 Library of Congress Catalog Card Number: 2003930986

07 06 05 8 7 6 5 4 3 2 1

Interpretation of the printing code: The rightmost number of the first series of numbers is the year of the book's printing; the rightmost number of the second series of numbers is the number of the book's printing. For example, a printing code of 05-1 shows that the first printing occurred in 2005.

Printed in the United States of America

Note: This publication contains the opinions and ideas of its author. It is intended to provide helpful and informative material on the subject matter covered. It is sold with the understanding that the author and publisher are not engaged in rendering professional services in the book. If the reader requires personal assistance or advice, a competent professional should be consulted.

The author and publisher specifically disclaim any responsibility for any liability, loss, or risk, personal or otherwise, which is incurred as a consequence, directly or indirectly, of the use and application of any of the contents of this book.

Most Alpha books are available at special quantity discounts for bulk purchases for sales promotions, premiums, fund-raising, or educational use. Special books, or book excerpts, can also be created to fit specific needs.

For details, write: Special Markets, Alpha Books, 375 Hudson Street, New York, NY 10014.

Unless otherwise noted, all photos are Copyright © Steven Greenberg.

Publisher: Marie Butler-Knight Editorial Director: Mike Sanders

Senior Managing Editor: Jennifer Bowles

Acquisitions Editors: Renee Wilmeth and Michele Wells

Development Editor: Jennifer Moore Production Editor: Janette Lynn Copy Editor: Molly Schaller Cartoonist: Shannon Wheeler Cover/Book Designer: Trina Wurst

Indexer: Aamir Burki Layout: Ayanna Lacey Proofreader: Donna Martin

Contents at a Glance

Part 1:		Digital Capture: The Future Is Now 1	
	1	Look, Ma, No Film: Why Digital Photography? The pros and cons of digital photography.	3
	2	Pixel, Pixel, Little Star, How I Wonder What You Are! Learn the basics of digital photography and how digital cameras work.	19
Part 2:		Cameras, Computer Hardware, and Software for Digital Capture 29	
	3	So Many Choices: Camera Models That Show Off Their Style Learn how to decide which camera is best for your needs.	31
	4	Attention to Details: Features You Need to Know to Get the Camera You Want A full description of the digital camera features you should look for when making your purchase.	43
	5	Mac Versus Windows: System Requirements for Digital Capture What you'll need from your computer to make and edit digital photos.	67
	6	Software: What You Want to See Is What You Get Learn what software you'll need to take and enhance your images.	87
Part 3:		Let's Take Pictures 95	
	7	Exposure Made Simple The mystery of exposure revealed!	97
	8	I Can See Clearly Now: Lenses How to use and get the best from your lenses.	109
	9	Composition: No Snapshots Here! An easy guide to making your photos look good.	123
	10	Lighting: It Makes or Breaks a Shot! Learn to light a photo like a pro.	143

	11	Resolution: Is Bigger Better? How big does your file need to be?	159
	12	Learning File Formats and Compression Learn to safely make your images smaller and to store and send them by modem—without losing detail.	167
Part 4:		Let's See It: Imaging Techniques 179	
	13	Downloading Your Images Downloading your images from your camera.	181
	14	Improving Your Images Before getting really creative, try some basic image control tools.	189
	15	The Wonderful World of Color Learn the secrets of color correction and image enhancement.	205
	16	The Selection Tools Learn to use selections to isolate areas of your image.	221
	17	Adding Fills and Color Adding color and texture to your images.	233
	18	The Ultimate Retouching Tools Fix those nasty spots and remove unwanted objects.	247
	19	The Text Tool Now you can also add text and text effects to your images.	259
	20	Using Layers to Add Images and Elements Adding layered images and elements to your photos and controlling their positions and size.	269
	21	Filters and Effects Learn to enhance your images—or just make them look surreal!	287
	22	What You See Is What You Get: Calibration The hardest part of digital photography made easy.	303
Part 5:		Output 313	
	23	Print It Out Print out your images and make them look as good as they did on your screen.	315

24	E-mailing Your Pictures to Mom and Other Cool Tricks Display your digital images on television or turn them into wallpaper for your computer, plus learn about AOL and Apple applications that can turn your digital photos into great prints.	323
Appendix		
A	Speak Like a Geek: Digital Photography Words	333
	Index	341

Contents

Part 1:	Digital Capture: The Future Is Now	#
1	Look, Ma, No Film: Why Digital Photography?	3
	Painting with Light: A Brief History of Photography	4
	Schulze's Silver Substance	5
	Heliography	
	Daguerreotypes	
	Talbotypes Father of the Yellow Box	،ا
	Fast Forward: Digital Cameras	8
	First, the Good News: The Advantages	
	of Digital Photography	9
	Now for the Bad News	11
	Go for It!	14
2	Pixel, Pixel, Little Star, How I Wonder What You Are!	19
	It's a Three-Color World (RGB)	19
	Eye to Eye: How the Camera Mimics Your Eye	21
	In the Beginning There Was Film	24
	Pixel Schtick: How Digital Cameras Work	25
Part 2:	Cameras, Computer Hardware, and Software	
	for Digital Capture	29
3	So Many Choices: Camera Models That Show Off Their Style	31
-		
	Research, Research	
	One- to Three-Megapixel Cameras	35
	Three- and Six-Megapixel Cameras	36
	Midrange/Semipro Cameras	37
	Professional Cameras	38
× 4	Attention to Details: Features You Need to Know to Get the	
	Camera You Want	43
	Camera Design	44
	Split/Pivot Cameras	44
	Other Design Considerations	45

	Battery Life	46
	Battery Types	
	Battery Chargers	48
	Tips for Preserving Battery Life	
	Lenses	
	Flash	
	Guide Numbers	53
	Testing the Flash	
	Other Flash Features to Consider	
	Viewfinders	
	Selected Delete	
	Onboard Storage	
	Downloading Options: Kodak DOCK	60
	Burst Exposures	62
	Metering	63
	Resolution	63
	Speed and Sensitivity	
	Extras	64
	Bundled Software	
	A Final Word	
5	Mac Versus Windows: System Requirements for Digital Capture	67
	Windows or Mac?	68
	General Requirements	70
	Central Processing Unit (CPU)	70
	Random Access Memory (RAM)	70
	Bus	70
	Clock Speed	
	Hard Drive	
	Ports	
	Modems	
	Graphic Cards	75
	Monitors	75
	Peripherals	
	DVDs and CDs	18
	DVDs and CDs Printers	
	Printers	78

6	Software: What You Want to See Is What You Get	87
	Improving Composition and Image Quality	88
	Proprietary and Third-Party Software	
	Proprietary Software	
	Third-Party Software	
	Managing Your Images	
	Album Software	
Part 3:	Let's Take Pictures	95
7	Exposure Made Simple	97
	The Lens	97
	The Shutter	
	F-Stops	
	Shutter Speed	
	Putting It All Together: The Relationship Between	
	F-Stops and Shutter Speed	100
	ISO	102
	Creative Control	
	Shutter Speed	
	Depth of Field	
	Manual or Automatic Exposure	106
8	I Can See Clearly Now: Lenses	109
	Types of Lenses	
	Autofocus Lenses	114
	Focal Length	
	Taking Angle and Area of Coverage	
	So What's Normal?	116
	The Telephoto Lens: A Long Story	
	Wide-Angle Lenses: A Short Story	
	Zoom	
	True Zoom Versus Electronic Zoom	120
9	Composition: No Snapshots Here!	123
	Not in the Center, If You Please!	124
	Balance	
	Horizon	
	Cropping: Be Frugal!	
	Color	120

	Contrast	131
	Negative and Positive Space: The Final Frontier	132
	Movement	132
	Viewpoint: Low, Different, or Political	134
	Perspective	
	Foreground/Background	136
	Line and Imaginary Line	
	Watch Your Background	
	Texture	
	Scale	
10	Lighting: It Makes or Breaks a Shot!	143
	Using Available Light	143
	Backlighting	144
	Nighty Night!	145
	Flash	146
	Fill Flash	
	Bounce Flash	
	Using an Extra Flash	
	Get a Bracket!	149
	Adding Lights	
	Color of Light	151
	Lighting Setups: You're a Pro Now!	
	Lighting Safety Tips	
	Stand Still: Working with a Tripod	157
11	Resolution: Is Bigger Better?	159
	Image Resolution/Monitor Resolution	159
	Demo: Calibrating Your Image Resolution and Monitor	
	Resolution	160
	Printer Resolution	
	The Inkjet Exception	
	How Big a File Do You Need?	
12	Learning File Formats and Compression	167
	Getting Quality Images	167
	Lossy Versus Lossless Compression	168
	Lossless Compression	169
	Lossy Compression	169
	Archiving Programs	170
	WinZip for Windows	170
	DropZip and StuffIt for Macs	171

	File Formats: Acrimonious Acronyms	.172
	JPEG	
	TIFF	
	GIF	
	EPS	.174
	PDF	.175
	FlashPIX	.175
	BMP	.176
	So Many Choices!	
	Save It Once!	.177
Part 4:	Let's See It: Imaging Techniques	179
13	Downloading Your Images	181
	Hooking Up the Camera	182
	Downloading Via the Camera Manufacturer's Software	183
	Downloading Via Image-Editing Software	184
	The Fastest Way: Downloading Directly from Cards	187
14	Improving Your Images	189
	Getting Started	189
	Shaping Your Image	
	Free Resize	
	Photo Size	
	Canvas Size	195
	Orientation	
	Crop	198
	Correcting Photos	198
	Perspective	199
	Distort	200
	From Darkness to Light	201
	Quick Fix	
	Smart Fix	203
15	The Wonderful World of Color	205
	Viva Color!	205
	Color Balance	
	Hue/Saturation and Lightness	
	Variations	
	3.7	200

	Other Color Worlds	210
	RGB	210
	Bitmap Mode	
	CMYK	
	LAB	211
	HSB	212
	Grayscale	212
	Indexed Color	
	What Is Bit Depth?	
	A Sharper Image	
	Sharpen	
	Sharpen More	215
	Sharpen Edges	
	Unsharp Mask	
	It's All a Blur	218
	Blur	218
	Blur More	218
	Soften with Smart Blur	218
	Despeckle	219
16	The Selection Tools	221
	Getting Started	221
	Why Use Selections?	223
	Selection Tools	
	Select All, None, and Invert	
	Marquee Selection Tools	
	Lasso Selection Tools	
	Selecting by Color	
	A Selection Saved Is a Selection Earned: Saving Selection	
	Addition and Subtraction, All Without a Calculator!	
17	Adding Fills and Color	233
	Fills	234
	Selection Fills	
	Gradient Fill	
	Demo: Using a Filter to Change the Weather	
	Paint Tools	239
	Paint Tools	
		240

	The Pencil Tool	
	The Airbrush Tool	245
18	The Ultimate Retouching Tools	247
	Getting Started	248
	Demo: Removing Distracting Portions of an Image	, ,
	Using the Clone Tool	249
	Cloning Between Two Photos	252
	The Spot Healing Brush and Healing Brush	253
	The Red-Eye Tool	255
	Cloning Patterns with the Pattern Clone Tool	255
	Fixing Minor Blemishes with the Dust and Scratches	
	Filter	256
19	The Text Tool	259
	Adding Text	259
	Demo: Applying a Drop Shadow	
	Changing the Opacity of Your Type in Photoshop	
	Elements 3.0	266
	Demo: Making Your Type Glow	266
	Vectors to the Rescue	268
20	Using Layers to Add Images and Elements	269
	What's a "Layer"?	270
	Lemme See One	
	Using Layers: The Basics	
	Adding Layers	
	Activating a Layer	272
	Showing and Hiding Layers	
	Deleting Layers	273
	Understanding Layer Hierarchy	274
	Working with Layers	276
	Rotating, Distorting, and Resizing Layers	276
	Moving Layers	276
	Erasing Layers	277
	Transitioning from One Layer to Another	
	Feathering	279
	Soft Edges Make Pleasing Pictures	280
	Putting It All Together: Panoramas	281
	Putting Images Together as One	281
	Assembling the Panorama	201

	Moving Images to the Proper Location	
	Removing Images	283
	Blending Your Images Together	
	Using an Adjustment Layer	
	Using the Smudge Tool	
	Using the Clone Stamp Tool	284
	Restoring Color	284
	Perspective with Panoramas	
	Fix Problems Before They Exist	
	Other Photoshop Elements Goodies	285
21	Filters and Effects	287
	Daddy, What's a Filter?	287
	Whoa, There!	
	Obtaining Filters	288
	Let's Go	
	Artistic Filters	
	Blurs	
	Texture Filters	
	Demo: Applying Multiple Filters	206
	Create Your Own Filter	298
	Create Your Own Filter Effects Make Quick Work of Photo Transformations	298 299
	Create Your Own Filter	298 299
22	Create Your Own Filter Effects Make Quick Work of Photo Transformations	298 299
22	Create Your Own Filter Effects Make Quick Work of Photo Transformations Let's Have an Effect!	298 299 300
22	Create Your Own Filter Effects Make Quick Work of Photo Transformations Let's Have an Effect! What You See Is What You Get: Calibration How the Pros Do It	298 300 303 304
22	Create Your Own Filter Effects Make Quick Work of Photo Transformations Let's Have an Effect! What You See Is What You Get: Calibration How the Pros Do It CIE	298 309 304 304
22	Create Your Own Filter Effects Make Quick Work of Photo Transformations Let's Have an Effect! What You See Is What You Get: Calibration How the Pros Do It	298 300 303 304 304
22	Create Your Own Filter Effects Make Quick Work of Photo Transformations Let's Have an Effect! What You See Is What You Get: Calibration How the Pros Do It CIE ICC Profiles Calibrating Monitors and Printers Calibrating a Monitor with Macintosh/Windows	
22	Create Your Own Filter Effects Make Quick Work of Photo Transformations Let's Have an Effect! What You See Is What You Get: Calibration How the Pros Do It CIE ICC Profiles Calibrating Monitors and Printers Calibrating a Monitor with Macintosh/Windows Calibrating a Printer with Macintosh/Windows	
22	Create Your Own Filter Effects Make Quick Work of Photo Transformations Let's Have an Effect! What You See Is What You Get: Calibration How the Pros Do It CIE ICC Profiles Calibrating Monitors and Printers Calibrating a Monitor with Macintosh/Windows	
22	Create Your Own Filter Effects Make Quick Work of Photo Transformations Let's Have an Effect! What You See Is What You Get: Calibration How the Pros Do It CIE ICC Profiles Calibrating Monitors and Printers Calibrating a Monitor with Macintosh/Windows Calibrating a Printer with Macintosh/Windows	
22 Part 5:	Create Your Own Filter Effects Make Quick Work of Photo Transformations Let's Have an Effect! What You See Is What You Get: Calibration How the Pros Do It CIE ICC Profiles Calibrating Monitors and Printers Calibrating a Monitor with Macintosh/Windows Calibrating a Printer with Macintosh/Windows Manual Labor: Printer Calibration Made Hard	
	Create Your Own Filter Effects Make Quick Work of Photo Transformations Let's Have an Effect! What You See Is What You Get: Calibration How the Pros Do It CIE ICC Profiles Calibrating Monitors and Printers Calibrating a Monitor with Macintosh/Windows Calibrating a Printer with Macintosh/Windows Manual Labor: Printer Calibration Made Hard Tag Your Images with Color Calibration Information Output	
Part 5:	Create Your Own Filter Effects Make Quick Work of Photo Transformations Let's Have an Effect! What You See Is What You Get: Calibration How the Pros Do It CIE ICC Profiles Calibrating Monitors and Printers Calibrating a Monitor with Macintosh/Windows Calibrating a Printer with Macintosh/Windows Manual Labor: Printer Calibration Made Hard Tag Your Images with Color Calibration Information Output Print It Out	
Part 5:	Create Your Own Filter Effects Make Quick Work of Photo Transformations Let's Have an Effect! What You See Is What You Get: Calibration How the Pros Do It CIE ICC Profiles Calibrating Monitors and Printers Calibrating a Monitor with Macintosh/Windows Calibrating a Printer with Macintosh/Windows Manual Labor: Printer Calibration Made Hard Tag Your Images with Color Calibration Information Output	

	Let's Print!	318
	Printing Multiple Copies on One Page	
	Printing a Contact Sheet Directly from Your Camera	
	Photo-Quality Papers: Suitable for Framing	321
	Third-Party Inks	
24	E-mailing Your Pictures to Mom and Other Cool Tricks	323
	Preparing Your Images	324
	Sending Digital Photos via E-Mail:	
	Attaching and Embedding	325
	Demo: Sending Attachments Using Microsoft Outlook	
	Demo: Embedding Attachments Using Apple Mail	326
	What's Your URL?	327
	Hi, Mom! I'm on TV!	
	Sprucing Up Your Screen with Wallpaper	328
	Using AOL's You've Got Pictures	328
	Using iPhoto to Get Booked	329
	Other Cool Things You Can Do with a Digital Camera	330
	Some Helpful Websites	330
Appendi	X	
A	Speak Like a Geek: Digital Photography Words	333
	Index	341

Foreword

The digital revolution is the best thing that ever happened to photography. Freed from the tyranny of photo-processing labs, today's digital photographer easily controls every single aspect of the creation of his images. From shutter click to poster print, the power is entirely yours to do with as you please, with no waiting, no public mistakes, and no unwanted interference from the "experts."

While this newfound creative freedom is undeniably liberating, taking full advantage of it entails learning a slew of new terms and skills, many of which are drawn from the world of personal computing. But fear not! The book you hold in your hands is designed to take you from zero to light speed—even if you possess only basic computer skills and can barely tell the shutter release from the power button on your new digicam.

In an engaging, lighthearted style that never takes itself too seriously or talks down to the beginner, *The Complete Idiot's Guide to Digital Photography Like a Pro, Fourth Edition*, gives you the know-how to make amazing, professional-grade photographs. From the fundamentals of f-stops and shutter speeds, to mastering the powerful automated functions of your digital camera, the authors take your hand and guide you every step of the way.

As a young man, fresh out of school, I worked as a photographer's assistant for the top gun studio photographer in town. Seeing daily the kinds of mysterious mojo he relied upon to make his photographs, and how many ways things could go horribly and embarrassingly wrong, I dreamed of a day when we could manipulate every resolvable dot we captured with those mighty Hasselblads and Sinars. In my personal landscape photography, I grew increasingly frustrated with the craft throughout the 1980s. The pleasure just drains out when you have to wait days or weeks for a custom lab to render your vision—and it sometimes cost me hundreds of dollars to get what I wanted up on the living room wall. I even resorted to buying a Minolta-made Polaroid camera, just to recapture the joy of photography I once felt. When digital cameras became affordable, I was first in line. The fun was back! I created *Digital Camera Magazine* in 1997 and not a day goes by when I don't shake my head in wonder at the marvelous things I can easily do with my cameras, computers, and software.

In the course of my work, I've read hundreds of books on digital photography. Most of these were written quickly to capitalize on a hot trend, rehashing the basics like some tired old textbook from the 1950s. In my experience, only a few of these titles manage to capture the pure, unalloyed *joy* that digital technology brings to the art and science of photography. And among those, fewer still can infect the reader with the

desire to *go out and take pictures*, making concrete the occasionally abstract concepts of digital capture and image editing. Best of all, this delightful little book makes the process of learning digital as enjoyable as it is informative—a rare thing in the world of photography writing.

Buy it, read it, then put it down and go rediscover your world through the lens of your digital camera.

—David T. MacNeill, editor-in-chief, Digital Camera Magazine

Introduction

We are in the age of information. With a few pecks at our keyboards and a glance at our monitors, we can find out almost anything. We can access, store, and manipulate massive amounts of information, all due to the digital age.

Our ability to rapidly acquire and process information, coupled with the exponential growth of technology, has led to the development of wonderful tools, including digital cameras. Image-enhancing software, cheap and transportable storage devices, and ever-increasing computing power have made it possible to photograph without film.

Computer stores are everywhere. You might be in a computer store at this very moment, reading this book (please buy it, it's great!). Look down the aisles and you'll see cartons of computers, miles of monitors, and plenty of peripherals. But now, more and more shelf space is being given to digital cameras. Yes, it's true, Toto—we're not in Kansas anymore; we've entered a wonderful and colorful world.

This book takes in a wide view of digital photography. We'll start with a quick history of photography and along the way learn the basics of exposure and composition. We'll also learn how to purchase a digital camera and how to use and get the most out of it. Enhancing and manipulating an image can be fun and exciting, and we'll look at those issues, too.

For a little additional help along the way, you'll find these extras throughout the book:

Say Cheese

Find all your digital photography tips and tricks here.

In Plain Black & White

If you just get fed up with all the jargon and buzz-words that surround technology, fret no more. This is the place to get up to speed on the latest "digitese" and impress your technophile friends with your word power.

Flash

Be sure not to miss these warnings about hang-ups you might encounter while becoming a digital image enthusiast!

Behind the Shutter

Here, I share some inside stories, notes, and general wisdom that can broaden your understanding of digital photography.

Trademarks

All terms mentioned in this book that are known to be or are suspected of being trademarks or service marks have been appropriately capitalized. Alpha Books and Penguin Group (USA) Inc. cannot attest to the accuracy of this information. Use of a term in this book should not be regarded as affecting the validity of any trademark or service mark.

Part

Digital Capture: The Future Is Now

When does the future become the present? When does futuristic technology become new technology? When will we all have tri-corders? Technology becomes real when it can be seen and when it can be used. As a professional photographer, I have been using digital cameras almost exclusively for 10 years. If you look in the advertising sections of the newspaper or in the dozen or so computer catalogs you get in the mail each week, you'll see digital cameras everywhere. All the photographs in this book were taken with a digital camera. The future is now—and it's affordable!

Look, Ma, No Film: Why Digital Photography?

In This Chapter

- Looking into the history of photography
- Understanding the advantages of digital photography
- Understanding the disadvantages of digital photography

Why digital photography? Because we are control freaks, that's why. We want to move, recolor, and manipulate our photos. We want to see them right away, and we want to show them to everybody. With digital photography, I can e-mail the most adorable picture of my wife and my dog to my parents, my in-laws, my wife's grandma, my sister, my wife's sisters, or anyone who has ever sent us a holiday card, or I can post it on our family website for all the world to admire. (Of course, the true power of digital photography is that I can make our dog, Wrinkles, look adorable in the first place.)

Digital photos of Wrinkles have been the star of our family website many times.

Painting with Light: A Brief History of Photography

The first cameras were not anything like what we use today. They were, however, used for the same reason: to capture light. The earliest cameras were, in reality, just darkened rooms. A small hole in a window shade or in the side of a wall let light in and a perfect (albeit upside down) image of what was outside the room would appear on a far wall or some other surface. This device was called the *camera obscura* (literally "dark room"). We do not know who first used the camera obscura as a tool to aid draftsmen and illustrators, but there are drawings of it in Leonardo Da Vinci's notebooks from the late 1400s. The camera obscura also became a great source of entertainment for the general public.

Behind the Shutter

Camera obscuras can still be found today. Unfortunately, many are in danger of being dismantled or are in poor repair—including the 50-year-old Giant Camera overlooking Seal Rock in San Francisco, which was slated to close at the end of 1999. After many friends of camera obscuras waged a campaign, the camera was added to the National Register of Historic Places on May 23, 2001. If you would like more info on camera obscuras, check out www.brightbytes.com/cosite/cohome.html. An Internet search using your favorite search engine is also a great way to get more information.

Behind the Shutter

When I was in college, some of my friends made a camera obscura of their dorm room. They blocked out all sources of light from the room, covered a window (which faced out onto a park) with opaque paper in which they cut a small hole, and fashioned a shutter out of tape. On the opposite wall, which was the focal point, they hung rolls of transparency slide film. After the tape was removed and the film was exposed, they rolled the film up, placed it in a light-tight box, and had it developed! To display the developed images, my friends built a huge backlit box with a frosted piece of Plexiglas. It was beautiful!

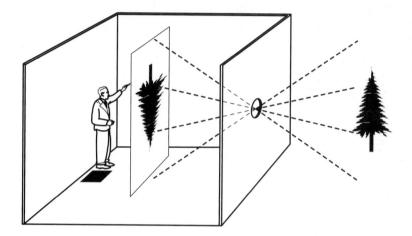

Some camera obscuras were as large as rooms. Others were small and portable and mounted on horse-drawn wagons.

In 1764, Count Francesco Algarotti devoted a chapter to the camera obscura in his *Essay on Painting*. He said, "The best modern painters, among the Italians, have availed themselves greatly of this contrivance; nor is it possible they should have otherwise represented things so much to life." The camera had grown from an amusement center to a tool. This was also the beginning of painting by numbers.

Schulze's Silver Substance

In 1727, a German physicist named Johann Heinrich Schulze discovered that light could be used to alter substances. He put silver, chalk, and nitric acid together in a bottle, did the hokey pokey, and shook it all about. He then exposed the mixture to bright sunlight and found that the mixture darkened to black. To prove that this was a photosensitive reaction as opposed to a heat-induced reaction, he repeated the process but exposed the mixture to intense heat. Proving his theory, this experiment produced no change in the mixture.

As the camera obscura became much smaller, it began to be used in the field to help artists render life and nature.

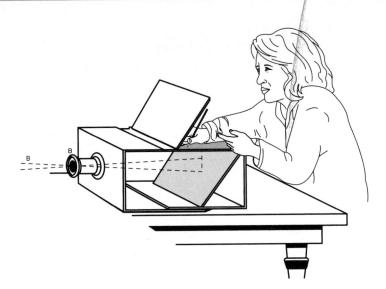

Heliography

Joseph Niépce (pronounced NEE-epps), a Frenchman, began to experiment with photosensitive materials around the early 1800s. Niépce found that bitumen, an asphaltlike substance, would harden when exposed to light. He coated metal plates with bitumen and exposed them to light inside a camera obscura. After a long exposure, the plate was washed to remove the "unexposed" bitumen, and was then dipped in acid, which etched the exposed metal. Finally, the plate was coated with ink and struck to paper. A print of the original image was produced. Niépce called this process *heliography*.

Daguerreotypes

Around 1825, another Frenchman, Louis Daguerre, was experimenting with the same process. Although Daguerre and Niépce did collaborate on the photographic process, Daguerre took a slightly different direction. He chose to coat a copper plate with silver, and then expose the silver to iodine fumes, creating a silver-iodide salt. This made the plate photosensitive. The plate was then placed in the camera obscura and exposed to light for a long period of time. As demonstrated by Schulze, the silver-iodine would darken when exposed to light. The downside for Daguerre? After it was exposed, the silver salts would continue to darken until, eventually, the entire image became black.

Daguerreotypes were originally rare and expensive; only the very rich could afford daguerreotypes. Later, after the Civil War, they became very common and affordable to the general public.

Daguerre solved this problem by accident: he left an exposed plate in a cabinet in which mercury was being stored. When he retrieved the plate, he noticed that the image had stopped developing; it did not continue to darken. The mercury fumes had fixed the image. Because this was not the healthiest way to make a photograph or to

remove the unused silver, Sir John Herschel, a British astronomer and scientist, suggested in 1819 that the plate be washed with a solution of *sodium thiosulfate* (formerly called sodium hyposulphate, thus the photographer's slang "hypo"), which would chemically remove the unexposed silver. Daguerre called his photos *daguerreotypes*.

(Na₂S₂O₃), a.k.a. sodium hyposulfate, is called "fixer" by those of us who still "do film."

Talbotypes

Working at the same time as Daguerre was Englishman William Henry Fox Talbot. Fox Talbot used a similar process to Daguerre's, except that he used paper instead of metal for his "plate." The image he produced was a negative. (Remember, where light struck the silver, it turned black; where it didn't, the silver was unaffected or remained white. The daguerreotype was also a negative image, and had to be held at a proper angle for it to look "positive.") Talbot took the paper negative, waxed it to make it

translucent, and sandwiched it face to face between sheets of glass with another sheet of sensitized paper. He then exposed the sandwich to sunlight to produce a "positive" image. Talbot could now reproduce his—you guessed it—talbotypes over and over

Behind the Shutter

Some of the most beautiful prints I've ever seen were made with 16X20-inch glass plate negatives that were printed out on paper with an albumen and silver emulsion. Albumen, which is made from egg whites, forms a colloidal suspension, which holds the silver nitrate particles. This mixture is called an emulsion. The emulsion can be coated on paper, glass, or even tin.

again. This was the first negative-to-positive process, the avenue all photography took for more than 100 years—until digital came along.

Father of the Yellow Box

In 1888, George Eastman perfected the process of flexible, acetate-based films. Eastman's new company, Kodak, marketed a camera that contained a roll of film long enough for 100 exposures. The user would return the used camera to the Kodak Company, which would process the film, print the images, and return them to the owner with a freshly loaded camera.

Fast Forward: Digital Cameras

As with many of our modern inventions, digital photography owes much of its advancement to the military and to space exploration. The need to take sharper images and to view them as quickly as possible lent much to the development of digital cameras and imaging technology. Using digital technology, images could be beamed from miles above the earth to reveal hidden missiles or help predict crop growth. Unmanned spacecraft beamed back our first look at the dark side of the moon and the heavens above.

In 1981, the Sony Corporation produced the first consumer electronic camera, called the *Mavica*. Short for *magnetic video camera*, the camera produced still video images (the Mavica wasn't *truly* a digital camera, because its images were actually analog recordings). The race to produce "filmless" cameras was on.

In 1994 Apple Computer, in collaboration with Kodak, developed the first truly digital camera, the QuickTake. (How very forward thinking of both companies!) The handheld camera had a fixed-focus lens and could take anywhere from 8 to 32 images, depending on the resolution of the images. Images were stored internally and could be downloaded to a Mac or PC via a serial port. It sold for about \$700.

Behind the Shutter

There are many rumors about how George Eastman coined the word Kodak. Some thought it was in reference to the sound the shutter on his cameras made, but as he explained: "I devised the name myself. The letter K had been a favorite with me—it seems a strong, incisive sort of letter. It became a question of trying out a great number of combinations of letters that made words starting and ending with K. The word Kodak is the result."

Kodak also produced one of the first "professional" digital cameras, called the DCS 2. It produced, in a single shot, a 4MB color image. The camera was built on a 35mm Nikon SLR (single lens reflex; for an explanation of this camera type, see Chapter 3) platform, but a digital chip was fixed in the camera's back in place of film.

Several years ago if you'd asked companies like Kodak, Fuji, Agfa, or Polaroid why they produce cameras, you'd get an interesting answer: to sell film. Film is where they make the most profit. Why, then, would they become involved in the digital-camera market? Here's my guess: they saw the writing on the wall. For the most part, these companies have ceased to produce film cameras, although they will continue to make film for some time to serve the existing base of film cameras.

Behind the Shutter

The DCS 2 was the first digital camera I owned. My introduction to digital photography cost me \$35,000, not including the necessary computer, software, training, and aspirin. Don't worry—it won't cost you that much these days!

These days, everyone's in on the digital camera action. Of course, most of the major camera manufacturers are producing digital cameras; even more interestingly, companies such as Leaf are evolving their scanning technologies into digital camera equipment such as digital camera backs. Some high-end digital cameras are really camera-mounted scanners.

First, the Good News: The Advantages of Digital Photography

Digital cameras are everywhere. Store shelves are lined with them, and Sunday newspaper circulars are filled with advertisements for them. But why buy one?

If you are perfectly and completely happy taking pictures with your film camera, then don't buy a digital camera. But remember, you have to finish the whole roll, bring the film to the processor, and wait for the prints to come back, just to find out everyone in the "once-in-a-lifetime picture" had their eyes closed. Let's also not forget that you have to pay for the processing and buy film. Oh, by the way, you had better buy a few extra rolls, some for indoors and some for outdoors. So what are the advantages of digital?

- No more film! That's right, ladies and gentlemen, children of all ages, you'll never need to buy film again. Using a digital camera means that you can take pictures without paying for film or wondering which type of film to buy.
- ♦ No running out of film. If you are careful with your storage, you will also never run out of film. The storage cards, which fit into your digital camera, can hold large numbers of images. Most digital cameras can now accept mini—hard drives that have very large storage capacities. With a few of these storage cards in your camera bag, you can go on taking pictures for days.
- ♦ No more processing costs. No matter how you get your film processed, it gets to be expensive. You can't get around paying for processing unless you take digital photos. And if you choose to have your photos processed professionally, you can choose to get your photos back as digital files on CDs in addition to or instead of prints.
- "I wanna see them now!" Digital photography enables you to see your photos instantly; no more waiting for your film to return from the lab. Many cameras have LCD preview screens, so you can see the image instantly, or you can download your images to your computer as soon as you take them.
- ♠ Reshoot! If somebody walked into your carefully composed shot or if the baby's eyes were closed when the shutter snapped, you'll know it immediately. You can simply retake the image. You can also preview all the poses you just took of your dog and delete the ones you don't like.

Behind the Shutter

As a professional photographer, digital photography has become an indispensable tool. My clients can use my computer monitor to view the image I have just taken; they can approve it on the spot or we can make changes. When the image is finished, I can then move on to the next setup or job. I don't have to wait for my film to come back from the lab or worry that I missed something in the Polaroids.

- ◆ Control. If you couldn't get close enough to your subject or the camera wasn't level when you took the picture, have no fear! You can fix it. You can easily crop or rotate your picture, remove spots, fix color, and lighten, darken, blur, or sharpen your images. With a little skill, you can even add Uncle Harry into the family photo even though he arrived late. Try that with a drugstore print!
- Get out of the dark. For those of you who spent hours splashing about in your darkroom to produce only a few prints, you are free. You can set up your computer in the light of day and image edit all you want. Imagine! You can be social and manipulate images at the same time. You can see and be seen by your family and friends. If you have special talents, you can even work on your computer and watch the football game simultaneously!
- Everyone can see it. With the advent of e-mail and modems, you can easily send a photo of a newborn to distant relatives or post it on your website. You no longer need to take the time or spend the cash to make multiple copies of an image and distribute them.
- ♦ It will last forever. Negatives and prints fade. They are subject to ultraviolet light, humidity, and grubby fingers. Digital images, however, will last forever if carefully stored! There are some concerns over long-term storage on both magnetic media and CD/DVD, but if you back up your data you should be safe. And if your printout of the image gets damaged or you want to make a duplicate, all you need to do is pull up the file and reprint it. Your only cost is a sheet of paper and the ink/toner.
- Get green! Digital photography is environmentally sound. There are no processing chemicals to wash down our sewers, and the massive amounts of water and electricity used to process film are no longer needed. Plus, you won't need to worry about recycling those little plastic film containers. (You do recycle them, don't you?)
- ♦ It's fun! Photography is fun, and digital photography is more fun! And because you don't have to worry about having enough film with you or whether the picture came out, you might even say it's liberating. So grab a camera, take a few shots, and go have fun!

Now for the Bad News ...

There are some downsides to digital photography. Digital photography is not yet perfect, and we are all still paying for the manufacturers' research and development costs.

Although storage devices are getting less expensive every day, they still are not as cheap as a cardboard shoebox. Here are some of the cons:

- ◆ Limited resolution. If you are going to use the image in a company newsletter or on a website, you will probably have no problem using a digital camera. If you plan to enlarge the picture to poster size and frame it on the wall, you will need to use one of the high-end digital cameras with 12- or 14-megapixel output. If, for example, I were to spend hours to climb to the top of a mountain (and I do), I would not use a low-end digital camera to capture the skyline for a print on my wall or to sell as a stock image. I would have no problem, however, using a low-end digital camera to grab a shot of my wife skipping over the rocks and streams (and she does).
- ♦ This stuff can be expensive. With digital cameras costing from about \$100 for a "point and shoot" to more than \$8,000 for some of those bells and whistles, many of these cameras are not cheap.
- ◆ Equipment upgrade. Assuming you already have a computer, you might need to buy more RAM (memory). If you don't already have a good color printer, you had better put one of those in your shopping cart, also. (While you're at it, please buy a decent surge protector.) If you are serious about this new hobby, a larger monitor screen will help keep eye fatigue down.
- ♦ Shutter lag. Most point-and-shoot digital cameras have a delay between when you press the button and when the camera takes the photo. This shutter lag can be several seconds in some cameras. Cameras with such shutter lag are completely unsuitable for photographing rapidly moving subjects such as animals and children. Information on shutter lag is generally hidden somewhere in the technical specifications of cameras, so be sure to check this information for any camera you are considering buying.
- ♦ Noise. If you were to look in the dark areas of an image, such as in a shadow or on a black surface, you might see *noise*. Hmm. Seeing noise. Now that's a funny thing! If you think of digital information as a television signal, noise would be just like the static you get when you try to tune in to a weak station. Noise generally appears as blue or red/blue static in the shadow areas. Noise often looks like film grain in high-speed film.

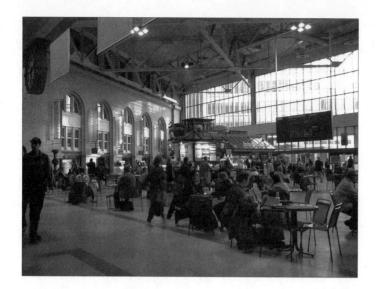

A dark interior, such as Boston's South Station, can wreak havoc with your camera. Bright areas, such as the windows, make automatic exposure even more difficult.

• Pixilation. When you have enlarged an image too much, you'll see pixilation, or little squares in the image. These squares occur when the image file doesn't contain enough information to properly display the image at the size you've speci-

fied (another word for the information in a photograph is *resolution*). Sure, you can continue to make the image bigger, but that means your computer will only make up the information it needs to display the image, *interpolating* it.

◆ Stair-stepping. Another result of low resolution is *stair stepping*, which usually occurs on diagonals in an image (you guessed it: they look like little stairs). The more information (resolution) your image has, the smaller those stairs become. You might also see stair stepping on round objects or curved objects, such as balloons or wheels.

In Plain Black & White

Interpolation is a technique that the computer and software use to estimate the tonal value for a missing pixel that should appear between two existing pixels. This is also known as an *intelligent guess*. It is much better to have the information there in the first place than to have your computer think it up for you.

Color distortions. A digital camera might just get the color wrong. No, you're not going to see blue grass or red skies (unless you're on Mars), but you might see orange when you expect to see yellow, or purple when you expect blue.

Color distortion is usually due to poor interpolation by the camera software. Most of the time, this can be easily corrected; I'll show you how in Chapter 14.

- ♦ Wait, wait. Most cameras, in order to save battery power, automatically go into an energy saving or *sleep* mode if not used for a few minutes. Depending on the camera and how "awake" it is, there can sometimes be a second or two delay between the time you press the shutter button and when the camera actually takes the picture. You might also have to wait a few moments after taking one picture before the camera is ready to take the next one (the camera might have to process the image and store it to memory).
- ◆ The learning curve, again. Taking a picture with a digital camera is not any more difficult than with a film-based one; it might even be easier for you. Getting the image out of the camera, processing it, and getting a great-looking print, however, are not going to be as easy as they were before (at least not at first). You are going to have to learn some new skills and invest some time in practicing them.

If you enjoy playing with your computer and learning new skills, digital photography can be a lot of fun. If not, you might not want to "do the digital," or you might want to let your local camera store deal with downloading your pictures and printing them for you.

Go for It!

Digital photography can be a load of fun and an inexpensive way to take pictures after you get yourself set up. It provides a spontaneous way to create images without having to worry about film, processing, and the costs involved, and it gives you the freedom to create images, explore, and be an artist. Digital photography can also be an invaluable business tool, providing a great way to communicate ideas and broadcast images.

So who needs a digital camera?

◆ Insurance agencies are using digital cameras to take photographs for claim records. Agents can take a picture of a crumpled fender or broken window, attach it to the claim form, and instantly e-mail it to the central office. This can cut a day or two off the settlement time (oh, happy clients!). Also, the image can become a permanent (read: non-fading) part of the electronic record and can be accessed by anyone at the firm at any time.

Realtors can use digital photographs to show off the beautiful houses they are listing. The images can be shown to a prospective buyer, published into a listing sheet, or even posted on a website. With QTVR (Quick Time Virtual Reality), virtual tours of the inside of a home or office building can be produced to show to a client.

Behind the Shutter

With the advent of Quick Time Virtual Reality (QTVR) technology by Apple Software, photos can be taken of an object or a scene and then the images can be animated. To begin, the object is rotated in front of the camera, and a picture is taken each time the object moves 10° until it has completed a 360° revolution. To photograph a scene, the same process takes place—except that this time the camera rotates 360°, taking one picture every 10° for a total of 36 shots. You can post these QTVR images on a website or display them as part of a multimedia presentation. The viewers can see all 360° of the object, or take a virtual tour through a hotel lobby or museum. Recently, sports television has taken advantage of this technique by placing multiple cameras in fixed positions around the playing field or arena. They then can show the audience a replay and rotate the point of view as the play advances.

While still in their offices, realtors can show pictures of homes to prospective buyers.

Small business owners and professionals can use digital photography to help skip the traditional prepress scanning process. They can save time—and we all know time is money! A word to the frugal here: be sure you know what you're doing

- before you try to "go it alone." It is very costly to have a press house fix your mistakes. A missed deadline can also be very expensive!
- ♦ Retailers can create databases of photographs of all those various gizmos they sell, which means their customers don't have to use their imaginations to see all the large and the small gizmos in red, green, blue, or whatever variation is available. Imagine the competitive edge you'll have! Again, using QTVR photography, you could even animate your gizmo so that your customers can see the top and bottom or all four sides.
- ◆ Digital pictures are perfect for the web. (Note: The smaller the file size is, the faster the image can be delivered to your screen from a website.)
- ◆ Digital photography is great for use in small offices. You can produce newsletters or take reference photos of products for your sales force. You can use a digital camera to photograph a new client so all your staff and sales team will be able to greet your new client on sight and by name. Interoffice mail can be made more personal and websites more informative.
- ◆ Doctors, dentists, and surgeons can use digital cameras to take reference photos of patients. You can show your patients before and after images; you can use images for your medical records, or attach them to an insurance claim. But before you spring for a digital camera, spring for a few new magazines in your waiting room!

Digital cameras have more than enough resolution for website photos.

- Newspaper and other journalistic photographers are using digital cameras on an increasing basis. The resolution from a mid- to high-end camera contains plenty of information for the typical newspaper or magazine. In fact, many of these digital images are being delivered via satellite. Photographers are carrying small uplink satellite dishes to beam their images directly to their editors' desks.
- ♦ At home, you can take pictures of all your valuables—not to show to your friends, but to keep as a record for insurance purposes. (It might be a good idea to keep a copy of the files in a safe place outside of your home.)
- ◆ Take family pictures. You can take these cameras anywhere. You can take tons of shots and edit out the ones you don't want later. You'll be surprised at the pictures you'll take when you are not worried about wasting film.
- You can make art! You can have loads of fun being creative and manipulating images. You can take many views or variations of a picture; you can take pictures at different times and places and collage them together. This can be a very liberating experience.

I use a newsletter to inform my clients about recent events at my studio. Digital photography is a great way to facilitate the newsletter and improve its visual appeal. Digital photography can be used to enhance reality. Can you tell which flowers are original, and which were cloned?

The Least You Need to Know

- Photography as we know it began with the invention of the camera obscura.
- ♦ Although photography originated as a chemical process, all aspects are rapidly changing to digital. You can run with the herd or be left behind in the dust.
- ◆ There are many pros to using a digital camera, but there are some cons as well. One of the cons is that it is still relatively expensive to buy a digital camera with fully professional features—features that have been on moderately priced film cameras for some time.
- You can use digital photography for many purposes. If you have aspirations of building a website, you will find that creating your original images digitally is much easier and faster than scanning from film.

Pixel, Pixel, Little Star, How I Wonder What You Are!

In This Chapter

- Getting the lowdown on pixels
- Making the most of light in your photography
- Understanding how digital cameras work

So what is a pixel? (Hint: They are not small fairies with rapidly beating wings.) What are light rays? How does the camera work, and how do you change those light rays into electronic data? Read on!

It's a Three-Color World (RGB)

When white light is passed through a prism, it is separated into its component colors so that a whole spectrum of color is visible. You could reverse this process, stuffing the entire spectrum of color back through the prism to get back to white light, but you don't need to—all you really need are red, green, and blue. If you don't believe me, go and try it yourself. If you do believe me, go and do it anyway; it's an impressive demonstration.

We call this color world the RGB color world (where RGB stands for red, green, blue), also called RGB color space. And because we added the three colors together to get to white light, the process is called additive color. While we're at it, we might as well call those three colors—red, green, and blue—additive primary colors.

Behind the Shutter

If you're a nonbeliever, conduct the following experiment: Get three strong flashlights, and cover one with a red gel, one with a blue gel, and one with a green gel. Then tack a piece of white paper on your wall. Darken the room, and shine the lights on the paper. You should get white light. (If you feel foolish doing this, get your kids to do it as a science fair project.)

Some of you might be jumping out of your seats and yelling, "But green isn't a primary color!" Well, you're right and wrong. The additive primary colors are red, green, and blue. For any coloring matter such as dyes, pigments, or paint, you are dealing with subtractive primary colors, which any artist will tell you are red, yellow, and blue. If you don't believe me, check out a few books on color theory from your public library and look it up for yourself. If you are curious, it makes for a mind-boggling, but fascinating read.

Additive and subtractive primary colors may be easier to understand if you take a look at the double triangle pictured here.

The classic double triangle.

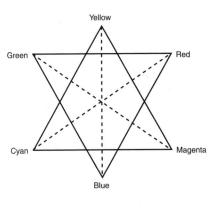

Okay, this part gets tricky, but hang in there. It will all make sense in the end. Take a deep breath; I promise there will be no test. Let's say the green light that you're stuffing back through the prism was blocked. The resulting color would be magenta, a subtractive *secondary color* that is opposite green in the classic double-triangle illustration, and a combination of the two remaining primary colors, red and blue. The other subtractive colors are yellow, which is the opposite of blue, and cyan, which is the opposite of red.

To make this discussion more relevant to photography, suppose you were to reduce the amount of green in a photograph. Yes, you guessed it: the picture would appear to be more magenta.

When you look at printed color photos in magazines and books, you will have the impression of seeing all colors. In fact, there are only three colors of ink used: cyan, magenta, and yellow, the subtractive primary colors. In theory you could print with just those three, but because it is difficult to get really dense blacks from combinations of these three subtractive colors, black ink is also added. This is referred to as four-color printing, the most commonly used type of color printing. You will also find when you begin to work with inkjet printers that many of them also use the same three subtractive colors plus black. (In the printing industry this is referred to as CMYK color printing, with K standing for black. Don't ask me why!)

Eye to Eye: How the Camera Mimics Your Eye

The color our eyes see is a result of light reflecting off an object. An apple appears to our eyes as red because the apple's skin absorbs both blue and green light and reflects back only the red. (Unless, of course, you are looking at a Granny Smith apple.)

Our eyes are made of three basic parts:

- The *lens* focuses the light on the back of the eye.
- The *iris* helps form the *pupil*, the little black hole, which regulates how much light enters the eye.
- ◆ In the back of the eye is the *retina*. On the retina are the light-sensitive cells that send the nerve signals to the brain. Some of the light-sensitive cells on the retina see red, some see green, and some see blue. Your brain processes all the information and voilà, you see color! (See what I mean about RGB being primary colors?)

It's no wonder that the camera mimics the eye almost exactly. Both incorporate the same two fundamental laws of light:

- ◆ Light travels in a straight line unless it is interrupted, or bent. This explains why an image is inverted when it travels through a lens. As the light travels from the top of your subject, it continues through a hole in your camera (the lens) and to the bottom of the back of your camera. As light travels from the base of your subject, it again passes through the lens and continues to the top of your camera back. Voilà, your image is inverted. This theory works for eyeballs, pin holes, lenses, and camera obscuras.
- When light enters a denser medium, it bends. To get a little more complicated, when entering a thicker medium, light bends toward the denser part of the medium. This is how a lens works. This is also why a fish seen in a stream or lake isn't where it appears to be, a fact that makes spearing a fish extremely difficult.

Just as early inventors of flying machines mimicked birds, camera designers mimicked the eye.

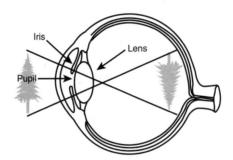

The eye is a good model to copy for our camera. It has all the necessary parts we need. First, we'll use a few lenses to focus the light. Next, we'll use a mechanical diaphragm to replace the iris and regulate how much light enters our camera body. And finally, we'll use film or an electronic image sensor as our retina.

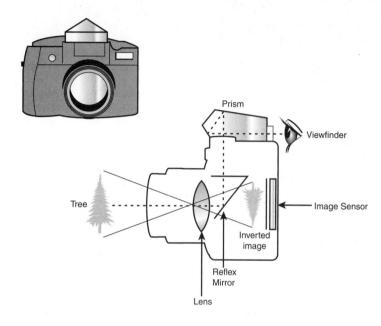

In this diagram of a typical single lens reflex camera, light travels through the lens, reflects off the mirror, and is redirected by the prism to your eye. When the mirror is in an "up" position, the light continues to the back of the camera and strikes the film.

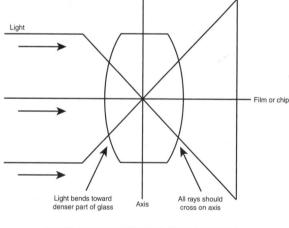

Notice how similar the lens is to the eye!

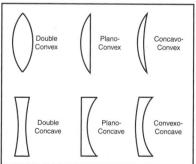

In the Beginning ... There Was Film

Let's start by discussing how black-and-white film works:

- 1. Silver iodide crystals are suspended in a gelatin emulsion. Think of emulsion as Jell-O® with pieces of fruit (silver iodide crystals) floating in it. The emulsion is coated onto a clear substrate. (We call this substrate *film*.)
- 2. The silver is exposed to light (a picture is taken).
- 3. The film is developed. The silver, in the form of silver iodide crystals, is "binary" in the sense that it can exist in two states, excited by light or not excited by light. Development converts the excited crystals into metallic silver grains. Areas of the film that get a lot of light end up with lots of black silver grains, areas with less exposure end up with fewer grains, and areas with no exposure end up with no grains. The density of the silver grains determines how dark a given area of the film turns during developing.
- 4. The development is stopped (stop bath) and the unexposed silver is removed (fixer). It is then washed to remove all chemical residue.
- 5. The film is dried. We now have a negative!
- 6. Light is sent through the negative onto another film (or paper) to make a positive. (Remember, two negatives make a positive.)

So just how does color film work, exactly? To put it simply, color film is broken down into three basic layers. (Actually, there are many more layers, but I'm trying to keep things simple.) There are two types of color film, color negative and color slide (transparency) films. The two work in reverse of each other. Color slide film is easier to understand because it is a direct positive-to-positive process, as follows:

- ♦ The red-sensitive layer turns red when red light strikes it.
- ♦ The blue-sensitive layer turns blue when blue light strikes it.
- You guessed it: the green-sensitive layer turns green when green light strikes it.

Sound familiar? When light is passed through slide film and all the layers of color, we see a colored picture.

Color negative film has a pronounced orange/brown color after developing due to a mask that is added to make color prints turn out better. The actual image colors in a

color negative are reversed, so a red object produces a green image. Projecting this back onto color paper with a similar composition (minus the orange mask) produces a positive color image.

Behind the Shutter

In case you're curious, here's how this all works: When light strikes its corresponding layer, it excites the silver residing on that layer. The layers are filtered so that only red light affects the red layer, only blue light affects the blue layer, and so on.

But wait! Doesn't silver turn black or shades of black? How can silver turn into a color? Here's how: the silver, in its excited stage, activates a *color coupler* (the color coupler is mixed with the silver in the emulsion).

When the film is being processed, it is dunked into a solution called *developer*, which contains chemicals that work in combination with the color couplers. Those excited color couplers combine with other chemicals in the emulsion to form transparent colored dyes inside the film layers.

After the chemical developing is stopped, a bleaching bath followed by a fixing bath is used to convert the silver into water-soluble silver salts that are removed by washing, leaving only the color dyes. There is no silver in a color negative or in a color print—it's all left in the fixer.

Pixel Schtick: How Digital Cameras Work

Instead of film, digital cameras contain *imaging arrays* onto which the lens focuses light. (Many people call arrays *chips*, which is perfectly legal; no points will be deducted from your score.) On these chips are CCD (*charged coupled device*) or CMOS (*complimentary metal-oxide semiconductor*) sensors.

When the CCD or CMOS image sensors are struck by light, they generate an electrical charge that is turned into binary information by the camera's processor. This digital information, the ones and zeros (or offs and ons), are the heart of how computers work. In fact, the capability of the processor to change color and brightness information into machine code is the reason we are able to manipulate a photograph in the first place. In a color camera, the image sensors are filtered to accept only certain colors—you guessed it: red, green, and blue.

Digital cameras capture information in many ways:

The simplest type of array aligns the individual sensors in a line. This is called a *linear array*. A linear array can capture only one color at a time; the array is

Behind the Shutter

CMOS chips used to be found in certain modestly priced digital cameras and web cams, but great improvements have been made in CMOS sensitivity, and CMOS sensor chips are now used in some of the very highend digital cameras, such as those from Canon, and in professional digital backs for medium format cameras.

moved across the long direction of the image plane three times to capture color (once for red, once for green, and once for blue). The major drawback of a linear array is that the subject cannot move, and the lighting must be constant during the exposure. Many photographers using linear array will use photo-floods or filmmaking equipment to light their sets. There can also be color registration problems if the camera moves because the chip must return to the exact same starting place at the beginning of each scan. This type of array is used in some scanning backs for medium- and large-format professional cameras. They are used for very high-resolution images of nonmoving subjects.

In Plain Black & White

So what is a "pixel"? I've been throwing the word around a lot so far. A pixel, which is short for picture element, isn't a thing, exactly; it is more of a description of a thing. If you were to enlarge a digital photograph, eventually you would see little squares of color. These are pixels, which are created by the image sensors. You might say you are seeing the CCDs or CMOSs themselves, but you would be wrong, so don't say that. CCDs and CMOSs only tell the imaging software to draw or create a little square to represent how much light struck it and what color the light was. The more pixels there are in a picture, the higher the resolution the picture is said to have.

♦ The next step up the evolutionary chain is the *tri-linear array*. This array has three rows of image sensors on it; each row is filtered for one of the primary colors. The array scans the image plane only once, which greatly reduces the time it takes to make an exposure. Color registration is also greatly increased. Because there is little to no interpolation, these arrays are very accurate when it comes to color. If these arrays are long enough and allowed to travel over a

large distance, they can produce very large files. These arrays are commonly used in professional still-life photo studios, but again, the array must be moved down the image plane, the subject cannot move, and the scene must be constantly lit.

♦ Single-shot color can be produced by a *stripped array*. This is the most common type of chip set you will find in today's cameras. The image sensors are again arranged in rows and columns, but tiny (one might say itty, bitty) colored filters are arranged over the individual CCD or CMOS. The filters can be arranged in a repeating simple pattern (RGBRGB) or in a more complex pattern (RRGBR-RGB). The patterns differ depending on the chip and camera manufacturers; color resolution depends on what type of chip is being used and what type of interpolation is being done.

Behind the Shutter

On color film, the red, green, and blue layers are stacked over each other. As the light passes through these layers, true (accurate) color occurs. Because the CCDs and CMOSs are not layered over each other but rather sit side by side, you can run into some problems with the color. If a beam of red light strikes the red-filtered sensors, everything is fine; life will be beautiful. But if the red light strikes a differently filtered sensor or a different color strikes the red sensor, you have problems.

But not to worry. Interpolation algorithms look at the information as it comes off each sensor and decide whether the information is correct or not. The algorithms look at the information and say, "Yup, that looks like red light. Pass it on," or "Nope, that's not red, but it looks like blue." (Go ahead, put your ear up to the back of a camera!)

There is also a unique CCD sensor chip made by Foveon that has the red, green, and blue sensors in layers on top of each other just like color film. In theory this should produce much better color fidelity. Currently the Foveon sensor chip is used only in the Sigma digital SLR cameras.

The Least You Need to Know

- The visible spectrum can be broken down into red, green, and blue primary colors.
- Cameras and lenses mimic the human eye.

28

- Digital imaging sensors are activated by light and send electrical impulses, which are changed into digital signals.
- ♦ There are many variations of digital cameras. These include scanning backs and one-shot action backs. These produce black-and-white (B&W) and color (RGB) images.

Part

Cameras, Computer Hardware, and Software for Digital Capture

The blazing speed of computers has spawned a revolution in software development. Software has, and probably always will, lag behind CPU development. Nevertheless, today's software programs enable us to manipulate images in ways we've never dreamed of before. Once upon a time, we were happy if we could rotate a black-and-white image. Today, we can correct the color of an image, triple its size, and sharpen it, all with a few keystrokes.

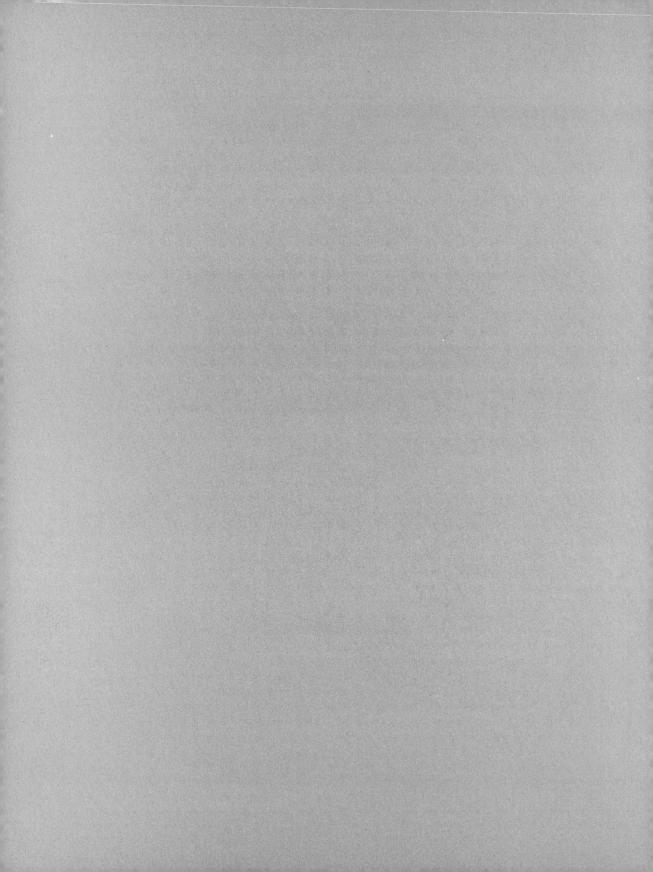

So Many Choices: Camera Models That Show Off Their Style

In This Chapter

- Getting the scoop on various camera types
- Figuring out the best camera for you
- Understanding megapixels

Digital cameras are being produced with so many variations in size, design, and features that it's hard to single out any one of them as the best. It seems as if almost every day a new camera is coming out with a new or better feature list than the last. Although we will be looking at specific cameras and their features, reviewing specific camera models would be fruitless because the industry is moving at such a quick pace. By the time you read this book, some of the camera models on the shelves today will no doubt have been replaced by newer and fancier siblings.

The most enjoyable part of writing this edition was to see the advances in camera technology, specifically the chip technology. The chip sizes have

increased in size from 1 megapixel to 8 or more megapixels. (Don't worry—read on to find out what a megapixel is.) Not only is that a huge size increase, but the most amazing thing is that the price has actually come down! There are many new bells and whistles, and onboard storage technologies have really advanced, as well as the capacity of storage cards. You can now take tons of photos without having to fill your pockets with storage cards.

In addition, many gadgets are coming out that incorporate cameras along with other features, such as cell phones with built-in cameras and MP3 players that also serve as digital cameras. The image quality of these multi-use devices has improved greatly in recent years, and they are certainly no longer just toys.

Research, Research, Research

The best way to get the down and dirty about a specific camera is to do a bit of research. Most of the photography, digital imaging, and computer magazines review digital cameras regularly—it seems as if a new review about a specific camera comes out in each issue. Also, you will find overall "compare and contrast" reviews about cameras grouped by price range, resolution, or ease of use. Many of these reviews rate the cameras, such as on a scale of 1 to 10, or with stars, shutters, or other weird icons. You might even see a "best buy" or "editor's choice." You can also find great information on the web or in a consumer's guide magazine such as *Consumer Reports*.

Another good way to learn about what's new and hot is to look at the manufacturers' advertisements and their websites. See what they are hawking and why, and what gizmo or feature they have that is different or new. Watch out for confusing terminology, however; one manufacturer's "supersonic zoom system" might be identical to another's "wonder wizard system."

Say Cheese

It's important to set up a budget before you go out to buy a camera. A budget helps you decide which camera, printer, or accessories to buy. Plan for the future. Will this be the last camera you ever plan to buy? (I hope not.) Is your purchase planned to get you started, or will you upgrade your equipment in a few years? Do you want to invest in a system that can be upgraded, or will you just go out and buy new stuff in a few years? Do you want to get cutting-edge equipment, or will last month's "wonder" technology do? Some of these decisions might be influenced by your economic advisor (in my case, my wife); other times, you've just gotta have the best camera on the block!

Narrowing It Down: Digital Camera Types

First, let's figure out what type of camera you need. Basically, three major groups of small, portable digital camera designs are available, each with advantages and disadvantages:

♦ Viewfinder cameras. Viewfinder cameras are simple (not to be confused with *inexpensive*) cameras. You will find both traditional and digital cameras in a viewfinder configuration. With a viewfinder camera, you view the subject through a viewing-only lens that is separate from the lens that takes the picture. (I'll refer to the latter lens as the *photographic lens*.) On a less-expensive model, the

viewfinder might be a simple hole in the camera body, covered by clear plastic.

The good thing about viewfinder cameras is that they are usually smaller and weigh less than the other types. The downside is that you experience *parallax* because the viewfinder and photographic lens are not one and the same; the image you see is not identical to the image that is captured on the film (see the following figure).

Since you don't have to focus or set the exposure on these cameras, they are often called "point and shoot" cameras.

In Plain Black & White

The best way to demonstrate the effect of **parallax** is to look at an object first with one eye closed, and then the other. The object you are looking at appears to shift! Which view is correct? Try this again with your finger held in front of your face; the effect intensifies when the object is closer.

- ♦ Single Lens Reflex (SLR) cameras. The single lens reflex (SLR) camera corrects the parallax problem because, through the use of a prism and mirrors (not to be confused with smoke and mirrors), you look directly through the photographic lens to view your subject.
- Rangefinder cameras. Rangefinder cameras are similar to viewfinder cameras in that they have an optical viewfinder, so you don't look through the photographic lens, but they differ from most viewfinder cameras in that they don't have an automatic focusing feature. You focus the camera manually by lining up two images seen in a small patch in the center of the viewfinder. Many serious photographers prefer manual focus because it gives them full control of where the area of sharpest focus is within the image (you might not always want it in the center). Rangefinder cameras also incorporate a moving viewfinder mask, which

compensates for parallax. At the time of writing only Epson has introduced a digital rangefinder camera, but others have been announced as under development by Leica and Zeiss Ikon. Photographers who are making the transition to digital from a film-based rangefinder camera system might find digital rangefinder cameras more intuitive to use.

The problem of parallax.

One of the most important features of a digital camera is the size of the imaging array, also referred to as the "chip" (see Chapter 2). There are two factors that make a difference to you in chip size. First of all, there is the physical size of the image area of the chip. You will see some chips referred to as "full frame." This description harks back to 35mm film cameras, in which the full film frame measures 24×36mm. A "full frame" chip is one that closely approximates these dimensions. Many photographers would prefer to work with a camera with a "full frame" chip if they are used to working with 35mm film cameras, because their lenses will work exactly the same on such a camera. If the digital camera has a smaller chip, the effect is to magnify the focal length of the lens. We'll talk about this more later on when we talk about lenses.

The other way in which chip size varies is in the number of pixels the chip has in its image area. Let's consider a hypothetical chip with 1,000 pixels in each dimension. If you multiply length by width you will get 1,000,000 pixels. One million pixels is a megapixel. If you look at ads for digital cameras you will see that the megapixel number is mentioned often. This explanation of pixels and megapixels is simplified. We'll go into it in more detail just a little bit later.

Behind the Shutter

Question: We call 35mm film by that name because ...

- (a) the length of a frame, horizontally, is 35mm.
- (b) the film measures 35mm in width.
- (c) all the other names were taken.

Answer: B

One- to Three-Megapixel Cameras

Many cameras used to have chip arrays measuring 1,280×960 sensors on the chip (see Chapter 2 if you need more information on sensor arrays). If you multiply 1,280×960 you get 1,228,800 sensors. Each sensor generates a pixel, giving you just over one million pixels. These numbers are rounded off for convenience, so a camera with such a sensor would produce images with about one million pixels. One million pixels is called one megapixel, or 1MP for short. Cameras with 1MP sensor arrays are called, appropriately enough, 1-megapixel cameras. The number of pixels is determined by multiplying one dimension of the sensor array by the other, and it is then rounded off to the closest megapixel value for convenience.

Flash

Some cameras depend on interpolation to increase image size. The new information (data), which is created during the interpolation to increase the image size, is a result of a "best guess" by the camera's processor. It is not as good as the original data. Typically, poorly or overly interpolated images will have poor color quality and will be soft (lack focus and sharpness). Unless you are working on a tight budget, stay away from cameras that depend on a lot of interpolation. These cameras won't provide an image with a lot of detail.

Because the Internet exists in a 72 dpi low-resolution world, you do not need high-resolution digital photos for Internet use. If you are planning to only use your camera to post your photos on a website, a 2- or 3-megapixel camera will provide you with everything you'll need.

The cameras also range in complexity, from the simple PHI (Push Here Idiot) to some that have so many bells and whistles you should expect to keep the instruction manual always at the ready. Using a 3MP camera, you can expect to make good-quality prints up to 8×10-inch, depending on image quality.

Flash

The "depending on image quality" caveat is not meant to be a dodge. If your image has a lot of diagonals or detail, such as texture, the image quality is going to suffer if you make your print too large. You can still make a big print—just stand back from it a bit! If, however, your image doesn't have a lot of detail (it's a nice, big, blue sky, for example), you can make bigger prints.

Three- and Six-Megapixel Cameras

Although 2-megapixel cameras are still available on the market, for "short money," 3- and 6-megapixel cameras are very plentiful.

The Fuji Fine Pix F450 digital camera offers a low price and fits in your pocket.

Let's take a moment to do some math and see just what all those megapixels add up to. A 2-megapixel camera has a CCD chip size of about 1,200×1,800 pixels, give or take a few. A 3-megapixel camera has a chip size of about 1,536×2,048 pixels. Let's look at this in another way that might be more familiar to you. A 2MP camera will produce a 6-megabyte file. At 150 dpi (dots per inch), this would yield an 8×10-inch print. A 3MP camera will produce a 9-megabyte file (that's 50 percent bigger) which in turn will print up at almost 10×14 inches. Better yet, you could increase the dpi and produce an 8×10-inch print at 200 dpi or better. Not bad!

So which one to buy? This is not an easy question to answer. Within a given price range, there are two ways you can go: you can get the highest megapixel camera with a small set of features or you can get a low-megapixel camera with a large feature set.

Another thing you can try is to buy some digital media and take it with you when you go to test cameras. If you have a Pocket PC PDA or recent Palm that's all the better, as most PDAs can handle the same CompactFlash and Secure Digital storage media as digital cameras. If you don't have a PDA, you can get a USB or FireWire card reader for \$30 and up at your local computer retailer. You should consider buying one anyway, if you're that serious about a nice digital camera. Take a few shots, jot down notes about the order in which you tested cameras, and take them home to view and print.

Say Cheese

When you insert a storage card in a digital camera, the camera creates a folder on the card. The folder is typically named after the model of the camera, so it's easier to tell where each picture sample came from. You can see these folders on a PDA or computer using file-browsing software that came with the PDA or the card reader.

If you can view the images on a computer monitor, take a close look at the shadow areas. See if you can see "noise" or grainy color variations in the deep shadows and/or blacks. This is a really good test of how well a chip handles low light and reproduces color. If you see a lot of noise, gently put the camera down, smile nicely at the salesperson, and try another one.

Midrange/Semipro Cameras

Midrange, or semipro, cameras have sensors that begin at 6- to 8MP and go up from there. Not surprisingly, these babies are, on average, pricey—from just under \$1,000 to well above \$5,000—but remember that for this type of money you are going to get

a lot of camera (usually an SLR) with a lot of bells and whistles. Most important, you can be sure that the image quality of the photos taken with these types of cameras is going to be a lot better than the quality of those taken with the 2MP or 3MP cameras. (For that money, I certainly hope so!) You should expect to be able to easily make a 5×7-inch to well over 8×10-inch print and still hold good detail.

Be ready for life's big moments!

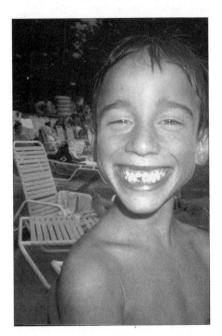

Behind the Shutter

Did you ever wonder how the daily newspaper was able to run a photo of an "Olympic Moment" within hours of it actually happening? Many news photographers now carry wireless and satellite equipment that enables them to send images directly from their current location to the photo editor's desk. As Jimmy Olsen would say, "Holy Cow!"

Professional Cameras

Professional-level digital cameras start at about \$1,500 and range up to just short of the cost of a compact sedan! Typically these will be 8-megapixel and larger in sensor size. Many of them have sensor arrays that are smaller than a standard 35mm film frame (24×36mm).

Because the image from the lens is being projected onto an area smaller than a 35mm film frame, this effectively increases the magnification, usually by about 1.5×. This magnification factor is really nice to have with telephoto lenses but no fun at all with wide-angle lenses because it makes them less wide.

Recently some manufacturers have introduced digital SLR cameras with so-called "full frame" sensor arrays, that is, sensor arrays that are the same size as a 35mm film frame. These cameras do not have the lens magnification factor, and give the same angle of view and magnification with lenses as you would get with those lenses on a 35mm film camera.

Other companies, such as Leaf and Phase One, manufacture detachable *digital backs*, which fit onto a *medium format* camera body in place of a film magazine. These typically are mounted on a Mamiya, Hasselblad, or Rollei camera.

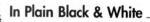

Medium format cameras are designed to use 120-size roll film, and most have removable film magazines that can be changed in mid-roll. It was an obvious move for some manufacturers to make digital backs which could be used in place of the film magazines, allowing photographers to go digital while keeping the same camera and lenses.

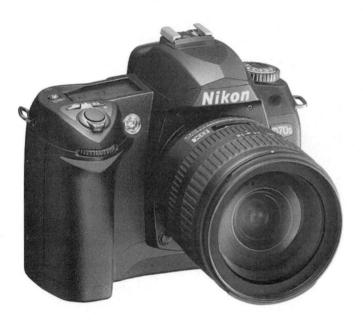

Nikon offers the professional photographer the D series of cameras that uses traditional camera bodies and lenses married with digital chips set on the film plane.

Phase One camera back P25 mounted on a medium format SLR camera.

Scanning-back cameras usually are designed to slip onto the back side of a 4×5-inch view camera. These babies put out 100 to 200MB files. You can do a whole lot with that much information! A good example is shown in the following figure.

Phase One PhotoPhase FX scanning back.

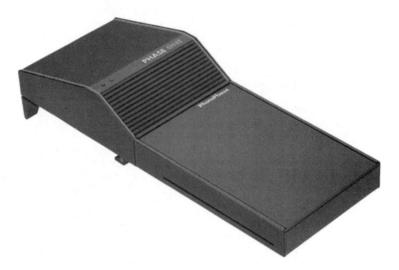

The Least You Need to Know

- With all the available options and choices, your best bet is to do your homework to find the best deal.
- Decide how involved you want to get when taking pictures. Don't buy more camera than you need, but leave yourself some room to grow.
- Don't become "camera poor." Be sure you have enough cash left over to buy a few batteries and any computer equipment you might need.
- The bigger chip size your camera has (megapixels) the better the possible print quality.

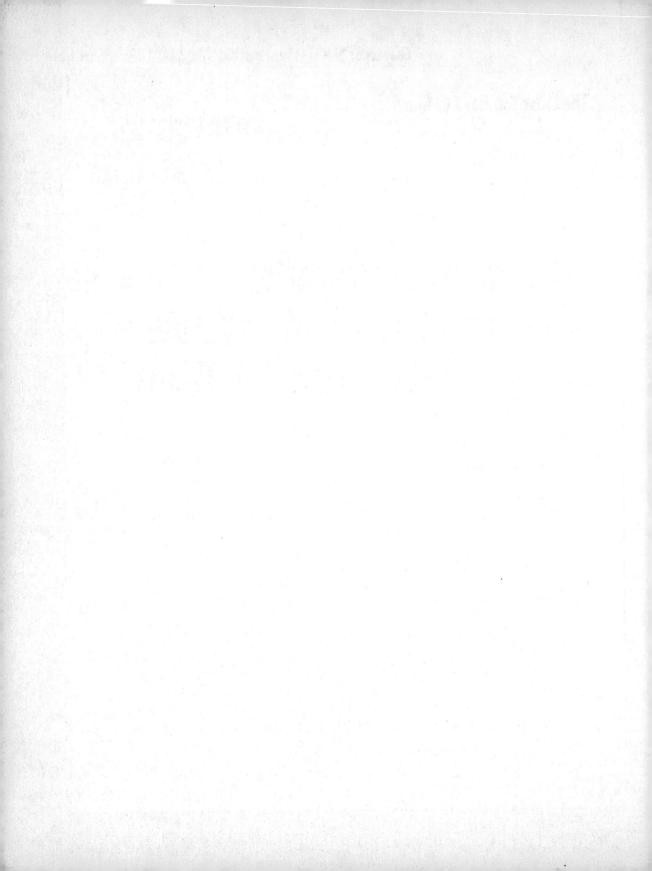

Attention to Details: Features You Need to Know to Get the Camera You Want

In This Chapter

- Getting to know digital camera features
- Looking at lenses
- Learning about flash
- Spotting a quality LCD screen or viewfinder
- Understanding image storage and downloading

When it comes to which features on a camera you want or need, the decision-making process can get very confusing. I suggest you first decide how you will be using your camera. Will you use it mostly outdoors, or will you need to make very detailed reference photos? Do you need a powerful flash, an accurate metering system, or both? Do you want a camera that can slip into your pocket, or are you comfortable lugging

around a camera bag? If you can test the camera out before you buy it, great. See whether your camera dealer will let you walk around with a demo model for a while.

Camera Design

Digital cameras are being manufactured in many new sizes and shapes; some no longer look like their traditional film-based cousins. The main reason for this is that they do not have to adhere to many of the mechanical restrictions that film-based cameras do, such as film transport systems. The only two parts of the camera that need to be aligned are the lens and imaging array. After that, anything goes!

Split/Pivot Cameras

Some digital cameras *split*, or *pivot*. This design is found mostly on cameras that have LCD view screens and no optical viewfinders. The LCD screen stays with one half of the camera, and the lens and flash stay with the other. This design can enhance your ability to see the image on the LCD screen and, at the same time, make taking the picture easier. These cameras are great, especially if the LCD panel can be used as a real-time viewer (like a movie camera). For example, you can hold the camera over your head in a crowd, point the lens toward the subject, and follow the action on the LCD screen. Up periscope!

Nikon's Cool Pix 4500 splitbody camera takes a little getting used to, but after that it's great.

Say Cheese

Many times you'll see news photographers holding cameras over their heads in a crowd to get a shot. These guys, including me, have a pretty good idea what the camera is seeing. We also cheat a bit by putting on a wide-angle lens, ensuring coverage. It is a lot better than missing an important shot or photographing the back of the head of the photographer in front of you. Try it out. You've got nothing to lose—you're a digital photographer now!

neck Out Receipt

ictorville City Library

aursday, Jan 16 2014 11:24AM

tem: 81483000302650

itle: The complete idiot's guide to digital pho

ography like a pro all no.: 775 G 2005

ie: 02/06/2014

ank You!

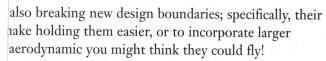

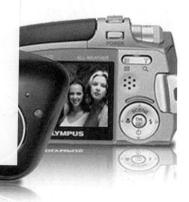

A very slick-looking Olympus Stylus Verve.

No matter what the camera looks like, however, you should pick it up before you buy it. (If you were to spend this much money on a new sports coat, you would try it on, wouldn't you?) You are going to be holding this thing a lot, so you should see how it feels. Those of you who "hunt" with your cameras (you know who you are) will appreciate a comfortable camera. Ask yourself the following questions:

- ♦ Is it well-balanced?
- ♦ Is there a good place to hold it?
- If you are a southpaw, does it work for you?
- If you hold the camera up to your eye, does your elbow end up in a place that would be uncomfortable after a while?

Of course, it isn't *that* important that the camera be able to twist, bend, or tie itself into a knot. Many of the basic camera shapes still function perfectly well. So before you purchase a camera, it is important to evaluate how you have been taking pictures or how you plan to take pictures in the future. It is also important to determine how the camera fits into your budget. You can save a lot of money if a simpler camera style will work for you. That way, you can spend the money you save on more important items, such as a better printer.

Battery Life

No digital camera works with dead batteries, so you should check out how many batteries your camera needs, and what kind. Almost all digital cameras on the market today use rechargeable batteries of one sort or another. A few models can also be powered by ordinary alkaline AA cells. Pay attention to the camera manufacturer's specifications. Many of these specs tell you how many pictures your camera will take on one battery charge. Be sure the specifications include flash use, because you will probably be using the built-in flash a lot.

Battery Types

There are many types of batteries on the market today. Some batteries, which are usually rated for photography, deliver full output and then die suddenly; others—usually cheap, general-use alkaline batteries—output less and less power until they're dead. Let's look more closely at each battery type:

◆ Alkaline batteries are the most common and the cheapest, but they are not intended to be recharged.

Flash

If you plan to travel to other countries, make sure the battery charger that comes with the camera is a multi-voltage design for worldwide use and be sure to buy the appropriate plug adapters for the countries you are visiting.

Flash

If you plan on recharging, please be sure you are buying the correct batteries.

Ordinary Lithium batteries can explode if you attempt to recharge them.

- Lithium batteries, which are also not rechargeable, offer longer life than alkaline batteries but are a little on the pricey side.
- NiCd (Nickel Cadmium) batteries are rechargeable and make good economic and ecological sense. NiCd batteries must be completely drained before they are recharged; otherwise, they develop a "memory." In other words, if your battery is recharged while it is two-thirds full, it will always need to be recharged when two-thirds full and will take only a two-thirds charge. Camera companies are phasing out NiCd batteries in favor of Lithium Ion batteries.
- NiMH (Nickel Metal Hydride) batteries are also available for use in cameras; they provide even greater power and endurance than NiCd cells. NiMH batteries also have the great advantage of not developing a memory, and can be

"topped off," or recharged to full, at any time. These batteries are a little more pricey, but well worth the extra cash. Camera companies are phasing out NiMH batteries in favor of Lithium Ion batteries.

♦ Lithium Ion batteries are the current favorite of the camera companies and more new digital cameras use them.

They are economical, because they can be recharged almost indefinitely, and do not have a memory like NiCd cells.

Lithium Ion batteries are designed for recharging, unlike the ordinary Lithium batteries.

Newer battery technologies are always being developed. For example, some manufacturers are working on prototype fuel cells small enough to power cameras and small electronic devices. At the time of writing, Toshiba had just announced a new type of rechargeable battery that can be fully recharged in only an hour. Most other types of batteries require several hours for a full recharge.

Small auxiliary battery packs that contain four to six high-capacity batteries are available for many higher-end digital cameras. These batteries can be plugged into the DC power port on the side of your camera, where the charger or external power source is normally plugged in. These power packs may last two to three times longer than the on-board batteries. Many professional photo or video stores carry these.

Flash

Many rechargeable batteries, especially NiCd batteries, develop a memory. If they are not fully drained before you recharge them, they will either not fully charge again and/or not deliver their full capacity. The solution to this is to fully discharge the batteries prior to recharging. Most newer digital cameras use Lithium Ion batteries which do not have the memory effect of NiCd cells.

Say Cheese

If you suspect your batteries are weak, or if your camera is acting a little slow, here's a great way to drain your batteries before recharging them: place the batteries in a flashlight that can be left on. When the flashlight no longer works, you can be reasonably sure that the batteries are completely drained. Then go recharge them.

Say Cheese

Keep your rechargeable batteries in sets to be sure all the batteries in a particular set are drained by the same amount and match each other in voltage and internal resistance.

Color code your batteries or write "set one," and so on, on them.

Some digital SLR cameras can be fitted with a "vertical grip" on the bottom. This L-shaped grip serves several functions. The bottom part of the grip can hold an extra rechargeable battery park for your camera, effectively doubling your shooting capacity between battery recharges. On most cameras this grip also gives you a secondary shutter release and other controls, which you can easily reach with the fingers of your right hand when you are taking vertical photos.

Flash

Be careful where you charge your batteries. I have found that the charger and the batteries can get quite hot. Be sure there are no combustibles, such as paper, near the charger.

Battery Chargers

If you use rechargeable batteries, you're going to need a battery charger. Many battery chargers allow you to "trickle-charge" the batteries. Trickle chargers supply a small charge to the battery, after it has been fully charged, without overcharging them. That way, you can keep your batteries in the charger, always at the ready. Nontrickle chargers can overcharge or ruin your batteries.

NMH battery charger can charge all sizes of NMH batteries

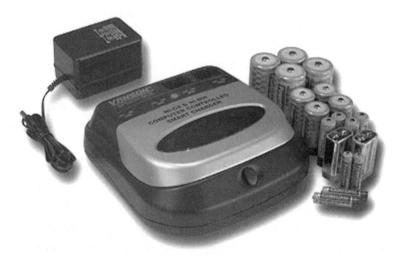

Some cameras come with an AC adapter, which allows you to plug your camera into a wall outlet and operate the camera without batteries while they are charging. Some even allow you to charge your batteries while they are still in the camera. If you don't mind trailing an extension cord, you can run the camera from the wall outlet. Don't

attempt to use the AC adapter in another country unless you are certain that it is a multi-voltage type that automatically adjusts for the main voltage, and make sure you have the proper plug adapters when traveling.

Tips for Preserving Battery Life

The most frustrating problem with digital cameras—and their "weakest link"—is how quickly their batteries lose power. You can take steps to preserve your battery life by keeping the following tips in mind:

- Keep your AC adapter handy. Try to use it when you are at home or transferring files to your computer.
- Turn off your flash when you don't think you'll be using it. (See Chapter 10 for more flash hints.)
- ♠ Run the camera with the LCD monitor in the off mode as much as possible especially if you just have the camera dangling around your neck, but still on. On many cameras a quick partial pressure on the shutter release button will switch off the LCD monitor but leave the camera in its sleep mode, ready to be awakened for picture taking by another partial pressure on the same button.

Be sure to check the batteries in your camera before you plan to take pictures. Always keep an extra set charged. If you plan to be taking a lot of pictures, take a few sets of batteries with you. You won't regret it.

• Let it sleep! When the camera goes into its power saver or sleep mode, it will turn off most of its power use and wait for you to awaken it. Usually a simple tickle of the shutter button will do.

A battery pack like this one can hold multiple highcapacity batteries bundled together and can connect directly to your camera.

Lenses

Unless you are going to be the first digital "pin-hole" photographer, you need a lens. With the exception of some upper-end SLRs and digital rangefinder cameras, most digital cameras come with one lens—usually a wide-angle to telephoto lens combination (28mm to 150mm), commonly called a zoom lens—permanently attached. (You'll learn more about lenses in Chapter 8.)

Be aware that most lenses on digital cameras are rated by what their 35mm equivalent is. The lens may really be a 7 to 21mm zoom, but what its 35mm equivalent is depends on the size of the sensor array. The 7 to 21mm zoom is actually equivalent to a 28 to 84mm lens on 35mm equipment. This can be very confusing if you are new to digital cameras and the conversion factors created by different sensor sizes. There is more about this in Chapter 8.

Say Cheese

When you are comparing cameras to buy, don't be fooled by a lens that might be a few millimeters better than another. If there is less than a 10 to 15 percent overall difference, it's not a consideration. Also, you will see the effect of small differences in focal length more at the wide end of the zoom range. If you like to shoot a lot of wide-angle photos, make sure the lens will go wide enough to make you happy.

If you want to know how much of a zoom lens to buy, consider the following:

♦ Look through the lens. Place a group of people 10 or 15 feet away, zoom all the way out to wide angle, and see how many people will be in the shot. If you

Flash

Many cameras depend on interpolation to increase the size of an image, or "zoom in." Often called "digital zoom," this is not a true zoom, and the image will degrade due to the interpolation when enlarged. Be careful to know the true optical focal length of your lens.

think you need an even wider view, you can either buy a wider zoom, or take a few steps backward! (Taking a step back can be the difference between a 23mm and 28mm lens, for example.) You can apply the same test to the telephoto end of a zoom. If your kid is playing center field, you need more of a telephoto lens than if he or she is pitching. With a camera that has a smaller chip array, or that depends on interpolation, filling the frame of the view-finder is much more important than with a camera using a larger chip. Remember, you

want to get as much original image data into the camera as possible so that you will end up with a better-looking image if you need to crop or enlarge the image later.

Some camera companies and some independent suppliers such as the Tiffen Company (best known for filters), make add-on supplementary wide-angle and telephoto lenses. These screw onto the lens just like a filter. Supplementary lenses vary in quality, so be sure to shop carefully. Also, be aware that the supplementary lenses fit onto the lens, but not onto the viewfinder, so you will need to use your camera's LCD monitor to see how they affect your image.

- How does the lens operate? Can you zoom manually, or do you have to push a button and let a motor do it? How fast does the lens zoom if it is motordriven?
- ♦ How crisp is the lens? How good does the image look? Is there good contrast in the picture? Evaluate these criteria by viewing images photographed by the lens on your computer screen. (Be sure you use the same computer screen when you compare lenses!)
- ♦ How sharp is the image? Many lenses use plastic lens elements. Plastic optics today can be as good as, or better than, glass, but many people still think that glass optics are better. However, a camera that does not have a big imaging array or that depends a lot on image interpolation does not need the best optics. The camera won't be able to reproduce the difference in detail that a high quality lens would produce.
- Can you attach filters to your lens? Do you need to buy filters that will work only with this camera, or can you use them on other equipment? Can you use previously purchased filters? Some cameras offer a built-in lens cap device that automatically covers the lens when it is not being used. Some recommend as a matter of precaution to always have a UV (ultraviolet) filter over your lens. The UV filters are clear and serve two useful purposes: they filter out UV light (haze) and protect the lens from dirt, fingerprints, and dog noses. Keep in mind, however, that a filter introduces two additional surfaces to keep clean, and these surfaces can cause additional flare in some lighting situations. It makes no sense at all to buy a high-end multicoated lens and put a cheap single-coated filter on the front of it. If you feel you must put a protective filter on the front of your lens, get the best one you can afford.
- ♦ How fast is the lens? The more light a lens can pass through to the chip or film, the faster it is said to be. If you anticipate taking lots of photos in dim

light, buy a fast lens. Lens speed is calibrated in *f-stops*, which are numerical values that tell you how much light can pass through a lens. The lower

Say Cheese

Is an f-stop of 2.8 faster than an f-stop of 3.0? Yes, but not by much. If it came down to deciding whether to buy a camera with an f/2.8 lens versus one with an f/3.0 lens, all other things being equal, including the cost, I would buy the faster f/2.8 lens.

- the f-stop number, the faster the lens. For example, an f-stop of 2.8 lets in more light than an f-stop of 3.5. Why the goofy numbering system? Bookmark this page and read Chapter 7; otherwise, just take my word for it for now!
- Does the camera have auto-focus? Most cameras employ sophisticated methods of automatically focusing the lens using the contrast of an image to determine whether it is in focus. It really doesn't matter how a camera autofocuses, as long as it does it well.

My suggestion? Pick up the camera you are planning to buy, and see how long it takes to focus. If you are using a non-SLR camera, listen for the whirring (if there is any) to stop, or look for an "in focus" indicator to pop up in the viewfinder. See how well the camera focuses, and on what, when two objects are at different distances from you (an example of this would be if your image depicted a single person standing a few steps in front of a group of people).

Depending on the style of your photography, you may choose to focus manually. Most viewfinder digital cameras do not have a manual focus option, but all digital SLR cameras do, and rangefinder cameras only focus manually. Manual focus can be very important for some types of photography, and most really serious photographers would not want a camera that does not offer a manual focus option. If your camera really wants to focus on a group of leaves and not the flowers in front of them, you will want a camera that lets you manually override this, or offers a close-focus setting.

A fixed-focus lens, for instance, is generally found on less-expensive cameras. Though it might well be your only option for reasons of budget, in most cases it can serve you well. You are limited as to how close you can get to your subject, but focus on all cameras extends to infinity.

Check out the information on your lens to find out the maximum f-stop and focal length.

Flash

Most digital cameras have a built-in flash or LED for those times when a bit of extra light is needed. Some newer digital cameras use sensor arrays that are so sensitive to light that no flash is needed, and a simple white LED or two can provide enough light for excellent photos.

A bigger-looking flash doesn't necessarily mean it is more powerful than a smaller one. The best way to tell how much *flash power* you're going to get is by reading the Guide Number or doing your own testing.

Say Cheese

Borrow a flash meter to get a qualitative answer to flash output. Most photo stores that carry professional equipment should have a flash meter available for you to use and can show you how to use it. However, many flash meters are not able to correctly read the very brief duration pulse produced by automatic flash at close distances. Check the instruction manual of the flash meter to make sure it can read short duration flash.

Guide Numbers

All camera makers tell you somewhere in the specifications how powerful the flash is, expressed as a Guide Number (GN). The GN indicates the light output of an

electronic flash, which is the product of the f-stop multiplied by the distance. For example, if you get a perfect exposure with the diaphragm (lens opening or lens aperture) set to f/5.6 and your subject is 10 feet away, multiplying 5.6 by 10 gives a Guide Number of 56.

Guide Numbers are geometrical in progression, not arithmetic. So a flash with a Guide Number of 80 is exactly twice as powerful as a flash with a Guide Number of 56. The progression is easy to remember if you know the progression of f-stops (see Chapter 7 for a detailed explanation of f-stops). This progression is 1.4, 2, 2.8, 4, 5.6, 8, 11, 16. Each step in this progression cuts in half the amount of light passing

Flash

If you are looking at manufacturers' specifications in advertising and on websites, make sure that you are comparing apples to apples and oranges to oranges. Some manufacturers will quote their Guide Numbers in metrics rather than feet. To convert a Guide Number in feet into a metric Guide Number, divide it by 3.3, and to convert a metric Guide Number to feet, multiply it by 3.3.

through the diaphragm, and requires twice as much flash power for proper exposure. Equivalent Guide Numbers would be 14, 20, 28, 40, 56, 80, 110, 160, with each Guide Number being twice as bright as the one before. But you really don't need to memorize this, just grasp the concept, and have a general idea of how much light you need. Generally, a flash with a Guide Number of 56 or higher will be adequate for all general photography.

Sometimes you will see Guide Numbers expressed in two numbers, as in 56–80. This means that the flash zooms along with the lens, covering a wider area when the lens is zoomed out to its wide-angle settings. The same light over a wider area equals a lower Guide Number at the wide-angle settings.

Testing the Flash

To test a camera's flash, shoot the same subject, at the same distance, with two different cameras (be sure to test cameras with equal chip sensitivity/ISO ratings), and then see how bright the subject appears after you've downloaded each image to your computer and opened them in your image-editing program. Also look behind the subject to see how much of the background is lit. The more the background is exposed, the better. Set the camera to wide angle, and repeat the test. Again, the more area that is exposed, the better.

Other Flash Features to Consider

You should also consider where the flash is located on the camera body. The flash should be as far away from the lens as possible (this might be a little tough to accomplish on a camera with a small body). This distance helps render better shadows and helps you avoid the "deer caught in the headlights" effect. Cameras with flash units right next to the lens greatly increase the odds of your subjects getting *red-eye*.

Small but effective flash mounted on a Minolta body.

In Plain Black & White

Red-eye occurs when the flash is too close to the lens. Because the flash is directing light straight into your subject's eye, you are actually photographing your subject's retina, which is red due to all of the blood vessels in it. This happens more frequently when your subject's iris is dilated (opened wider), such as in a darkened room. Some cameras employ "red eye reduction" gizmos—most work by strobing the flash a few times before the actual exposure is taken or shining a bright continuous light into your subject's eyes, to force the eye's iris to close. The strobing technique works adequately, although it does rob the flash of a lot of its firepower for the actual exposure. Also, if you notice, most of the people in the photo have annoyed or quizzical looks on their faces! Check out alternative lighting techniques in Chapter 10.

Recycle time, the time it takes the flash to recharge, is also important. There is nothing worse than waiting for your flash to charge. When the batteries in your

Say Cheese

Many digital cameras now also have a video mode and can record short video clips as well as still images. Since this book is about still photography we won't go into this feature in depth, but you can shoot short movies with sound and download them to your computer to play or to send to friends.

camera are fresh, your flash should recharge almost instantaneously. A good indication that your batteries are getting *tired* is when the flash starts taking too long to recharge. How long is too long? Without getting too philosophical, too long is when you have to wait for the flash instead of taking pictures! Swap out the batteries for a fresh set.

On cameras that split or twist, the flash should "travel" with the lens and remain pointed in the same direction as the lens. Although I have not seen this yet on built-in flash, another option would allow the flash to point in another direction to help facilitate bounce-flash techniques.

Viewfinders

There are a couple of types of viewfinders you should be aware of:

♦ Most cameras incorporate an LCD (liquid crystal display) screen on the camera body. These flat screens show you what the lens is seeing. (They might show you the image you have just photographed, or they might be *active*, and show you a real-time view of what the lens is pointed at.) These types of viewfinders

Flash

LCD screens can be difficult to see outdoors and in bright light. Several companies make accessory hoods that attach to the border of the LCD monitor and block extraneous light. If you try one of these and still can't see the screen in bright light, that camera is not for you.

can be a lot of fun. Using an LCD screen, you can take a picture, and then pass the camera around for all to see.

Most LCD screens must be looked at straight on to work. You should see how well they work in subdued or bright lighting situations. Also, look to see what information is offered on the screen. (Is frame count, compression rate, battery condition, time and date, or other information available?) Although it might not be a significant amount, be aware that an LCD screen is going to draw power from your batteries.

A bright LCD screen helps you preview your images.

◆ A simple optical viewfinder might also be incorporated into your camera (if no LCD screen is available, this is your only way of seeing your subject). Depending on whether your camera has a metering system, you might see information (lights and dials) in the viewfinder; you might also see scribed markings indicating what your camera sees when it's in the telephoto or wide-angle mode. Ideally, your viewfinder will have an indicator to tell you that the flash is recharged, as shown in the following figure. I like this feature; it lets me frame up a subject and fire the camera without taking my eye from the viewfinder.

An easy-to-see-through viewfinder is a must. This one has an adjustment for your eyesight, a plus for those of us who wear eyeglasses.

If your camera relies on an optical viewfinder, think about the following:

- Can you see through the viewfinder?
- ♦ Is the viewfinder too small?
- ♦ Will your nose get in the way?
- If you wear eyeglasses, will they get in the way?
- If there is no protection on the eyepiece, will you scratch your eyewear or your forehead?
- What information, if any, is in the viewfinder? If a metering system is present, can you see it well?

If, on the other hand, your camera relies on an external LCD viewfinder, consider these issues:

- ♦ Can you see it well?
- Does the LCD viewer work well in brightly lit situations?
- Can you see the LCD viewer in dimly lit situations?
- ♦ Is the LCD viewer big enough?

Another type of viewfinder now seen on some cameras is the internal LCD viewfinder. With these you look into an eyepiece just as with an SLR camera, but instead of viewing an optical focusing/viewing screen, you actually see a magnified view of a small LCD screen inside the camera. This type of viewfinder has advantages over an external LCD because it is fully shielded from light and works just as well in bright sun as in dimmer indoor light. Most cameras that use internal LCD viewfinders also have an external LCD on the back of the camera, and it can be used as an alternate viewfinder when lighting conditions allow you to see it easily. It can also be used for playback.

Selected Delete

Although this might sound like a type of weapon from a *Terminator* movie, selected deletion makes great use of the LCD screen. With the LCD screen, you can review—on the camera—all the images you have taken that still remain in memory. You can then delete the images you don't want, like the one where everyone has his or her

eyes closed. This is a great way to save space on your storage media. Just be careful not to accidentally delete images you want to keep. Most cameras allow you to lock the images you want to keep to prevent accidental deletion.

Onboard Storage

Unless you plan to have your camera permanently tethered to your computer, which is no fun at all, it needs some kind of onboard storage for your image files. Many storage options are available. Here are some considerations:

- Most cameras today have some built-in memory (referred to as RAM) in addition to removable memory. Cameras can access the built-in RAM memory more quickly than they can access memory on a removable card, which is why the built-in memory is usually used as a buffer. That is, the camera saves images in its buffer before sending them to the hard-card removable memory; this enables you to more quickly take your next picture. You might also have the option of saving your image with different compression modes while the image is still stored in the camera's built-in RAM. You will usually see the built-in RAM size in the camera specifications. Generally speaking, a larger buffer means you can shoot more pictures without having to pause for the camera to catch up. This can be important in action photography.
- ◆ Flash card memory (removable storage media), sometimes called "digital film," uses SRAM (static RAM technology, which will hold its data without electric current), and is found in many sizes, shapes, and storage capacities. There are four types of memory cards in common use today. The most common is the CompactFlash card, used in most of the higher-end and professional cameras. A bit less common are the SmartMedia cards. The two newest types are the small SD (Secure Data) cards, and the even smaller XD cards. Some cameras have more than one type of card slot and can accept more than one type of card. There are also Microdrives, which look just like thick CompactFlash cards, but are actually miniature hard drives. These are becoming less common as the storage capacity of the other media is increased beyond one gigabyte.

New storage devices are always in development. For example Sony Corporation markets *memory sticks*, which measure $0.85 \times 1.97 \times 0.11$ inches and hold up to 1 gigabyte of information (and will soon hold more). These SRAM devices are designed to interchange between cameras, printers, and computers. Sony even markets TV sets with a slot for memory sticks so you can view your digital photos on your TV set.

It's surprising to see how small the camera is compared to the memory.

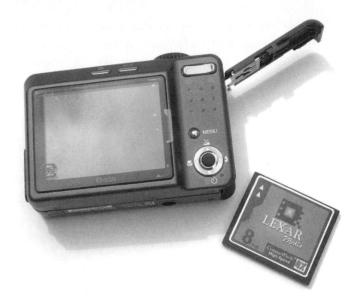

Sony also markets a mini CD that fits into their Mavica CD camera line. This CD is actually burned onboard by the camera and can hold 156MB of data! The cost of the mini CD can be less than \$1 if bought in bulk. For a little bit more you can get a CD-RW disc that can be read and burned over and over. Both types of mini CD can be read in the regular CD/DVD drive on your computer, and image files can be easily copied onto your computer's hard drive.

Downloading Options: Kodak DOCK

Digital technology offers two ways of getting information from your camera to your computer (or vice versa):

- ♦ **Direct cable.** If you download by direct cable, it's best to leave the cable attached to the computer. That way, you'll avoid playing with cables instead of downloading. With a direct cable connection the image folders will show up on your desktop when you connect the camera. Depending on your computer and camera combination, moving images to your computer may be as simple as drag and drop, or may require the use of software that came with the camera.
- Card Reader. These are inexpensive devices that you can leave connected to your computer. Just take the storage card out of your camera and put it into the slot in the card reader and your files will automatically pop up on the desktop of your computer.

Consider the following options when deciding which way you want to download your images (you should also consider the additional cost of cables or readers):

• Most cameras allow you to download via a cable, usually through a USB cable that connects to the back of your computer. USB2 cables and connections, which allow much faster data transfer, are quickly replacing the "plain vanilla" USB that we know and love. USB2 cables and connectors are identical to the original USB in appearance. Some higher-end cameras now use FireWire (also known by the catchy name IEEE 1394) cables for much faster information transfer.

The business ends of a USB cable.

◆ If you choose not to connect your camera directly to your computer, all of the memory cards require some sort of reader to allow you to send image data to your computer. Many laptops come with PCMCIA slots built into them, and you can buy adapters for most types of memory cards that enable you to use your memory cards directly in the laptop. However, if you don't use a laptop, you'll probably have to buy a PC reader for your desktop machine.

The Belkin card reader will read any type of removable storage card.

♦ Kodak and HP have developed a dock with a cradle into which certain cameras can be placed to transfer files to the computer or printer. The dock is attached to the computer via a USB cable. This is a very quick, no-fuss way to transfer files. The dock can also be used as a battery charger and powers the camera while it's attached.

Say Cheese

Many cameras are equipped with video-out plugs that allow you direct output from your camera to a television set. You can preview your images on your set or, with included software, give a slideshow. This is a great way to show your family and friends the images you have taken without first downloading them to your computer. If you're visiting your computer-phobic grandmother, this can be a great option!

The Kodak camera dock allows simple camera-to-CPU or camera-to-printer transfers.

Burst Exposures

When you take pictures with a digital camera, there is usually a lag time between exposures, which is due to the camera processing or shuttling information between the RAM and the storage device. To counteract this, some higher-end cameras offer a *burst mode*, which allows you to take a certain number of photos in a rapid sequence

Say Cheese

One nice thing about using storage cards is that you can download information from one card into your computer while shooting pictures with another card in your camera.

(the number of exposures and the lag time between varies with the camera model). This is excellent for taking live-action shots such as at a sports event or of a fast-crawling baby. As if that's not cool enough, some auto-exposure cameras use burst mode to quickly take four or five shots of the same image, varying the exposure, and you can then select which exposure is the best!

Metering

All digital cameras on the market today have some sort of light meter built in. If the camera has a manual exposure setting, this will allow you to precisely control your exposure. This comes in handy in toughly lit scenes, such as one with backlighting, which can fool an automatic meter. But even if you don't have manual control, some cameras enable you to select either the shutter speed or the f-stop. This is called *shutter* or *aperture priority exposure*, and it's a nice compromise over fully manual exposures.

We'll get into the topic of exposures a bit more in Chapter 7.

Resolution

A camera usually creates your image in full resolution (using every sensor on the chip) as a RAW file. To save space on your hard drive, however, your camera might offer you the ability to save images in different file formats or with lower resolutions. Each manufacturer handles this in different ways. One way is to actually take a photograph, reduce the file size, and then store it (some cameras compress the image even further after this process). Although this allows you to keep a lot of images in storage, it has the disadvantage of making your files low resolution.

You can also shoot a full-resolution image and then compress it using a compression rate that you select. Although the compression process degrades the images slightly, this is a better way to go. (Resolution and compression are covered in more detail in Chapter 12.)

Speed and Sensitivity

Most digital cameras allow you to vary the sensitivity, or *ISO* rating (see Chapter 7), of the chip, which has the same effect as using a higher- or lower-speed film. Specifying a faster ISO rating enables you to shoot in lower-light situations and gives you some degree of control over the exposure. Realize, however, that using a faster ISO rating usually means that some sort of amplification is being done on the chip, which produces "noise." Noise appears mostly in dark areas of your image as blue and red/blue "static."

In Plain Black & White

ISO ratings on film indicate the film's sensitivity to light. Typically, photographers use a lower ISO for photography outdoors in bright light and a higher ISO for indoors and low-light situations.

Behind the Shutter

When photography began to make the transition to digital, people wanted to work with familiar numbers, so camera makers began to put ISO ratings on digital cameras. Although we should call these "ISO Equivalent ratings," nobody wants to use that cumbersome term. Anyway, ISO ratings on digital cameras do not directly correspond to ISO ratings for film. If you are operating your digital camera manually and using a hand-held light meter, you will probably find that you have to alter the ISO setting on the meter to get the correct exposure on digital. High-end digital SLRs have more light sensitivity than film, so you generally have to increase the ISO setting on the hand meter to get the correct exposure. Many professional photographers have found that they need to at least double the ISO.

Extras

You should look for a few more bells and whistles on a camera when buying one:

- Your camera should have a threaded hole on its bottom to allow you to attach it to a tripod. Be sure the tripod mount will not be in the way of the door for the memory cards. Otherwise, you will have to remove your camera from the tripod to change cards.
- Another good thing to have is a flash cord socket, called a PC socket. This allows you to fire an off-camera flash via a PC cable connected to the flash and the camera. You'll probably find PC sockets on more-expensive cameras.

Flash

Don't overtighten a tripod screw; you might drive it into the camera body. I did!

Say Cheese

If you don't have a cable release, try setting the camera on a tripod or a surface that is not moving, and set the self-timer. Your camera will go off with nary a shake!

- ♦ How are you ever going to be in your group shots if you don't have a self-timer on the camera? Most cameras do have them, but double-check! Make sure the delay time of the self-timer is long enough for you to get yourself in the photo. Most cameras have a 12-second delay.
- A cable release (a mechanical or electrical cord that you attach to your camera and use to fire the shutter) is a great thing to have if you are going to be taking pictures with a slow shutter speed or in low-light situations. Using a cable release prevents you from shaking the camera when you press the shutter button.

Bundled Software

Most cameras come with some sort of bundled software. Be aware that although many of these might be complete programs, some might be "lite" versions or timed versions that stop operating after a specific amount of time. Check this out before you think you're getting the deal of the century.

A Final Word ...

It is always hard to decide when to buy new equipment, but if you need the new equipment immediately, for whatever reason, find the best deal out there and go for it. On the other hand, if you're in no real rush, remember that there is always something better—some new gadget—on the horizon. Do your research to find out whether something big and new is about to come out, and decide whether you can live without it. If you can live with yesterday's technology (which worked great yesterday), you can get a good deal. If, however, you want the newest and best, get the new stuff—but be careful what you buy. The technology might still have a few bugs in it, or it might quickly be replaced (can you say *Betamax?*). But whatever you decide, don't miss any great shots by putting off your decision!

The Least You Need to Know

- ♦ Features can drive up the cost of your camera. Deciding which features you'll need and which are unnecessary extras will help your camera-buying decision.
- Learn to preserve your batteries. Take extra batteries with you, and don't forget to bring the charger along.
- When shopping for cameras, check out the lens image quality carefully before you buy.
- Images are stored on removable media cards. Be sure to leave money in your budget for a few extra cards.
- Your images can be viewed through the lens or via an LCD screen on the back of the camera. The images can be seen in real-time or as on demand review.
- You can download your images directly from the camera or by removing the media and "reading" it. Also, many printers can also read and print directly from the media cards.

Mac Versus Windows: System Requirements for Digital Capture

In This Chapter

- Comparing Macintosh and Windows platforms
- Deciding how much computer you need
- Buying the best monitor for your needs
- Shopping for peripheral devices
- Buying a printer and scanner

There are so many automobiles on the market today! There are sports cars, family cars, and SUVs (we'll buy anything that is spelled with an acronym); some cars offer huge, powerful, gas-guzzling engines, some cars offer tons of cargo space.

No, I haven't suddenly switched to writing *The Complete Idiot's Guide to Buying a Car*; rather, I want to make a point. Almost any car can get you down the road. Likewise, you can use almost any computer to store and

manipulate images you obtain with a digital camera. The issue is how well the computer you use can handle the task.

Windows or Mac?

The first question that might come to mind is: do I need a Windows machine or a Mac? The answer is simple. They both work, and work well!

Apple's Macintosh was the first computer to offer any graphic software and photo manipulation, and in the beginning, most photo-manipulation software was developed solely for Macs. Macintosh computers also were the first to offer millions of onscreen colors, which is very important when working with onscreen photographic images. Today's Macintosh computers have integrated color management, which makes it much easier to match your colors when sending files to others and when making prints. Windows still has not been able to implement this, even though they licensed the technology from Apple. The result is that true color management is much more difficult on a Windows computer and requires third-party software that does not come with the computer.

Nonetheless, Windows OS (operating system)—based machines have come a long way since they first appeared. Windows offers a usable GUI (Graphical User Interface, the way the computer's desktop looks and works) that is an alternative to the Macintosh computers. Windows computers can be powerful graphic machines. Windows-based systems are also capable of displaying millions of colors and tacksharp resolution as long as the video card and monitor supports it.

Most camera manufacturers design their software and equipment to work on either platform. Most also include software that will work on both systems with the camera. (In some cases essential software must be purchased separately. Make sure the camera you plan to buy comes with all the software you will need to use it). If you already own a Windows platform and are comfortable with it, you might want to stay with it.

Say Cheese

The prices listed were sampled at the time this book was written. It's very likely that they have gone down a little by the time this book is published.

If you own a Macintosh system, ditto! If you don't own a computer at all or are considering changing sides, go do your research. Macs are generally easier to learn than their Windows counterparts. When comparing prices, make sure to factor in all of the integrated software that comes with Macintosh computers but that must be bought separately when buying most Windows-based computers.

It is possible to purchase a complete Windows system for around \$300 to \$700, or an old Mac for as low as \$300, but I'm not sure you'd really want these low-end systems for your digital photography. Low-cost systems are so inexpensive because several corners must be cut to drop the cost of manufacturing them. These systems are also far more likely to be way out of step with current technology. You wouldn't skimp on buying tools or children's safety equipment, so why should you skimp on a computer? Expect to spend anywhere from \$1,000 to \$3,000 on a new computer.

If you've never purchased a computer, consider a Mac first. The new Apple iMacs are powerful, low-cost winners that can be had for as low as just under \$1,000 and have an integrated LCD monitor. Desktop systems start at about \$1,500, although you'll have to buy a monitor for a desktop Mac. Before you buy a computer system or a camera, decide where you are going to get technical help. Will your dealer supply it? If you buy equipment from a superstore, can they supply help? If you purchase off the Internet, will the dealer offer technical support? If you live near one of the growing number of Apple retail stores, you can take your Mac in for service. Many equipment manufacturers offer websites for help, and they might also offer phone support. Call up a manufacturer or visit its website, ask a question (make one up!), and see how long it takes to get an answer. Are you put on hold for an hour? When you get through (or find the right web page), do you get the right answer?

When you buy an Apple computer you can purchase the optional Applecare plan, which adds an extended manufacturer's warranty and gives you unlimited access to call-in technical support. Apple's technical support is the best in the business.

If you already own a computer system, you might find that the software packaged with the camera is out of date. You can typically find updates at the camera maker's site. If not, call technical support fast because they owe you an explanation. Most of the software and equipment that is on the market now is designed to work with Windows XP or with a Macintosh. Ask your dealer/supplier questions. Will the software work on your system? Remember that you might need to upgrade software

down the line; will the upgrades be backward-compatible to your system? In other words, will newer software still run on an older computer or operating system? If you can get a demo version of the software before you purchase the camera, install it and see how it performs. Does it choke your machine? Does it bother you to have to work a little slower? You might ultimately decide to start out with your current system and buy new equipment later.

Behind the Shutter

Apple computers are easier to plug and play, meaning that adding equipment and new software or upgrading is generally easier and less time-consuming than is the case with a Windows PC.

General Requirements

It can be frustrating to use a computer with insufficient memory or processor speed. Let's take a look at what you'll need.

Central Processing Unit (CPU)

The CPU of a computer is the part that does all of the thinking. It also plays the role of traffic cop for all of the other components in a computer. For Windows systems, CPUs are generally from Intel and AMD. From Intel, the low-cost chips are called Celeron and the current cream of the crop is the Pentium 6. AMD offers the Duron and Athlon chips to compete. Apple uses Motorola's G3, G4, and G5 processors, and at press time has announced that they will be switching to Intel chips.

Random Access Memory (RAM)

RAM is where the CPU stores data it's working on. The CPU gets that data from the hard drive in your computer, and when it's done with that data, it puts it back on the hard drive. So why not just get it straight from the hard drive? RAM is a great deal faster than the hard drive. Windows XP Home and Professional both require 256MB of RAM. Macs typically come with 256MB of RAM, although some G5 systems come with more. If you anticipate using Adobe Photoshop Creative Suite 2, Adobe's top-of-the line image manipulation software application (discussed later in this book), on your Mac, 256MB will not be enough RAM. Generally speaking, when working with images, the more RAM the better, and I recommend fitting your Mac with the maximum amount of RAM that it will support. 1GB of RAM is perceived as about the minimum these days for serious imaging work. Although Adobe Photoshop Elements 3, Adobe's simplified and less-expensive image manipulation software application (discussed later), does not require so much RAM, later upgrades might require more, and it is best to start out with as much as you can afford.

Bus

The *bus* is the path the information flows through, connecting all the peripherals (such as the hard drive, graphic card, and CPU) together. I like to equate the bus to a highway. The faster the speed limit and the wider the highway, the more cars will get through. The bus is usually tied to a specific type of platform. For example, the bus on a G4 Macintosh is slower than on a G5 Mac.

Say Cheese

If you want to purchase more RAM, shop around either on the web, in the back of computer magazines, or by making a few phone calls. You can find great prices, but beware—not all RAM is created equal! Try to get RAM from reputable makers like Kingston and Crucial. Also, RAM is sold in many configurations. Be sure the RAM you buy will work on your machine. If you have a Mac computer, you can be safest by buying RAM directly from an Apple Store near you or online.

Although installing RAM is not difficult, you might want to have a qualified repair technician install your new RAM. Because RAM can be damaged by a spark of static electricity, if you decide to do it yourself, invest in a static dissipation wrist strap (about \$7 at most computer stores) and follow the instructions in the RAM package and supplied by your computer's maker.

Clock Speed

Clock speed measures how fast your CPU can think and is another component of speed and performance. A CPU running at 700MHz is slower than a 1.0GHz machine. What does that mean to you? If you are working on a 10- to 50MB file, it might take a few seconds more to rotate a file on a 700MHz than on a 1.0GHz. However, if you are working on a 100MB file, like I usually do, it could mean a difference of a few minutes. Another thing to consider is the CPU series. A 1.0GHz Celeron is not as fast as a 1.0GHz Pentium III, and an AMD Athlon XP 1700+ is just as fast as an Intel Pentium 42.0GHz.

Say Cheese

Apple systems use processors from Motorola. The chips that Motorola makes are called RISC (Reduced Instruction Set Computer or Chip, depending on who you ask), which means that they understand instructions that are all the same length. Intel and AMD processors are CISC (Complex Instruction Set, well ... you know) –based, which means they process instructions of different lengths. This approach enables RISC systems running at 1.0GHz to equal speeds of 1.5- and 1.7GHz CISC systems.

Hard Drive

The hard drive is like a filing cabinet; it's where you store all your information. The rule here is, again, the more, the merrier. Hard drives are cheap; the difference between an 80 GB and a 120GB hard drive is not minimal; the 120GB drive is better and cheaper than the 80GB. How? The economics are simple when you understand

the hard drive market. Prices are determined by the OEMs (Original Equipment Manufacturer, like Dell, Apple, or HP) because it's the OEMs that buy in bulk. When OEMs stop buying 80GB drives and start buying 120GB it becomes expensive to make the 80GB drives, so prices go up on the 80GB and down on the 120GB. This is why you'll see a 80GB drive for \$99 and a 120GB drive for \$119 at your local computer dealer. Look for this trend and buy wisely.

There is a difference of opinion about how you should handle hard drive storage. Some advocate buying your computer with the largest built-in hard drive available. Others suggest getting two or more smaller drives. The fact is that hard drives do fail, and if you have two or more smaller drives rather than one big one, you will lose less if a drive crashes. I would consider a 120GB hard drive just about the smallest you would want in a computer to be used for digital imaging. You can get your computer with two or more 120 GB hard drives installed at the factory, or you can add additional external hard drives to increase your storage capacity. Regardless of how much hard drive space you have, you should always back up all important files onto some other storage media. We'll talk about all of that in more detail shortly.

External hard drives come with stands for your desk.

Say Cheese

On Windows platforms, you will probably see drives that plug into IDE connections on the motherboard. Most of these spin at 5,400rpm, but you might also see drives spinning faster, at 7,200rpm. Although the rpm is an important factor in how quickly you can access information, it is not the only one. Unless you are planning to do intense multimedia presentations or digital video editing, don't worry about access speed.

Ports

Ports are the outlets on your computer where you plug in all your cables. In addition to the monitor port and keyboard port, you will usually find a USB (or FireWire)

port or two for your camera (if you can't find them, see whether your computer is using the same port for more than one task).

The following list describes the different types of ports:

♦ A serial port is the port used on older Windows computers to connect peripheral devices, chiefly printers. Serial ports are disappearing as more and more peripheral devices use USB, USB2, and FireWire connections. It's unlikely that you will need a serial port unless you have an older printer.

Behind the Shutter

FireWire devices may be connected or disconnected while the system is running. There is a right way and wrong way to do this "hot swapping," though, so make sure to read your computer's operating manual and do it the right way. Doing it wrong won't hurt your computer, but it could cause your system to lock up and have to be rebooted.

Flash

USB, USB2, and FireWire devices can be "Hot swapped," which means that you can plug or unplug them while the computer is running. Plug a mouse into an Apple iBook and you will be able to use it right away. Plug a FireWire-capable camera into that PC and transfer the pictures immediately. Although you can plug in almost any device and use it immediately, you might have to follow a procedure prior to unplugging. On a Mac you must drag the icon of the device to the Trash/Eject, wait for the icon to disappear from the desktop, and then unplug. Don't worry, if you forget to do this it won't hurt your computer, but your computer will yell at you with pop-up windows telling you that you've offended it, and you might need to shut it down and reboot to make it happy.

- ◆ USB (Universal Serial Bus) and USB2 ports are standard for all new computers—Macs and Windows—as well as on most cameras. They are fast, and more important, are universal to all new equipment. They also greatly increase your machine's capability to be plug-and-play—compliant.
- ◆ IEEE 1394 (FireWire) ports are commonplace on current Macintosh computers and are becoming more common on PCs. Many peripherals, including most

digital video cameras, DVD players, and even some MP3 players (most notably the Apple iPod), are coming with FireWire as a standard. FireWire connections are very fast and robust. If your computer does not have any FireWire ports, you can buy an inexpensive FireWire board and install it to add one or more FireWire ports.

Modems

With so much of our lives now revolving around e-mail and surfing the web, it is almost impossible to own a computer and not need a modem. All modems on the market today offer at least 56Kbps (Kilobytes per second) speed, though today most people find 56Kbps and even faster POTS (Plain Old Telephone Service) modems agonizingly slow. There are several options to get much faster modem operation. One of these is DSL (also sometimes called ADSL for Analog/Digital on Same Line). DSL uses your standard telephone line but transmits digital data on it at a very high speed. You can use the same line for regular telephone calls and fax at the same time as the modem, which is quite convenient. DSL is on all the time, so there is no need to log in every time you want to go on the Internet. Even faster than DSL is the

In Plain Black & White

56Kbps speed refers to the best possible download speed from your ISP (Internet service provider) via standard phone line connections (the maximum upload speed on these modems is only 36Kbps). Poor phone lines, older switching technology, and sometimes your modem's mood will slow the download. I find that during peak usage times (between 6 and 11 P.M.), the Internet gets very busy and modem speed can get very slow.

cable modem. Cable modems "piggy back" your Internet service on the same cable that brings you your cable television. Generally this service is relatively inexpensive and many cable TV companies will give you the modem at no charge if you agree to keep their service for a specific amount of time. If you find a regular telephone modem too slow, check with your telephone service provider to see if they offer DSL and with your cable TV company to see if they offer cable modem service.

You will also possibly hear about satellite modem service. At the present time this is not very satisfactory because it uses the satellite signal to download data to your computer, which is blisteringly fast, but it still relies on ordinary telephone lines for outgoing data, which can be very slow. Two-way satellite modem service is coming, and after it is fully implemented it might be the best of all modem services.

Graphic Cards

Most very low-cost computers (in the \$300–\$400 range) offer video (this drives your monitor) that is integrated into the motherboard. This is fine as long as you don't ever need more graphics power. Most machines, however, offer the graphic/video cards as stand-alone boards that take up one of the accessory slots. The benefit of

stand-alone cards is that you can upgrade your video card without getting a new machine, should you find that you need a faster or improved video/graphics card.

The amount of VRAM (Video RAM) on your video card determines how large a monitor you can use and what bit depth you see (for now, we'll define bit depth as the amount of color you can see). You don't want to cheap here. Do not purchase a 2D card with less than 8MB of VRAM. With more VRAM available, you can get better texture and colors, and you will see a marked increase in video speed.

Say Cheese

A lot of different video cards are available; many are geared toward 2D image graphics, whereas others include 3D graphics. The 3D cards greatly improve your video performance when it comes to viewing games. (You are going to play a few games, aren't you?)

You can have the fastest computer in the world, but if your video card is slow, the benefits of that fast computer are counteracted. The faster your video card, the faster your screen redraws, so you will see the changes you made to your images faster.

Monitors

Which monitor you buy might be the most important decision you make as far as image quality is concerned. If you can't see the image you have taken and its details, you will have a hard time editing it. However, there are so many monitors on the market that buying one can easily become confusing.

Before you buy a monitor, it's a good idea to see what's hot and what's not. Pick up a computer magazine or visit a website that features tests and comparisons. Many of these reports will make it easier for you to compare monitors of similar size and with similar features. They might even rate the monitors as a best buy or editor's choice.

LCD, or "flat screen," and CRT monitors come in all sizes. A flat screen monitor will take up less space on your desk.

Behind the Shutter

Many professional photographers, illustrators, and graphic designers use two monitors with their systems. One monitor, which is run off the onboard video card, displays the imaging software's tools, such as the color palette. This monitor is referred to as the toolbox monitor. The other monitor, which is usually run off an in-slot monitor card, shows only the image. The benefit here is that the image can be viewed without the clutter of the software interface. Remember, on some computers each monitor needs its own video card.

Consider monitor size when buying a new monitor. Monitor size is typically measured diagonally from corner to corner of the viewing area (the monitor's case might take a little off this dimension). Some computer systems come with 15-inch monitors, which are pretty small for imaging. (If you find that you are leaning into your screen or you are constantly cleaning off nose prints, your screen is too small!) If you can, buy a computer without a monitor or try to trade up to a monitor that measures 17 inches—a great size for most imaging. Monitors should cost between \$100 and \$700, with most found in the \$300 to \$600 range (you will pay more for extra controls, higher resolutions, or faster refresh rates). The next size up from a 17-inch monitor is a 19-inch model, which ranges in price from \$300 to \$1,100. On top of the heap, king of the hill, and all-out huge, are the 21- to 23-inch monitors, which are primarily used by professionals and cost up to \$2,500. For the most part, monitors are universal, so you do not have to buy the same brand monitor as your computer.

Flat-screen LCD monitors are becoming more popular due to their thin profile, lighter weight, smaller footprint, and much lower heat production. Additionally, unlike older CRT monitors (Cathode Ray Tube, which work like traditional TV sets),

LCD monitors emit no radiation. Another concern is that CRT monitors flicker—that is, they alternate between showing an image and going black—at the same rate as the power supply. That's 60 cycles per second in the USA and 50 in many other countries. Some people find they get eyestrain and headaches from working for hours in front of a CRT monitor. LCD monitors do not flicker and, for most of us, are much easier on our eyes. LCD monitors are sharper than CRT screens, but they have the disadvantage that most of them are fixed resolution. They also have more contrast than CRT monitors, typically in the 300:1 or 400:1 range for the better ones. This makes graphics and type appear sharper but won't affect the contrast of your digital images on the screen.

If you want to save yourself a lot of eye, neck, and back strain, set your workstation up with your body in mind. Your keyboard should be on your desk or keyboard tray, resting at the level of your elbows when you are sitting in a chair. (That is, if you are sitting in your chair with your arms at your side, the desktop should be at the same height as your elbows).

The next important thing is the monitor height. The monitor should be at your eye level when you are sitting in the chair. You should not have to look down or up at it. This will greatly reduce neck strain.

If you find yourself squinting at the screen, try to reduce the ambient lighting in the room. Put up a few shades or turn off some lights. I usually have a small desk light on my desk lighting up my paperwork or keyboard. Because you are sitting so close to the screen, especially for those of us who wear glasses, you might consider asking your optician to make you glasses that are set up for your computer monitor.

Peripherals

Many peripherals are available to enhance your computer. These gadgets take up much space in computer stores, and many pages in catalogs. Some of them, such as a CD/DVD burner, are pretty handy to have. Others, such as a coffee cup holder that attaches to your monitor, are not really needed. Take a few moments to think about what you are buying and how it will fit into your system "plan." Will your purchases enhance your system's capabilities or just look cool on your desk?

DVDs and CDs

As discussed previously, you need a way to take data off your hard drive to store or transport. Graphic files can take up a lot of space, so you will need reliable storage external to your computer. DVD/CD recorders (commonly called "burners") are great for archiving information. The drives range from under \$100 for an entry-level drive to over \$500 for a drive with all the bells and whistles. The blank media is also incredibly cheap. A blank DVD hich holds about 4.7GB can be bought in bulk for well under a dollar, while a blank CD, which holds 650MB or 700MB, costs less than a quarter. Most recently double-sided DVDs have been introduced that hold twice as much data. I strongly recommend that you consider buying a DVD/CD recorder, if your computer doesn't have one built in. Besides, it's cool to make your own video DVDs and audio CDs! CD-RW drives allow you to use special CD-RW discs that can be erased and re-used like space on your hard drive, and they're often as cheap as plain CD-R discs. Oh, and you can permanently burn a CD-RW as if it were a CD-R. Today DVDs, with their much greater capacity, are rapidly replacing CDs as recording media. A recent trip to an office supply store revealed many shelves of blank DVDs and only a handful of blank CDs.

Printers

It is a lot of fun to take pictures and see them appear instantly on the LCD screen on the back of your camera. It is even more fun to see the images on your big new 17-inch monitor (you did get the 17-inch monitor, didn't you?). But what makes the whole process totally worthwhile is printing out the images on your own printer. You can make an image any size you want, and make as many as you want, just for the cost of the paper and ink! Your printer might well be as important a piece of equipment as your camera; a few extra dollars spent on the right printer is well worth it.

Finding the right printer can be a chore, though. There are dozens of consumer models available at local stores such as CompUSA, Circuit City, Staples, and the like that come in under \$200. You'll find printers from HP, Epson, Lexmark, Brother, Canon, Samsung, and many others. All printers in this range are ink jets, though Epson, HP, and Canon have developed technologies that allow previously simple ink jet printers to output excellent images with great clarity onto special photographic paper.

Although it would be impossible to test each printer, some displays at major retail chains do offer demonstration printouts. Give some of these a whirl and see which you like better, though avoid trying this if there is only one demo printer. You'll have

nothing to compare it to. In the end, buy the best printer you can for the money you budget to spend. However, I recommend sticking with one of the major name brands to insure that ink will remain available in the future. Some smaller printer companies have gone out of business in recent years leaving their users high and dry.

The Epson Photostylus sixcolor printer is designed to print photos and, with its specially formulated inks, delivers rich colors.

Also, try to figure out the cost per print for ink and paper. You might find that the low-priced printer you are looking at isn't such a good deal because the ink is much more expensive than the ink for another printer that costs a bit more. It has long been said that some companies practically give away their printers because they make their real profit on the ink.

Behind the Shutter

Don't rely too much on the demonstration images that the manufacturers distribute or spit out automatically from the printer at the dealer. These images have been tweaked to make the printer look wonderful, taking advantage of the printer's capability to print some specific colors well. Additionally, an image might be chosen that has an "expanded" (very detailed) shadow or highlight area. I know; I've been paid to "tweak" a few in my time!

The image quality should be the paramount reason you buy a specific printer. However, there are a few more things to consider.

Inkjet Printers

Inkjet printers, ranging in price from under \$100 to well above \$500, have become very popular. Inkjet printers spray ink through tiny jets, or nozzles, onto the paper. Pretty simple, huh? All in all, inkjet printers deliver great and affordable results, but there are some downsides:

- ◆ Inkjet printers can be very slow. It takes a lot of time for the print head to scan across the page and deliver ink. Pay close attention to the page-per-minute (PPM) specification when you choose a printer. (You'll have to spend more money to get faster PPM technology.) Make sure you are comparing apples to apples by checking to make sure the stated pages per minute is for photographs and not just text. Most printers can print simple text files very fast. Canon printers are the current speed champions in printing photos, but things change rapidly in the printer business, so check specifications before buying.
- ♦ Although it's not always considered a downside, some printers cannot cover the entire page with ink. They will leave a small border of nonprinted paper. Some printers can print "borderless" images, but you might pay a bit more for this option.
- Some of the newer printers have more than one place to put the paper. This means you can put in two different kinds of paper; for example, ordinary paper for proofing and document printing and photo paper for printing photographs. You can also put in two different sizes of paper and switch between them as needed. Just make sure the right type and size is selected in the printer driver before you click that PRINT button!
- ♦ Many inkjet printers are four- and six-color printers. Some of the newest models designed for printing photos use eight colors. The first color is always black (K) and usually is in its own color ink cartridge. The next three colors—cyan, magenta, and yellow (CMY)—make up the needed inks to print color. The next two are specialty inks, usually an extra lighter cyan and extra lighter magenta, which really make the images sing. The eight-color printers add dedicated green and red ink cartridges for even better photographic quality. Some printers, usually the more expensive ones, will have separate cartridges for each color, while some will have a group cartridge for all the colors. I recommend the eight-color printers for maximum quality in your color prints. Regardless of how many colors, I recommend a printer with each color in its own cartridge so that you are not throwing away perfectly good ink when you change cartridges.

Although you can use "plain old" paper to get a quick draft image printed, a better paper grade, such as a good-quality laser paper, yields better results. For the best results use paper specifically designed for printing photos on inkjets. Some manufacturers, such as Epson, sell paper, but you can also find papers by nonequipment manufacturers, such as Luminos, that work wonderfully. For you old darkroom folks, yes, that's the same Luminos that manufactured darkroom paper. The best thing to do is get a sampler pack at a photo store and try out the various brands and surfaces and see what you like. I would use these papers for "final" images, and use cheaper paper for working prints.

Dye Sublimation

Some feel that dye sublimation (dye-sub) printers deliver the quality closest to a photographic print. Dye-sub prints look and feel much like the drugstore color print you are used to looking at, delivering excellent color clarity and sharpness. Dye sublimation printers typically are much more expensive than inkjet printers and the media (color ribbons and paper) are pricier. With dye sublimation printers you can only use the manufacturer's paper, so you are limited to one or two paper surfaces. With inkjet printers you can use a virtually unlimited variety of papers.

Behind the Shutter

Dye-sub printers lay down one color of dye, push the print out, and then suck the print back into the machine to lay down the next color. Because the dyes bond with each other, this is a natural way to produce color, but I admit that the first time I saw this, I thought the machine was broken.

Color Laser Printers

Laser printers work by magic. No, not really! A laser "exposes" a drum inside the printer. (Remember, a laser can produce a very small dot!) As a result, the drum is charged with static electricity. The drum picks up colored toner, which sticks to the static. The drum transfers the toner to the paper. The toner is then thermally fixed to the paper (this is why the paper is warm when you pick it up). A color laser printer produces a lot of heat—nothing dangerous, but it will warm your room up a bit—and consumes a lot of electricity. Generally speaking, color laser printers do not produce prints approaching the true photographic quality you can get from good inkjet or dye-sublimation printers; they are more suited to general office printing.

Behind the Shutter

Many printers have sockets on them that allow you to connect your digital camera directly to the printer and make prints without using a computer at all. True, you have limited control over the images and must print them "straight" with no cropping or manipulation, but many times you might want to make quick "proof" prints just to see what you have, and printers with this capability make it a snap. Also, many printers now incorporate card readers, allowing you to take the storage card from your camera, plug it into the printer, and print away. Canon even makes compact inkjet printers (and some small-format dye-sub printers) that can be powered by rechargeable battery packs. With one of these printers you can make instant prints from your digital camera even if you are miles away from the nearest electrical outlet.

Scanners

Another accessory that you might want to consider for your digital darkroom is a scanner. A scanner can be a great way to add many of your old photos into your digital archive. You can use a scanner to reproduce or manipulate images you already have taken or images someone else has given you (my mom is always finding old prints that she wants me to scan in and reproduce).

Scanners cost anywhere from under \$50 for a basic one to several thousand dollars for a high-resolution one. You will find many, many brands of scanners on the market; this is because scanners are the forerunners of digital cameras, and have been on the market for quite a while.

The Epson Perfection flatbed scanner fits nicely on your desk.

Two different types of scanners are available on the market:

- Flatbed scanners. Flatbed scanners are used mainly to reproduce reflective art, such as photographic prints or paper (also known as your kids' artwork from school). These scanners look like a rectangular box with a hinged cover; under the cover, you'll find a glass plate on which you put your image face down. The scanner head and mechanism are under the glass surface. You can lower the cover to hold the artwork flat, or simply to keep the glass clean when not in use. Many flatbed scanners come with slide/negative adapters that allow the scanner to be used as a slide or negative scanner. These can work well in the better models but are not as good as dedicated film scanners.
- ◆ Film scanners. Film scanners are made to scan 35mm (or larger) slides and negatives. Generally, these scanners cost more than flatbed scanners, starting at about \$300 and ranging well above \$2,000. These scanners cost more because they contain high quality lenses, along with a light source to illuminate the film. Basically, when scanning a mounted slide, the slide is inserted into a slot and the scanner does the rest. Some scanners even offer a transport mechanism, which

enables multiple slides to be loaded up and scanned automatically. For scanning negatives these scanners have a holder (typically for a strip of six 35mm negatives) that fits into the scanner for negative scanning.

You are not going to get your scanner to budge one dot without some kind of controlling software. The software that comes with your scanner enables you to specify the size of your image, the contrast, and the white and black point, and to adjust for color. You might also be able to sharpen your image using your scanner's software.

Software, be it stand-alone or plug-in, comes *bundled* with your scanner. Stand-alone software, as you might have guessed, works independently of any other software (other than the operating system, of course). Plug-in software works from within

Flash

Speed is a definite factor to consider when purchasing a scanner, which is one of the advantages of a single-pass scanner. When comparing scanner speeds, be sure you are comparing scanners of similar resolutions.

Say Cheese

Get your final image as close to correct as possible during the scanning process. For one thing, it is less time-consuming; you don't have to waste a lot of time in an image-editing program to get things right.

other software, such as your photo-imaging software or illustration software. In some cases, you might even be able to control your scanner from your word-processing software.

You will probably think of your scanner software as an "acquire" module that enables you to scan images and save them as a file to your hard drive or view them onscreen. However, this doesn't mean that you shouldn't think about what features you want in your scanner software. For example, your scanner software should allow you to perform a preview scan—a quick screen resolution scan that gives you a good idea of what the image will look like, as well as whether it's correctly set up in the scanner. You can also crop a preview-scan image, saving you time if you want to scan only a small section of the image. The most important thing your software needs to do is let you see your preview scan as large as possible on your screen—not just a tiny image that you can't see any detail in. Also, you need a large preview image to select points to apply your adjustments, such as selecting white and black points, contrast, brightness, and the like.

Many of us find that the bundled software that comes with some scanners isn't very well designed. Independently developed scanner drivers might deliver much better performance from your scanner, as well as being easier to use. One example is VueScan, which offers inexpensive drivers for most brands and types of scanners. You can download a trial version to see if you like it better than the manufacturer's driver. VueScan information can be found at www.hamrick.com. Another independent scanner driver is SilverFast AI, which is designed for serious and professional photographers. SilverFast AI is somewhat expensive, so it makes no sense to add it to a low-priced scanner.

Behind the Shutter

Several manufacturers have introduced multiple-purpose devices that combine several features into one. A good example of this is the Epson Stylus Photo RX600. This useful gadget combines a six-color photo-quality printer, a flatbed scanner, a slide/film scanner, a color/black-and-white copier, and a card reader for all types of storage cards into one unit with about the same footprint as a printer alone. Were compromises made to get all of this functionality into one gadget? Not at all. It does an exceptionally good job on all of its functions, and costs less than if you bought equivalent single-function devices. If you feel that you will want both a scanner and printer you should definitely look at these combination devices.

The Least You Need to Know

- Both a Mac and a Windows machine can perform well if you do your homework before you buy.
- Buy the biggest monitor you can afford.
- Buy a removable storage device or some way to back up your treasured data.
- Watch out for consumable costs when buying a printer.
- If you buy a scanner, get one that is as versatile as possible.

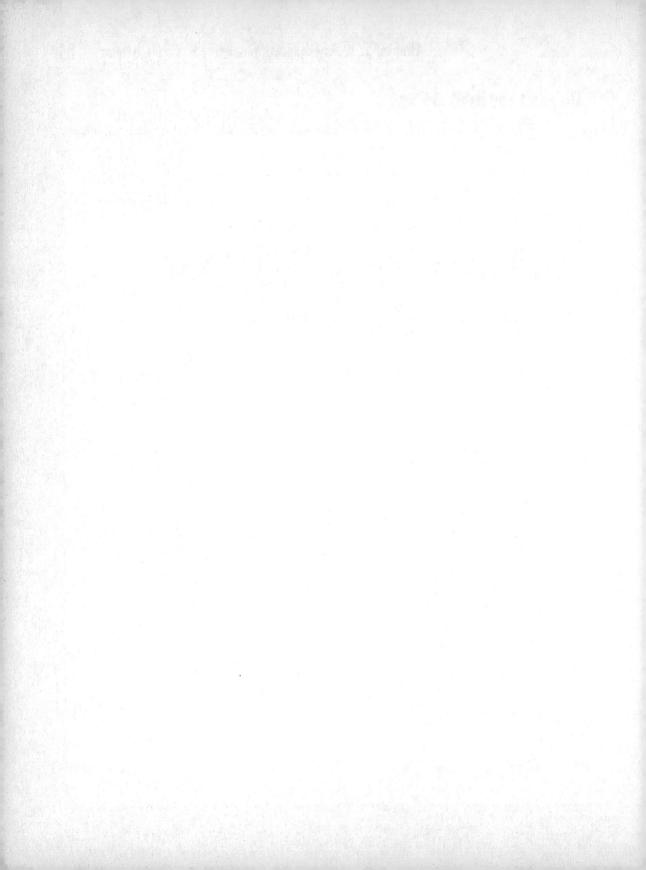

Software: What You Want to See Is What You Get

In This Chapter

- Using image-editing software
- Improving composition and image quality
- Storing your images
- Creating photo albums

All of the fun in digital photography is in controlling and manipulating your images. You can accomplish this and more with the many image-editing software programs that are available. You will also find software that allows you to store and retrieve images just like a photo album. Small business and home office software can even help you create a brochure or newsletter.

Let's take some time to overview what image-editing software can do.

Improving Composition and Image Quality

There are many ways to improve your image's composition and quality:

- ◆ Cropping. The first major duty of image-editing software is to help improve composition. With little trouble, you can crop your images, enabling you to reframe them or change their proportions.
- ◆ Resizing. You might also want to resize your image, enlarging it or reducing it. If you were not holding your camera perfectly straight and your horizon line is sinking to the left, no problem. You can rotate your image and straighten up the skyline.
- Adjusting brightness and contrast. If your image looks a little flat, you can increase the contrast. Suppose the photo you took of a house was a little dark because it was in the shade; no problem, just brighten it!
- ♦ Changing colors. You can change your image's color, adjust the contrast, lighten or darken it, and saturate or desaturate the color—all with your image-editing software. You can reshape reality!
- ◆ Cutting and pasting. With a little skill and practice, you can cut and paste images from one photo into another. If Uncle Joe was late showing up for the family group photo, you can take a separate photograph of him and paste him into the group shot. Here's another example: I recently took a picture of a bunch of irises. I wanted a photo just filled with the flowers but I didn't want to take the time to arrange three dozen flowers. I copied a few of the flowers and pasted them back into the shot in different places.
- ♦ Applying filters and special effects. You can apply many special effects to your images using your image-editing software. You can make your photo look like an oil painting, or add a texture to your backgrounds. Just as you could put filters over your camera lens, you can apply filters to your image. For example, if you choose a distortion filter, you can spherize your image and add reflection to it to make it look like you were looking into a crystal ball.

As you can see, there is almost no limit to what you can do to a digital image. If you can imagine it, you can do it. Remember, all you are doing is manipulating pixels by using image-editing software. Also remember that the phrase you've been hearing all your life—"A picture never lies"—no longer applies. Ever since a photo editor at a magazine moved the great pyramids of Egypt closer together to fit them onto the magazine cover, photography has not been the same.

Proprietary and Third-Party Software

Most cameras come bundled with free software. This is handy, because it means you won't have to go out and immediately buy software. Some cameras come with software designed by the manufacturer, while other cameras are bundled with third-party software. We'll take a look at both.

Say Cheese

The most important piece of software to be bundled with your camera is an image-enhancement program such as Photoshop or Photoshop Elements. After that, cataloging or "shoebox" software is a big help. Special effect software is great to have, also, but it's a lower priority if you are counting "freebees." Web design software can also be found bundled. Remember, many of these programs are "light" versions and might not be fully functional.

Proprietary Software

Some camera manufacturers bundle their own proprietary image-editing software with their cameras. Most proprietary software packages more than cover your basic image-editing needs. The software enables you to download the images from your camera, adjust color, lightness, and contrast, and perform most of your basic image-enhancement tasks. You can also cut and paste, crop, enlarge, retouch, and make

selections. These software packages also usually help you print your images as single photos or grouped on a contact sheet. Proprietary software can even help you access the Internet and e-mail your images. If all you are interested in is basic image manipulation, a proprietary software package is all you need.

Say Cheese

Most of the software distributed with cameras will work on either a Mac or a Windows platform.

Adobe Photoshop

Photoshop is a robust image-editing program and, by far, one of the most popular on the market. Virtually every imaging professional—professional photographers, art directors, designers, illustrators, and even people in the motion picture industry—use Photoshop. Photoshop is also the core of most image-enhancement used with printing presses. It would not be a long stretch to say I owe a lot of my career to

Photoshop. The current version of Photoshop is Photoshop CS2, which has become an integrated part of what Adobe calls its Creative Suite.

Behind the Shutter

The Adobe System was founded in 1982 and is the father (mother) of all imaging software found today. Photoshop, the original imaging software, is the basis of all photo and image-manipulation software. Adobe made digital photography possible, even before digital cameras were commercially available. Although there have been many challengers to Photoshop, it still stands as the premier model for all image programs. Additionally, Adobe Illustrator has contributed to and is the model for all digital illustration. Many, if not all, professional photographers and illustrators owe their current careers to Adobe.

It's a good idea to get used to the Adobe way of doing things, because Adobe has a major share of the imaging and illustration market. As you get more serious about imaging, which I know you will, you will find Adobe Photoshop CS2 a natural step up from Photoshop Elements 3.0, which I have used throughout this book.

Photoshop can be used to make complex image manipulations such as collages and multiple-layered images. It can also be used for complex color corrections and color management, and to help make images press-ready. Although Photoshop is a complex and in-depth program, it can be mastered with a little practice. If you decide to use Photoshop, which is available for both Windows and Mac, be aware that it needs a lot of RAM (at least 500MB) and a quick processor to run. Before buying Photoshop, you should master Photoshop Elements 3.0.

Although you can buy the current version of Photoshop, Photoshop CS2, as a standalone software application, it is just one part of the Photoshop Creative Suite, which also includes InDesign CS2, Illustrator CS2, GoLive CS2, Acrobat 7.0 Professional, Version Cue CS2, and Adobe Bridge. The package price of the entire Creative Suite 2 offers a considerable saving over the cost of all of these applications if bought separately, so if you think you will want to use some of the others it might make more sense to buy the package to begin with. Adobe updates all of their software frequently, so before buying check to see what the latest versions are. After you have bought any of Adobe's products you can usually upgrade for a nominal fee when a new version is introduced. This allows you to remain up to date without spending a fortune on new software.

Photoshop Elements 3.0 is somewhat like a simplified version of Photoshop and is a much less expensive way to get your feet wet in Adobe's pond. I'll use Photoshop

Elements 3 for the examples in this book, but you can do the same things with Photoshop, and many of the same things with other software applications.

Third-Party Software

Many cameras come bundled with third-party software—that is, software from third-party vendors that the camera manufacturer is licensed to distribute.

Flash

Be aware that some third-party software might be "light" versions that do not have all the functionality of a full version. You might also find software that is set to work for only a short period of time; after that, you'll have to pay for a fully working version. You might even find demo software that lets you do everything except save or print the image. This can be especially aggravating.

Adobe Photoshop Elements 3.0

One of the most popular nonproprietary software programs you will find bundled with a camera is Adobe's Photoshop Elements 3.0. Photoshop Elements 3.0, baby brother to Adobe Photoshop, can perform all the functions that the proprietary software can and more. For example, using Photoshop Elements 3.0, you can save the selection you made to be used again or as a mask, and you can apply filters and special effects to your images. I highly recommend that you use this program as your image-editing software of choice. Besides, it's inexpensive. Demo copies are available for download from Adobe's website and might even be distributed with some of the more recent cameras.

Paint Shop Pro

Paint Shop Pro 9.0 by Corel Software has the added bonus of being both a bit-mapped and vector-based graphics program. This means that you can edit photos and illustrate with the same program. This is the best of both worlds. Paint Shop Pro also offers some web graphics goodies, including compression and the ability to slice images. Just as with Photoshop and Photoshop Elements, Corel offers a somewhat stripped-down version of Paint Shop Pro 9.0 called Paint Shop Studio. Corel also offers Paint Shop Photo Album 5.0, an organizing and filing application.

Behind the Shutter

An interesting image manipulation software package is available on the Internet. It is called The GIMP. The GIMP is the GNU Image Manipulation Program. What does GNU stand for? According to its originators it stands for "GNU's Not Unix", but it doesn't really matter what it stands for. GNU is another operating system like Windows, Mac OS, Unix, and so on. The neat thing about The GIMP is that you can run it on any system, including Mac, Windows, and even Unix. It does a lot of the same things that Photoshop does, and many users find that it meets their needs just fine. The best thing about The GIMP is that it is freeware. That's right, you can download it and use it absolutely free! To find out more about The GIMP and decide if you want to give it a try, go to www.GIMP.org and read all about it.

Managing Your Images

After you've begun collecting all these photographs, you'll soon realize that your previously unlimited hard disk space has become a precious commodity. With the promise of freely reclaimable picture media that incurs only the cost of time, you'll take more and more pictures, and with a high-resolution camera, this can build up fast. These files must be stored somewhere, or posterity is only a joke. That's where CD-R/RW and other removable media come in. But how should one work with them and organize them logically? In the past, it was necessary to install a separate program for organizing and retrieving images. But now that Photoshop CS2 and Photoshop Elements 3.0's expanded browsers offer very advanced file organizing and retrieving capability, most of us find that we no longer need any other software to handle our image organization, filing, and retrieval. However, if you are relying on the image editing software that came bundled with your camera, you might need software to help you deal with your image files as their number grows.

Album Software

Many imaging software programs include album software, but in case yours doesn't, you can always buy stand-alone album software such as Microsoft's Picture-It Premium 10, Ulead Photo Explorer 8.5, Extensis Portfolio 7.0, and Adobe Photoshop Album.

The techniques and technology used in the various albums differ in complexity and abilities. It would be difficult to review each album program, as they are constantly evolving in their capabilities. If you are shopping for cataloging software, my

suggestion is to test-drive a few packages by downloading demos from the software developers' websites.

When deciding what type of album software to buy, keep your current and future catalog and retrieval needs in mind. Although it will be hard to do, try to estimate how many photos you are going to need to store. You will need to ask a few questions when deciding which software to purchase:

- What are the capacities of the program?
- ♦ How many images can it store?
- Will the program keep track of multiple disks?
- How good is it at retrieving images?
- Can you use simple searches, such as looking for keywords in the image's filename or description?
- Does the program create its own image formats, or can you use your own?
- Will it compress your files?
- Will it alter your images?
- Can you re-create a catalog description file if the original files get lost or damaged?

The easiest way to evaluate software (of any type) is to check out the advertising. You can learn a lot about specific software by what is said and—more important—what is not said about it!

The Least You Need to Know

- Image-editing software will help you improve and manipulate your images.
- Camera manufacturers and third-party developers make image-editing software.
- Catalog software will help you store and retrieve your images.
- Album software allows you to build photo albums that you can store on your computer or print to send to friends and family.

Let's Take Pictures

It's easy to pick up a camera and take a picture. All you do is look through the viewfinder and press the button. But to make a photograph, that's another story altogether.

The difference between taking a picture and making a photograph is control. It is not meant to be a difficult task or hard work. The more fun you have making a photograph, the more satisfying and creative your results will be.

Chapter

Exposure Made Simple

In This Chapter

- Understanding f-stops
- Learning about shutter speed
- ♦ Figuring out film/chip speed
- Using creative controls
- Making the most of depth of field

Taking a photograph that will reproduce what you saw through the view-finder involves correctly exposing the chip. Too much light produces washed-out images; not enough light reproduces dark, murky images.

The Lens

Let's explore, for a moment, how the light gets to the digital chip. Providing that the lens cap is off and your fingers are out of the way, light enters your camera through the front of your lens. It then passes through a series of lens elements that bend the light and send it on its way to be focused on the film plane (where the chip is found). The lens elements are usually found in groups of two or three, and are grouped together to form optical

groups, or *components*. Depending on the design of the lens, you might find two to five sets of groups or components in a lens.

Inside your lens, somewhere between the groups of lens elements, is an iris diaphragm, also called the *aperture*. The diaphragm regulates how much light passes through the lens. Your finger, lens cap, and camera strap might also accomplish the same effect, although the results will not be desirable.

The diaphragm, which is located between the groups of elements in the lens, is made up of tiny blades that can be opened and closed.

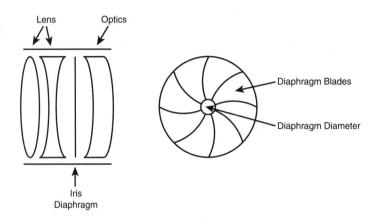

The Shutter

Next, there must be a way to limit the amount of time that the light strikes the film plane; this is where the *shutter* comes in.

A focal plane shutter is designed with two sets of overlapping blades, sometimes called "curtains." When the shutter fires, the first set of blades is driven across the sensor chip by springs, exposing it to the light that has come through the lens. When the sensor chip has received enough light, the second set of blades is spring driven across the sensor chip to once more block off the light. The blades usually move from bottom to top of the camera body. After the exposure a motor drives both sets of blades back to their original position but keeps their edges overlapped so that no light gets through. The camera is then ready for the next exposure.

With some cameras, the shutter is incorporated into the lens itself. These are called *inter-lens* or *between the lens* shutters. In most cases the shutter is a set of blades that open and close by spring action and sit just behind the diaphragm. The blades operate with a reciprocating action (just one set of blades opens and then closes to make the exposure). Some simpler cameras use a design in which the shutter and diaphragm are one and the same. The diaphragm remains closed until the shutter

release is pressed; it then opens to the desired diameter. The diaphragm then closes when the proper amount of time has passed.

F-Stops

So what is an f-stop? The *f-stop*, or *f-number*, refers to the diameter of the iris and how much light it lets through the lens. F-stops do not at first seem to be named in a clearly logical fashion. The f-stops progress in a series of numbers, each of which lets in half as much light as the number before it. The higher the f/number, the smaller the diameter of the diaphragm opening. The progression goes like this:

♦ f/1.4	♦ f/16
♦ f/2.0	• f/22
• f/2.8	♦ f/32
♦ f/4	♦ f/45
♦ f/5.6	♦ f/64
• f/8	♦ f/90
♦ f/11	

An f-stop setting of f/8 lets in twice as much light as f/11, but half as much light as f/5.6 (remember: the higher the f/number, the smaller the diameter of the iris). This will not be confusing if you understand that the f-stop is an abbreviation and only shows the bottom of a fraction. That is why the slash mark "/" is used. f/8 is actually 1/8, meaning it is letting through 1/8 of the theoretical maximum amount of light. The reason for the unusual looking progression is that these are geometric progressions rather than simple arithmetic progressions. This is because the diaphragm opening is round (or approximately so). (I'm sure you'll be happy when I tell you that you don't have to know a thing about the math to take great photographs.) By the way, the reason they're called "stops" is that they originate from the early days of photography when plates with different-size round holes were put into a slot in the lens to "stop" a specific amount of light from getting through.

Of course, there are also half stops. Half stops are f-stops between the "regular" f-stops. These will enable you to fine-tune your exposure.

Lenses are referred to by their focal length, such as 135mm or 35mm (we'll get to focal length in Chapter 8), but you'll also see a second number associated with the

description of the lens, such as f/2.0 or f/3.5. These numbers refer to the maximum opening of the lens, also called the *speed* of the lens or how *fast* the lens is. An f/2.8 lens lets in twice as much light at its maximum opening as an f/3.5 at its maximum opening. The f/2.8 lens also costs more than an f/3.5 lens of the same focal length. You will also see f/1.2, f/1.4, and f/1.8 lenses; these are pretty fast lenses—twice as fast (or more) than most consumer-level cameras' lenses, which are usually f/2.8 or so.

Shutter Speed

Behind the Shutter

Undoubtedly, a few of you tech heads want to know the formula for determining an f-stop. Remember: the f-stop indicates the diameter of the opening in the diaphragm; it's the ratio of the diameter of the diaphragm opening divided by the focal length of the lens. So if you are using a 100mm lens and you select f/4, the diameter of the iris will be 25mm. I hope I've made you happy!

(Just to complicate things, the diameter in the previous example would not actually be 25mm, because the f-stop is really determined by the apparent diameter of the opening as seen through the front of the lens! So its actual size must account for the magnification of the lens elements in front of it. That's why lens designers usually have big bottles of aspirin on their desks!)

Putting It All Together: The Relationship Between F-Stops and Shutter Speed

You might have noticed that both the shutter speeds and f-stops work in increments of a half or double. This works out well because the shutter speed and f-stop are used in conjunction with each other to obtain a proper exposure. (Remember again that a proper exposure is made when the chip is exposed to a specific amount of light.)

For a moment, however, let's forget about f-stops and shutter speeds. Let's play ball. Say you have a team of eight players that has arrived at the stadium on the team bus. All eight players need to be on the field to start the game. Between the team bus and the field is a gate, which is open only two feet wide. For all the players to get on the field, they must disembark from the bus and walk through the gate. So one by one and slowly, they walk through the gate.

The coach of the team is upset about how much time it takes the team to get on the field. "Let's show a little hustle, boys!" He orders the players back onto the bus and tells them to do it all over, but this time twice as fast. The players are dumbfounded. They cannot figure out how to get onto the field any faster. From the back of the bus, a small voice is heard; it's the water boy. "Open the gate four feet wide. That way, you all can go through the gate two by two and get onto the field twice as fast." Such a smart boy!

Okay, back to photography. As you have seen, there is a direct relationship between the f-stop (the gate) and the shutter (the speed of the players). Each time you open up the f-stop (make it wider), twice as much light can get to the film to expose it. You therefore need to increase the shutter speed to get a proper exposure. If for some reason (and there will be) you decide to use a smaller diameter aperture (higher f-stop number), you must slow down the shutter speed. Remember, the longer the shutter stays open, the more movement will be recorded—also known as blur!

Let's get a little more specific. Say your light meter indicates that you need to use the f-stop f/11 at ½25 second to expose your photo properly. You decide, and rightly so, that the soccer player you are photographing is running down the field at a quick pace, and you'll need a faster shutter speed. Well, if you open your f-stop up to f/8, you can shoot at ½50 second. That works, but what if you want to freeze the action of the players? You decide that you should set your shutter speed to ⅓500 second. What would your f-stop need to be? Time's up: f/5.6!

Behind the Shutter

Modern light meters work because as light strikes a photosensitive cell, it produces a small voltage that is amplified to move a meter needle or to operate an LED or LCD indicator. If the meter is built into a camera the information is usually fed to the camera's exposure system to automatically set shutter speed, aperture, or both. On a hand meter the photographer must manually transfer information from the meter to the camera.

The following figure further illustrates the relationship between shutter speed and aperture. Notice that the proper exposure line runs through f-stop and shutter speed "sliders" (for this demonstration, we will keep the sliders locked in position). When the proper exposure line moves to the left, a proper exposure still results because as the f-stops are increased (the aperture is made smaller), the shutter speed slows down. When the aperture is made smaller, less light gets in to the film; therefore, the shutter must stay open longer. If you move to the right, and the aperture size is made larger, the shutter speed must speed up. Of course, you can also see this relationship from the point of view of the shutter speed: if you move the exposure line to the right or left, the shutter speed increases or decreases and the f-stop setting follows.

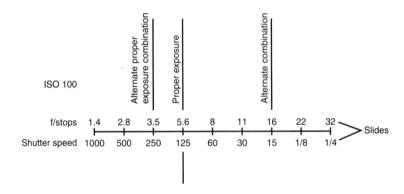

In all these examples, the relationship between the f-stop and shutter speed has been fixed. We've been picking arbitrary "proper exposures"—f/5.6 at $\frac{1}{125}$ of a second or f/16 at $\frac{1}{15}$ of a second. Have you been wondering what sets up this exposure relationship? Read on!

ISO

The ISO number is the rating given to a film, or chip, that describes how sensitive the film or chip is to light. The higher the ISO rating, the more sensitive or faster the film is. If the ISO speed of film A is double that of film B, then type A film will be twice as fast as B. Generally, you will find ISO ratings between 50 and 400 on film (slide films are usually slower than negative films). On digital cameras, where the chips are given ISO ratings, you will find ISO ratings as high as 3200.

The one drawback to using higher-speed films is that film grain, which looks like tiny dots, is more apparent. This can appear as a texture in your film and affects the sharpness of your images. The general rule is to use the slowest film you can get away with. On a sunny day, an ISO 100 film serves well. Inside, however, you should use an ISO 400 or ISO 800 film, because it is more sensitive to light.

One of the benefits of using a digital camera is that you can change the ISO rating of your chip. Digital cameras have an optimal ISO setting, which is determined by the manufacturer of the camera. You get your best results by using the optimal ISO rating for your digital camera, but this rating can usually be altered. Of course, just as with film, digital cameras suffer with excessive ISO speed. Higher than optimal ISO ratings produce noise, which is usually most apparent in the dark or shadow areas (it looks like a blue/black or blue/red dot pattern).

Say Cheese

If you get into a dimly lit situation, try turning on some lights or using a flash before you push your ISO rating.

In some situations you might find the grainy look of the highest ISO speed on your camera produces a nice "pointillist" look, like a Seurat painting; and if you like that look, you can use it to create artistic images.

Flash

Most photographers have found that digital cameras require less light than film cameras at the same ISO rating. This is particularly true with off-camera flash. Many digital camera makers now offer advanced flash units that can be used for automatic exposure off the camera without the inconvenience of connecting cords. You can set the off-camera flash units to produce different proportional light output and have great control over the look of your pictures. Outfitting yourself with three or four flash units can be expensive and will appeal primarily to the more serious photographers.

This is not to say, however, that cameras designed to work optimally at ISO 400 are noisier than cameras designed to work optimally at ISO 100. Nonetheless, you can be sure that if you push the ISO 100 camera to ISO 400, the image it produces will be noisier than the "optimal" ISO 400 camera.

Creative Control

The advantage of all the give and take of the exposure system is the creative control you gain. This is your camera, you are making the photographs, and you have the control. Just don't let it go to your head!

Shutter Speed

The first control you gain is the ability to pick your shutter speed. With a fast shutter speed, you can capture and freeze action. With a slow shutter speed, your images can blur a bit. (After all, what better way to show a speeding car than to have it blurred a little?) You can also slow down your shutter speed to use a higher (read: smaller) f-stop.

Depth of Field

Your second creative control is created by your lens. It is called *depth of field* and has nothing to do with the height of grass. Depth of field is the distance between the closest part of the image that is in sharp focus and the most distant part that is also in sharp focus. If all the objects between two and five feet from your lens are in focus, you have a depth of field of three feet. With a shallow depth of field, you can, for example, take a portrait of someone and have them in focus and have the background be out of focus or blurred. With a deep depth of field, you can take a picture of your family and have all the mountains in back of them in focus. Very nice creative control!

A few things affect the depth of field, and you can control all of them:

- The closer an object is to your lens, the shallower your depth of field will be. If you find yourself on your hands and knees, trying to take a full-frame close-up picture of the first spring crocus, you will have a hard time getting the entire flower in focus. (By the way, this is not necessarily a bad thing; you can tell all your critics you were being creative!) If you are taking a picture of your family, who are standing 15 feet away from your camera, you can be sure that the background behind them will also be in focus. (This all hinges on the fact that you got your family in focus in the first place!)
- ◆ Depth of field can be controlled by which f-stop is used. This is a lot more practical than moving the crocus back and forth in front of your lens; this is also going to make all the exposure control contortions worthwhile. Without going into a long technical dissertation, please believe me when I tell you that the higher the f-stop number (the smaller the diameter of the diaphragm opening), the greater the depth of field, so you can creatively control the focus of your subject by choosing which f-stop you use (along with how close or far that subject is from you). Note, however, that if you want to alter your depth of field by choosing which f-stop you are going to use, you have to let the shutter speed fall where it may (remember, the f-stop and shutter speed are closely related).

Try to retake that photograph of the crocuses, but this time, back up a little and get a group of the flowers in focus. Let's say that your exposure indicates you should have

an f-stop of f/8 (forget about shutter speed for now). So what is in focus? If the whole group of flowers is in focus, that's fine. But is the grass behind the flowers also in focus? Is that a little distracting to you? Well, it is to me, so I'm going to open up the f-stop to f/3.5 or so. Now the flowers are in focus, but the grass is out of focus.

Say Cheese

Don't take boring photos. This demonstration has shown you that you have the control you need to take wonderful photographs!

Suppose your flower plot is three feet deep from back to front. Suppose, too, that the depth of field at f/3.5 is three feet. If you focus in the middle of the flower plot, all the flowers will be in focus and the grass behind them will be out of focus. What happens if you *shift* your focus so that you are focusing on the space in front of the plot of flowers (keeping the same f-stop as before)? Anything that is 1½ feet in front of the flowers will be in focus, as will all the flowers in the first foot and a half of the plot. All the flowers behind that first foot and a half, along with the grass behind the plot, will be out of focus. This might be a nice effect, especially if the flowers in the back of the plot were looking a bit shabby or thinned out.

A wider or lower f-stop number yields less depth of field. Also, the closer you are to your subject, the less depth of field you have to work with. A smaller or higher f-stop number yields more depth of field.

Suppose, however, that some wonderful gardener has ripped up all the grass and replaced it with a sea of flowers! This time, you want to get them all in focus. All you need to do is focus somewhere in the middle of the group of plants and close down the f-stop all the way to f/22 (or more), and everything will be in focus.

Manual or Automatic Exposure

If after all the explanation about exposure you would rather not deal with any of it, relax. Almost all cameras come with fully automatic exposure control. You'll find this easy to use and, as long as you don't get yourself into an exposure pickle (this is a nontechnical term), you should make great photos.

The mid- and upper-priced cameras give you more creative control over your f-stops and shutter speeds. Many cameras give you the option of picking which aperture to use and letting the camera's metering system select the correct shutter speed. This is called *aperture priority exposure* (marked Av, for "Aperture value," on most cameras). Many cameras also offer the opposite, letting you pick the shutter speed and having the camera choose the correct f-stop. This is called *shutter priority exposure* (marked Tv, for "Time value," on most cameras). As you can see, there are pros and cons to both systems. Today most cameras also offer one or more "flavors" of programmed exposure control, usually marked P on the camera's controls. When set to the P mode,

the camera selects both aperture value and shutter speed automatically based on a programmed sequence the manufacturer has decided will work best for most types of photography.

Additionally, many cameras have exposure modes identified by pictorial icons and designed for specific types of photography. A good example is the sports/action mode, indicated by a drawing of a running figure. This mode favors fast shutter speeds to help stop action in your photos of rapidly moving subjects. Another pictorial mode is portrait, identified by a drawing of a person's head and shoulders. This mode will favor sufficient depth of field to keep the whole face in focus but allow the background to blur. Different manufacturers offer different pictorial modes, so check the manual that came with your camera to see what they are and what they are best used for. They can greatly simplify the task of producing good photographs under widely varying conditions.

In Plain Black & White

A few of the more expensive digital cameras employ center-weighted and matrix-based exposure systems. A center-weighted metering system bases a high percentage of its exposure setting on what it reads in the center of the image. This is a very good system, because a difficult background will not adversely affect the exposure, such as in a backlit situation. Matrix-based metering systems read multiple spots in the image and use a complex built-in algorithm to determine proper exposure based on detailed analysis of hundreds of typical photographs. This comes in handy when, for example, you photograph the interior of a room with an open sunny window. If the meter were to take an average reading, the window light would cause the aperture to close down and the room would be too dark. With a matrix system, the window light and the interior lighting are taken into account. The system would know that the window light is a small part of the photo and would give more emphasis to the interior, making it brighter.

Some digital cameras might not have shutters at all. You will find this especially true on lower-end cameras. These cameras replace the shutter on the camera by turning the imaging sensor on and then off for the duration of the desired shutter speed. Different manufacturers achieve the results in different ways. Don't be disappointed. If you didn't pay a lot for your camera, you still will get excellent results.

On some of the high-end digital SLR cameras, the mechanical shutter is only used for the slower speeds. At the higher speeds it simply opens and closes, and during the

time it is open the imaging sensor is switched on for the very brief time of the actual shutter speed. This allows very fast speeds to be reached by cameras with simple mechanical shutters.

Say Cheese

Even if you don't have shutter or aperture control over your camera, you might be able to force your camera to "think creatively." If you can adjust the ISO rating of your camera, you can make your camera change shutter speeds or pick a different aperture. Let's assume, for example, your camera is set to shoot at 1/60 second and the ISO dial is set at 100. If you were to change the ISO to 400, making your

camera two stops faster, your shutter speed would be increased to $\frac{1}{250}$ second. The same effect can be had on the aperture. It depends on the camera system as to which will be affected by your change. Bear in mind that you might suffer the effects of noise if you mess with the ISO speed too much.

Another way to fake out your camera is to put a neutral density (ND) filter over the lens (a neutral density filter can be purchased at a good camera store). ND filters are neutral gray tinted filters that darken the image without imparting color to it. This forces either the f-stop to open up more or the shutter speed to slow down, depending on your camera. Note: if you want to use ND filters, you must be sure that your camera is taking its meter readings through the lens and not through a metering port somewhere on the front of the camera. If your camera is not metering through the lens, you must cover the meter port with the ND filter as well.

The Least You Need to Know

- It is important to understand the basics of exposure and the creative control you can gain by manipulating the variables.
- Depth of field can be controlled by your aperture choice.
- Shutter speeds will control how you capture movement.
- With most cameras you can control your exposure or have the camera set the exposure for you.

I Can See Clearly Now: Lenses

In This Chapter

- Focusing
- Shooting with wide-angle lenses
- Shooting with telephoto lenses
- Shooting with zoom lenses
- Choosing the appropriate lens

In Chapter 7, we talked about focus in relation to depth of field. But how, exactly, does "focus" work? Here's the skinny: Rays of light travel in a straight path through a transparent medium, such as air. When the light rays travel from one medium to another of different density (for example, from air to glass), they bend. This bending of light is called *refraction*. As the light rays pass through the lens, they refract and converge, or meet. This convergence point is called the *focal point* or *focal plane*. (The focal plane is the correct place to locate the *film plane*, which is where your film or CCD chip is located.)

Say cheese.

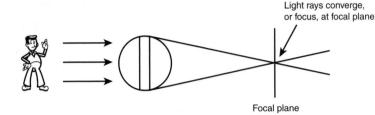

Whoops! Light rays converge past the film plane, making the image you want to photograph out of focus.

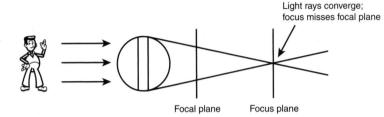

If the distance between the lens and the film plane is not correct for the distance between you and the subject you are photographing, the focal plane will not fall at the film plane. You are out of focus!

You can focus your image by adjusting the spacing of the lens elements in the lens (or moving the lens as a unit) so that the focal plane falls on the film plane. Have you ever held an SLR (single lens reflex) camera and turned the focusing ring on the lens barrel? If so, you were, in reality, moving the lens groups, or moving the whole lens as a unit, and adjusting the focal plane to fall on the film plane.

Types of Lenses

A fixed-focus lens is a simple lens that has no moving parts. The lens is designed to focus on an average *taking* distance from the camera—usually anywhere from 12 feet to infinity. Fixed-focus lenses, which are usually found on low-end point-and-shoot cameras, often don't deliver sharp images. The cheapest of these might have a single molded plastic lens element, although many will have lenses with several elements for better image quality. If you're interested in doing any serious photography, you need to find a lens that can be focused. Such lenses generally have multiple lens elements in them. These lens elements are usually organized in groups. When you turn the focusing ring or knob on your lens (or when your camera's autofocus system does it for you), you are moving the lens elements or groups to focus the light on the focal plane. You will find these types of lenses on mid-range and professional cameras.

It used to be that lenses with plastic elements were the "cheap sisters" of glass lenses, but much progress has been made in optical resins (plastics, in common parlance) in

recent years. Many high-end professional lenses today have one or more molded optical resin lens elements. Also, a number of lens makers are now using hybrid lens elements, which are glass lens elements with optical resin molded onto the surface. This allows the lens maker to produce complex aspherical surfaces for better lens quality at a much lower cost. A lower manufacturing cost translates into lower prices on the dealer's shelf.

Cheap filters can also change focus. This is OK if your camera is an SLR because you will be focusing through the filter. But with viewfinder and range-finder cameras this may alter your focus.

These days you will often see the terms "aspheric" or "aspherical" mentioned in lens advertisements and on lens and camera packages. Glass lenses are made by cutting optical glass blanks to the right diameter and thickness and then using abrasives in machines to polish the glass to the desired curvature. This curvature is most easily attained if it is a portion of a sphere, and lenses made in this way are said to be spherically ground or have spherical surfaces. A lens with spherical surfaces can focus an image perfectly onto a spherical surface, but not onto a flat surface like film or a digital sensor. For this reason multiple lens elements are combined to form a photographic lens, and by using elements with different curvatures and different glass types, lenses can be made which focus the image onto a flat surface. However, this is much easier to do if one or more of the lens surfaces are not spherical but have curvature that varies from the center to the edge of the lens. Such lenses are called aspherical lenses, or aspherics.

Using aspherical lens elements allows the lens designer to produce a better lens while using fewer elements. However, aspherics made by grinding optical glass are very expensive to manufacture, and lenses using such aspheric elements are very expensive. By using optical resins (similar to those your eyeglass lenses are made from) this cost can be greatly reduced because the resin lens elements are molded to shape, not ground. Resin (plastic) lens elements have made it possible to manufacture lenses of exceptionally high quality at very reasonable prices. Canon has developed a process for molding optical glass into aspherical lenses. Their glass-molded aspherics are more expensive to make than resin aspherics, but perform better in some types of lenses. The bottom line is that a lens with one or more aspheric elements will generally perform better than a lens with no aspheric elements, regardless of whether the lens elements are glass or plastic.

Behind the Shutter

One reason for keeping the number of elements in a lens to a minimum, besides cost, is flare. At every air/glass interface in a lens, most of the light passes through the lens, but a certain amount is reflected off the glass. In a lens with only three or four elements, the percentage of light lost through reflection isn't a big deal. But what about a modern zoom lens with 13 or more elements? The amount of light lost is considerable. Additionally, this lost light bounces around inside the lens from surface to surface and ultimately comes back out of the back of the lens as a veiling haze, called "flare." This flare reduces the contrast of the image and can show up as colored blotches or splashes in an image if there is a bright light source in the image. You've certainly seen this effect on TV and in movies when the sun is in the image and you see multiple colored reflections that are the shape of the diaphragm opening in the lens. Years ago optical scientists found that applying certain types of coatings to the lens surfaces would greatly reduce the amount of light that is reflected. More recently, coatings with multiple layers have been developed which reduce reflections even more. Lenses that have multiple layer antireflection coatings are often called "multicoated," or are marked with "MC." Some manufacturers have their own names for multicoating. If you have a choice between a multicoated lens and one without multicoating, always go for the multicoated

Filters can also contribute to flare. A filter adds two additional surfaces to cause reflections and flare. Buying a multicoated lens and putting a filter on it that isn't multicoated is just not a good idea.

Autofocus Lenses

Unless your camera has a fixed-focus lens, it probably employs some sort of autofocus mechanism. The advantage of using an autofocus lens over a fixed-focus lens is that your lens can be precisely focused for the correct subject-to-camera distance. Your images will look much crisper than they would if they were taken with a fixed-focus (or, as most professional photographers say, a Coke bottle) lens. The two different types of autofocus cameras are ...

- ◆ Passive autofocus systems, which are found on higher-end cameras, focus a lens by assessing the contrast of the image. If you compare an out-of-focus image to an in-focus image, you will see that the in-focus image has much more contrast.
- Active autofocus systems, used on many point-and-shoot cameras, send out an
 infrared beam that reflects from the subject back to a sensor in the camera. Such
 systems use triangulation to measure the distance and set the lens to the correct
 distance.

Autofocus systems have a few weak points:

- ◆ If something—such as a fence—comes between the camera and your subject, the camera's focusing system might set the focus for the fence instead of your subject. Active autofocus systems measure the distance to the nearest solid object, and if that object happens to be the glass in a window, your intended subject outside the window will be out of focus.
- If your subject is near a large object, that object can reflect the measuring beam instead of your subject, skewing the distance measurement your camera uses to focus.
- If you are photographing a group of people who are at various distances from the camera, the camera might have trouble determining the correct focus.

Focus Lock

Autofocus systems that offer a *focus lock* are a good way to get around the aforementioned problems. With a focus lock, you can prefocus the camera, lock the focus, and then move the camera to get the image you want. For example, suppose you want to photograph your kid standing on a stone wall, with a beautiful sky behind him, but you want to compose the image so that he is to the side of the viewing frame instead of smack in the middle of it. Odds are that if you simply snap the picture, your autofocus will focus the camera to a distance of infinity instead of on Junior, because autofocus lenses typically focus on the middle of the viewing frame. To rectify this, do the following:

- 1. Frame the image so that Junior is more prominent (that is, closer to the middle of the viewing frame).
- 2. Let the camera focus.
- 3. Lock the focus (typically applying light pressure to the shutter release button does this).
- 4. Reframe the image to get the composition you want.
- 5. Shoot the picture.

Close-Up Shots

Taking close-up shots drives your camera and its lens into contortions. If you look at a good 35mm camera lens, you'll notice that it *racks*, or *extends*, way out when focused on a close object. Many autofocus cameras have a *macro* setting, which adjusts the lens

for close-ups. Sometimes the lens groups inside the lens are adjusted; other times, some other special arrangement is made to allow for close-ups. When you take close-ups, try to use the macro setting as much as possible. Not only will it help you focus your close-up image, it will also help increase your depth of field (which is almost nonexistent when you are close in).

Say Cheese

If you point your camera at someone but have to wait for it to focus, they'll probably figure out what you are trying to do, and you'll lose your candid shot. If, however, you use the focus-lock feature, you can focus on someone or something else (be sure the dummy subject is about the same distance away from you as the intended subject), lock your focus, and swing your camera back around to take your candid

If you have your camera set up to take wide-angle pictures, you might be able to take candid photos without even looking through the viewfinder. Most professional photographers are very good at this technique, especially sports and news journalists.

Taking Care of Your Lenses

Even the very best lenses don't work very well when dirty or scratched. Here are some ways to keep your lens in good shape:

Say Cheese

Always carry lens-cleaning materials in your camera bag. Your kit should include lens-cleaning paper or a soft cloth (be sure the paper or cloth is not full of dirt!), lens-cleaning fluid, and a soft lens-cleaning brush. (I like the kinds that have a small bellows or squeeze bulb built into them.) You can buy all these items at a camera or photo supply store.

◆ If your lens has dust or grit on it, the first thing you should do is try to gently brush it off or blow it off with a squeeze bulb. The best bulbs are the kind used to suction mucus from a baby's nose (really!). If you use a brush, it should be one designed for this purpose and not used for anything else. You can also try lightly swiping at the lens with a cloth designed for cleaning lenses (do not use one of those silicon impregnated cloths unless you want to ruin your lens). Always point the lens down when blowing or brushing so that the debris you remove falls away from the lens and not back onto it.

- If the lens is smudged, put a few drops of lens-cleaning fluid on your cloth or lens-cleaning tissue, and then gently wipe the lens. Start in the center and wipe in a spiral motion, moving from center to edge. After you remove the gunk, you can try polishing the lens gently with a dry cloth. Never put the cleaning fluid directly on your lens; it can seep in between the lens and lens body and you will end up with fluid inside your lens!
- ♦ A great way to keep your lens clean and safe is to cover it with a clear filter. If your lens has screw threads on its front barrel, you can buy a filter to fit on it. The best filters to buy are UV (ultraviolet) filters, which are clear and also provide the added benefit of reducing UV haze. These filters are cheap protection, and if you scratch one, you can just throw it away (recycle!). Just remember that if you use a filter, you must keep it scrupulously clean.

Focal Length

Focal length is important because it tells you how big your image will be on the focal plane. It will also help you approximate the visual angle and area of coverage of the lens. (I'll explain this in a second.) The focal length of a lens is the distance, in millimeters, from a virtual point (called the rear nodal point) in the lens to the focal plane when the lens is focused at infinity. Don't worry; you don't have to do this yourself. The manufacturer does all the testing of the lens design well before you ever see the camera.

Taking Angle and Area of Coverage

The following diagram describes the two important features of a lens:

- ♦ The first thing to look at is the *taking angle* or *visual angle* of the lens. Both describe how wide the lens can "see." Sometimes this might be referred to as the *field of view (FOV)*. Lens #1 sees a small portion of the image because it has a small visual taking angle; lens #2 sees much more, or a wider angle, of the picture.
- ◆ The second thing to look at is the area of coverage, which is the area that the image covers on the film plane. (Note: Because the lens is round, the area of coverage is circular.) Notice that on lens 1, the coverage is much larger than the size of the chip or film frame, meaning that the chip will capture a tightly

cropped portion of the full image. Lens 2, however, has an area of coverage that is about the same size as the chip, meaning that this chip will capture most of the image.

Angle of view determines how wide an area a lens can see; area of coverage indicates how much of the image will show up on the film plane.

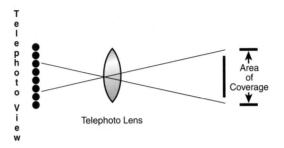

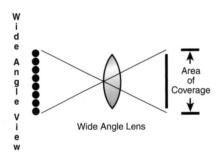

The visual angle and lens coverage usually work in conjunction with each other. However, it is not uncommon for a lens to have a wide angle of coverage *and* a wide visual angle. Actually, depending on the lens design, any combination of coverage and taking angle is possible.

So What's Normal?

The taking angle and area of coverage are much more important on large-format cameras where large film areas come into play. A normal lens has a visual taking angle that is approximately the same as your visual taking angle (that is, close to what you see without turning your head). A normal lens also has an area of coverage that is close to the same size as the diagonal measurement of your chip (see the following diagram to see how the chip diagonal is the same as the diameter of the area of coverage).

A normal lens will have a field of view approximately the same as your vision.

On a 35mm camera, a 50mm lens is considered normal. Although it is slightly telephoto, it is closest to the human field of view. (The diagonal measurement of a 35mm piece of film is 44mm, which would make a 44mm lens truly normal, but I've never seen a 44mm lens!) On a typical digital camera, the CCD chip is much smaller than a 35mm film frame. Therefore, a normal lens on a digital camera is much smaller. Because the CCD chip sizes vary from manufacturer to manufacturer, a normal lens on one digital camera might not be a normal lens on another. Also, as the chips become larger, such as on the new 12 to 14MP (megapixel) cameras, what was normal last month might not be next month. Typically, a normal lens for a digital camera ranges from 4.5mm to 30mm.

The Telephoto Lens: A Long Story

Telephoto lenses have *long* focal lengths, which is why they are called *long lenses*. Telephoto lenses have a very narrow angle of view. On view cameras, where the lenses are designed to swing and tilt (see Chapter 3), wide coverage is very important. It also makes view camera lenses very expensive. My 150mm (normal for a 4×5 view camera) cost \$1,500!

Most commonly, a telephoto lens is used to photograph objects that are far away to make them look bigger. Conversely, because of the angle of view, you can photograph an object that is near and fill your frame with only part of the subject—such as when you want to photograph one person in a group of people. A slightly telephoto lens makes a good portrait lens, and enables you to get a nicely filled frame without standing too close to your subject.

Behind the Shutter

To confuse the "normal" issue even more, some manufacturers label their lenses as equivalent to 35mm camera lenses. I reviewed one camera with a lens marked as 9.2mm to 28mm (zoom). This would be a "fisheye" lens on a 35mm camera. This camera lens was marked as a true measurement. Another lens was marked 28mm to 110mm (zoom). How can this be? Either the second camera has a huge CCD chip array, or its manufacturer is giving the camera's focal lengths in 35mm equivalents.

Because chip sizes vary from camera to camera, and unless you know what size the chip is, you will have no idea what the normal lens is unless the 3mm equivalent is indicated. Also, most of us are familiar with 35mm cameras, and are comfortable with the idea of using that marking system. As long as you know what system is being used, all should be well. The only problem lies in being able to compare one camera to another. It makes for great confusion!

One characteristic of a telephoto lens is called *visual compression*. Because you can get objects that are far away as well as objects that are close by in the frame at the same time, the objects look like they are compressed in space. To add to this, remember that objects that are close to the camera look very big in the frame.

Take a look at the following photograph to see how the buildings look compressed and stacked, one next to the other.

A telephoto lens brings the object closer and also "compresses" the image.

If you are using a telephoto lens to photograph objects that are at different distances from each other, the added effects of compression can contribute to a shallow depth of field. Be aware of the limited depth of field, and focus carefully. You might even be able to use this shortcoming to your creative advantage. Also, because of your narrow angle of view, camera shake is much more apparent. Your margin of error when holding a camera with a telephoto lens in your hands, especially in dimly lit situations, can be small. Brace yourself against something to steady yourself, or prop your camera up on something to steady it.

Wide-Angle Lenses: A Short Story

Wide-angle lenses are basically the opposite of telephoto lenses: they have a short focal length and a wide angle of view. They also have a small area of coverage on the film plane, meaning that your film or chip captures nearly the entire image.

Wide-angle lenses are used to photograph large areas, especially if you cannot get far enough away. Some of the most wonderful skyline shots and mountain views would need to be taken from three states away if you used a normal lens! Wide-angle lenses have a great depth of field, which means that you can photograph objects that are relatively close to you and still have other objects in the background stay in focus, as shown in the following photograph. On the downside, you see a lot of distortion in a wide-angle shot; your horizon line might even seem to bend! However, this can lead to some interesting effects.

A wide angle lens lets you get more view in your image. Also note that an extremely wide lens such as the one used here can cause distortions if not held perfectly level.

Zoom

A *zoom* lens is a lens that has multiple focal lengths, which can come in pretty handy—especially if you have only one lens bolted to your camera. A zoom lens has many groups of elements in it, which shift internally to provide the different focal lengths.

It used to be that serious photographers steered away from zoom lenses because they were not as sharp as lenses with only one focal length, often called prime lenses. But zoom lens technology has moved ahead by leaps and bounds in recent years, and today many zoom lenses approach or even exceed the quality of prime lenses. Also, the range of zoom lenses has increased. It used to be that zoom lenses of any quality were only 3 to 1 designs, which means the longest focal length is three times the shortest, such as a 35 to 100 zoom. Today zoom lenses come in much wider ranges, such as 28 to 300.

Because of all the glass in zoom lenses, they are usually a stop or so slower than a prime lens. Zoom lenses can also be harder to keep in focus. You should always check the focus after you zoom. Having an autofocus camera that refocuses after or as you zoom is a good idea—thankfully, most autofocus cameras have this feature.

All in all, unless you are using a high-end professional camera and can interchange lenses, buying a camera with a built-in zoom lens is a great idea.

Say Cheese

Have you ever put your hand over your eyes to shade them on a sunny day? If so, did you notice that your vision improved? Well, guess what? If you do the same for your lens, your picture will look better, also.

Always try to use a lens shade when taking pictures, particularly any time that a lot of glare or stray lights are hitting your lens. It is the easiest thing you can do to improve your shots!

True Zoom Versus Electronic Zoom

Many manufacturers give a specification for their zoom lenses, such as $3\times$, $4\times$, and so on. Basically, this tells you that your lens zooms in a range that triples or quadruples itself. An example of a $3\times$ zoom is a 25mm to 75mm zoom. When you see a specification for your zoom lens such as $3\times/2\times$, you are in for a ride! This type of specification

indicates that you are getting a true 3× zoom lens, and your camera can zoom in two more times electronically.

So how do you suppose the extra zoom is accomplished? Time's up! Your camera is going to interpolate the image, also known as enlarging it, to simulate the zoom. This is not a great idea unless you really need it, because as soon as you start electronically enhancing an image, you invite pixilation (image distortions) and color errors. Do not buy a camera based on the extra electronic zoom; you can do the same, if not better, in any image-manipulation software.

The Least You Need to Know

- Focus is the meeting of the rays of light, after they pass through the lens, on the focal plane.
- On many cameras the lens can automatically focus, or be focused manually.
- Wide-angle lenses let the camera "see" a wide field of view.
- Telephoto lenses make images appear to be closer to the camera and have a narrow field of view.
- ♦ A zoom lens has a variable field of view.

Composition: No Snapshots Here!

In This Chapter

- Balancing your composition
- Creating visual interest
- Establishing a point of view
- Using color effectively
- Composing with texture and patterns

Even with all the tools you have at your disposal, you can still take terrible pictures if you don't compose them well. A good composition is a careful arrangement of all the objects in your photograph. Take a look at photographs you see in magazines and books. What makes them interesting? What makes them sparkle? Recording the moment is a good use for photography. But why not tell a story at the same time? A photograph should challenge the viewer to imagine what is happening in the picture. It should be inviting. Instead of taking a picture of your family on top of a mountain, take a picture of them standing next to the signpost that says how high the mountain is. Now the viewer can see how much you accomplished.

If a picture is worth ten thousand words, let it speak for itself. Before you take a picture, think about why you are taking it. What are you trying to say? What is the story? How do you feel about where you are? Can you make the viewer feel the same way? Ask yourself, "How can I make this a better picture?"

Make your photos visually interesting. Don't just use the viewfinder as a targeting device. A good photographer (and by the time you finish reading this book, you will be one) frames the picture in her mind's eye before taking it. Take time to look at what you are shooting. Enjoy the moment! Have fun!

Not in the Center, If You Please!

The subject in your photo should be the interest point, and the story line of your photo should revolve around your subject. All the artistic elements in the photo should lead your eye toward the subject. Draw in your audience; involve them.

One way to involve the viewer in your photograph is to guide her eye through the photo—in other words, her eye should start somewhere in the photograph and travel across it. Imagine a photograph of a line of people waiting; at the end of the line is a clown making a balloon animal for your child. When you view that photo, your eye travels across the group until it gets to the end. And not only have you made the viewer's eye travel across the photo, you've also told a story at the same time.

The longer a viewer looks at a good photo, the more interesting it becomes. You can enhance a viewer's visit to your photo with color, shape, and subject. Keep the viewer's eye moving. If you always put your subject dead center in your photograph, you quickly kill the viewer's interest. The viewer looks at the photo, looks at the perfectly centered object, and leaves. Next!

So where do you put the subject in your photo? Take a look at the following figure for a classic composition diagram. Begin by imagining a tic-tac-toe game in your frame. The areas where the lines cross are your *bot spots*. Try to center your subject on one of these spots.

The following two photographs illustrate the difference between placing your subject smack in the middle of your frame and placing your subject elsewhere. Don't you agree that the second photograph is much more compelling than the first? Notice that its subject is on the lower-right hot spot.

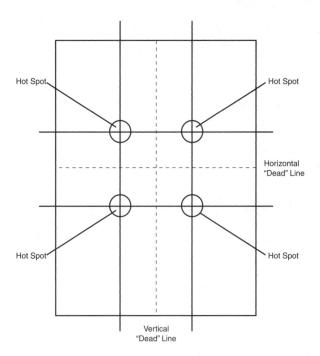

A composition diagram helps place the subject of the photo.

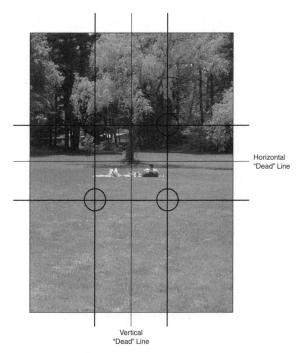

See the next image for a better composition.

Notice how much more compelling this image is than the first.

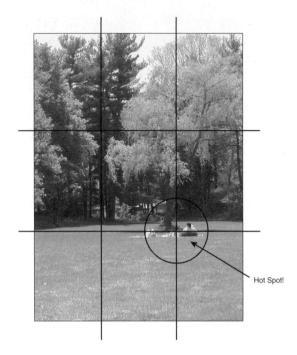

Of course, this doesn't mean you have to leave an empty space in the middle of your photo. Imagine you are taking a picture of a sailboat on the harbor. The sun is shining on the water, and birds are soaring through the air. Where do you put that boat? You could put the boat on the horizontal dead line and slightly to the right, and the image looks okay. But try placing the boat in the lower-right hot spot. Doesn't that feel better? Maybe you can get the birds to fly through the upper-left area or put the fluffy clouds or the setting sun there.

Let's take another mind's-eye photo. Your darling daughter has a new kitten sitting in her lap. (If you don't have a darling daughter or a kitten, you can substitute freely. It's your mind.) Put your daughter's face in the upper-left hot spot, and put the kitten in the lower-right hot spot. Nice picture. Composing your picture this way gets nice viewer involvement, as the viewer's eye travels from the girl's face to the kitten and back again.

The cat's face balances the face of the little girl.

Balance

Your photos should use balance to make them exciting. In the picture with the little girl and the kitten, the kitten served as a balancing object for the little girl. In our imaginary photo of the sailboat, the balancing object was the birds, the clouds, or the setting sun.

The balancing object and the subject don't have to be the same size; a small object can balance a large one. The idea is that your eye travels from the subject to the balancing object and back. The balancing object should be a clearly defined object or action.

Let's take a few more mind's-eye photos. On the right side of your photo, imagine a big, beautiful flower. On the left, maybe coming in from the lower-left corner, is a bumblebee. Obviously, the bee and the flower are not the same size, but look how each balances the other.

Try another one: Your two-year-old son has just built his first tower out of wooden blocks. He is so proud of himself; he's smiling from ear to ear. But next to him, coming into the frame, is the puppy, headed directly for the tower. Click! You've got a great photo. You're telling a story, your composition is exciting, and the small puppy balances out the boy.

You don't need two objects to have balance in your photograph. Suppose you just baked an apple pie, and you want to take a picture of it. How can you compose your shot? Try taking a wedge out of the pie to show the contents of your pie, and also to

give your pie some dimension. You'll find that the missing pie piece, or the space it leaves, balances the rest of the pie. Then put the pie off-center in the frame—the missing pie space should be slightly over the center line. Notice how the space and the pie balance each other.

Horizon

The horizon line can be a powerful composition tool. The sky, the water line, the roofs of buildings, clothes hung on a line, a fence, or a tree line can be used as horizontal elements, and can also set the horizon in your shot. As a general rule, the horizon line should not divide the picture exactly in half; a shot with the horizon line neatly dividing the sky and water is usually stagnant and boring.

If you take another look at that composition diagram I showed you earlier, you'll see the horizontal lines that run through the hot spots. These lines divide the frame into thirds. It's a good idea to place the horizon line in your photo so that it divides the frame in a like manner. Another rule I try to follow is to keep my horizon line parallel to the bottom of the frame. Take your time and be sure things look straight in the viewfinder. There is nothing more disconcerting than having a boat sailing uphill in a photo!

This photo shows the water line and horizon over Boston Harbor.

Cropping: Be Frugal!

The frame in your photograph should contain only your subject and its balancing object. Don't get sloppy. If you don't crop out unnecessary objects or people in your shot, your image becomes *diluted*. The viewer will get confused about the subject of your photograph. Are all the objects in the shot important? If you are photographing a scenic view, such as a skyline, don't include more than you need to. Also remember, especially with a digital camera, that resolution is a premium. If you use software to crop an image after you take it, you affect the optimal resolution of the image. Be frugal. Get everything you need in your image, and nothing else!

Use your telephoto or wide-angle lens to help you fill the frame, and be creative by using the effects of compression and distortion. If you need to move a little closer to your subject to fill the frame, do so. Take a few extra moments to compose your shots.

Here are a few guides to follow when deciding when to take an image as a horizontal or vertical composition:

- Use your camera in a horizontal composition when you need to fill your shot with a landscape. Group shots, scenic views, and crowd shots all work well horizontally. A horizontal shot emphasizes the width or breadth of your photo.
- Vertical shots are a great way to emphasize height. They make wonderful portraits. Also, photographing a small object and a tall object in a vertical frame is a great way to show height comparisons.
- When photographing for a newsletter or magazine, be sure you photograph your subject in both orientations if you can. Your art director might have a layout that calls for only one or the other. Chances are that if you don't ask beforehand, you will use the wrong orientation. (That, folks, is one of "Murphy's Laws" that professional photographers hate!)

Take your time to fill your frame. Make every pixel count.

This shot is composed and cropped poorly.

This is an example of a tightly cropped photo. The photographer has moved in much closer to isolate the interesting part of this scene and eliminate most of the boring stuff.

Color

Color can be a wonderful compositional tool. A vividly colored bed of tulips can be an interesting photograph; an old red barn can tell a wonderful story. Frame your image so that the barn is predominate in the image; this allows you to use the color of the barn to your advantage. Of course, too much of a good thing can be a disadvantage; be careful not to get too carried away with color. Just as you wouldn't wear a suit of clothes with many different colors in it, you should try to avoid shots that

suffer from the same. A shot, for example, with a lot of red and a few other colors works well, because the reds hold the composition together and the other colors add balance.

You can use saturated colors to aid your composition. In addition, contrasting colors can work well together, setting one another off. For example, instead of photographing a red rose with the sky in the background, try to frame it so the green leaves of other flowers form a background. The contrast of the red and green colors makes your photograph vivid. Monochromatic colors also work well as compositional tools. A stand of green trees in a forest or a pool of blue water with a child floating in an inner tube are good examples. If you fill your frame totally with sand dunes, all the same color, the lines and shapes of the dunes jump out at you, making an interesting composition.

Color can also be used to set the mood in a photograph. The subtle colors at dawn or dusk help you feel as if you are there, or involved in the photo. An image featuring objects that are predominantly red exudes energy and excitement. An image with pastel blue or green tones makes you feel cool and calm. *Lack* of color also can help compose an image. Imagine, if you will, a foggy harbor, devoid of all color except the gray mist. A lone red boat floats at the dock. The red boat adds interest and brings a little life to the image. Another good example is a snow-covered field with just a hint of color from a child in a snowsuit.

Contrast

Contrast can be achieved in many ways in a photograph. Color can be used to create contrast, or contrast can be created by the use of lighting. Deep shadows and well-lit areas can create wonderful contrasts in an image. Textured objects, when put on or adjacent to a smooth background, can set up image contrast—for example, a beautifully detailed piece of tree bark with an out-of-focus soft background.

Strong light and shadows can create an interesting composition.

Negative and Positive Space: The Final Frontier

The space that your object takes up in your frame is called *positive space*. The space that is not used, such as the background, is called *negative space*. The positive and negative spaces in a photograph work together to reinforce each other. Imagine you are taking a picture of a tree branch with a blue sky in the background. If you look at the pattern formed by the interweaving branches, you see that the blue sky plays an important part in the image, supporting the pattern. The sky is as important to the composition of the image as the tree branches are.

In the collage image of a lamp in the following figure, the spaces between the lamp structures (that is, the negative spaces) that are colored begin to form an image all their own. The contrasting colors also help support the image.

The colored background space works as negative space to help "set up" the lamp parts in the positive space. Both are compositional elements.

Movement

One of the most important attributes of a modern camera is that it can freeze motion. Speeding cars, children on bicycles, and kites flying through the air can be frozen in time. Stop-action photographs can hold a viewer's attention for quite a while. Most digital cameras have an action mode that is best to use for this type of photography.

If your camera does not have an action mode, use shutter-priority automatic and select a fast shutter speed. Some of the more basic cameras do not offer either of these options, but will generally select a fast shutter speed outdoors in bright light.

Behind the Shutter

Early photographs by Eadweard Muybridge were a massive study on movement. He would shoot a series of photographs of a person jumping using what was then a high-speed camera. His series on animal locomotion was used to prove a bet about whether a horse has all four feet off the ground when galloping. Much later, Doctor Harold "Doc" Edgerton of the Massachusetts Institute of Technology (we Bostoners call it MIT) made many studies of high-speed movement, such as the famous photograph of a bullet being shot through a playing card.

Speed doesn't always need to be represented by stop action. A little blurring of an object is just as effective, if not more so, for showing how quickly an object is moving. Slow down your shutter speed to help create the illusion of movement. Alternatively, if you have an automatic camera, you might try putting neutral density filters over your lens to trick your meter into slowing down the shutter speed. Another good way to show speed in a photograph is to employ a little trick I call "action panning" (also called a "drag-shutter effect").

Panning the camera helps create the illusion of action. Experiment with a few shutter speeds and panning speeds—remember, it won't cost you any film!

To create the illusion of movement through action panning, begin by setting your shutter speed at about ½0 of a second or slower. The exact speed isn't important, but it will alter the results of the effect, and you might want to experiment with different shutter speeds to see which produces the effect you like most. To enhance the effect, use a telephoto lens. (Note: This technique works best when your camera is in a horizontal mode.)

As your subject, let's say it's a race car, comes into frame, start panning your camera in the same direction in which the car is traveling, and hit your shutter while continuing to move the camera.

Your results should be a combination of stop action and motion blur. The background is almost all blur, because it is put into motion by your camera motion. The car, however, which remained relatively in the same spot in your frame, has a bit of stop motion effect to it, but not completely.

Because the viewfinder of an SLR camera blacks out during the time the shutter is open, this technique is definitely easier with a viewfinder or rangefinder camera. But with a bit of practice you can learn to do it with an SLR.

Viewpoint: Low, Different, or Political

The point of view (or POV) that you use to photograph your subject can greatly add to its visual appeal. If you can avoid it (and you usually can), don't shoot an object straight on; doing so can make your shots boring. Instead, look at your subject from different angles. Will shooting partially from the side enhance the image? Will a total side view look even better? Shoot from a low angle looking up, or a high angle looking down. If you are shooting a scenic view, consider where you are going to put your horizon line. Consider using your wide-angle lens to create an interesting distortion.

Of course, you should be careful not to go overboard. If your point of view distracts too much from your subject, your photograph won't work. Don't let your fancy footwork rob your subject of its reason for being photographed in the first place. Confusing your viewer because you fell in love with a point of view will not help your image.

There are no hard and fast rules about point of view. Just try to remember the composition guide and place your interest point on the hot spot.

Explore different points of view to make your subject look interesting.

Flash

Your safety should always be a prime concern when taking photographs. Years ago, I was photographing a high school basketball game. I was intent on following the action through my viewfinder. As the ball got bigger and bigger in my viewfinder, I got more excited about what a great shot I was going to get. Finally, reality—and the ball—struck me! There is no feeling like having your camera smashed into your face.

So be careful when taking photographs. Don't hide behind your camera, thinking it is a special magic shield. Many professional photojournalists have been injured and a few have died because they forgot they were mortal. Watch where you are stepping when you are taking photographs. Don't go out on a limb, literally, to get a great shot. Think safety!

Perspective

Many photographs suffer from a lack of dimension. They look flat and unrealistic. Adding an element in your photograph that creates perspective can often help. Usually, featuring two lines that start out separate but converge somewhere in the photo (the point where the lines meet is called the *vanishing point*) helps create the illusion of perspective and depth. The human brain knows that when two lines that are normally parallel meet, the vanishing point is in the distance. A good example of this is a railroad track or highway, but look for rooflines, fences, and even power lines to help create perspective.

Perspective caused by receding lines of railroad tracks adds depth to a shot.

Another way to create perspective in your photograph, especially if a railroad track or a road is not handy, is to twist your object or shoot it slightly from the side. As you can see from the following photograph, the objects not only show their size and shape, but as the images recede into the background, they create depth.

Receding lines created by the side of the box and the chess pieces add perspective and depth to the photo.

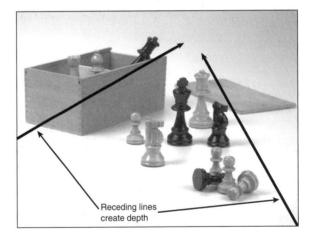

Foreground/Background

If you have a familiar object in your foreground and another in your background, you can create a sense of depth. For example, let's say you have two adults in your photograph. The adult closer to your camera appears bigger in your image, and the adult in the background appears smaller. This lends a sense of depth to the photograph.

Overlapping images also help create depth in your photograph. Say you photographed your cat—okay, anybody's cat. Directly behind the cat, but in the distance, is a sofa. In the photograph, the sofa looks smaller than the cat. The viewer's brain, when looking at the photo, associates distance in the shot, because it knows that the cat can't possibly be larger than the sofa. (Although I have seen a few cats that are as big as chairs!)

The field and goal net add depth to the photograph.

Line and Imaginary Line

An object or series of objects can create a line or visual path through a photograph. This helps engage the viewer and deliver the photograph's message. You can also use an imaginary line to create interest and help your composition. Sometimes objects in your photography can be used as strong compositional tools to lead the eye toward your subject. These real or *regular* lines can be as obvious as the pipes in the following photograph.

Let's use our mind's eye again to create a few examples. Say you have a photo with a child pointing up in the air and crying. Above the child, a balloon sails away into the sky. With this photograph, you have told your viewer that the child is upset by the escaping balloon, but you have also created an interesting visual. The viewer's eye follows the imaginary line between the child's outstretched arm and the balloon. This is a successful image. Congratulations!

In another mind's-eye shot, a dog stares at a spot on the floor with great intensity. In the photograph, a tiny spot can be seen just beyond the dog's nose. Could it be an ant or a tiny morsel of food? Whatever it is, the viewer's eye travels back and forth from the dog's nose to the spot on the floor.

Old pipes add direction and line, drawing your eye toward buildings in the background.

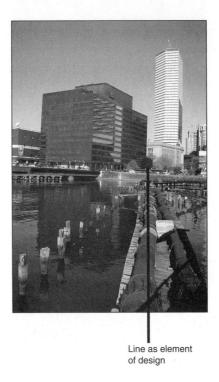

Try to keep the imaginary line contained in the image; that is, do not offer an "end point" to the imaginary line that exists outside of the composition. If the dog was intently staring at something outside of the frame, the viewer's eye follows. After the eye leaves the image, it probably won't come back.

Watch Your Background

Don't get so involved in your subject that you forget to look at what else is in your viewfinder. The quickest way to ruin a photograph is to have a distracting background.

Sometimes it is unavoidable—you cannot prevent someone from walking through your photo ... or can you? If I have a friend with me when I'm taking a photograph in a public place, I ask my friend to be sure no one walks in front of me while I'm taking the shot.

Look around the area you're about to shoot, and pick up any stray pieces of paper or litter. A white piece of paper can be a distracting object in your shot. (Besides, people will think you are really cool if you pick up litter!) Look in the background behind

your subject; remove stray coffee cups and dinner plates. Don't photograph someone with the company bulletin board behind her. You are in control of your photograph; take the time to look at what is going on in your image before you hit the shutter.

This photo would have been improved if the photographer had taken the time to clean up the cluttered desk behind the subject, or had moved to a different position to avoid the cluttered and distracting background.

The most criminal act you can do when taking someone's picture is to have something behind them appear to be growing out of his or her head! Watch your background. Be sure no trees, poles, books, door trim, and so on are lined up behind your subject's head. Watch out for power and telephone lines when photographing outdoors. Sometimes you can change your point of view to avoid a power line, and sometimes you can't. Of course, with a little bit of digital imaging, you can erase those power lines—but it still takes time and effort to do so.

Texture

Texture can be a wonderful aid to composition. An image made completely of a textured object, such as an old piece of weathered wood, can be wonderful. Of course, you should be sure to balance a textured object with something else in the frame that has no texture. Even a smooth background works to balance your subject. Take the time to explore the textures of wood, stone, paper, and even water. By exploring the natures of these objects, you can learn much about yourself and how you view your world.

Texture can also be created by patterns. The pattern in the weave found in cloth is an example of texture. The small ripples in a pool of water, the cells in a honeycomb, and even the patterns in clouds, are all wonderful forms of texture.

An intricate pattern of colors can form texture. For example, the delicate purples and yellows of a field of wildflowers can create a wonderful blanket of color and texture. Take a good close look at an old piece of painted wood. Find a piece that might have been painted a few different colors over the years, and you will discover wonderful textures.

Even in black and white, these flowers create a wonderful repeating texture.

You can use your texture as a background element or in the foreground. It can be the entire subject photograph, such as a beautifully weathered old tree stump, or it can be used as a background, such as a piece of crumpled newspaper with a delicate flower or piece of pottery in its center.

Scale

In a portrait or even a landscape, the scale of the objects is not important. We know how big the average person is. With a few visual clues, such as a tree, we can generally get an idea of how large our landscape is.

Many still-life photographs, however, can suffer from a lack of scale. If there are no visual clues to help identify the size of an object, the image can become confusing. For example, in the following photo of the nuts and bolts, we would have no clue as to their size without the pen being in the shot. Even if we used a wrench or a screw-driver as a scale reference, the size of the bolt might still be in question.

The pen helps clarify the size of the bolts in the shot.

Last, and most important of all, remember that all rules are made to be broken, including the rules of composition in this chapter. Sometimes really great results can come from intentionally breaking the rules. Don't be scared to try just about anything when taking photographs.

The Least You Need to Know

- To keep your viewer interested, create a story with your composition.
- Balance the objects in your photo.
- Don't place your subject in the center of the frame.
- Draw your viewer's eye into the shot using "line" and perspective as composition tools.
- Color and texture can also be used as composition tools.

Chapter

Lighting: It Makes or Breaks a Shot!

In This Chapter

- Using available light
- Using flash to create your own light
- ♦ Lighting setups that can make your pictures shine

Now that you can create beautifully composed images, you need to start thinking about lighting. Lighting is as important to your image as the composition and can add mood, create depth, and emphasize form.

Using Available Light

Using available light, such as sunlight, is often the easiest way to take a photograph. The light is believable and natural.

The time of day influences the angle of the light. In the morning and just before sunset, the sun is low on the horizon, and casts a beautiful sidelight on your subject or scene. At "high noon," the sun is well overhead; the shadows it casts are short, but intense. At 3 P.M., the light is much more angled and casts very different shadows (go look for yourself!).

The *color* of light can also be affected by the time of day, and even the season. During most of the day, when the sun is high in the sky, the light is neutral. When the sun is low on the horizon, especially during the summer months, it picks up a warm yellow tone. This can be dramatic and beautiful.

Weather affects light, too. Whereas a clear day proffers brilliant, intense light, an overcast day tenders soft, diffused light. In some situations, this can be pleasing; other times, it takes away your shadow detail and makes your images look flat.

Behind the Shutter

There is nothing worse than showing up to take a picture and finding the building you want to shoot completely in shadow. That's why most professional location photographers carry a compass in their camera bag. After all, we all know that the sun rises in the east and sets in the west. By paying attention to what direction the camera will be facing and what time of day the shoot will occur, a photographer can predict where the sun will be and how the lighting will look in a scene. If you miss a shot because the sun is in the wrong place, figure out a good time to come back and grab a quick shot. Want to know the time of sunrise or sunset on any day of the year just about anywhere on earth? The U.S. Naval Observatory maintains a website that lets you enter the location and date. It then gives you sunrise time, sunset time, beginning and end of twilight, and the time of solar transit (when the sun is directly overhead). It also gives you moonrise, moonset, and moon transit times, as well as the phase of the moon. When making a trip to a place you've never visited before, you can use this in your planning to decide which time of day to visit specific sites for the best photographic opportunities. You'll find this useful website at aa.usno.navy.mil/data/docs/RS_OneDay.html.

Backlighting

The general rule to using sunlight as a light source is to try to position your body so that the sun is behind you (the photographer), or over your shoulder. That way, the light falls on the front of your subject. Of course, you can't always depend on the light being exactly where you need it. Many times, it comes from behind your subject, casting it in shadow. This is called *backlighting*.

When an exposure meter reads a scene, it expects to find bright areas and shadow areas. The meter assumes that if all these areas were totaled up, the average light would be a medium gray. So when a meter detects a bright area behind your subject, it shuts down your aperture to compensate in an attempt to render an average exposure. Unfortunately, that leaves your subject in the dark. What's a meter photographer to do?

Well, if your camera has an exposure override, allowing you to open up the aperture or slow down the shutter, you can easily correct for this. Give your subject a few

more *stops* of light, and your image will be properly exposed. Many consumer cameras now come with a backlight feature in their menu. As an alternative, many cameras have light meters that let you take a spot reading and lock in the exposure. Spot reading allows you to gather a reading in a smaller area. You could, for example, measure only the shadow area, and then lock in the exposure settings. The camera then automatically opens the aperture and ignores the backlighting.

Behind the Shutter

A bright area behind your subject, such as a white wall or pool of light, also creates backlighting. You should be aware of these types of light sources in addition to that great bright orb in the sky.

Say Cheese

The only drawback to overriding backlighting by adjusting your exposure for the shadows is that the brighter areas in the image will be overexposed. One way to avoid this overexposure is to add some light to your subject by filling the shadow area with reflected available light. A large white card or a white bed sheet can be used to reflect the light back at the subject. If you want something fancier, camera stores sell a variety of portable reflectors, some of which collapse to very small sizes for carrying and storage.

Nighty Night!

Shooting photographs at night is not as hard as it used to be. With your fancy preview LCD screen, you have a good idea of what your exposure should be. When

shooting at night, definitely use a tripod; also use a cable release or fire the camera using the self-timer. Some cameras have a night exposure mode designed just for this purpose.

When photographing at night, try using various shutter speeds. You can get a nice effect from the streaks of lights from a car's taillights if you use slower shutter speeds. If you are trying to photograph fireworks, try varying your

Say Cheese

Another way to avoid overexposing the bright areas in your backlit image is to leave your settings alone, but use a fill flash. You'll learn more about this technique later in this chapter, in the following "Fill Flash" section. shutter speed to capture different types of bursts. Some cameras might even let you hold the shutter open as long as you like; this is called a *bulb* setting. Of course, you can always manipulate your images by using image-editing software to make your own fireworks!

Keep in mind that long exposures on digital cameras cause a buildup of noise, just like using very high ISO speeds does. You might want to experiment to see just how long your exposure can be before the noise becomes objectionable. Some cameras have a noise reduction exposure mode. In this mode you take the exposure as you normally would and the shutter opens for however long you like. As soon as the exposure is finished and the camera shutter has closed, the camera makes a second "exposure" of the same length with the shutter closed. The camera's software then "subtracts" the second exposure, which will have only recorded sensor noise, from the first exposure and gives you a photo with no noise or greatly reduced noise. It works great, but you can't take another photo until the camera has finished the process.

Flash

Gone are the days of flashbulbs and flashcubes. Most consumer-level cameras, digital and film-based alike, come with built-in flash. These built-in flashes generally pro-

Behind the Shutter

You might notice that electronic flashes throw a cool or slightly blue light. This is because the color temperature of a flash is about 6,500° Kelvin. Many professional photographers will tape a slightly yellow (05Y) filter over their flashes; this will help warm up the color of the flash and cast a more naturally colored light.

vide enough light to take a picture indoors, provided that the subject is within 10 to 12 feet of the camera. Built-in flashes will allow you to take photos in low-light situations, but will not render a natural lighting effect (the flash will usually look a bit harsh).

Don't expect that tiny little flash to light up the entire room; it is just not strong enough. In the same regard, don't expect a flash to even reach a subject that is more than 20 feet away from the camera. I always have to laugh when I watch a televised sports event and I see flashes going off in the stands—those flashes will never reach the field!

To use your flash effectively ...

- ♦ Keep your subject 10 to 15 feet from the camera.
- Keep your subjects in an area no wider than six to eight feet, because light from a flash does not spread well.

- Keep your flash higher than your lens. Don't have it lighting from an angle lower than the lens, or pointing up.
- Avoid cameras with tiny flashes or flashes mounted very close to the lens.

Fill Flash

Some cameras have a "fill flash" setting, which lets you add light to your image without affecting your exposure settings. This is because your meter is working with the available light, and not accounting for the light that will be provided by the flash. A fill flash simply adds lighting to the backlit (shadowed) areas, opening them up. You can also use the fill flash in normal sunlight to fill in (and, as a result, soften) the shadows on your subject. Don't be surprised if your subject seems to pop out a bit when you use a fill flash; the flash might be just a bit brighter than the available light. Of course, all this works only if your subject is within a reasonable distance from you, the photographer.

I almost always use a flash when photographing out-doors, especially when photographing people. The reason for doing this is to "open up" the shadows by throwing some light into them and decreasing the overall contrast so the shadows won't be inky black and lacking in detail. Of course, you could do the same thing with a big reflector, but a flash is so much easier to carry around.

Bounce Flash

Many times, using an on-camera flash can make your subjects look like deer in head-lights. One way to correct for this is to bounce your flash off a wall or ceiling (this might not be possible with some low-end cameras). If you can point your flash at the ceiling or a wall and still keep your lens pointed in the right direction, you can greatly soften the output of your flash. When the light bounces off the ceiling, it both diffuses and lights your subject more from above.

Using an Extra Flash

One way to add more flash power to your exposure is to get an extra flash. Stand-alone portable flashes are not very expensive—you might already have one for your old film-based camera. You can preposition your second flash so that it is aimed at your subject, or set it up so that it bounces off the ceiling to provide a nice, soft fill light.

Here's a good example of using a fill flash outdoors. The shadows have been lightened, allowing important details to show.

Before

After

Your extra flash needs to have a *slave* sensor (also called *slave trigger* or just *slave*) on it so that it knows when to flash. A slave sensor detects the on-camera flash going off, and sets off the auxiliary flash at the same time. (As an alternative, many professional

photographers trigger the slave flash via a radio slave system to prevent the slave flash from activating when someone else in the room takes a picture with a flash.) You can buy a slave sensor for your flash if it doesn't have one built in.

If you decide to buy a slave sensor for your extra flash, make sure you buy one of the digital types. An ordinary slave sensor will not work correctly with most digital cameras. This is because the built-in flash on digital cameras sends out a very brief preflash (which is used by the camera to measure how much light the subject needs)

and then fires the flash at the determined brightness for the actual exposure. The preflash and flash come so close together that in most cases you won't realize that the flash is firing twice. If you try to use an ordinary slave sensor it will respond to the preflash and fire too soon, before the shutter is open. Wein Products make digital slave sensors that can be switched to work properly with your system and ignore the preflash.

Say Cheese

Remember that when you are bouncing the flash off a wall or ceiling, you are sending the light on a far longer journey. Its apparent output might be greatly diminished.

Be sure to keep track of where your additional flash is and where it's pointed. You don't want to end up photographing your flash as it goes off, or having it send its light directly into your lens. Also, don't be fooled into thinking that the second flash must be close to your camera! When I am shooting at a party or during a family event, I generally carry a spring-loaded clamp so I can rig a second flash up somewhere high in the room.

Get a Bracket!

To avoid red eye and reduce harsh shadows, you should place your flash as far away from your lens as possible. To aid in this, many photographers mount a second flash on a *flash bracket*, which is basically an L-shaped handle that attaches to your camera. The bottom of the L attaches to the base of your camera, and the leg of the L holds the auxiliary flash over the camera and to the side. You can aim your flash at the ceiling to diffuse the light, or you can aim it directly at the subject. If you use a flash bracket, you might want to turn off the on-camera flash to avoid harsh shadows on and behind your subject.

For the flash to operate, it must be connected to the camera body through a PC cord, or via a hot-shoe extension cord. That way, the flash goes off at the same time as the shutter. Counting on an optical slave is not a good idea, because the sensor will be behind or above your built-in flash and might not detect when the built-in flash goes off.

What a rig! A flash bracket gets the flash away from the lens. This really helps prevent "red eye." You can also "bounce" the light off the ceiling to help soften the flash effect.

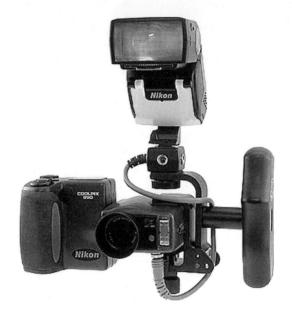

Say Cheese

Because most auxiliary flashes are powerful compared to the tiny on-camera flash, consider putting diffusion material, such as a small white handkerchief or a piece of cheesecloth, directly on your flash. Alternatively, go high-tech and buy some plastic diffusion material, lighting filters, or gels at a camera store or even a theater supply store. The major manufacturers of lighting filters and gels are Rosco Filters Co. (www.rosco.com) and Lee Filters. Rosco also manufactures wonderful set paints. Another good source for almost all things photographic is *Photo District News*, which is a magazine published for professional photographers. Its website (www.pdn-pix.com) has a wonderful resource section.

Adding Lights

If you don't want to be securing auxiliary flash units all over a room, there is a simpler way: turn on a few lights! Try setting up a few clip-on lights and using brighter bulbs in some of the lamps and fixtures in the room. Reflectors can be used to concentrate and focus the light; typically bowl-shape metal reflectors work well. The shape and size of the reflectors determine how wide a beam of light is thrown and how hard the light will be.

Color of Light

We've all heard the phrases white hot and red hot, and we've all seen heated metals glow and emit light. Many years ago, a system was devised to determine what color light was during these observations. A black body (a black piece of metal) was heated, and as it was heated the metal changed color, its temperature (measured in Kelvin) was taken, and the color of the glow was noted. It was observed that the hotter the metal got, the closer the color came to white. White hot metal was measured at 5,500° Kelvin; interestingly, average daylight at noon is rated the same. We now use the Kelvin scale to describe the color temperature of light (see the following table).

Color Temperature of Light Sources

Source	Color Temperature	Photographic Mood
Candles	1,950° K	How romantic
Dawn	2,000° K	Also romantic
Household incandescent	2,800° K	Very yellow
Fluorescent tube	3,000° K	Yucky color!
Photo incandescent	3,400° K	Constant color
Noon sunlight	5,000 to 5,500° K	Clear white
Sunny day with some clouds	6,500° K	Looking cool
"Incredible" blue sky	11,000 to 18,000° K	Wear sun block!

Interestingly, artists, designers, interior decorators, and some others refer to colors exactly backward from reality. They call colors with lower color temperature "warm" colors and colors with higher color temperature "cool" colors. Obviously they don't know about color temperature!

If you look at different light sources, such as a standard light bulb or sunlight, you will notice that they are different colors. A standard tungsten light bulb, such as a household light bulb, burns at about 2,700 to 2,900° Kelvin. In relation to sunlight, this appears yellowish. Tungsten photographic lighting equipment "burns" at 3,400° Kelvin; daylight-rated photographic light bulbs burn at 5,500° Kelvin.

Behind the Shutter

Commercial photographers often use soft boxes to produce an even, diffused source of light. A soft box is a box made of flameproof, lightweight material, the front of which is translucent. The light source is mounted inside the soft box, so the light shines through the diffusion material.

If you don't want to buy a soft box (and I wouldn't blame you, they can be expensive), you can rig a simple substitute. Hang a white cloth sheet from a stand or a clothesline, and shine your light source through the sheet in the direction of your subject. Although this method doesn't pass as much light as a professional soft box, it delivers a soft, diffuse light. Be careful not to burn or overheat the cloth; keep your light source a safe distance from the cloth.

When your camera detects light falling on a subject, it must determine the color of the light source. Most cameras (or their software) automatically adjust for the correct color temperature; this is called *white balance*. If your camera (or its software) does not adjust for color temperature, the images carry a color cast (an overall tint of color). Imagine your camera is set to work only at 5,500° Kelvin. If you brought your camera inside to photograph under household lighting, everything would have an unpleasant yellow cast. Alternatively, if your camera were set to see tungsten lighting, then all your outdoor shots would look very blue. If you want proper, or neutral, colors in your pictures, be sure your camera is set for the color temperature of the main light source.

Flash

Be careful when adding light to your subject. Use similar types of sources in the same environment. If you mix lighting, such as using a flash and tungsten lights, you end up with a strange and unwanted colorcast. Your camera adjusts for one of the sources or the other. If it decides to average the color temperature, you will see blue and yellow light in your image.

Of course, you might decide not to correct for the color temperature. For instance, if you were to take a moody candlelit picture, it would be a shame if the warm light of the candles were overcorrected to a neutral color. If you can turn off the white balance correction, try to do so. If you are setting the white balance using software, try leaving it off. Experiment and practice. Remember, you are not wasting film and you have nothing to lose.

Flash

All digital cameras have to have the white balance set to get normal, neutral colors in photographs. Most of the lower-priced cameras do this automatically and seldom have a manual override. More-sophisticated cameras have an automatic white balance setting, and you can use that most of the time. But there are times when automatic white balance is not ideal. Suppose you are photographing a friend outdoors. First you make some wide shots that include a lot of background, and then you either zoom in or move progressively closer to your friend until you have a tightly framed head shot. When you look at your photos later on your computer you see that your friend's complexion varies considerably between the wide shots and the close-up. That's because the camera is set up for an "average" scene; that is, it assumes that all of the colors in the scene will combine into a neutral gray if added together. In the wide shots there is a mix of colors that work out close enough to neutral to give a proper neutral white balance for the shot. When you zoom in closer and closer, more and more of the frame is taken up by your friend's face, and that does not average out to neutral gray.

Better cameras usually have white balance setting that you can manually select. In our example you would set the white balance for outdoor sun, and this would produce the closest possible white balance throughout the sequence of photos. Also, some cameras have the ability to set one or more custom white balance settings. How this works varies some between cameras, but often you just snap a photo of a white card under the lighting you wish to balance for. You can also use the custom white balance to trick the camera into producing warmer or cooler (in the artist's sense of those words) colors. A company called WarmCards even makes sets of colored cards to make this task simpler (www.warmcards.com).

Lighting Setups: You're a Pro Now!

Photographic lights come in two basic types:

- Hot lights. So-called because these types of lights get very hot. They use reflectors and specialty screw-in bulbs, which can be purchased from photographic suppliers. Photoflood bulbs come in plain and in blue, and I recommend blue because those mimic daylight. More expensive "hot light" systems use tungstenhalogen bulbs, which are brighter and last longer.
- Studio flash. Professional stand-mounted flash units run on AC rather than batteries.

You can produce good photos with either of these systems if you spend the time to learn how to use them.

When first getting into lighting, start off by deciding what the important part of your photograph is, and then decide how you want to light it. Try the following:

1. Add the first light, which is called a *key light*. The key light delivers the main and brightest light. It defines your subject's features and contours to provide three-dimensional modeling. It can come from directly in front of the subject, but it adds more dimension if it comes from the side. As you can see in the following figure, a key light casts a harsh shadow.

A key light casts a strong, hard shadow.

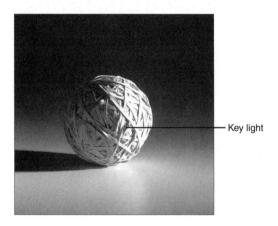

2. Before adding another light, see what a fill card will do. Place a white card opposite the key light. It bounces light back onto the object, and fills in the harsh shadows.

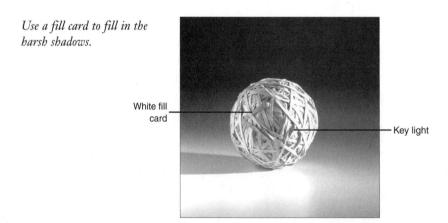

3. If you need more light to fill your shadow, you can replace the fill card with another light source. (I'll call this a *fill light*.) To keep some of the shadow detail, this light should be dimmer than the key light. If the key light and fill light are the same intensity, move the fill light farther away from the subject, or try diffusing it. In the following photograph, note the shadow thrown by the fill light to the right of the ball.

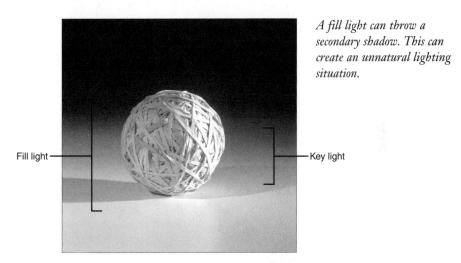

4. Product shots might need a top light, called hair light when photographing people, which should be placed above the object. You can place the light slightly behind or in front of the subject, depending on the effect you want to achieve. This light also should be diffused—be careful not to cast a heavy shadow on the product! When photographing a person (or when photographing an object that is very textured, like the one shown here), using a hair light can add a nice effect. Place the hair light above and behind the person; it picks up the texture of the hair and adds some nice highlights. Be careful not to shine the light into your lens.

Practice your lighting techniques! Try out different types of light sources, and experiment with different placements. If you really want to get fancy, try coloring your light sources. Red lights add a sense of action to your shot, whereas blue light often gives the feeling of calm or coolness. Experiment with different colors and color combinations to get the mood you want. Creative lighting can produce exciting and pleasing results.

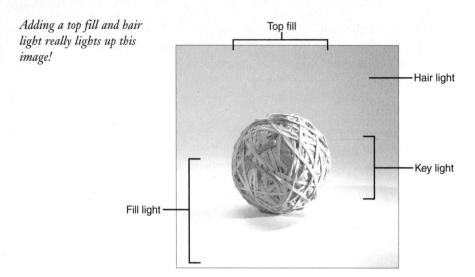

Lighting Safety Tips

As with all things in life, you should consider the safety hazards of using lighting:

- Don't overload your electrical circuits when using lighting.
- Use heavy-duty extension cords.
- Place your electrical cords carefully to avoid creating a trip hazard.
- Weigh down your light stands so they don't tip over. You can make inexpensive weights by filling one-gallon plastic bottles with water or sand.
- Be careful of the heat the lamps produce. You can easily burn your subject.
- Don't touch the bulbs with your bare fingers, even when cool. If you get oil from your fingers on some types of bulbs it will cause them to burn out prematurely.
- Be careful when using colored gels on your lights. If they get too hot, they might melt. Also, and this is extremely important, use only photographic gels or theater gels on your lights. They are designed to be used near high-temperature lighting.
- Do not move a light when it is on! Light bulbs are very fragile when they are hot—especially when lit. They might shatter or explode when moved. Turn lights off before you move them!

No matter how tempting, do not use electric lights around swimming pools. More than one photographer and model have been killed when someone tripped over a light stand and a light fell into the water.

Say Cheese

If you have forgotten your tripod and find yourself in need, here is a good trick: Hold your camera to your eye, and relax your arms and body. If you stiffly brace yourself, you are going to shake. After you take several deep breaths, exhale slowly. At the end of the exhalation, trip the shutter. This not only reduces shake in your body, it will calm you down. If you find this technique helpful, you might consider signing up for a yoga class!

Stand Still: Working with a Tripod

When your camera's shutter speed falls below a certain threshold (which varies from person to person) you will not be able to hold it without shaking it. In a low-light situation, such as with an interior, you can be sure you'll need a tripod.

Say Cheese

How low can you go? No, I'm not talking about limbo! You need to know what's the slowest shutter speed for hand-holding your camera. It varies, of course, from person to person, but as a general rule you can hand-hold steadily down to a shutter speed that is the reciprocal of the lens focal length. In this case it is the 35mm equivalent focal length that matters. So if you're using a lens that is equivalent to a 500mm, you won't likely be able to hand-hold it steadily slower than about 1/500 second; with a 30mm lens you can hold steady down to 1/30 second. What this means is that it is harder to hold a telephoto steady than a wide angle. At speeds below these you will need a tripod or other support for your camera.

When you buy a tripod, be sure to get a sturdy one. Better tripods will have a Teflon-like surface on the legs to aid them in movement. The taller the tripod and/or the more compact it is, the more you will pay for it. Pay close attention to the pan head, which attaches your camera to the tripod—it should be sturdy and have smooth movements.

158

Most higher-end cameras will have a socket for a remote release, a device that allows you to fire the camera from a distance by means of a cable that attaches to the camera. This can be a threaded socket in the middle of the shutter button, designed to accept a mechanical cable release, or it can be an electrical socket that accepts the plug from an electrical release cable. Although mechanical cable releases are universal and all use the same thread, electrical releases are generally specific to camera brand. Be sure you are buying the right thing when you get one of these.

Additionally, many cameras have built-in infrared receivers for remote control photography. In some cases the transmitter comes with the camera, but in most cases you will have to buy it as an accessory. For more sophisticated photography, radio remote release systems are also available.

The Least You Need to Know

- Use available light for your basic exposure.
- Don't let your meter be fooled by bright or dark backgrounds.
- Use a flash to add light to your photos.
- Use your flash as an indirect source of light.
- Use reflector cards to fill in your shadows.
- Use additional light sources to add creativity to your images.
- Each light source has its own color.

Resolution: Is Bigger Better?

In This Chapter

- Understanding the importance of image resolution
- ♦ Adjusting your monitor's resolution
- Printing your images
- Comparing ink jet and laser printers

We all remember Goldilocks and the Three Bears. One bed was too soft, one bed was too hard, and one bed was just right. Resolution behaves a lot like our friend Goldie. Too little resolution causes your images to lack detail; too much resolution clogs up your computer and printer and robs you of speed; and the proper resolution is just right.

Image Resolution/Monitor Resolution

Your camera can produce images at various resolutions. As a general rule, the larger your file is, the more you can do with it. If your file size is too small, you won't be able to reproduce large images and still have detail. The drawback to large images is that they take up a lot of storage space in your camera's onboard memory, and on whatever media you use for long-term storage.

The resolution of your monitor is measured in pixels, just like the resolution of your images. Monitors can display your images at various resolutions, which affect how those images look onscreen (however, it doesn't affect the resolution of the images themselves).

Demo: Calibrating Your Image Resolution and Monitor Resolution

Both the screen resolution and the size of an image affect how that image is displayed on the monitor, but don't take my word for it! Humor me by performing the following steps, which illustrate how your monitor resolution and image resolution work together.

Important note: Monitor resolution on most flat-panel LCD monitors is fixed and cannot be changed. If you have a flat-panel monitor you can skip this demonstration.

On a Windows computer:

- 1. Click the Start button, click Settings, and choose Control Panel.
- 2. Double-click the Display icon.
- 3. Click the **Settings** tab, and look for the Screen area slider at the bottom of the panel. Drag the slider to set your screen resolution at 640×480 pixels. You can see the change in the small view monitor or by hitting **Apply.** If you decide to select **Apply,** be sure you write down your current settings so you can change them back if desired.

Changing the screen resolution changes how the onscreen image is displayed.

- 4. In Photoshop Elements 3, open the **File** menu and choose **New** (alternatively, press **Ctrl+N**, or **Command+N** on the Mac).
- 5. In the New dialog box, shown in the following figure, type 9.4 in the Width field (don't worry about adjusting the Height field), and 72 in the Resolution field. (You'll understand why you're entering those particular numbers in just a moment.) Be sure to select inches as the measurement for the width and height (note that you can change this to pixels, centimeters, points, picas, or columns), and that pixels/inch is selected for resolution. Click OK.

Select the width and resolution in the New dialog box.

On a Mac computer:

- 1. Click on the Apple in the upper-left corner of your desktop.
- 2. Select System Preferences.
- 3. Click on **Displays**.
- 4. Select the desired resolution from the list displayed.

Look! The image's window fills the width of your screen when viewed at 100 percent. So how did I know to enter **9.4** in the **Width** field in step 5 to make the image fill the whole screen? Here's a hint: your monitor is set up to *display* images at 72ppi (pixels per inch). Give up? Okay. Divide 640 pixels (remember that you set your monitor's screen resolution, or the total number of pixels available on your screen, to 640×480 in step 3) by 72ppi, and you get 9.4 inches!

So what happens if the image is 9.4 inches at 100ppi instead of 72ppi? Well, the image will no longer fit on the screen at 100 percent—you're out of screen pixels! You can display it at 100 percent and scroll the screen to view the image in its entirety, or you can increase the screen resolution. If you increase the resolution to 1,024×768 (or thereabouts), you will again be able to see the image at 100 percent—with a little screen to spare. (9.4 inches×100ppi = 940 pixels to display. We set the screen to be 1,024 pixels wide, so we can see the entire image.)

Say Cheese

To keep things simple, just worry about the width of the image, and likewise the width of the screen. Don't worry about adjusting the height of the image.

Say Cheese

By the way, when you first open an image in Photoshop Elements 3, it opens the image at the largest zoom size that fits, in full, on the screen.

To see the entire image onscreen without changing the resolution, begin by specifying that the screen display only some of the total pixels available. So instead of specifying that you want to see 100 percent of the pixels in the image, you can tell your software (in this case, Photoshop Elements 3) to show a smaller percentage of pixels. For example, if you choose 25 percent, you'll see only one in four of the pixels in the image (thus, losing some detail), but you won't have to use the scrollbars to view the image in its entirety.

Just as you can zoom out to view more of the image on your screen (thus, making the image appear smaller), you can zoom in to make the image appear larger to view more of its detail, as shown in the following figure.

Printer Resolution

Printers usually have a fixed resolution at which they best reproduce an image. For most dye sublimation printers, this is usually 300dpi (dots per inch); it varies with inkjet printers. So what happened to the ppi (pixels per inch)? Printers don't print pixels; instead, they lay down tiny dots of ink or dye to produce an image. The printer should, at the very least, print one dot for every pixel.

To get the best image reproduction from your printer, you should maximize your image size. Also, the resolution of your image should be the same as your printer resolution, if you can swing it. If your printer has a resolution of 300dpi, then your images should have a resolution of 300ppi (pixels per inch). Note, however, that this need not be the same as your monitor's screen resolution, which is why the printed image will not be the same size (in inches) as it was on your screen.

If your image is too small or has less resolution than your printer, one of two things will happen:

- Your printer might just leave a space between each dot when it prints. As a result, your image will lack detail and sharpness.
- Your printer might interpolate information to fill in the gaps between the pixels. As we know, interpolated information is not as good as original information. Your images might still not look sharp, and might lack detail.

The moral of this story: if you want great detail and print quality, start out with enough image data.

The Inkjet Exception

There, on the side of the box that contains a shiny new inkjet printer, is a label proclaiming, "This printer capable of 2,440dpi!" Wow! That's a lot better than the 300dpi quality of my laser printer!

Well ... it is, but it isn't.

Inkjet printers can reproduce a very tiny dot, much smaller than the dots that dye sublimation printers can produce. Also, inkjet printers can move their inkjet heads in very fine increments. By using this technology, the inkjet printer can lay down many dots when printing. Instead of printing one dot for each pixel as a laser printer would, an inkjet printer can lay down two, three, four, or more! That means your 300ppi file can be printed at 1,200dpi, because the printer lays down four dots for each pixel. The benefits to this can be finer detail and better color blending. Don't confuse this with interpolation, however. The printer is not making up information to go between the missing pixels. Instead, it is repeating the information it already has. That is, the printer is printing your 300dpi file at the same resolution, except it is using more dots to do it.

You will need to do a side-by-side comparison to decide which printer gives you the more pleasing result. It is almost like comparing apples to—well, more apples!—each printer has its pros and cons. It is very difficult to say that a 1,200dpi inkjet printer produces a better print as compared to a 300dpi printer. But the point is that a 1,200dpi inkjet is not four times better than a 300dpi printer.

In any case, if you plan to use your printer at a high dpi setting, be sure you are using good-quality paper. Also, remember that it takes a lot longer for your printer to cough up a print. You might want to proof your image out at a lower resolution before you go the high-resolution route.

How Big a File Do You Need?

With small and lower-end digital cameras, you will probably not run into the problem of having too large a file size. Again, whatever size you decide to make your print, the dimensions of the print and its resolution should match the printer's settings.

If your image is too big, however, your printer will throw away information—think of this as *reverse interpolation* or *downsizing*. You should make the image smaller before you send it to your printer, but be sure you never resize the original image. Instead, copy it, and then resize the copy. You might find that you need to make a few "variations" of your print, depending on the printer and paper type.

If your printer gives its specifications in lpi (lines per inch) instead of dpi, fear not. To determine how much resolution you need, double the lpi required; the resulting number will be your dpi/ppi setting. For example, if your printer wants an image at 133 lpi, your image should be 266 ppi.

Most inkjet printers will not show significant improvement in print quality at resolutions higher than 200dpi. You can try this on your own printer to see if you can see any difference between an image with 200dpi and one with 300dpi. If you can't see any difference, there is no point in saving files at higher resolutions because they will just take up more storage space.

Some printers, Epson in particular, are happier with files saved with dpi that are multiples of 120. Epson's printer driver will convert the image to 360dpi anyway, and this involves the dreaded interpolation, so giving it an image saved at 360dpi in the first place will produce better prints.

Say Cheese

If you are going to be sending your digital image files to a commercial printer to be printed, it's always a good idea to call the printer and ask them at what line screen they will be printing. Line screen, "printer talk" for lpi, refers to the lines per inchused on the printing plate, which in turn will be used make the final printed material.

The lower the line screen, the "coarser" your image looks. The type of paper the printer is using determines the proper line screen. A newsprint type of paper doesn't hold a lot of detail. A low lpi is used so that detail will not be "clogged" up as the ink soaks into the porous paper. Glossy paper (called coated paper by printers) holds detail much better because the ink won't soak into the paper as readily. Make sure to get all of the printer's specifications for digital files so that you will be supplying things in proper form to produce the best quality. Printers use CMYK files to make their printing plates, but your digital files are RGB. Unless you become a real expert, you should not attempt to make your own CMYK conversions. Let the printer do it. They know how to do this properly for the ink and paper they will be using.

The Least You Need to Know

- Monitors used to only display images at 72dpi. This has, therefore, become the default resolution to use for images that will be displayed on a computer monitor.
- ♦ You need to have enough resolution in your images to print properly. A printer usually has a higher resolution than a monitor.
- ◆ The size of an image onscreen might differ from the size it prints out at, depending on the onscreen pixel ratio.
- Enlarge your image to the size you plan to print to get a better reproduction.

Learning File Formats and Compression

In This Chapter

- Getting the lowdown on resolution and quality
- Learning the ins and outs of compression
- Clearing up confusing file types

To reduce storage size, your images can be *compressed*. Compressing images enables you to store more on your camera's internal memory and computer's hard drive, but unfortunately, compression might (and often does) destroy information.

Getting Quality Images

The best image quality that you can have is from an uncompressed original image (what I call a *straight* image). If image quality is important to you, you should try to find a way to get your images from your camera without compressing them. Unfortunately, many (if not all) mid- to lowend cameras don't give you the opportunity to download your information

before it has been compressed. How, then, can you be sure you end up with the best possible image file—especially for those once-in-a-lifetime shots?

Well, it's confusing. Determining what the quality of your image will be requires an understanding of image size, resolution, *and* compression—and each camera manufacturer describes its options differently:

◆ Image size/resolution. Your camera might give you anywhere from two to five options on what size your finished image will be, usually presented in pixels (for example, 1,152×864 pixels, 640×480 pixels, and so on). The lower the *resolution*,

Say Cheese

You might think that taking a smaller image and compressing it only slightly would give you a better image than taking a larger image and compressing it a lot, but that's not true. The problem is that the smaller image has started out its life with less detail; the larger file, when uncompressed, still holds more resolution (it might, however, suffer from interpolation).

the smaller the *file size* and, consequently, the less *compression* required. If you simply intend to put your images on a website, you don't need a lot of resolution. If you intend to print your images, select the highest resolution available.

◆ Compression. One would think that the *quality* of the image would have to do with how much image information is available, but that's not what the manufacturers are talking about. Instead, your camera's quality setting represents how much the image is *compressed*. The more compression an image undergoes, the more quality is lost. If given the option, choose the highest quality possible.

Some cameras do not give you the option to pick the resolution and compression rates. Instead, you'll see Good, Bad, and Ugly settings, which determine the compression and resolution at the same time. The camera either shoots at a low resolution and compresses less, or shoots at a high resolution and compresses more! The only way to get a clue as to what's going on is to look at the final image size. For example, suppose you applied the Good setting to one copy of an image, and applied the Bad setting to another copy of the same image. If both the images end up the same size, then you know that the compression rate was varied. If the images end up sized differently, then you know that the resolution was changed. As you can see, this type of blind quality control is not the most desirable.

Lossy Versus Lossless Compression

Lossy and lossless might sound like Vegas streaks, but instead they refer to types of compression schemes.

- ◆ **Lossless compression.** A compression scheme in which no information is lost during compression or retrieval (also called *run-length encoding*).
- ♦ Lossy compression. A compression scheme that loses or throws away information in order to compress your file. Lossy compression relies on your brain and eyes to "fill in" the information it threw away when you look at the file after it has been retrieved.

Let's look more closely at these compression schemes.

Lossless Compression

Instead of saving all the color information in your file pixel by pixel (which would offer no compression at all), lossless compression keeps track of the location of each pixel of color. For example, the compression process logs the color green, noting all the places in the photograph where that color is located, and then saves that information. So instead of saving 1,000 pixels of green, it saves 1 pixel of green and a directory of the locations in the photo where that color resides. This takes up a lot less space than saving each individual pixel and its location. When the file is uncompressed, the process happens in reverse. The compression scheme rebuilds the file using the colors it has stored and the directory that outlines where they should be located. There is very little visual difference between the original and the restored files. Because the "logging" process is not perfect; it cannot exactly reproduce the original file.

Using lossless compression is a safe way to save your files, but the drawback is that the compressed file doesn't end up being that much smaller than the original file.

Lossy Compression

Take a close look at any two objects that are adjacent to each other in a photograph—for example, a shiny red Porsche against a deep blue sky. Now look at the edge where the car ends and the sky begins. Notice how the pixels begin to *tween*, or blend from red to blue? This tween information is exactly the information that lossy compression software is going to chuck. It relies on your brain to detect where there should be tween information and to put it in for you when you look at the photo. One additional disadvantage of using lossy compression is that every time you resave an image, you lose even more information. Eventually, your image is going to look like a pile of mush.

The benefit of using lossy compression is that you can compress images to very small sizes. This aspect comes in especially handy when you are sending images via e-mail or posting them to a website (besides, website images usually are so small that most of the detail is lost anyway). The smaller size greatly speeds download time.

Archiving Programs

After a while, you will find your hard drive brimming with hundreds of images you just can't throw away. You will need to back up your hard drive onto portable disks, such as CD, DVD, or additional hard drives. Simply copying files off your hard drive onto a disk is an easy and quick way to store images and files. The problem with this is that you will need many disks to back up all your files. What do you do?

Archiving programs are designed to help solve storage problems. These programs will help you store your files and keep track of them. The archiving program will compress your files, without losing any data, so you will use far fewer disks than if you were just copying them onto a disk. The programs will also keep track of your files, creating catalogs or disk file directories. Some programs will simply compress your files and offer simple file directories. More elaborate programs will create backup logs and might offer file histories.

WinZip for Windows

WinZip (www.winzip.com), which is used on Windows platforms and is available as *shareware* and as a commercial program, is a lossless compression program. It can reduce image files about 20 to 30 percent. Text documents (such as Word documents) and computer program files compress up to 60 percent.

In Plain Black & White

Private individuals or small companies, usually to help fill the gaps left by large software companies, develop **shareware** programs. These programs are offered at a low cost or free, and are usually downloadable from user group bulletin boards or websites. If a fee is involved, it is usually small—\$1 to \$50—and generally goes to the programmer to help defray his costs in operating his website or developing the program code (although some shareware programmers derive their sole income from developing shareware programs).

Not only can WinZip compress many files at the same time, it can *archive* the image files into a single file. You can usually tell when a file has been zipped, because it has the extension .zip in its filename (as in File.zip).

To restore an archived file back to its original form, run the file back through the zip program. Typically, you will use a program such as Un-Zip, or something similar-sounding, to restore the file. Usually this requires little more than dragging and dropping the file onto the archiving program's icon. Zip files can also be archived as self-extracting archive (SEA) files (Mac only), which do not require the use of the Un-Zip program to be unpacked. SEA files might be a bit larger than ZIP files, because they contain a small amount of computer code to run the extraction. SEA files are useful if the computer that is doing the unpacking does not have the Zip program installed on it.

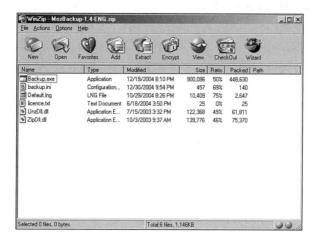

WinZip compressed these files with an average savings of 35 percent.

DropZip and Stufflt for Macs

DropZip and StuffIt Expander, which is manufactured and sold by Allume Systems (formerly Aladdin Systems) (www.allume.com), also employ a lossless compression scheme. However, this scheme has been developed to work on Macintosh platforms (although Allume also provides an expander program for Windows platforms). DropZip works similarly to WinZip. DropZip does not add further compression to the files you are combining into a .zip folder, but packages them into a single, convenient unit for e-mailing or storing.

StuffIt Expander also will open a self-extracting format, SEA. SEA files are larger than .zip files because they also contain the code needed to perform the extraction. Note: because SEA files can be opened only on a Macintosh, it's a good idea to save

your files as .zip files so that they can be read by both Macintosh and Windows machines (besides, the files will be smaller).

StuffIt saved 43 percent with lossless compression.

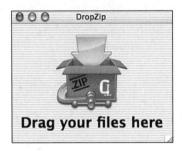

File Formats: Acrimonious Acronyms

So many file formats are available that it is often confusing to figure out what they all do. Some formats are specific to a program or manufacturer; others indicate industry standards. We will look at only the formats that relate to pixel-based images.

Some formats are used to compress images, others are used to reduce color information, and still more have been developed specifically for web usage. Not every format can be read by every software application. Let's take a few minutes here to look at some important image formats.

JPEG

JPEG (short for Joint Photographic Experts Group and pronounced *jay*-peg) files are lossy compressed files. The JPEG format can be read by all computer platforms; because JPEG files are small in size and extremely portable, they are an excellent (and the preferred) way to deliver images over the web. The amount of loss depends on how much compression you use when making the JPEG file. In Photoshop Elements 3 and Photoshop CS2 you will see a popup window when you are saving a file as a JPEG. In this window is a compression slider that enables you to set compression and quality. If you set the slider to 12 (maximum quality and minimum compression), JPEG becomes, for all practical purposes, a lossless file. The lower the number you pick with the slider, the more compressed the file will be and the more information will be lost. For e-mailing and Internet posting, a setting of 6 is usually about right, and no loss will be visible on monitors.

JPEG files can be made very small and can also be *interlaced*, meaning that they will open on a web page at a low resolution at first, and then "fill in" their resolution as

Plate 1.1

It's always fun to keep your eyes open and look for unusual shapes. Don't be afraid to crop using your eyes and camera frame ... or your computer!

Plate 1.2

Be ready for life's surprises.

Plate 1.3

Don't be afraid of using only one color. Here, it helps bring out the leaf's texture.

Plate 1.4

The foreground and the beautiful sky horizon help draw the eye to the Boston skyline.

Plate 1.5a

Plate 1.5b

Creative framing can turn an ordinary shot into something special.

Plate 1.6

Panning the camera helps create the illusion of movement. Experiment with a few shutter speeds and panning speeds. Remember, it won't cost you any film! For details, see "Movement" in Chapter 9.

Plate 1.7

By carefully adjusting this photo's shadows and highlights, the fine architectural detail of the stairs at Copley Church is brought to life. For details, see Chapter 10.

Plate 1.8

By contrasting the old and new, you can emphasize the uniqueness of both.

Plate 1.9a

The Hue/Saturation dialog box in Photoshop Elements 3.0 gives you three sliders that you can use to adjust the hue, saturation, and brightness (called Lightness) of your photo. Refer to "Hue/Saturation and Lightness" in Chapter 15 for more on this feature.

(Copyright © 2005 Bob Shell)

Plate 1.9b

When you use the Saturation slider, don't overdo it or you will end up with a really weird and unflattering result.

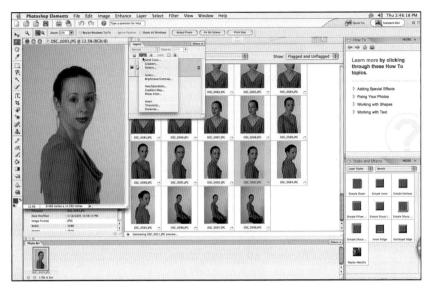

Plate 1.10a

By making your adjustments on an adjustment layer you can preserve your original image unaltered. You can easily control how much of any effect is applied to an image by keeping it on a separate layer. See "Hue/Saturation and Lightness" in Chapter 15 for more on this feature.

(Copyright © 2005 Bob Shell)

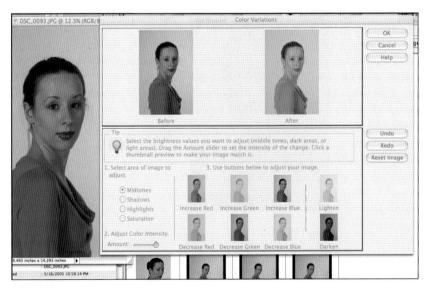

Plate 1.10b

Using Color Variations lets you view a number of different versions of your image on-screen and decide which, if any, is the look you want. See "Variations" in Chapter 15 for more on this feature.

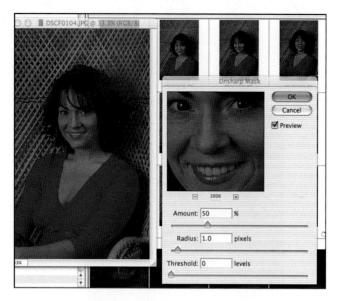

Plate 1.11a

Unsharp Mask allows you to adjust sharpening of your image with great finesse so that you can add just the amount that is right for a specific image. See "A Sharper Image" in Chapter 15 for more on this feature.

(Copyright © 2005 Bob Shell)

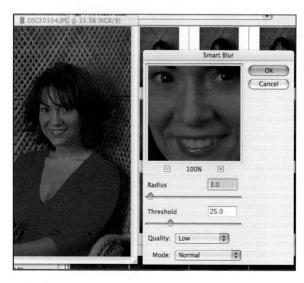

Plate 1.11b

Smart Blur is somewhat the opposite of Unsharp Mask, and allows you to soften an image in a very controlled way. It can be just the right thing for a portrait. See "It's All a Blur" in Chapter 15 for more on this feature.

Plate 1.12a

Plate 1.12b

These two images show how you can selectively remove color from part of an image by selecting and desaturating it. See "Demo: Removing Color from Portions of Your Image" in Chapter 16 for details.

Plate 1.13

You can select areas of the same color by using the Magic Wand tool and setting its sensitivity. See "The Color Magic Wand" in Chapter 16 for details.

Plate 1.14

You can use Photoshop Elements 3.0 to apply filters and color corrections to specific areas of your photos. (For details, see Chapters 15 and 16.)

Plate 1.15a

Plate 1.15b

Plate 1.15c

This photo was taken on a day when the sky was completely overcast. This produced a completely featureless and boring sky. I pasted in a sky from another image that had a dramatic sky and used the Color Picker to select and add some more color to that sky. The finished image is much more attractive than the original. For details see "Demo: Using a Filter to Change the Weather" in Chapter 17. (Copyright © 2005 Bob Shell)

Plate 1.16a

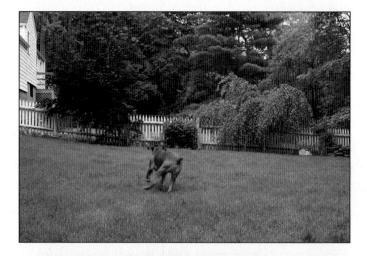

Plate 1.16b

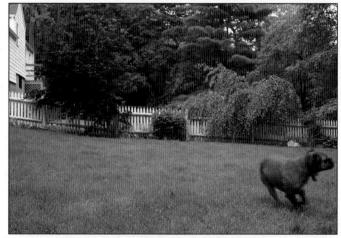

Plate 1.16c

It's sometimes hard to keep Mugs out of my photos. But I was able to clone parts of the shot from the middle photo into the top photo to end up with a Mugs-free shot on the bottom. For more on cloning, see "Cloning Between Two Photos" in Chapter 17.

Plate 1.17
Texture is everywhere—even on this bulletin board!

Plate 1.18

Color doesn't always need to be bold and saturated. The pastel bues of this dune cliff are subtle and soothing.

Plate 1.19

The interplay of positive and negative space makes for a dramatic seashore shot.

Plate 1.20
Monochromatic color can be used effectively as a compositional tool.

Plate 1.21
Creative shooting and composition can make the ordinary extraordinary.

Plate 1.22
The yellow diagonal wire makes for an exciting abstract image.

Plate 1.23

Each element in this photo is on its own layer. The transparency between each image is accomplished by using the Erase tool with various opacity settings. This is a wonderful example of using layers effectively. For details on using layers, see Chapter 20.

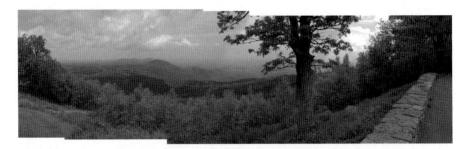

Plate 1.24a

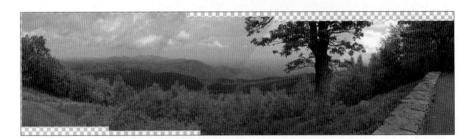

Plate 1.24b

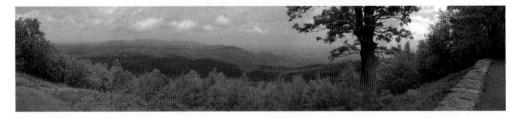

Plate 1.24c

Photoshop Elements 3.0 can make panoramic images from several composite shots. In the top figure, you can see how three images have been combined into one. There are some distinct lines of demarcation between shots after using the panorama feature to combine the shots. For details on creating panoramas, see "Putting It All Together: Panoramas" in Chapter 20.

the remainder of the file is downloaded. The benefit is that the web viewer can get an idea (albeit a bit blurry) of what the image will look like, and not feel frustrated waiting (and looking at nothing) while the image downloads. If the viewer is not interested in the image, he can move on to something else. This speeds web-page viewing along.

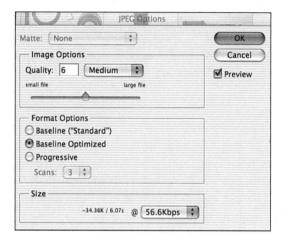

JPEG is the primary lossy compression format used.

Say Cheese

For those of you who want to know the who, what, where, when, and how you took a picture, you're in luck! This data, which is called "metadata," is stored along with your image data in the JPEG EXIF (Exchangeable Image Format) format. Many higher-end consumer and professional cameras can store data in this format.

Most current image manipulation software can read some, or all, of the EXIF data. If you want to read all of it, you will most likely have to use the viewer or browser made by your camera's manufacturer. There are also stand-alone EXIF reader/editor programs available, some of them as shareware. A Google search on EXIF reader will show you what is currently available for download.

This info can help you learn how your camera is making exposure decisions. It will also help you remember when you took them!

TIFF

TIFF, which stands for *Tagged Image File Format*, is one of the most universal formats for pixel-based images, and can be opened on Macintosh and Windows-based machines. Although TIFF uses no compression in its most commonly seen form,

Behind the Shutter

With some files, you see a .tif file extension instead of the .tiff extension, but fear not; these files are indeed TIFF files. In the old days, before Windows, DOS machines allowed only three-letter extensions, such as .tif, .doc, or .let.

when you save a file in TIFF format you will see an option to use LZW compression. LZW compression is a completely lossless type of compression, which cuts the size of TIFF files about in half. But, because more processing is required in opening an LZW compressed TIFF file, such files will take more time to open on most computers. TIFF images, whether LZW-compressed or not, are not welcome on the web or as e-mail attachments because they are large, bulky, and slow to open.

GIF

GIF (pronounced jiff), short for *Graphic Interchange Format*, was developed by CompuServe as a compressed graphic format. GIF files are still widely used on the web. Because the compression algorithm, which is incorporated in the GIF format, was designed mainly to handle text formats, GIF files support only 8-bit color and best handle icons, text, and line drawings.

GIF files can be delivered over the Internet, and support interlaced graphics (which enable the image to be displayed partially as the web page downloads). In addition, simple animation can be delivered via the web using animated GIFs, which consist of a batch of GIF files that are delivered "flip book" style.

EPS

EPS (*Encapsulated PostScript*) files can be huge, because they incorporate the Post-Script language and the original file. *PostScript* was invented by Adobe as a language to tell printers how to print a file. A PostScript file tells any printer that supports the Post-Script language how big a file is, which font or fonts it uses, and other information about the file. This enables the printer to print the file as it was intended to look.

EPS files contain a few lines of code in the *header* of the file that enables the images to be inserted into word-processing and other documents. This makes EPS files portable, but also large and slow to work with. This slowness is compounded by the fact that the image-processing program must process the PostScript instructions in addition to the image, which slows the computer down quite a bit. For these reasons, EPS files are not a great format for the web.

PDF

PDF (*Portable Document Format*) is a modern version of the EPS format. Like the EPS format, PDF contains instructions for the printing device such as font, size, and color descriptions. The PDF file is not a single file, but an entire document that contains page-layout, image, and color-management information.

Using PDF files is an excellent way to distribute large documents, especially over the Internet. Because Adobe and other companies freely distribute PDF readers, many software programs are being distributed with PDF manuals instead of actual printed instructions. This enables software developers (and anyone else who needs to distribute manuals) to save a lot of money by not printing and shipping books.

Many government organizations, corporations, and even small businesses are increasingly relying on PDF as a reliable format to route important documents both internally and externally. The upshot being the professional sector is now incorporating PDF into its normal everyday operations.

To write a PDF file, you need a PDF distiller such as Adobe Acrobat, which allows the page layout to be *published* into PDF format. PDF files are very small, because many of the layout and type specifications are contained in code that *describes* the layout or file instead of containing the actual file.

FlashPIX

FlashPIX, developed by a group of software and imaging companies (including Kodak, Hewlett-Packard, Live Picture, Inc., and Microsoft), is another modern file format, and is excellent for the web. FlashPIX uses lossy compression to store the complete image and multiple lower-resolution versions of the file.

As the user calls for an image at a specific resolution, the FlashPIX format delivers the specific resolution to fill the section of the screen called for. Remember, when you enlarge an image, you will be filling the entire screen; you don't need to load file information into RAM that will not appear on the screen. If the user calls for a higher or lower resolution, that file is quickly *swapped* in. This enables a very speedy change in onscreen resolution. Also, because only the information needed for the specific resolution is loaded into the computer's RAM, more RAM is left over for other duties. For example, instead of loading all 20MB of information for an image that requires only 100KB to display the image, FlashPIX enables you to download only the 100KB you need; thus, much less RAM is used. Also, a FlashPIX image can be downloaded into a web page at a low resolution, with a more detailed version of the

image ready and waiting to be loaded into RAM if needed. This decreases the download time and increases image detail.

BMP

BMP files are a standard bitmap file format used by Windows. You will see these files associated with Windows programs. BMP files offer out-of-date compression schemes and do not resize well. Don't use the BMP format if you can avoid it.

So Many Choices!

If you are storing finished images and you are pressed for space, use the JPEG format. Make a copy of the original image and try a few different compression ratios until you find the right file size you need. Unfortunately, you can't predict the file size beforehand.

If you can afford the storage space, save your files in a lossless format. If you plan on storing a lot of images, it might pay to purchase a CD/DVD recorder and store your images on recordable CDs (CD-R) and DVDs. Blank media are inexpensive.

TIFF and PICT formats are great formats in which to store your images if you plan to do more work on them. They are lossless, but not compressed. They also open quickly. If you plan to store your images later, you can compress the files with Win-Zip or StuffIt. TIFF files are the most universal, and are a safe bet. They can be opened on a Mac or Windows machine.

If you have an image that will be placed on a website, JPEGs are the way to go. Also, if you plan to deliver your image via a modem and it will be viewed on a monitor only, go JPEG!

When you create a JPEG file using the normal Save As command, you are also creating a thumbnail (the little copy of the image that shows up on your desktop and in image browsers), which is stored within the JPEG. Additionally, all of the EXIF data tags along with the JPEG.

Many image manipulation software applications now offer an additional option besides just Save As. This is Save For Web. When you create a JPEG file using the Save For Web function, the JPEG is created without a thumbnail, and the EXIF data is stripped away. This creates a smaller file optimized for best Internet display. It's a bit inconvenient having no thumbnail to view with your browser, but the images will work much better on the web and load very fast.

GIF files are an excellent format for logos, line art, and solid-color images. They are quick, can be compressed, and can be interlaced. Do not use a GIF format to save or deliver an image unless it is part of a logo.

Save It Once!

I was walking my dog the other day and one of my companions stopped me and asked, "Hey, Mister Photo Book Wizard (I prefer to be called "Smart Pants"), how come when I send pictures to my friends via the Internet, they look grainy and all messed up?" After a quick thank-you (the wizard part), I asked her how she was opening, editing, and saving her images to determine my answer.

To start with, her camera was saving the images in a lossy compressed format that she couldn't control. Then as she was editing them and resaving them, the images were again compressed. Additionally, her e-mail program was compressing them once again. It was a wonder that there were any original pixels left at all!

As her camera offered no control over compression (there's a reason to buy a camera that does), I suggested that she import the images directly off the storage media, then open them in Photoshop Elements 3, and then save the original image in a TIFF format and to keep using this format until she was done with all of her editing. Both of these formats offer lossless compression. After she was done editing she should save a copy of the file as a JPEG file with as little compression as she could afford (about 6 on the slider). This way she has already eliminated a few rounds of compression. I also suggested that she turn off the compression in her e-mail program and send the JPEG file she made.

This involved a few more steps than she had intended, but the image quality was greatly increased.

The Least You Need to Know

- You can compress your files to save space.
- Lossless compression does not change the file; lossy compression throws away some information. The files will be changed in appearance.
- ◆ There are many file formats, but most of us end up only needing to use two or three.
- Choosing the right format will preserve your image data and make it readable for other users.

Part

Let's See It: Imaging Techniques

You can manipulate exposure, shutter speed, and focal length to draw attention to your subject and add life to your images. Your point of view and use of lighting can create mood or just add detail to your subject. And when you download your images from your camera to your computer, you can enhance and manipulate your images in ways you've never dreamed!

Scratches, errant telephone wires, and missing teeth can be fixed. Perspective can be controlled, color can be enhanced, and images can be sharpened or blurred. You can combine elements from many photos to create a brave new world. Images that existed only in your imagination now can come to life on your screen and in print.

Chapter 3

Downloading Your Images

In This Chapter

- Downloading images via the manufacturer's software
- Downloading images using Photoshop Elements 3.0
- Downloading images directly from a removable disk
- Getting images off storage cards

You have been running around taking pictures all day. Your pockets are brimming with storage cards, stuffed with wonderful images. Your friends are driving you crazy asking for prints. You have all these fancy and wonderful toys at your ready.

It would be impossible—not to mention boring—to cover the details of using each individual camera and software package on the market. Fortunately, in the process of reviewing cameras and software packages, I found many similarities in the ways cameras operate and the ways software is formatted—many programs work the same way, even though their interfaces look different.

If I happen to be demonstrating how to use the exact type of camera and software you are using, you're in luck. If, however, I am not using your specific setup, just try to understand the basics of what we're trying to accomplish, and apply it to your situation. When all else fails, read the

instruction book that came with your camera. Believe it or not, some of the instructions actually work. Also, don't be afraid of making mistakes; you won't learn otherwise.

Flash

The demonstrations that follow do not in any way reflect an endorsement of any one product. I've picked software that I hope is readily available and will have a common interface and functionality. I've also tried to review software that I think will be fun to use and add enjoyment and creativity to your photographic experience. But as always, my advice to you is to get out there and experiment!

Hooking Up the Camera

Before you download images from your camera to your computer, no matter what type of software you are using, you must connect the two. Following is a general procedure for hooking up a camera; most cameras and cables work in the same way. Check your instruction manual before connecting any cable, just to be safe.

- USB, USB2, and FireWire (IEEE-1394) were made with the express intent of
 using them while the devices are turned on or "hot." Although you could choose
 to turn off your computer and camera before connecting them, you could save
 yourself the trouble and time waiting for everything to reboot each time you
 plug in a new device.
- If you're using an older Windows machine, you should definitely think about adding a USB card if you have a slot available on your machine, or, better yet,

Say Cheese

Don't force a cable into a port.

If it doesn't fit easily, be sure you have the right cable.

Before you connect any cables, inspect them. Check to see whether your cable has any damage or foreign objects stuck in the connections.

upgrade to a newer computer because most old Windows "boxes" are pretty slow for digital imaging use. Look on the back of your machine; if you find a "slot cover" still there, you probably have room for a USB or FireWire card. On current Windows machines look for one of the USB ports, sometimes found on the keyboard, and attach the cable. If the USB ports are taken and you have several USB devices, get a USB hub! They are inexpensive and very useful. USB connections are goof-proof!

There are two types of USB ports: powered and unpowered. Typically, if you have USB ports on your keyboard they will be unpowered. Many peripheral devices must be run from powered USB ports or they will not work. The package or documentation will usually tell you whether the port must be powered, but not always. Just to be on the safe side, if you add a USB hub, make sure it is the powered type. Then you can run any device from it.

If you're using a Mac, just connect the cable to any USB port on the computer and the USB connection on the camera body. FireWire equipment is connected in a similar fashion.

Find the other end of your cable.
 Take a look at the pin setup, and check the sockets on the camera to help you align the cable properly. Gently insert the cable into the socket on the camera.

Sometimes camera equipment and other peripherals are not recognized by the computer. If you are lucky, you won't be the first user to find this disparity, more commonly called a bug. Take a trot over to the camera manufacturer's website and look for a newer version of the software driver or control panel. Download it, install it, and carry on.

Say Cheese

Hooking your camera up to your computer every time you want to download images can become a pain in the neck (or somewhere lower!). It's much easier to just buy a USB or FireWire card reader and leave it connected to your computer all the time. Card readers are inexpensive and simple to use. You simply remove the storage card from your camera and plug it into the slot on the card reader; your image folder will automatically pop up on your computer's desktop. You can then drag and drop to copy image files into your selected folder on your hard drive. It takes longer to read these instructions than it does to do it!

Downloading Via the Camera Manufacturer's Software

In most cases you do not need any additional software to download your images into your computer. When you connect the camera or card reader to your computer, a folder will typically pop up on your desktop. The images are in there, although you

might have to open a couple of levels of folders to see them. All you really need to do is create an empty folder on your computer, give it an appropriate name, and drag and drop the images into that folder. Your system will then copy all of the image files into the folder. Be absolutely sure you don't unplug the camera or take the card out of the card reader until the copying process has been completed. After you've downloaded the images but before you unplug the camera or remove the card, you might also need to follow a procedure to clear the camera or reader folder from your desktop.

Say Cheese

Although you could do so, it is never a good idea to delete images from the camera card with your computer. This can result in a card that your camera cannot recognize and can render a card useless. Only delete images from the storage card using the camera. If you are removing all images, use the camera's Format command. I usually do this a couple of times before reusing the card just to make sure the formatting has been done properly.

Every camera will have a different way to connect to the computer. Many will have more than one way to access the onboard photos. Camera manufacturers typically include their own proprietary software, or some variation or adaptation of canned software that has been designed specifically to work only with their cameras. This software is called *OEM* (original equipment manufacturer) *software* (it might or might not have been developed by the manufacturer, but they like us to think it was, so we will). This does not include brand-specific software such as Adobe Photoshop Elements 3.0 or Photoshop CS2, although they also might have been supplied with your camera.

Before you start, be sure you have the correct version of software for your operating system. Nothing is more frustrating than trying to shove a square peg into a round hole! Also, and this is really important, *back up your hard drive* in case something goes awry during the process of loading new software. Follow the instructions in your software manual *exactly*. After you've finished backing up your machine, go ahead and install the software that came with your camera (refer to relevant documentation that came with the camera as needed).

Downloading Via Image-Editing Software

As we discussed previously, many cameras come with their own software. These imaging programs, on average, do just enough to get by. They offer color correction,

resizing, cropping, and the like, but with few options. If you want to do more with your images, you need to use different image-editing software.

Behind the Shutter

TWAIN drivers allow software, especially image-editing programs, to communicate directly with the camera, and are distributed with many cameras and scanners by their manufacturers. The TWAIN driver is installed into your imaging software when you install your camera software onto your system. A camera that can use a TWAIN driver is called TWAIN-compliant. TWAIN drivers are written in a universal language and can be used by most computer platforms and operating systems (OS). You will almost always find the TWAIN access option in the File menu. Depending on the imaging software, you need to select either **Acquire** or **Import** to download the image via the TWAIN driver (you might also have to pre-select the TWAIN device). You might not even realize you are using a TWAIN driver because many are transparent to the software you are using.

Adobe Photoshop Elements 3.0 is one imaging program that is written for nonprofessionals. It can handle all the basic photo imaging, and much more. I will be using Adobe Photoshop Elements 3.0 for most of the demonstrations in this book; it is widely distributed and bundled with some cameras at no cost. It works much like its big sibling, Adobe Photoshop CS2, featuring many of the same options and features.

Click the Connect to Camera or Scanner button to begin to open your photo.

(Copyright © 2005 Bob Shell) Before you can download images using Adobe Photoshop Elements 3.0, you must first install it on your system. Read the instructions thoroughly before you start to install the program. As always, be sure to back up your hard drive before adding any software; you won't be sorry!

After Photoshop Elements 3.0 is installed, you can get to work downloading images:

1. In Windows, open Photoshop Elements 3.0 by clicking the **Start** button, choosing **Programs**, and then clicking **Adobe Photoshop Elements 3.0**.

(Or double-click the icon that was placed on your desktop during the installation process.)

On a Mac, click the **Adobe Photoshop Elements 3.0** folder in your dock. If you want it in your dock and it isn't, just drag and drop its icon from the Applications folder on your hard drive to where you want it in the dock and a new icon for it will appear there.

2. Be sure your camera is connected to the computer and is turned on before proceeding.

Click the Connect to Camera or Scanner button on the Welcome screen.

- 3. The "Select Import Source" dialog box opens on your screen. Be sure your camera is connected to the computer and is turned on, and then select your camera's driver from the list.
- 4. When you click **OK**, the TWAIN driver for your device will open and start connecting to your camera.

You will see this opening screen every time you open Photoshop Elements 3.0. If you are importing images directly from your camera to your computer, you would click on the Connect to Camera button in this screen. In this demonstration I have clicked on the Connect to Scanner button, which opens up the dialog box showing the choices available for import.

(Copyright © 2005 Bob Shell)

Flash

Remember: All TWAIN drivers are not alike. Each manufacturer builds its drivers a little differently from the rest. It's impossible to describe how to use every driver for how every camera works! It would take hundreds of extra pages to do that!

Most drivers follow a common course of action, but don't worry if your driver does not exactly follow this domonstration. Try to find buttons that perform similar tables, and lead

exactly follow this demonstration. Try to find buttons that perform similar tasks, and look for patterns in button operation. Use your intuition, follow your gut, experiment, and stay calm! You won't damage your software, camera, or files.

- 6. You now see the **Digital Camera Driver** screen. Your driver display will likely look different. This one scans the camera that it is connected to and loads thumbnail images of everything stored in memory.
- 7. Click the **Select All** button or highlight individual images to select them, and then click the **Save to Folder** button.

Say Cheese

The download interface, which is specific to your camera, allows you to access some or many of your camera's functions, possibly including the ability to adjust the camera's settings and defaults.

- 8. Choose which folder you want to put the images in; you can create a new folder or use an existing one.
- 9. The software begins to download the images. This process can take a while.
- 10. When the file transfer is done, click the **Close** button to exit the download interface and return to Photoshop Elements. You can now open your images and begin to manipulate or improve them.

The Fastest Way: Downloading Directly from Cards

You do not have to directly download from your camera. If you have a pocket full of storage cards you might want to use a card reader. That way, you can download images to your computer while you continue shooting with your camera. (Obviously, you need to have at least two cards to work this way.) This is the fastest way to transfer images from your camera.

Card readers are available for each type of removable storage card. The camera manufacturers supply some card readers, and others are after-market devices. (Before you buy a card reader, be sure it will work with your system.) I use a reader that can read both SmartMedia and Compact Flash. PCMCIA—type adapters are an excellent choice for you laptop owners, and plug directly into the PCMCIA slots that most laptop computers have.

The Least You Need to Know

- You can download your images by using the software supplied by the camera manufacturer.
- You can also download your images by using a TWAIN driver and your imaging software.
- The fastest way to download is by removing the storage card from the camera and downloading directly using an external card reader.
- If members of your family have digital cameras that use different types of storage cards, you can buy card readers that will read multiple types of cards.

Improving Your Images

In This Chapter

- Getting started
- Reshaping your image
- Resizing your image
- Reorienting your image
- Correcting the perspective of your image
- Correcting the brightness/contrast of your image

One of the most important reasons to shoot pictures with a digital camera is the control it can give you over your images. You no longer have to settle for poor-quality photographs! With the use of imaging software, you can control and manipulate the color, contrast, size, and even sharpness of your image. Of course, reality dictates that not all pictures can be fixed to perfection, but digital pictures make it much easier to try.

Getting Started ...

Before you get down to the business of improving your images, you should, of course, start Photoshop Elements 3.0. (See Chapter 13 if you're not sure how.)

It's easiest to work on image files that you have already copied onto your hard drive and put in folders. You can use the File Browser in Photoshop Elements 3.0 to view thumbnail images of all of the image files in a folder. This makes it easy for you to find the image you want very quickly visually without having to remember file names.

You can customize the enhanced File Browser in Photoshop Elements 3.0 in a variety of ways. You can select thumbnail size and preview size, and you can resize all windows in the File Browser to set things just the way you like.

Say Cheese

Some cameras start over in their file numbering each time you do a new shoot. So you might end up with the first image in every folder named DCS0001.jpg, and so on. This can be a problem if you plan to move images around from folder to folder, because you cannot have two files with the same name in a folder. Check your camera's instruction manual and see if it offers the option to keep all file numbers sequential regardless of your stops and starts. Most of the better digital cameras let you set them this way, and it will save you all sorts of headaches in file renaming when you want to rearrange images from folder to folder.

The great thing about Photoshop Elements 3.0 is that you can rearrange image files within a folder by simply dragging and dropping, and you can move images from folder to folder by dragging the image to the Folder palette and dropping it into the folder you want to put it in. If you use a Mac, you can set iPhoto (the great photo organizing tool that comes with Macs) so that Photoshop Elements 3.0 is its editing tool, and all changes you make are automatically updated in iPhoto.

Photoshop Elements 3.0 also allows you to tag your photos with keywords. You can then do searches to find all images with specific words. Say, for example, that you have two sons, Bob and Joe. You can add Bob's name to all photos he appears in. Similarly you can add Joe's name to all photos he appears in. Months or years later you can do a search and quickly find every photo with Bob, Joe, or both of them. You can leave the files where they are in chronological folders, or you can move them all into a special folder.

Photoshop Elements 3.0 also allows you to see most of the metadata your camera writes into your image files, and allows you to edit many of the metadata fields. You can also search for images using words in the metadata, date, and a variety of other search criteria.

Say Cheese

Digital cameras record an image file each time you take a photograph. This is what you see when you open a file with Photoshop Elements 3.0 or other software. At the same time, digital cameras also record a whole host of other data that is embedded in the image file, but not visible when you view the file. This information is called "metadata." You may also see it called "EXIF" (exchangeable image file) data. Cameras typically record the date and time that the photo was made (but only if you set your camera's clock!), and many also record such things as the focal length of the lens used, shutter speed, ISO setting, camera exposure mode, whether the flash was used or not, and so on. Most of the metadata will be displayed in its own window on the lower left when you open an image in Photoshop Elements 3.0.

In fact, Photoshop Elements 3.0 is so flexible about how you can organize and find images that you probably won't need any other archiving software at all. And if you use a Mac, the combination of Photoshop Elements 3.0 and Apple's iPhoto is unbeatable.

There are three main areas of Photoshop Elements 3.0 you will use to improve your images:

♦ Palette well. *Palette* is the name Adobe uses for the small window that shows all of the options available with a tool, filter, or other image modifier. The palette well is in the top-right corner of Photoshop Elements 3.0, and you can dock palettes there when they're not in use. If the palette well is not visible, choose

Window, Shortcuts from the Menu bar. The Palette well is shown near the right in the next figure.

- ◆ Toolbox. This handy box holds tools for creating and editing images. If it is not visible, choose Window, Tools from the Menu bar.
- ◆ Menu bar. Contains menus for enhancing and improving photos, particularly in the Image, Enhance, Layer, and Filter sections. The Menu bar should always be visible. It is a series of words near the program window starting with File, Edit, Image, and so on.

Say Cheese

In almost all cases, Photoshop Elements 3.0's menus and controls are the same for Macintosh and Windows platforms. Note, however, that in certain instances, Macs use different keys than Windows to perform certain tasks. For example, Windows computers use the Ctrl key and Macs use the Command key. Similarly, the Enter key on the PC keyboard performs the same function as the Mac's Return key.

Use the Menu bar and Palette well (which appears at the top of the screen on the right side by "default") to dock any unopened palettes.

192

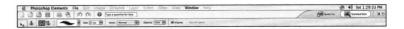

Say Cheese

When you open an image in Photoshop Elements 3.0, it typically retains the file format that the camera saved it in. In some situations it might, however, open the file in Photoshop .psd format. Psd is Photoshop and Photoshop Elements 3.0's own native or proprietary format (most image-editing programs have their own proprietary formats, which are lossless and preserve editing features such as layers). It is very good practice when opening an image file to first open File, choose Save As from the Menu bar, and save a copy in .psd format before editing the image in Photoshop Elements 3.0. When you do this the original file remains untouched, and any changes you apply from here on out do not affect the original. Here are some more saving tips:

- ♦ After you apply a few effects to the image, you should save the file—but be sure you don't save it with the same name and file type as your original file, or you will copy over it.
- If you plan to work on your file during another Photoshop Elements 3.0 session, leave it in the .psd format (because the .psd format might or might not be readable by other programs).
- If you plan to store or open the image file in another program, save the file in a nonproprietary format, such as TIFF. (If you want to archive the image, you can choose a high-value JPEG 2000, which is lossless, or compress the file.)
- Note that instead of using the Save command to save your image in a different file format, Photoshop Elements 3.0 requires you to either use File, Save As, or Save for Web from the Menu bar. A dialog box then appears in which you can name the file and save it in a number of common formats.

Shaping Your Image

You can, within reason, increase the size of your images. Be careful, though: if you resize too much, the image will start to degrade. In most cases, you can increase the size of your image 150 to 200 percent and still retain good detail.

Why would you want to enlarge your image? Suppose you took a picture and just couldn't get close enough. Or you took a photo and you cropped the image down to make a nice composition. You can then increase the size of the image so you can see the detail. Another good reason to increase the size of your images might be to use all those 8×10 frames your friends keep bringing over to the house (hint, hint!).

Photoshop Elements 3.0 allows you to resize your images in a number of ways, which we'll discuss in the following sections. The important thing to remember—and this is a constant through Photoshop Elements 3.0—is that there are many ways to obtain the same results. You can resize your image and change the proportions of the image (Free Resize) or resize the image and keep the proportions frozen (Resize). Choose your options and have fun. If you save your images before you start a resize operation, you can experiment without worry.

Free Resize

The Free Resize feature allows you to resize an image and change its proportions at the same time.

To use the Free Resize feature, do the following:

- 1. Open the Image menu, choose Transform, and select Free Transform.
- 2. You might be prompted to make your background a layer at this time because most transformations apply to layers; click **OK** and proceed. Because your photo has only one layer at present, this presents no problem.
- Small corner markers, or handles, appear in the corners and at the midpoints of the sides of your image. Use the midpoint handles to change the image proportions.
- 4. When you move your cursor over these handles, the cursor changes into a double arrow. Click and drag the cursor, and the image handles follow.
- 5. Click the checkmark in the Options bar; the image's size and proportions are altered. If you want to dump the changes in the trash and retain your original size, click the hashed circle instead. Note that you can use the undo feature after resizing to revert as well.

I often get frustrated when working on a small monitor and want to make the image bigger but run out of monitor real estate. It is tough to drag the resize handle when you bump up against the edges of the monitor. Here is a good solution: reduce the size of your image on the screen by zooming out from the image. Zooming out is something like taking a step back from your work to get a better overall view. It doesn't change the actual size of your image file. Click the **Zoom Tool** icon in the Toolbox (or press **Z**), hold the **Alt** key down, and click the image. Note that the mouse pointer changes to a magnifying glass and that the + changes to a - when Alt key is pressed. Clicking the image without the Alt key depressed will reverse the process. Alternatively, you can use the **View, Zoom Out** selection on the Menu bar or its keyboard shortcut—hold down **Control** and press the - key. To reverse the process, use **Control** and the + key (or = key, as it is not necessary to involve the shift key in this move).

Flash

Anytime you make a change to an image in Photoshop Elements 3.0 (or just about any other pixel-based, image-processing program), you remap the pixels in the image. That is, you are changing the position (or color, or whatever) of the pixels. Each time the pixels are remapped, your software is interpolating—the fancy word for guessing—where the pixels should go and what their values should be. Repeatedly re-mapping the pixels in an image can make the image look terrible!

One way to avoid ending up with terrible images is to always work on a copy of the original image instead of the original itself. That way, if things fall apart, you can always cut your losses and start over with a new copy. Secondly, learn to use the **Undo** button (or its keyboard shortcut, **Ctrl+Z** on a PC or **Command+Z** on a Mac). Using this shortcut enables you to undo your most recent changes to the image. Finally, if you like the changes you've made to your image, save the image before you make a mistake! That way, you won't have to start all over if you mess up or do something you don't like. Many professionals save progressive copies every few steps as they work, adding a number to the end of the file name, such as myfile 1.psd, myfile 2.psd, and so on, so they can revert one or more steps at any time. Remember: save often! Although Photoshop Elements 3.0 does not offer multiple Undo capability like Photoshop CS2, it does have a one-click solution under the Edit menu called Revert To Saved, which takes you back to the last saved version of your image. This can be invaluable when you realize that you should have stopped several steps earlier and are just digging yourself deeper and deeper into a hole.

Photo Size

As you can see in the following figure, there is an even more exact way to resize a photo. With the Image Size feature, you can resize an image to exactly the size you want. The Image Size feature is in the **Image** menu under **Resize**. You will get a submenu in which you will be presented with your options.

Notice that, when the **Constrain Proportions** box is checked, you can resize your image while retaining its proportions (notice also that the Width and Height entries are tied together as represented by the bracket connecting them). If you want to change the dimensions of the image and keep the file size constant, uncheck the **Resample** box. Then, as you change the dimensions of your image, the resolution will also change so that the file size is kept constant.

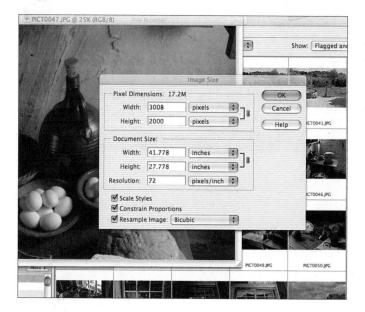

Use the Image Size dialog box to get precise image dimensions.

(Copyright © 2005 Bob Shell)

Canvas Size

If you need to add blank space around your image without increasing the size of the image itself, use the Canvas Size feature. To use this feature, open the **Image** menu, select **Resize**, and choose **Canvas Size**. You will see a dialog box such as the one shown in the following figure. The square in the center represents your image as it exists now; type in new dimensions to increase the size of the total space. By default your image will be centered on the newly expanded canvas, but if you need to add area only to one side or just to the top or bottom of your image, this is the place to

do it. Place your cursor on one of the arrows surrounding the white square (which represents the existing image) in the middle of the **Anchor** area and click an arrow to one side or the other. When you add canvas area after adjusting the **Anchor** grid, the new canvas is added to the side, top, or bottom, depending on your choice(s).

The Canvas Size dialog box lets you add blank space around your image.

(Copyright © 2005 Bob Shell)

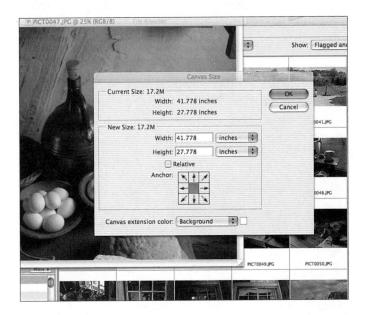

You can also use the Canvas Size dialog box to reduce the canvas area of an image. If you need to make your image a precise size, type those dimensions into the dimension fields. The image is equally trimmed on all sides. If you want to trim your image on one side only, you can move the square in the **Anchor** area accordingly. Type your dimensions in the fields as before, and click **OK**. You will be warned that the canvas size is smaller than your image. If you're sure you want to proceed, click **Proceed** and the resize takes place.

Orientation

Most digital cameras today feature automatic image rotation. So if you turn your camera on its side and shoot a vertical image, the camera adds a tag to the image that tells the imaging software to rotate it and in which direction. If your camera doesn't feature automatic image rotation, your vertical image opens on its side. To rotate your image, go to the **Image** menu, choose **Rotate**, and select any one of the several options. Note that the second set of options that contain the extra word *layer* only work when a layer is selected (for a detailed discussion of layers, see Chapter 20).

Behind the Shutter

Just so you understand what is going on, when you rotate your camera a gravitational switch is tripped and the camera responds to this by adding a tag to the image indicating camera rotation. Software applications like Photoshop Elements 3.0 read the tag that indicates camera rotation and rotate the thumbnail that is displayed in the file browser. This does not, however, rotate the actual image. It is not rotated until it is opened, and the rotation is only maintained if the image is saved after opening. This would only be a problem to you if you were also using some older software that doesn't recognize the rotation tags.

You can also flip an image along its axis by choosing Flip Horizontal or Flip Vertical. Flip Horizontal is like looking at the image in a mirror. This concept has always confused me, so let me try to explain: Imagine an axis drawn through the image from right to left and top to bottom. When you flip an image horizontally, the image flips at the midpoint of the horizontal axis; flipping vertically works the same way except that it flips at the midpoint of the vertical axis. The best way to see what will happen is to open an image and experiment.

If you need to tweak your image just a bit to straighten it up, or you want to rotate it other than 90°, choose **Image** (on the Menu bar), select **Rotate**, and click **Free Rotate Layer**. If you have not worked on this image before, you will be asked if you want to make it a layer. Go ahead and do so. Handles appear in the corners of the image. Using your cursor to drag and drop these handles, you can freely rotate the image any way you want. By the way, if you click your cursor inside the image and grab one of the handles on the edge of the image, you can move the image as if you were using the Free Resize tool and the rotate tool. This comes in handy if you need to resize *and* rotate an image.

Say Cheese

Like its more advanced sibling, Photoshop CS2, Photoshop Elements 3.0 can work with layers to achieve more complex image effects. To imagine how this works, picture a trio of overhead transparencies, each with an image painted on it. Now stack them. If you were to reorient one of the "layers" you would only rotate it and not the other layers. With our example, imagine turning the middle sheet on its side without moving the other pages. For more on layers, see Chapter 20.

You might have also noticed the Straighten and Straighten and Crop options under Image, Rotate on the Menu bar. The Straighten function is generally used for images brought into your computer by a scanner that are a few degrees off; it "fixes" images by guessing. If you attempt to apply it to a regular image, it will just make it look weirdly off-kilter.

(rop

Many times, your image might size out to be just a bit wider than you would like. For example, it might be $5\times7\frac{1}{2}$; and that might be a bit tough to shoehorn into a 5×7 picture frame. You also might find that just on the edge of your image is some unwanted element, like a part of someone's head or a wall. Cropping the photo is a great way to solve these problems.

To reshape or crop your image, do the following:

- 1. Choose Window, select Tools, and click the Marquee tool, which is the top left tool in the Toolbox. Alternately, you may press M on your keyboard. There are several different Marquee selection tools. Choose the rectangle.
- 2. Left-click your image and drag a box around the area that you want the image to be cropped down to. Anything outside of the marquee selection box will be deleted.
- 3. Choose **Image**, select the **Crop** command, and voilà!, your image is trimmed.

Say Cheese

There are many options for the Marquee Tool. When you press ${\sf M}$ or select the Marquee tool by clicking it, the Options bar appears. You can select either the elliptical or rectangle shape for your selection by clicking the correct shape toward the left of the Options bar. There are four choices on the Options bar to the right of that, and you should select the leftmost of those. If you do not set Feather to zero pixels, you will get a selection bigger than your selected marquee area. You also want the style to be normal. You can achieve all of these settings by clicking the leftmost button on the Options bar and choosing Reset Tool.

Correcting Photos

Sometimes photos will not appear normal because of the angle at which they were taken. Photoshop Elements 3.0 has several tools you can use to fix these perceptual deficiencies, including the Perspective and Distort features.

Perspective

The Perspective feature is a great tool to fix up images that have ungainly or incorrect perspectives. For example, if you photograph a tall building, the top of the building will look a lot smaller than the bottom. Also, the sides of the building will slope in toward the top. This is called *keystoning*. The Perspective feature can help you fix or control this effect. The Perspective feature is found in the Size menu because it is a form of resizing. You are actually resizing the top of the image while the base stays "anchored." You will notice that, if you were to pull the left-side perspective handle, the right-side handle will mirror the action (and vice versa). Check out the following demo to get a good idea of how this operation works.

To use Photoshop Elements 3.0's Perspective feature, find a picture of a tall building or a square object to assist in better understanding how this procedure works:

- 1. Open your tall/square image in Photoshop Elements 3.0. If you are using a tall building picture taken from ground level, you should notice that the top appears narrow compared to the bottom because of the keystoning effect. If the image is too large to view in its entirety, zoom out using **Control** and the key.
- 2. Expand the canvas by choosing **Image** on the **Menu** bar, selecting **Resize**, and clicking **Canvas Size** to allow extra working room (you will be stretching the top of the image).
- 3. Open the **Image** menu, choose **Transform**, and select **Perspective**. Handles appear in the corners of the image.
- 4. Grab the handle in the upper-right corner and pull it toward the right (see the following figure). You can pull the handles onto the unused portion of the Photoshop Elements desktop if you go beyond the canvas.
- Release your mouse button. After a moment, the image's perspective is altered.
- 6. Undo your change; try pulling the handles again, but this time pull to the right and up. (You might have to go through this a few times until you find the correction effect you like.)

Say Cheese

You might want to create a folder on your hard disk to keep all of your demo images or works in progress. I usually create a folder and name it "In Progress" for this purpose.

7. When you get it the way you want it, crop the image using the Rectangle Marquee tool found in the Toolbox as explained under the section called "Crop" earlier in this chapter.

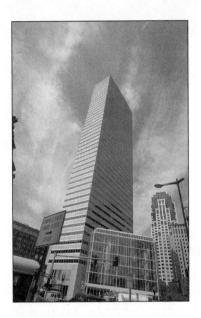

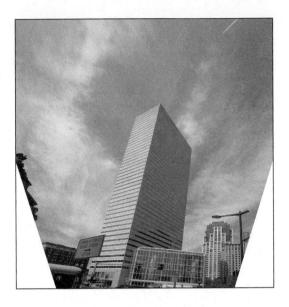

The perspective feature can really change your perspective as shown in the before (left) and after (right) shots. I left the canvas around the after shot to show you what it would look like before it's cropped. I could have help the photo along if I'd kept my camera parallel to the ground—you can't fix everything in Photoshop!

Distort

Using Photoshop Elements 3.0's Distort feature is a great way to correct an image that might not have been photographed "in square." If your camera was not perpendicular to a building or a product package, for example, one side of the building or box would slope toward the top more than the other. This can make an image look a bit strange. You can also use this technique to correct the perspective more to one side of the image than to the other side. Additionally, you can fill in with a color tone the white space that is created when you distort your image, or you can clone in some of thesky from the original image. (Usually, you end up cropping a portion of the newly distorted image and pasting it into another image; more about all that later on.)

Again, this feature is found in the Image menu under Transform. Think of it as resizing one side of the image more than the other.

The following steps show you how to use Photoshop Elements 3.0's Distort feature.

1. With any image open in Photoshop Elements 3.0, choose Image, select Transform, and click Distort.

- 2. You will see the now-familiar handles. Grab the handle in the upper-left corner and pull it halfway down and toward the center of the image.
- 3. Grab the handle in the lower-left corner, and pull it halfway up and toward the center of the image.
- 4. Let the image process, and voilà! It should look distorted, like the following figure.

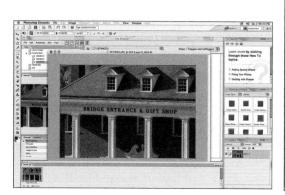

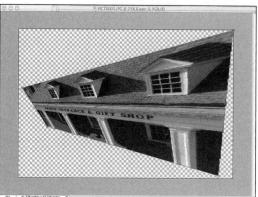

The Distortion feature lets you get carried away.

(Copyright © 2005 Bob Shell)

From Darkness to Light

Many times, your images might not come out exactly as you intended. They might come out a bit too dark or flat-looking (lacking contrast). The following features are the perfect tools to help fix up your images and make them sparkle.

Quick Fix

Using the Quick Fix feature is a quick-and-easy way to correct the contrast and brightness of your image. To use this feature, perform the following:

1. Open a picture that lacks contrast, maybe a rainy day photo or something with a bleak look.

- 2. On the far right of the very top bar of Photoshop Elements 3.0 you will see a button labeled Quick Fix. Click this and a "best guess" at contrast and brightness correction will appear in a new, large window. On the lower right of that window is a button you can click that will let you see before and after versions of your photo side by side. This makes it much easier to see exactly what has been changed, and will help you decide if you like the version Quick Fix has produced.
- 3. Now that you have the before and after versions displayed side by side, you can use the windows on the far right to make changes and see the results immediately. From top to bottom the windows are: General Fixes, Lighting, Color, and Sharpen.

In the **General Fixes** window you will find rotation icons that let you rotate the image 90° with one click, and a slider that lets you select the amount of Quick Fix that is applied. Play with this slider on some of your images to get a feel for what it does. In the **Lighting** window you have automatic **Levels** and **Contrast** controls that you can apply by clicking on buttons, and three sliders that control highlight, shadow, and midtones. Try all five of these controls on some test images and you will quickly learn what they do and how to use them on your images. The **Color** window is next, and its auto button may be all you need for many images. It also has four sliders for those who like to make their own decisions, **Saturation**, **Hue**, **Temperature** (as in color temperature), and **Tint**. Again, the quickest way to learn what all of these do is to play with them on some sample images. The last window is **Sharpen**, and it is pretty self-evident

Say Cheese

Many times, the dialog box or palette you need to use displays on the screen on top of your image, covering up a section of the image you want to see. To move it, click the dialog box's title bar, hold down the mouse button, and drag the dialog box anywhere on the screen you want.

as to what it does. Try playing with it on images of varying sizes to learn how much sharpening is best for each size and type of image.

In every case, if the results are unsatisfactory, click the **Reset Image** button and move through the settings again. Work with them a while and you will quickly find that you can make your images look just the way you want in a snap.

 If you like your changes, click **OK** and the modifications are saved to the image (you can still use the Undo function to go back). Otherwise, click **Cancel.**

203

Smart Fix

Smart Fix is a further development of Quick Fix. There are two ways to apply Smart Fix to an image. First, open the image in Photoshop Elements 3.0. You can then access Smart Fix by going to the **Enhance** drop-down menu and clicking **Auto**Smart Fix. This will apply Smart Fix to the image, but you have no control over how much it is applied. The second way to apply Smart Fix is to click **Quick Fix** after opening the image. In the windows on the right, the top one has Smart Fix and a button to apply it, but also has a slider to control how much is applied. If you set Quick Fix to display both before and after, then you can move the slider and see how your image changes and choose the version you like the most. In many cases, just applying Smart Fix from the Enhance menu will do a fine job, but the extra control is available if you feel that you need it.

The Least You Need to Know

- One major benefit of digital photography is that it gives you control over your images. You can easily resize them or correct errors in perspective.
- If you want to add blank canvas around a picture or crop unnecessary portions of an image, you can easily do so.
- ♦ You no longer have to suffer with drugstore prints that are too dark or the wrong color; you can make several adjustments using Quick Fix and Smart Fix.
- Always work on a copy of your image rather than the original.

The Wonderful World of Color

In This Chapter

- Use image color controls
- Learn about color modes
- Discover bit depth
- Control image sharpness, blur, and noise

Nothing can be more off-putting than incorrect or out-of-balance color. That's why, of all the changes and edits that you can make to a digital photo, the most important and most obvious are color corrections. These corrections make the image come alive. Take your time and edit your images carefully. With a little bit of practice you will be able to make your corrections quickly and with an expert's eye.

Viva Color!

Color controls can help you make your image really come to life. You can make minor corrections or huge shifts. Always remember not to get too greedy with color. What might look fantastically vivid and lush on your

monitor might look like mud on your printer. Your monitor displays color in a way (RGB) that your printer can't reproduce (CMYK). Professional graphic artists use specialized equipment that costs thousands of dollars to get their monitors to match their super-expensive printers. You can also calibrate your monitor. Read "Setting Up Photoshop Elements, Calibrating your Monitor" under Photoshop Elements Help (or turn to Chapter 22, where I discuss calibration in detail). Still, the best thing you can do is follow your "inner eye" and experiment! Test your selections on inexpensive paper, and when colors and shadows look good, then use photo paper.

Color Balance

There might be times when the color of your image is off a bit. For example, something might be reflecting color into your photograph (a brightly colored wall will add

Say Cheese

After you have read Chapter 16, come back to this demonstration. Isolate just part of an image, and repeat the steps. You will begin to see how many of the tools in Photoshop Elements can be used together.

Say Cheese

You can do Color Cast Correction for an entire image, a layer, or just part of a layer by selecting it. This is a very powerful feature, but it takes some practice. Be sure when picking a gray to pick a neutral, essentially halfway between black and white if possible.

a color cast to your shot). If you refer back to the color temperature table in Chapter 10, you can see that the lighting conditions also affect the true color of the image. Luckily, you're in control! You can easily adjust the color balance of your image:

- Open an image you have that has a color cast to it.
- 2. On the **Menu bar** choose **Enhance**, select **Adjust Color**, and click **Color Cast** to view a dialog box such as the one shown in the following figure.
- 3. Be sure the **Preview** check box is checked.
- 4. As instructed by the dialog box, click any area in the photograph that was supposed to be white, black, or gray. Go ahead and click around the image to see what colors it will change to. You can always use Undo to get back to the original.
- 5. When you're satisfied with the image, click **OK** and save.

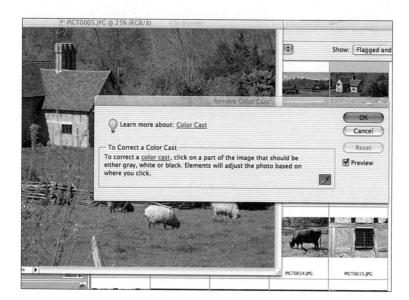

The Color Cast Correction dialog box is pretty foolproof. Just do as it says.

(Copyright © 2005 Bob Shell)

Hue/Saturation and Lightness

Hue (sometimes referred to as "color") refers to *where* a color appears on those color triangles I showed you in Chapter 2. Saturation, on the other hand, refers to *how much* of a hue or color is present, or how intense a color is. Both the hue and saturation of an image can be manipulated, as can the lightness of an image:

- 1. With a photograph image open on your Photoshop Elements 3.0 work surface, open the **Enhance** menu and select the **Adjust Color** item from the Menu bar. Choose **Hue/Saturation** to open the Hue/Saturation dialog box (see Plate 1.9a for an illustration of the Hue/Saturation dialog box).
- If anything is selected, deselect it with Select, Deselect on the Menu bar or Ctrl+D/Command+D and be sure the Preview check box is checked in the dialog box.
- 3. With the Edit drop-down box in the **Hue/Saturation** dialog box set to **Master**, move the **Hue** slider either to the left or the right. Notice how the hue (color) of the image changes? If you move the slider a bit to the right, you change the hue of

Behind the Shutter

Changing one color affects its opposite color (see the color chart in Chapter 2 to refresh your memory about color opposites). Adding more blue to an image is the same thing as taking yellow out of the image. Similarly, taking magenta out of an image is the same as adding more green.

the image from blue toward pink. Check out how the other parts of the image change hue, also. You'll be able to avoid altering the hue of your entire image after you finish reading Chapter 16, so don't fret.

Flash

Color shifts must be done carefully. Don't overcorrect your image. Unless you isolate areas in your image by selecting them (covered in the next chapter), your color correction affects vour whole image. Although having wonderfully green leaves is great, do you really want to add areen to all the other colors?

- 4. Fiddle with the **Saturation** slider (if you really want to have some fun, slide it all the way to the right). If an image has been captured with diffused (soft) light, "upping" the saturation can liven it up.
- 5. Play around with the **Lightness** slider; notice that doing so produces an effect similar to adding white to the entire image (or black, if you move the slider to the left). Note that adding lightness adversely affects the contrast of your image, which is probably why I honestly can't remember using the Lightness feature more than once or twice in my entire career. Nonetheless, check the control out and put it in the bottom of your bag of tricks.
- 6. If you like the result, save your image. If you don't like it, hold down the control key and a reset button magically appears in the Hue/Saturation dialog box in place of the Cancel button. This enables you to restart without having to close the dialog box. Refer to Plate 1.9b for an example of too much color saturation.

Adjusting color in this fashion actually changes the pixels in the image. Of course you saved a working copy so you could always back up to the original, but you would also lose all other changes you might have made. A better method is to add an adjustment layer and adjust the hue/saturation/lightness on the adjustment layer. By doing this you can later discard just this layer and retain other adjustments, additions, and changes to your image. Adjustment layers are special layers because they affect every layer below them. To use an adjustment layer ...

- 1. With an image open and the Layer palette open from the Palette well, select the topmost layer you wish to adjust.
- 2. Click the New Fill button (which looks like a circle with the top-left half darker than the bottom-right half) on the Layer palette and choose Hue/Saturation (which is probably the sixth choice from the top of the menu that appears). Refer to Plate 1.10a for an illustration of this step.

3. Now you will be back at the Hue/Saturation dialog box where you can make changes to the appearance of your image. Note, however, that the changes are applied to a special layer that has been inserted in the Layer stack.

Variations

The Variations feature is a great tool. It is a quick way to apply a variety of color corrections and hue/saturation mixes to an image. Instead of working through each dialog box and going back and forth to get the desired result, you can test your adjustments here and only commit to them when you like the outcome. Here's what you do:

1. With the image that you want to correct on your desktop, open the Enhance menu on the Menu bar, select Adjust Color, and choose Color Variations to open a screen with multiple small views of the image, as shown in Plate 1.10b. The adjustments are separated by type. You can change them by clicking the radio buttons marked Midtones, Shadows, Highlights, and Saturation.

paper.

- 2. Click the variation you like best; Photoshop Elements moves the image you chose to the center spot, and generates even more variations based on the image you chose (the images in this round have finer changes and smaller variations in relation to one another). Continue choosing variations until you either go crazy or find one you like.
- 3. Reset the image as needed to work through various changes. Each click adds to the overall modification, so be frugal with your clicks. If you make one extra click, you can use the Undo button instead of having to start from scratch.
- 4. When you find the variation that you want to use, click **OK**. Your image will appear as your selection.

Negative

Open the Image menu on the Menu bar, select Adjustments, and choose Invert to make your image look like a photo negative. I use this control a lot in my commercial work to add interest, especially in faded backgrounds. You might consider this tool a gadget!

Other Color Worlds

Color can be described in many ways; one way to characterize color is to call it a *mode*. The most common color mode is RGB (red, green, blue), though Photoshop Elements offers Grayscale, Bitmap, and Indexed color as well. Other commercial imaging programs, such as Photoshop CS2, can handle color in various other modes—such as CMYK, LAB, and HSB, in which the color can be manipulated or printed in different ways.

RGB

RGB is the most commonly found color world, or *color space*. We use this model because these are the colors our eyes and brain see and process. When you look around, these are the *spectra* of light commonly found—for example, you typically find blue skies, green leaves, and red berries. If there is no light—such as at night—you see no color; it is only when you add light, such as at dawn, that color becomes visible. This color model uses a process called *additive color*. (There is no color unless it is added.) Your computer monitor works using this process—it starts out with a dark screen until light gives the screen color.

Behind the Shutter

This way of describing color is linear, or one-dimensional. When you add brightness or tone to a hue, however, you bring your color into a dimensional space! For example, imagine the color red placed on the base of this space—call this the X-axis. If you add white, or light, to red, it becomes pink; the pink, or brightness, can be described as being on the Y-axis (this axis can be thought of as vertical, if you want). If you move or blend colors and brightness, you will be moving along a lateral, or Z-axis.

This is not intended to be a technical explanation of color theory, but rather to show you the dimensionality of color. Many color models use spheres, pyramids, or cubes to describe the color space. (And you thought you would never use all that high school algebra!)

Under this model, colors in a spectrum change from one hue to another. (You are probably familiar with color gradually shifting from red to orange to yellow to green, and so on around the color spectrum.) Different combinations of red, green, and blue

produce different colors. For example, you can combine red and blue, without green, to get purple. When red, green, and blue light combine at their fullest, white light is produced.

Bitmap Mode

In the Bitmap color scheme, colors are either on or off, hence black or white. Although it is supported in Photoshop Elements 3.0, it will seldom be used because grayscale (discussed later in this chapter) produces much smoother transitions from black to white, and thus better images.

CMYK

If you start out with a nice bright piece of white paper, it is as if you are starting with totally *on* or fully reflecting light. You cannot add any more light or color to a white piece of paper. You can, however, cover up, or *subtract* from, the paper to produce color. This process is called *subtractive color*, and is used by the CMYK color model. With the CMYK model, which is used in color printing, cyan, magenta, yellow, and black are used in separate layers to produce color on a press. Most desktop printers use this same method of color reproduction.

You will notice this if you refer to the color model in Chapter 2. It's of a Three-Color World (RGB) in which cyan, magenta, and yellow are opposite red, green, and blue, respectively. You also saw these colors interact in the color adjustment controls. Although cyan, magenta, and yellow *are* primary colors, they do not produce a good black when added together as inks on an inkjet printer (remember, *black* is the absence of all color). It is only when black (*K*) is added to the CMY model that inks can reproduce black and darken other colors. However, dye-sublimation printers use different types of dye and can produce blacks using only cyan, magenta, and yellow dyes. They are true CMY printers.

When you print an RGB image, your image is converted into CMYK on the fly. This is done by software, usually part of the printer driver but in some cases the software is sold separately. The software is called RIP, for Rasterized Image Processor. A raster is a grid pattern of dots as used in commercial printing or on your inkjet printer.

LAB

LAB color is a descriptive model based on a consistent set of references. In other words, the LAB color space takes the color-reproducing device (monitor or printer)

out of the color equation. If the color can be described independently of the reproduction device, the consistency of the color can be preserved. It is explained in detail in Chapter 22 when we discuss calibration of monitors and printers.

In Plain Black & White

The **gamut** of a color world refers to how many colors the color world or device representing that world can reproduce. The RGB color world has a broad color gamut. If, however, you were to reproduce the image on your screen using a CMYK device, you would probably be disappointed by how many colors cannot be reproduced. The color gamut of the CMYK model and CMYK devices is much smaller than for an RGB device. I will get into this in more detail when we talk about printing in Part 5.

HSB

The HSB model describes color based on hue (the wavelength, or color), saturation (how much of the color is present), and brightness (how much light is present). You might use the HSB model in the Hue/Saturation dialog box and in the Color Picker dialog box, but the images themselves are not in HSB in Photoshop Elements 3.0.

Grayscale

The grayscale color mode uses 256 shades of gray, from black to white, to represent color. You can also think of it as representing a percentage of black ink coverage in printed media. No black ink coverage is white, and complete ink coverage is black—and the rest is in the middle. You should be familiar with this color mode, because it represents all black-and-white reproduced images. Your imaging software determines which colors are represented by which shade of gray.

Indexed Color

With indexed color the image is reduced to 256 colors. If a color is not on this index, then the program must estimate to the closest color. It also sometimes creates an intermediate color by placing two or more indexed colors in a pattern of alternating pixels. This fools your eye into seeing a color between the two because your eye works to blend the neighboring pixels together. Blending several colors that appear to the eye as another color is called "dithering." Indexed color is usually not used when

an image is in production because—among other problems—it doesn't allow you to work with layers, but it is a great mode to use for line art like simple logos or buttons that contain only a few colors. When you save an image in png-8 or GIF format, it is reduced to indexed color mode at the time of saving.

To reduce the amount of color in an image, which often translates to a drop in file size, colors can be re-indexed or remapped. This comes in handy when you want to place an image on a website, where the size of an image is crucial to its speed of transmission. If you are interested in Indexing color and other advanced functions of digital imaging, you should consider using Photoshop CS2. Photoshop Elements 3.0 is more of an introduction version of Photoshop CS2 itself. What you learn in Photoshop Elements 3.0 translates almost perfectly to Photoshop CS2.

What Is Bit Depth?

Remember that your camera or scanner, both of which are RGB devices, can capture color information on all three layers. If your camera is capable of 8-bit color per channel, it can reproduce 24 bits of color for each pixel (8 bits of information from each of three layers of RGB color). In the following table you see that your camera can describe more than 16,000,000 colors. That's rich!

Bit Depth and the Number of Available Colors

Bit Depth	Binary	Number of Colors
1	21	2
2	22	4
3	23	8
4	24	16
5	25	32
6	26	64
7	27	128
8	28	256
16	216	32,768 (enough?)
24	224	16,777,216 (so they say)
32	232	Billions and billions!

Behind the Shutter

Your computer presents information in binary digits or bits. Binary code presents data in ones and zeros, or off and on. Color can also be presented as binary information, with black an off bit and white an on bit. The bit depth I just described is one bit deep (you are dealing with only one bit, either off or on); in binary, this is represented as two to the first power.

Let's expand your color world and use two bits. You can describe each bit as being either off or on, representing four colors; that makes your bit depth two deep, or two to the second power. Each time you increase your bit depth (which increases exponentially), you double the number of available colors.

You might see a camera or scanner described as being able to capture color in 12-, 14-, 16-, or even 32-bit color. This is wonderful, except you have one small problem: your printing device can reproduce color only in 8-bits-per-channel color. So what good are all those extra bits? What do you do with all the leftovers—sweep them under the rug, or feed them to the dog?

Because you have all this additional capacity for color information, you can capture and carry a lot more image detail. Instead of having an image that has no information in it in an 8-bit color image, you carry a lot more information in the same area if it is captured in 12-, 16-, or 32-bit color. To simplify the explanation, you can choose which of those extra bits you want to use when you reduce your image to 8-bit—this is done when you adjust for brightness and contrast. If you were able to view an 8-bit and 12-bit image side by side on your monitor, you would notice much more detail and color resolution in the 12-bit image. You would also be able to make much finer changes in the color, contrast, and brightness, as you'll learn to do next.

A Sharper Image

You can vastly improve an image by sharpening it. Many times, a tweak to the image's sharpness helps overcome any inadequacies in a camera's lens or chip, or any incorrect focusing.

Take a look at an image that is out of focus, and compare it to one that is in focus. The in-focus image has more contrast. This is the key to the Sharpening tool. When the sharpening filter is used, it creates the effect of increased contrast by creating a border between dark and light areas of the image. On the dark side of the border

(I can't resist a *Star Wars* pun here), the pixels are darkened slightly, creating an edge. On the lighter side of the same border, the pixels are lightened a bit. This also creates an edge. The visual effect of this double edge is the illusion of contrast or sharpness; your eye is fooled into thinking the image is sharp.

Say Cheese

Sharpening is always affected by the size of an image. If you plan to increase the size of your image, do so before applying any sharpening filters. Sharpening is always the last thing I do.

Sharpen

To sharpen an image, open the Effects menu on the Menu bar, choose Sharpen, and select Sharpen again. You have no control over this filter; no dialog box appears. It does its thing, and it's all over. Note: you might want to undo and reapply the filter a few times so that you can see just how much sharpening has been done (it won't be much).

Flash

Try to avoid over-sharpening your image—otherwise, it will look forced or overworked. It is better to leave an image a tad under sharpened than to take it too far. Of course, because all the sharpening filters affect the contrast of an image, you might do well to keep this in mind when adjusting your contrast as well. (Note: avoid applying any sharpening filters before making contrast adjustments.)

Sharpen More

I bet you can't figure out what this filter does! This filter (open the **Effects** menu, choose **Sharpen**, and select **Sharpen More**) increases the contrast of the edges at the borders. (Again, you have no control over the degree of the sharpening effect; you must simply apply it and see what happens.) This yields a sharper effect than just plain old Sharpen. (You guessed right!) Depending on your image, applying Sharpen twice might give the same effect as Sharpen More. If you're curious, try it out.

Sharpen Edges

Sharpen Edges (open the Effects menu on the Menu bar, choose Sharpen, and select Sharpen Edges) looks at the border areas and applies the Sharpen filter only in areas

that have a good deal of contrast. This filter is a bit more selective than the previous two, but you still do not have any control over the degree of the effect.

Unsharp Mask

You might think this is another one of my silly jokes, but I promise you that the Unsharp Mask (USM) filter is for real—and is very useful. USM acts like a combination of Sharpen, Sharpen More, and Sharpen Edges. This is the only sharpening filter over which you have any control, and the control you have is *very* powerful.

To use this filter, open an image you wish to sharpen and do the following:

 Open the Effects menu from the Menu bar, choose Sharpen, and select Unsharp Mask. You should see a dialog box such as the one shown in Plate 1.11a.

Behind the Shutter

We professional types call the visible edges between the contrast areas crunchies; they look almost like the pixels have been piled up along the edges. I confess—I use USM almost all the time to sharpen my images. It offers the most control, and leaves few to no crunchies in the image.

- 2. Be sure the **Preview** check box is checked if you want to see the effect on your image as you go. Alternatively, you can toggle between the before and after by clicking and holding on the image in the dialog box, which shows you before, and releasing, which shows you after.
- 3. The Amount field determines how much contrast there is at the borders between the dark and light areas. The higher the value in the Amount field, the more contrast.

 This creates the major part of the sharpening effect.
- 4. The Radius field determines the number of pixels (or how far or wide from the border) to which the contrast is applied. This affects the width of the edge. A low (less than 1) radius lessens the effect of the Amount field.
- 5. The Threshold field describes how much contrast must be present in the areas between the borders before the sharpening will be applied. If a zero (0) value is present (or no difference in contrast), the sharpening always takes effect. If a value of 5 is found, there must be five *levels* of contrast present before the sharpening can occur. Think of the levels as a ratio of contrast between the pixels, such as a contrast of 1:2 or 1:5.

- 6. The preview box near the top of the dialog box shows you what the filter will look like on the image if applied. Notice that you can zoom into the image to get a better look at what you are doing by clicking the plus and minus buttons below the preview. Again click and hold to see the before state.
- 7. When you are satisfied with the effect, click **OK**. If you are unsatisfied, either **cancel** or—if you want to try again—hold the **alt key** down and the reset button will appear (or use Undo) so you can give it another go from the default settings for this filter.

In the following table, I've given you some starting points for the settings to use with the USM filter. Remember, these are starting points, and this is not a "one-size-fits-all" filter. Different types of images with different contrast ranges and subject matters require varied USM settings. Experiment and check out your results.

Suggested Starting Values for the Unsharp Mask Filter

Amount (Percent)	Radius (Pixels)	Threshold (Levels)
50	.7	0
75	.8 to 1	0
100	1 to 1.1	0
125	1.1 to 1.2	0
150	1.2	0
175	1.3	0
200	1.5	1
200+	It doesn't matter—you're over-sharpening! Try applying 125 twice.	

It is difficult to say which filter to use on your image; all will work. USM works very well, but it takes some time, and a few rounds of experimenting to figure out the settings. Usually, a shot or two of plain old Sharpen works fine, but if not, you now have the USM solution in your bag of digital tricks.

Behind the Shutter

A larger file can stand much more USM than a small file before any ill effects are visible.

It's All a Blur

Blur filters are frequently used for correcting selected areas of an image. They can be used to correct stair-stepping at the edges of an image or to dissipate noise.

Blur

To apply the Blur filter, open the **Effects** menu and choose **Blur**, then choose **Blur** again. Just like the Sharpen filter, the Blur filter offers no control over how much the image is blurred. When you apply it, the image appears to soften slightly.

Blur More

To apply the Blur More filter, open the **Effects** menu and choose **Blur**, then choose **Blur More**. Not surprisingly, applying this filter renders a stronger effect than simply applying the Blur filter. Note: I would apply **Blur More** before I would apply the **Blur** filter twice.

Soften with Smart Blur

The **Smart Blur** filter is my blur filter of choice, because it is controllable. To apply this filter to an open image, do the following:

- 1. Open the **Effects** menu on the Menu bar, choose **Blur**, and select **Soften** to view the dialog box shown in Plate 1.11b. Note that this dialog box is laid out similarly to the Unsharp Mask dialog box.
- 2. You can again toggle between the before and after states by clicking the image window in the Smart Blur dialog box.
- 3. As with any dialog box with a preview window, you can click your mouse anywhere on the image on your desktop to display that area in the dialog box Preview window. (Again, click the zoom buttons below the window to view more or less of the image area.) If you prefer, use the hand in the dialog box preview window to drag to the part you wish to view.
- 4. Use the Radius slider to specify how much softening will occur. A lower number will soften/blur more.
- 5. Use the Threshold control to generate a smoother blur. A higher number will smooth more.

- 6. The Quality and Mode controls give different options. Quality is unexplained in the Photoshop Elements 3.0 documentation, but I would guess it relates to how much information is used when determining the blur. Mode, on the other hand, gives a different effect to transition areas. Normal works on the whole image, Edge Only adds black edges to areas of transitioning contrast, and Overlay Edge adds white to these areas.
- 7. When you are satisfied with the effect, click **OK.** Again you can hold the **alt button** and revert to the default settings for this dialog box if you are not satisfied, and you can toggle the before/after previews by clicking and holding your cursor in the dialog box preview screen.

Despeckle

Many times, your camera introduces *noise* (unwanted color flecks or static) into your images, usually in the dark or solid color areas. The Despeckle filter helps eliminate some of the noise—it won't get it all, but it will clean up a good portion of it. If you have an image with a solid color that appears "dirty," this is the way to clean it. A good example is the sky sometimes will show as very speckled after JPEG compression has been applied. Try fixing it with this filter. To use this filter, do the following:

- 1. Open any image with noise you have. If you don't have one, take an image with a solid color and apply significant compression when saving as a jpeg. Now we have some noise!
- Open the Effects menu from the Menu bar, choose Noise, and select Despeckle.
- 3. The Despeckle filter offers you no control; it does its thing, and that's that.

If you need more control, try the **Dust and Scratch** filter covered in Chapter 18.

The Least You Need to Know

- You can correct the color balance of your photos to make them look more pleasing to the eye or realistic.
- You can add or subtract the amount of color to saturate or desaturate your images.

- ♦ There are many ways to improve your images with the creative use of color manipulation.
- ♦ You can sharpen or blur your images to improve them.

The Selection Tools

In This Chapter

- Using selection tools to improve your images
- Using Marquee selections to isolate standard shapes
- Using the Lasso selection tools for freehand selecting
- Using the Magic Wand to make selections based on colors and tones

Without selection tools, image editing would be very difficult. The selection tools, which work hand in hand with other tools, effects, and filters, are the key to your ability to copy or remove pixels in your image. They enable you to protect unselected areas from retouching or color correction. When you master the selection tools, you will begin to truly appreciate how much control you have over your images.

Getting Started

Before I go too far into describing how you make selections and why, let's find the tools themselves. As with many Photoshop Elements 3.0 operations, there is more than one way to get to the selection tools. The quickest way is to select the tool from the floating Toolbox, which is always open by default (if you don't see the Toolbox on your screen, choose

Window, and select Toolbox from the Menu bar to open it). The Toolbox displays icons that you click to select the tool you want to use. It also has foreground and background color selectors. You'll use the Toolbox a lot as you edit your images.

Each tool can also be accessed via a letter key shortcut. For instance, you can press Ctrl/Command+C on the keyboard to call up the Crop tool, or Ctrl/Command+E to call up the Eraser. Unfortunately, Adobe does not include a list of all keyboard shortcuts in the spare little booklet that comes with Photoshop Elements 3.0. If you do a Google search on "Adobe keyboard shortcuts" you will find a number of websites offering complete lists as pdf files for free download. If you get used to the keyboard shortcuts to each tool, you might be able to work on images without the Toolbar visible at all.

The Toolbar contains your tools, including the Marquee, Lasso, Magic Wand, and Brush selection tools.

Say Cheese

Floating windows (like palettes and the Toolbar) are a great way to save time and keystrokes. They do, however, take up a small bit of your screen's real estate. You can drag the windows around your workspace by clicking and holding on the window's title bar, and dragging it anywhere on your screen you like. The beauty of floating windows is that you can keep them close to the area where you are working. That way when you need a tool, you don't need to move your mouse very far to get it.

Why Use Selections?

There are plenty of reasons to use selection tools:

- Using a selection tool in your image enables you to move pixels. You can cut and paste a selection, moving it from place to place within an image or from one image into another. Say, for example, that you've selected a cloud. You can move the cloud to another location in your image, or you can copy and paste the cloud, creating an entire storm if you want.
- After a selection is made on an area in a photo, it is isolated so that operations affect the selected area(s) only. This comes in handy if you need to apply a filter or a color correction to a specific area in a photo.
- A selection can also be used as a targeting device, allowing you to place an image that has been copied exactly where you want it. All you do is draw a selection in the place you want the new copy to land. When you drop the new copy into your image, it lands in your selection.

Imagine this scenario: You just took the most wonderful portrait of your entire extended family. Folks and relatives from all over the country gathered for this occasion. The sun was shining, and all was right in the world. To celebrate this happy occasion and to show off your new toys, you run inside to your computer and print out an image for everyone in the crowd. But there is one small problem: your nephew, Pete the Pest, has his eyes closed!

Say Cheese

If you double-click on the **title** bar of any open palette or the Toolbox, it rolls up like a window shade so that only the title bar and a small part of the window are visible. If you want an even better look at what you are working on, press the **Tab** key. This toggles the open palettes and Toolbar to be visible and invisible.

Say Cheese

If you want to leave your floating palette or the Toolbox in place for your next Photoshop Elements 3.0 session, simply leave them open when you shut down the program. The next time you start Photoshop Elements 3.0, the floating windows appear in the same locations, ready for use.

No problem. Simply photograph Pete again, keeping him at about the same distance and under the same type of light as in the original photograph. Then run back inside and download the photo of Pete's smiling face, open it, and select only his face. Then open the family portrait and select Pete's face (the one with his eyes closed). Now all

you need to do is paste the new photo of Pete into the selection on the portrait. Because you selected the area on the portrait, Pete's face lands in the right place. You have to do some resizing and rotating of the pasted section, but you can do that with no problem.

Selection Tools

Lets take some time to look at the specific selection tools that Photoshop Elements 3.0 makes available to you. Although you can follow along by just reading, I suggest you cozy up to your computer and open up an image. Be sure the floating Toolbox is on your screen; if necessary, choose **Window**, and select **Tools** from the Menu bar. You access one of the selection tools by clicking the icons on this toolbar. Are you comfortable? Let's begin.

Behind the Shutter

You can buy third-party filters, additional effects, or more powerful tools. Many companies, such as Extensis (www.extensis.com), sell add-on software that help make selections much easier.

Most of the time, you can download trial or demo versions from a company's website. This is great, because you can check out the software to see whether it does all that it says it will. Also, you can check to see whether it works on your platform and with your software. Best of all, you can check to see whether you like the software in the first place.

Select All, None, and Invert

Four very powerful selection tools are located under **Select** on the Menu bar. You'll find them in this list along with their keyboard shortcut forms:

- All. This selects the entire image. An animated dashed line appears around the entire image. We professional types call these "marching ants," and they indicate that an area has been selected. Use Ctrl/Command+A on the keyboard for the same effect.
- Deselect. If you want to drop any selection after it has been made or used, use Deselect. (The keyboard shortcut command is Ctrl+D on a PC or Command+D on a Mac—think "D" for "drop," as in "dropping" a selection.)

- Reselect. If you dropped something that you didn't want to, select this item or
 use Shift+Ctrl/Command+D to get it back. You can also use the Undo button
 on the Shortcut menu or Control/Command+Z, as this does the same thing.
- ◆ Inverse. Use this command (or press Shift+Ctrl/Command+I) to select the opposite of what was originally selected. For example, if you are working on an image of a flower, and you want everything but the flower in the foreground to be slightly blurry, select the flower, invert the selection, and apply the Blur filter.

Flash

There are two different button types in the Toolbar. One type gives you just one tool when you click it. The second type, which has a small black triangle in the lower-left corner of the button, has multiple tools hidden under it. There are three ways to open the correct tool:

- Click the tool and then select the desired tool from the choices on the Option bar.
- Left-click and hold until a sub-menu appears.
- Right-click the button icon and the sub-menu will immediately appear. Both the Marquee tools and the Lasso tools are multiple tool icons.

Marquee Selection Tools

The Marquee selection tools are the easiest and simplest of all the selection tools. They are so named because the border resulting from the selection of an object resembles an old movie theatre's marquee with the flashing lights. The tools are very helpful when selecting a large area to move, rotate, or resize within the image. The Marquee selection tools are the Rectangle tool and the Elliptical tool.

Rectangle Selection Tool

To use the Rectangle tool, click any corner of the area you want to select, and then drag down diagonally to the opposite corner. When you release the mouse button, your selection is complete, like the one shown in the following figure.

You can "constrain" the shape of the rectangle selection tool to a square by holding the **Shift** key while dragging. This constraint works in quite a few places—try using it to select a perfectly square object. If you prefer, you can use the **Style** drop-down box and select **Fixed Aspect Ratio**, which also results in a square selection. There is also

a choice for **Fixed Size**, which is helpful if you are trying to capture exact size portions of an image, say for making web buttons or icons.

When you just want part of an image to be affected, you select it with the Marquee tool.

(Copyright © 2005 Bob Shell)

After you've made a selection, you can click in the marquee box and drag to relocate it.

Flash

If you decide that an operation isn't going to work, but you've already started it, you can easily stop it by clicking the Cancel button in the palette. If no Cancel button is available to you, press and hold Escape (Windows)/Command+period (Mac) to stop the operation. This can save you a lot of waiting time, especially on time-consuming operations.

Demo: Removing Color from Portions of Your Image

Have you ever seen an advertisement or a photograph that seems to be black and white but has color in selected areas? I'll show you how it is done:

- 1. Open any image, and then click the **Marquee** tool from the Toolbox. If you want the color to blend out to the colorless part, try setting a Feather number between 5 and 25 in the **Option** bar text box.
- 2. Using your mouse, **Shift+click** and hold and drag to select a square area (about an inch or so) in the middle of your image.

- 3. From the Menu bar choose Select, then Inverse to select the area outside the box you just drew.
- 4. Open the Enhance menu on the Menu bar, choose Adjust Color, and select Remove Color (or just use Shift+Ctrl/Command+U).

Like Plate 1.12b in the color insert, the image, except for the protected area, becomes black and white; the area you protected when you drew the original square selection remains colorful!

The Elliptical Marquee Tool

The Elliptical Marquee tool works just like the Rectangle Marquee tool, except it draws circles or ovals. You can alter the shape of the oval, making it oblong or squat, by altering the direction you drag the cursor. To draw a perfect circle, hold down the **Shift** key as you drag to make a selection. When using the Elliptical Marquee tool, be sure anti-alias is checked in the **Tools** options bar at the top of your workspace, or you will get some jagged results.

Lasso Selection Tools

Lasso selection tools enable you to draw a selection in freehand. There is no fixed shape to the tool. These tools are precise, enabling you to follow along a line or a shape easily. The freehand selection tools are the Lasso tool, Polygon Lasso tool, and the Magnetic Lasso tool.

In Plain Black & White

Aliasing is an effect that makes straight lines look jagged. It looks just like the "stair stepping" we talked about in Chapter 2. Selecting the anti-alias option in Tools will smooth out this effect.

Say Cheese

You might have noticed that all the fixed selection tools draw across the screen in the direction of the cursor drag. If you hold down the Alt key (Option for the Mac), the selection grows outward from the center (the center being where your mouse was pointing when you clicked it to begin dragging).

Lasso Tool

You can use the Lasso tool to trace an object of unusual shape. To use it, click, hold, and drag your cursor around the object you want to trace. Note: for a selection to work, it must be "closed," meaning that you must drag all the way around the object until you reach the starting point. If you don't, the cursor "snaps" itself closed to connect the point where you released the mouse button to your starting point.

The Lasso tool is for freehand drawing where you control the path. Before starting, it's often helpful to zoom in on the object you want to select.

Lasso Polygon Tool

The Lasso Polygon tool is another freehand selection tool, but unlike the Lasso tool, which enables you to draw both squiggly and straight lines, the Lasso Polygon tool draws only point-to-point straight segments. Try using an image that has a clearly defined solid object in it to get a good handle on how this tool works:

- After selecting Lasso Polygon from the Toolbox, click to start your selection, move to your next position, and click again. Each click adds a segment to your line.
- 2. Keep clicking until you have nearly selected the entire object.
- 3. Double-click to close the selection and it might look something like the following figure.

The Lasso Polygon tool lets you select straight-line segments.

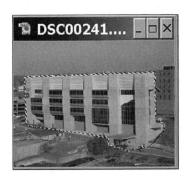

Say Cheese

Suppose you're tracing an image that contains both squiggly lines and straight ones. Drawing a perfectly straight line freehand is pretty hard. Usually, your hand tremors ever so slightly, making the line that's supposed to be straight look squiggly.

Fortunately, Photoshop Elements 3.0 provides a way for you to trace perfectly straight lines, even while using the Trace tool. To do so, press and hold the mouse button, and then press and hold the Alt (Option on a Mac) key on your keyboard. Release the mouse button (keep pressing Alt or Option), and move your cursor to the other end of the straight line. When the line is as long as you need it to be, click to anchor it. You can repeat this so long as you hold down Alt/Option, adding segment after segment. When you finally release the Alt (Option) button, you are again able to draw "squiggly" lines.

229

Selecting by Color

It is always easiest to let the computer do as much of the work for you as possible. Selecting by color is one way of letting your computer's "horsepower" do some of the work for you. Instead of drawing a complicated selection around a beautiful red rose, why not let the computer do it for you? By selecting the red color, your rose can easily be isolated from its green, leafy background. So easy and so simple!

The Magnetic Lasso

If you were following closely under Lasso tools, you might have noticed I skipped one, the Magnetic Lasso tool. If you have part of an image with a consistently defined edge, use this tool to follow the edge to make a selection. It works well even if the part being selected contains several different colors, as long as the edge is clearly defined. If the part to be selected is one solid color, then save the effort of dragging around it by using the next tool instead.

The Color Magic Wand

The Magic Wand enables you to make selections based on similar colors or tones. This comes in handy when you want to choose large areas of color, such as when you want to select the entire lawn or sky in a photograph. The downside of using this tool is that it can take a while for you to clean up all of the *blinkers* that were not included. This happens when a different color range is located inside of an object you select. You can **Shift+click** on these gremlins to add them to the active selection. I often use the elliptical or other selection tool to get the blinkers.

In Plain Black & White

At some point, you will be left with some small blinkers, or blinking selections, in your image. (You'll know what they are when you see them!) You could try selecting these portions of the image with the wand (thus ruining your eyes), but the easier way to finish is to change tools and utilize the Selection Brush tool for smaller areas, and brush over the blinkers to select them, or use the Lasso tool or Elliptical Marquee tool.

If you want similar colors regardless of where they appear in an image, un-check the **Contiguous** box in the **Options** bar, otherwise the Magic Wand won't select similar colors if there is a barrier of contrasting color. Note also that it will jump layers to get similar color if you select the **Use All Layers** option.

Say Cheese

If you accidentally add a large portion of your image to the selection, you can use the **Undo** command.

The Magic Wand's default Tolerance is set to 32. You can adjust this by typing a new value into the Tolerance box on the **Options** toolbar. Try using an image that has a single distinctly visible object to get a good handle on how this tool works. Essentially, just click inside the object you want selected.

If you set the tolerance too low, such as at 1, the tool selects only those pixels that are exactly the same color as the one selected by the wand. (Lower tolerances can come in handy if you want to pick a specific color and change it, however.) If you choose an excessively high tolerance, such as 255 (remember from Chapter 14 that there are only 256 colors available in an image), then all the pixels in your image will be selected. See Plate 1.13 for an example of the Color Magic Wand in action.

A Selection Saved Is a Selection Earned: Saving Selections

After all the work you have just done to make the most perfect selection, wouldn't it be nice if you could save it to use again? Even better, wouldn't it be nice to save a selection in progress—like if you haven't finished working on a selection and you need to close the file and do something else, like eat dinner? Saving selections also helps when you work on the same file over and over again.

Photoshop Elements 3.0 allows you to save your selections, a very powerful action. Here's how:

1. After you've finished making the selection that you want to save, open the **Select** menu from the Menu bar and choose **Save Selection.**

Say Cheese

To duplicate a portion of an image, press and hold the Alt (Option for the Mac) key as you drag the selection. The software automatically makes a duplicate of the image.

- 2. The New Selection item will already be selected in the Save Selection dialog box; your only job is to name the selection. When you are done, click **OK**. Voilà! You now have a saved selection ready for re-use.
- 3. To use your newly saved selection again, open the Select menu and choose Load Selection. Select your saved selection from the Selection pull-down menu, and click OK. Your selection will be restored!

Addition and Subtraction, All Without a Calculator!

What if you want to add to, subtract from, or otherwise combine a couple selections? As previously indicated, you can hold the shift key while making another selection to add to it or hold the alt key while selecting to subtract from the selection. If you want to save your fingers the walking, four options (pictured in the next figure) are located on the Option bar for most of the selection tools: New selection, Add to selection, Subtract from selection, and Intersect with selection.

The four options for selecting appear on the Options bar.

- **New selection** will remove any prior selection and replace it with the current selection.
- Add to selection will keep any existing selection and combine it with the new selection, just like holding the shift key did.
- Subtract from selection will take away
 the new selection from the existing selection, the same as holding the alt key.
- Intersect with selection will select only those portions of two selected parts of the image that overlap, tossing out the rest.

Flash

Four very powerful methods of adjusting selections are located under **Select, Modify** on the Menu bar. If you want to expand or contract by a set number of pixels, select only the border of what is selected, or smooth (think anti-alias) a selection, hit this menu item!

The Least You Need to Know

- Selections are an important part of preparing to enhance your images.
- Using selections, you can duplicate and move elements, and protect certain elements while you color-correct others.
- You can select large areas of your image using fixed selection tools or select very fine detail and shapes using freehand selection tools.
- ♦ You can use the Magic Wand tool to select a particular color or range of colors.
- ♦ You can save your selections for re-use in the same or other images.
- You can add to, delete from, modify, choose intersecting, expand, and contract selections.

Adding Fills and Color

In This Chapter

- Filling your selections with color
- Filling your selections with texture
- Drawing on your images using the Brush, Shape, Eraser, and Pencil tools

You can enhance your images by adding color or patterns. You can add these enhancements in a strong, bold way, blend one color to another, or subtly just add a tint.

For those of you who always wanted to paint and draw, you are in luck. Photoshop Elements 3.0 has tools that enable you to draw or brush color onto your photos. You can draw over a few faded pixels to beef them up or draw a smile on a face to add comic relief.

Photoshop Elements 3.0 offers a few different ways to add color to your image:

- Using fills, you can easily fill large areas of your images with colors or patterns. You can also use fill gradients that gradually move from dark to light, or even from one color to another.
- Using paint tools, you can draw on your image.

Let's first look more closely at the Fills tool.

Fills

With Photoshop Elements 3.0, you have two basic categories of fills at your disposal:

- Selection fills fill the selected portion of your image with a solid color or pattern.
- ♦ Gradient fills work similarly to selection fills, because they also fill in a selection. However, this type of fill fills the selection with two colors, fading one into the other.

Selection Fills

To apply a selection fill, begin by selecting the portion of the image that you want to fill (or select the part you don't and use **Select, Inverse** on the Menu bar). Then open the **Edit** menu and choose **Fill** to view the **Fill** dialog box. As shown in the following figure, this dialog box is broken into two main parts:

- Contents
- Blending

A selection is drawn in an image. The Selection Fill dialog box allows many options to be applied to the selection.

(Copyright © 2005 Bob Shell)

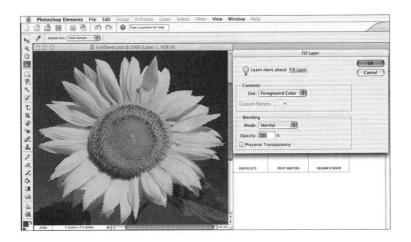

Contents

The Contents section offers two options:

Select the Pattern option from the Use menu in the Fill dialog box to fill your selection with the pattern you select from the Custom Pattern menu that will

appear. Use the small, round arrow button on the right side of the open **Patterns** menu to select the type of patterns, such as Artist Surfaces, Nature Patterns, and so on. Click **OK**.

Say Cheese

The options menu in the Custom Pattern menu is chock full of features, many of which you might never use. One feature you might want to pay attention to, though, is the Presets Manager. With this tool you can add more patterns by clicking the Load button. Patterns come in the form of a file with the .PAT extension. Just search for PAT and Photoshop using your favorite web search engine. There are hundreds of sites out there with patterns; some are free and others are fee-based.

Select the Foreground Color or Background Color options to fill the selected area in your image with color. This can be a little confusing. When you cannot select a color in the Fill dialog box, you need to select a color by using the swatches in the Color Picker palette.

The easier way to make a color fill for a selection is to use the Paint Bucket tool. Make your selection, select your color from the **Tools** palette, select the **Paint Bucket** tool, and click inside your selection. You'll have to experiment with what works best, but use the **Mode** and **Opacity** options to change how your modifications look.

Behind the Shutter

You can quickly undo mistakes with just a few keyboard strokes, thanks to Photoshop Elements 3.0's Undo States feature. The default number of Undo States is 50, but you can easily increase this number. Go to **Photoshop Elements** on the Menu bar, select **Preferences,** and then **General**. Change the default 50 to a higher number, like 100. Keep in mind that the more states you save, the more RAM and Scratch Disk space you'll need. So if you are on the lower end of the Minimum Requirements scale, leave it at 50.

To move back through the Undo States, use Ctrl+Z (Command+Z), and to move forward through the Undo States, use Ctrl+Y (Command+Y). Just remember that after you save changes you can no longer go back through the Undo States.

Blending

Use the **Blending** area of the **Fill Selection** dialog box to specify *how* the color or pattern you picked will be applied to the image:

- Use the **Opacity** field to specify how opaque the applied fill will appear. Choosing 100 percent means that the fill will be completely opaque. If you want the fill to resemble a tint rather than a robust color, try setting this field to 50 percent or less.
- Use the Blend drop-down list to specify how the fill will be applied. You have the following options: Normal, Darken, Lighten, Overlay, Difference, and Color.
- Select Normal to fill the selection so that it completely covers the base or layer below. See Chapter 20 to learn more about layers.
- Select Color to fill the selection so that the area below the selection keeps all
 its shadows and highlights. This is a good way to lay a color tone over an image
 while retaining the original image detail.
- ♦ Both the **Overlay** and **Difference** options are really esoteric functions that we graphics professionals like to make more complicated than they really are. Suffice it to say that they both involve multiplying or comparing color information—they can, however, produce cool results. The best thing to do with these modes is experiment.

Gradient Fill

Applying a gradient fill is similar to applying a selection fill; begin by selecting the portion of the image that you want to fill. After you have selected your target area, click the **Gradient Fill** tool in the Toolbox (it's the one that looks like a rectangle of varying shades of color and is located right under the Paint Bucket tool).

You will notice pretty quickly that this tool has plenty of bells and whistles.

Demo: Using a Filter to Change the Weather

Using selection tools and fills, you can borrow the blue sky from one image and place it over the gray sky in another. People will think you always go on vacation during the best weather! Here's what you do:

- 1. Open any weather-related images you have. One of a sunny locale and another of a dreary one will do.
- 2. Using either the Rectangle Marquee tool, the Magic Wand, or a Lasso Polygon selection tool, select the sky area in the background of the dreary picture, which will place "marching ants" around the sky as the next figure shows. Remember to make use of different tools and use the add and subtract options covered in Chapter 16.

Use the Magic Wand tool to make a selection in the sky area. Remember to uncheck the contiguous box if there are other areas of similar color. (For a color version of this photograph, see Plate 1.15a.)

(Copyright © 2005 Bob Shell)

- 3. Switch to your sunny image.
- 4. Click on the **Foreground** color block in the Toolbox to open its Color Picker shown in the following figure.
- 5. Move the pointer off of the Color Picker and it will change to an Eyedropper tool. You might need to move the Color Picker to see your target colors on the sunny day photo.
- 6. Place the eyedropper pointer at the very bluest part of the sky in the sunny day image and click. The blue of the sky fills in as your Foreground color. Click OK to close the dialog box.
- 7. Repeat steps 4, 5, and 6, but this time click the **Background** color block in the Toolbox and select a slightly lighter shade of blue, gray, or white, depending on your preference. Click **OK** to close the color picker.

The Color Picker dialog box is used to grab the natural blue-sky color from a photo. (For a color version of this illustration, see Plate 1.15b.)

- 8. After you have both your beginning and ending colors chosen, switch back to your dreary image.
- 9. The dreary image should still be on your screen, with the sky selected. Your beginning and ending colors are still in the Foreground and Background color blocks on the Tools palette.
- 10. Choose **Filter**, select **Render**, and click **Clouds** and Photoshop Elements 3.0 will build a nice blended sky for you like that shown in the next figure.

A beautiful blue sky; only you know the truth! (For a color version of this photograph, see Plate 1.15c.)

(Copyright © 2005 Bob Shell)

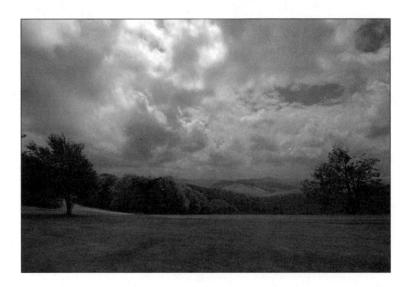

When you catalog your images, it's a good idea to make note of which images have great cloud formations and wonderful skies. This will be the beginning of a great archive of "bits and pieces" of images for you to use. I routinely use cloud formations I took years ago to fill in new images. It sure beats waiting hours for the right clouds to appear! It can be used directly, or with the Clone Stamp tool discussed in Chapter 18.

Paint Tools

The painting tools are a lot of fun to use. You can use them to clean up or enhance part of your image, or you can use them to draw on your photos. If you are using Photoshop Elements 3.0 to make presentations, you can draw arrows or circle parts of your images to draw attention to a specific point.

Behind the Shutter

Programs such as Adobe Photoshop CS2, Adobe Illustrator CS2, and Corel QuickDraw offer even more robust paint tools and options than does Photoshop Elements 3.0. Nonetheless, the painting and drawing tools that are included in Photoshop Elements 3.0 are quite a close match to what is offered in the full-bore Photoshop CS2 and offer plenty of options for digital image buffs.

Photoshop Elements 3.0 offers a variety of paint tools for you to use, including the following:

- Brush tools
- Eraser tools
- Shape tools
- ♦ Pencil tool
- Airbrush tool

Beginning with the brush, let's take each of the paint tools for a test drive.

The Brush Tools

The Brush tool is really two tools in one. It can be used just like a paintbrush, which is a very nice way to apply color in a freehand manner. It can also be used as an Impressionist Brush tool, which converts any image into a nice Van Gogh.

To use the Brush tools, choose the **Brush** tool from the Toolbox. Options for these tools appear on the **Options** toolbar, shown here, enabling you to specify the brush's **size**, **color**, **mode**, and **opacity** options. It might be a good idea when working with this or any other tool to click the left-most icon on the **Options** bar to reset the tool to the default settings.

The floating palette allows you to pick the brush's size, edge type, shape, and color.

Setting the Brush Size

On the left end of the **Options** bar is a squiggly line that represents the size and consistency of the brush stroke. You can select from numerous predefined styles by clicking the small arrow to the right of the iconic display. You can select from among several predefined sizes, or you can set the brush size manually by using the slider that drops down below the **Size** box when you click the down arrow on the right end of it. The characteristics of the brush will be preserved when you resize it.

Behind the Shutter

By default, the cursor for Photoshop Elements 3.0's Brush tool is a simple circle. However, you can use the Cursor Preferences dialog box (open the Edit menu, choose Preferences, and select Display & Cursors) to specify how you want your cursor to appear onscreen. This dialog box is divided into three sections; the section on the far left is for the painting tools—such as the Brush tool.

Choose the **Standard** option if you want your cursor to look like the tool's icon. For example, if you are using the Brush tool, the cursor looks like a little brush, making it easy for you to remember which tool you are using. If you choose the **Precise** option, your cursor resembles a small crosshair, making it easy for you to finely control the tool you're using. Finally, you can select **Brush Size** to make it so that your cursor reflects the size you've selected for the tool. You can switch from **Standard** to **Precise** on the fly by using the **Caps Lock** key. Lock it and crosshairs appear. Unlock it and you have your little paintbrush back again.

Setting the Brush Color

This is an easy one; the brush will paint in the foreground color set in the swatch in the Toolbox. If you want to change the brush color, click the swatch and use the Color Picker dialog box to find just the color you want.

Setting the Brush Opacity and Mode

You can alter the opacity and mode of the color drawn by the Brush tool.

You can use the **Opacity** menu to define the percentage of opacity that will be applied when you use the brush. You can effectively use this to apply a light mist around a friend or family member's head, making them appear lost in a fog of thought, or myriad other effects that can modify the emotion of a picture. (You can also control the opacity of the Brush tool by controlling the opacity of the layer on which you're drawing. See Chapter 20 for more information on layers.)

Select a mode from the **Mode** menu. Most of these are somewhat esoteric, so you might want to experiment with them. With some you won't even be able to tell if it did anything at all. Have fun with them.

Say Cheese

If you have a selection activated but hidden from yourself—for example, you might be zoomed in on a different section of your image—trying to use the Brush tool will be frustrating (remember, you can't draw outside a selected area). Select the **Zoom** tool and click the **Fit On Screen** button on the **Options** bar to find the selected area, or drop the selection (press **Ctrl+D/Command+D**) just to be sure.

Drawing with the Brush Tool

Click and hold the **mouse button**, and drag the **Brush** tool across your image. Squiggle it. Do the loop-de-loop. Dab. Have fun. Remember, you can also use a selection to limit where you draw. To get more complex and interesting results, create a new layer (see Chapter 20) before trying out an effect. This also allows you to later chuck that layer entirely when you are done playing around.

You can control the opacity of your brush strokes. Choose View, Grid from the Menu bar to create a drawing reference. This shows lines brushed at 100, 75, 50, and 25 percent opacity.

The Eraser Tools

The Eraser tools erase the image from the photo. If you are on the "background layer" of an image, the standard Eraser tool erases to black and white checkerboard underneath the image (see the following image). If you are on an upper layer, it erases the pixels on that layer, allowing pixels on submerged layers to show through.

The Background Eraser tool is a neat gadget. It works best on images with strongly contrasting elements. For example, a white table, chair, and umbrella set on a dark stone patio overlooking a smooth surfaced cobalt blue sea would be an excellent candidate (not to mention a fantastic vacation spot). The tool works by sampling, or looking at, what is directly underneath the "+" in the middle of the pointer circle and then removes that color in the brush area, as shown in the upper-left corner of the next figure. The idea is to drag it around the image while it removes elements that match what it finds.

Say Cheese

If you need to draw a perfectly straight line, press and hold the **Shift** key while you draw.

In the example image, you might want to remove the dark stone patio floor and replace it with a carpet texture fill. You would then click the stone area and drag the brush around, being careful not to drag across the white areas. The result is a complete removal of the stone flooring and a nice transparent place to insert your carpeting. The Magic Eraser tool works in a similar fashion, but with less control. You simply click a color and it removes that color from the entire image. This works best with solid colors or colors with only slight gradients. For complex surfaces it's easier to use the Background Eraser.

The Eraser tool behaves exactly like the Brush tool—almost. Like the Brush tool, you can specify the size of the eraser; unlike the Brush tool, no color selection need be made. You can use the numeric keys on the keyboard to set the opacity just as you did with the Brush tool. To open the Eraser palette, open the **Tools** menu and choose **Eraser.**

The Background Eraser tool exposes the transparent base layer of the photo.

(Copyright © 2005 Bob Shell)

The Shape Tools

The Shape tool is one of the best buttons on the Toolbar. It holds a plethora of tools:

- Use the Rectangle tool to draw either rectangles or squares.
- Use the Rounded Rectangle tool to draw a four-sided shape, but with rounded corners. That breaks up the squarish world that often follows digital images around.
- Use the Ellipse tool to draw ovals and circles.

Use the Polygon tool to draw shapes with a preset number of sides. The greater the number, the more likely you are to see the shape as a circle. You can also set special **Polygon Options** (see the little down arrow just to the right of the tool icons on the option bar, as shown in the figure), including a star.

By clicking the small arrow you get a drop-down Polygon Options dialog box, which can really unlock some great shapes for you!

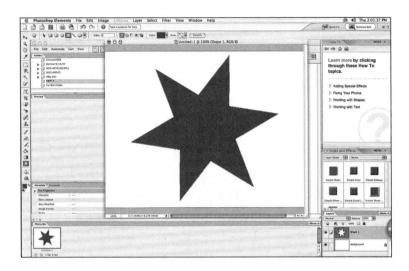

In Plain Black & White

Shapes in Photoshop Elements 3.0 are rendered in a special form called **vector** images. Vector images are discussed in some detail in the Text tool section of Chapter 19, but what makes this a huge advantage is that you can resize, warp, rotate, and mess with shape layers without any loss of quality.

- ◆ Use the Line tool to, well ... what can we say, you can draw a line as a shape or use the Brush or Pencil tools. One advantage of the shape tool is the resulting line is a *vector* image.
- Use the Custom Shape tool to draw a whole host of preset geometric shapes, arrows, and other neat elements to spice up your images. Don't be fooled by the word custom—Adobe defines the shapes, you don't!
- ◆ The Shape Selection tool is used to create a bounding box around the shapes you create so that you can resize, move, rotate, and generally just do as you please.

There are many options that go with the shape tools. Very similar to the additive and subtractive options for the selection tools discussed in Chapter 16, there are options to enable you to draw a new shape layer, add a shape to your existing layer, subtract

a shape from the existing image, render a shape comprised of the intersection of two shapes, or just the reverse of that, render a shape comprised only of that portion of two shapes that doesn't overlap.

One of the best features of the shapes Option bar is the Style setting. Be sure to click the down arrow on the right of the Style option menu, notice the small circle arrow that appears in that dialog box, click that, and play for hours with the various options found there. You will find some that make you forget to look up to see if it's time for bed!

The Pencil Tool

Located on the toolbar, it looks and acts almost like the Brush tool. However, it has a harder edge than the Brush tool. You can pick a soft-edged pencil, but don't be fooled: if you pick the same width and style of brush (now that is a confusing term—but they call the style of pencil a brush!) for the Pencil tool and for the Brush tool, the result will vary just a little in terms of the softness of the edges, with the Pencil tool producing a harder edge.

The Airbrush Tool

The Airbrush tool allows you to spray or speckle your paint on the image canvas. It is an option to the right of the Brush tool Option bar. You select it by clicking the icon. I don't need to tell you the magic of the airbrush if you have been to a beach town where they have T-shirt artists. Some very impressive effects are possible with practice using this tool.

The Least You Need to Know

- You can fill a selection with color.
- You can use Gradient Fills to change images wholesale or in a selection.
- You can draw on your image with the Brush, Pencil, and Airbrush tools or create shapes using the various shape tools.
- ♦ You can do more than just erase with the Erase tool.
- All drawing tools have numerous controls.

The Ultimate Retouching Tools

In This Chapter

- Using the Clone Stamp tool
- Retouching out unwanted elements
- Cloning from one photo into another
- Eliminating red-eye with the Red-eye Tool
- Using the Pattern Stamp tool
- Using the Dust and Scratch filter

One of the most useful tools in the Photoshop Elements 3.0 arsenal is the Clone Stamp tool. This fairy-tale tool lets you to copy over "bad" pixels with "good" pixels, enabling you to remove scratches, dust, and other annoying maladies on your photos and even take out (actually cover up) distracting elements such as a building from a remote seashore photo or phone lines from a scenery shot. This tool is so important and so beneficial to your photos that it deserves its own chapter.

Getting Started

Photoshop Elements 3.0's Clone Stamp tool is a descendant of Photoshop's Rubber Stamp tool, which is why the Clone Stamp tool's cursor looks like a rubber stamp. It is located second from the bottom-left corner in the Toolbox and can be selected by clicking the icon (you can also hit the **S** key on your keyboard when an image is open). When you click the **Clone Stamp** tool, the **Options** bar will change to reveal another tool on the same icon in the Toolbox called the Pattern Stamp tool. You can toggle back and forth between the two by using the icons near the left of the **Options** bar, or by right-clicking the icon in the Toolbox and selecting the one you want. For now we will concentrate on the Clone Stamp tool, and later in the chapter we will cover the Pattern Stamp tool.

Like the painting tools you learned about in Chapter 17, the Clone Stamp tool also uses a brush. The Clone Options bar features a brush menu from which you select the shape of the brush's tip. Some brush tips are hard-edged, which leave straight edges. Others have fuzzy tips, which leave soft, feathered edges (these are the best brushes to use, because they help blend the clone into the photo). There are also some very unusual tips, such as the Flowing Stars brush, which would be used more for effects than for picture correction. The text box to the right of the **Brush selection** drop-down menu produces a slider with which you can select an exact brush size, all the way from 1 pixel to 2,500 pixels in diameter. If you prefer, you can type the desired pixel number into this box.

The brush you selected is shown on your image as a circle that moves as a cursor when you move your mouse. The size of the circle changes as you select different brush sizes. If you want to locate the exact center of the circle, press your **Caps Lock** key, which changes the circle into a crosshair. Pressing the **Caps Lock** key again changes it back to a circle. Note that the crosshair does not change in size when you select different brush sizes—its size is constant.

I often work with the tool at about 50 to 100 pixels, but the type of cloning you are performing will dictate the pixel size you should use. You can see the outline of the tool in the default cursor setting and the **Options** bar will show you the size. There are two other options for your cursor (and any other additive tools like the Paintbrush or Pencil tools you learned about in Chapter 17). Here's how to control those other options:

 Open the Preferences menu (Photoshop Elements 3.0, Preferences, Display & Cursors). 2. Under the painting tools, the Brush Size button should be selected by default. If you leave it this way you will see a circle on your image showing the size of the brush. If you prefer, you can select **Standard** and see a nice little drawing of a paintbrush for your cursor, or select **Precise** and see cross-hairs for very precise positioning of your brush strokes. You might want to try each of these two choices to see what you prefer. After selecting one, close the dialog box by clicking **OK**.

For this particular tool I prefer the Brush Size selection so I can see the entire area to be affected.

As you go along, especially after you have accomplished a difficult clone, save your image again using a progressive name like *filename 1.psd*—you'll be glad you did. If things go sour, just use the **Revert** function in the **File** menu. Remember you only have a limited number of undo functions and each click of the clone tool is a step. The default is 50 levels of undo, but when using something like the Clone Stamp tool, which uses many repetitions, you might want to increase the number to the maximum of 100 undo levels. Use **Ctrl+K/Command+K** and increase the History States.

Demo: Removing Distracting Portions of an Image Using the Clone Tool

Open any image that you really don't like because of numerous "baddies," and I'll walk you through how to eliminate the problem. Examples of "baddies" might be a building in the background of your image, telephone lines running through your building, your mean uncle in the family picnic picture, or other distracting things in a photograph.

Do the following to use the Clone Stamp tool:

- 1. Click the **Clone Stamp** icon on the **Tools** palette or press **S**. If this opens the Pattern Stamp tool, click the left tool icon on the **Options** bar.
- The Clone Stamp options appear on the Options bar shown in the following
 figure, enabling you to choose an applicator—or brush—size, hardness of edge,
 opacity, and so on.
- 3. Perform any image correction you feel is necessary to make the image look as good as possible in a pre–Clone Stamp state, such as adjusting perspective (see Chapter 14) or balancing color.

With the Clone Stamp options you pick a tool's size, edge effect, and opacity, among other things. There are basically three types of brush under the **Default Brushes** (click the dropdown menu box between the Clone Stamp icon and the Size box on the **Options** bar to see the brushes): softedged, hard-edged, and special effects.

- 4. Zoom into the image so that the baddies you would like to eliminate and some surrounding good parts of the image fill your screen. You don't have to get all baddies in at the same time.
- 5. Open the brush selection dialog box by clicking the small down arrow on the **Options** bar and selecting the 35-pixel soft brush on the **Default Brushes** menu (it should be about the thirteenth one down). You get the paint for the Clone tool's brush by "sucking" the pixels that you want to clone from your image. To do this you need to change the Clone Tool into its "sucking" mode. Do this by pressing the **Alt** or **Option** key and holding it down until you put the Clone Tool over the area you want to clone. Your good pixels might be some bushes or grass if you are trying to cover a building surrounded by bushes or a lawn (like the following figure demonstrates), the sky if you are covering telephone wires, and so on. Make sure that the **Aligned** option is checked and the **Use All Layers** option on the far right side of the **Options** bar is turned off. Click the area and then release the **Alt** or **Option** key.
- 7. To "stamp" out the baddie, drag the cursor to place the cursor over the baddie. Now click if it is a small defect; the cloned pixels from the source will cover the spot you clicked. You can repeatedly click as you move around the baddie, or you can also click once and drag if you have a large good pixel area.
- 8. Save your image when you are finished.

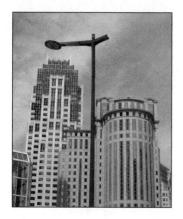

By using the rectangle selection tool to isolate the lamp pole, I used the Clone tool to rubber-stamp in the brickwork and clouds. In the middle photo I highlighted the areas where I used the Rectangle selection tool. The right photo is the finished product. After I finished cloning the sky, I added a 25-pixel feather to my selection and then used the Gaussian blur filter to smooth out the sky.

Behind the Shutter

As you clone, you will notice a small crosshair that follows along with your Clone tool. This crosshair indicates the spot from which the Clone tool is picking up pixels. It always remains in the same position relative to the clone tool as the original source was when sampled. If you find that you don't like the pixels being used as a source, change sources by using the **alt** key while clicking the new source; the relation between the traveling crosshair and the brush will change.

Also note that if you release the mouse button and start dragging again, the brush starts copying from the source point again. To make a perfect duplicate of an area, don't release the mouse button until you are finished making the copy.

Cloning takes a little bit of practice and a steady hand; I think it's the ultimate test of hand/eye/mouse coordination. This is a really good place to try and learn to use a

pen tablet. The tablets use the pressure you use to draw with to control the amount of "brush application." In other words, the harder you press with the tablet pen, the more ink, or in this case opacity, will be applied by the onscreen tool.

Flash

If you try to perform any operation outside an active selection, nothing happens!

I sometimes get lost when trying to remember what part of the image is selected. If this happens to you, zoom or move the image until you can see the border. If you see the "marching ants" there, you may have inverted the selection and included far more than you intended. Don't worry, you'll get the hang of it, and when you do, you will have fun!

Say Cheese

When cloning, change the clone source to avoid too much duplication. Gradient areas are the worst to clone in. Try not to drag the cursor along a gradient if it is going to create a noticeable line in the area you are cloning into. Instead, try using different-sized brushes. Clone sources from above and below the area you're cloning over. Dab at the spot you want to clone over. Lower the Opacity setting and clone the same baddie more than once. If your clone target area has grain in it, try to duplicate it. Try to match the source and target areas the best you can. Use the Zoom tool to get really close and align pixel by pixel. In other words, mix it up and take your time—a poorly done clone is easy to spot—but with practice cloning can really clean up your digital images.

Behind the Shutter

Sometimes you might need to work on both sides of a selection (suppose, for example, you also wanted to make changes to the tree without affecting the sky). If so, you don't need to redraw the selection. Instead, invert it by going to Select on the Menu bar and selecting Inverse (Shift+Ctrl+I). You can then draw or paint against the selection from the "other side."

Cloning Between Two Photos

Just as you can clone from one area of a photo to another, you can clone between two entirely different photos. Here's what you do:

- 1. Open the image you want to clone to (Image A).
- 2. Activate the Clone Stamp tool.
- 3. Open the second image, which contains the clone source (Image B).
- 4. Activate the Clone Stamp tool here, also.

- 5. Move the clone source crosshairs over the area you want to clone from in Image B.
- 6. Return to Image A by clicking the image or the top title bar. Your Clone Stamp tool should now be laying down pixels from Image B in the clone target in Image A.

I have found it helpful to make a layer in Image A and clone from Image B to the layer. I can then resize or reposition the layer. For example, in the following figure, I get rid of old Uncle Joe by reestablishing that area of the photo where the boats should be from a second snapshot taken moments later. I could not clone without duplicating the boats from elsewhere or the clone would be obvious. I use the Clone Stamp tool to lift the boats from the middle image and transfer them to the left image rendering the Joe-less image on the right.

Say Cheese

When you finish a clone, zoom out and take a look at it. Walk away from your monitor and come back to it. See whether the clone stands out from the image. If it does, fix it or start over. Particularly if you are doing some significant cloning, save intermediate copies under progressively numbered names so you can revert part of the way back if necessary.

You can use the Clone tool to stamp out Uncle Joe or other unwanted parts of an image. I happened to have two pictures, one where Uncle Joe is blocking the boats with his body (pretty literally) and one where he is not blocking the boats.

You can use the Clone tool to stamp out Uncle Joe or other unwanted parts of an image. I happened to have two pictures, one where Uncle Joe is blocking the boats with his body (pretty literally), and one where he is not blocking the boats.

The Spot Healing Brush and Healing Brush

The Healing Brush and Spot Healing Brush tools are new with Photoshop Elements 3.0, and they greatly expand the program's versatility. Many things that I would have done with the Cloning tool in the past can now be done with even more ease

with these new tools. To access these two new tools, go to the thirteenth tool on the toolbar, the one that looks like a Band Aid, and click it. This gives you the Spot Healing Brush. You adjust the size of the brush just as you did with the Cloning tool, in this case making it the size of the spot or blemish that you want to eliminate.

To use the Spot Healing Brush, simply place the circle indicator over the spot you want to eliminate and click. You'll see a "marching ants" circle briefly while Photoshop Elements 3.0 works its magic, and then the spot you wanted to eliminate will be gone. The Spot Healing Brush automatically finds pixels all around the area of the spot and analyzes them to generate the proper tone, color, and texture to invisibly cover the spot. Try it a few times and you'll see. It's like magic.

For larger blemishes that can't be as easily dealt with as small spots, you will need to switch to the Healing Brush. When you have the Spot Healing Brush selected in the toolbar you will see a bar across the top above your image window. In it are two icons, a Band Aid with a little arc just to the left of it, which is the icon for the Spot Healing Brush, and right next to it a Band Aid without the arc. That one without the little arc is the Healing Brush. Select it, adjust the brush diameter to your desired brush size, and paint with it to remove larger unwanted elements in your image. Practice with the Cloning tool and with the two Healing Brushes and you will learn when to use each for the best possible results.

When you need to repair a larger blemish or area, the Healing Brush is the tool you want to pull out of the Toolbar.

(Copyright © 2005 Bob Shell)

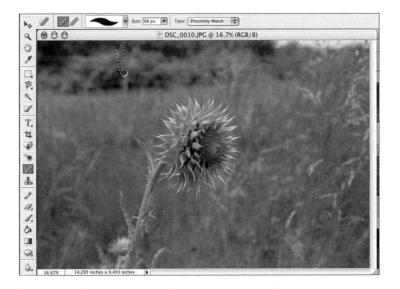

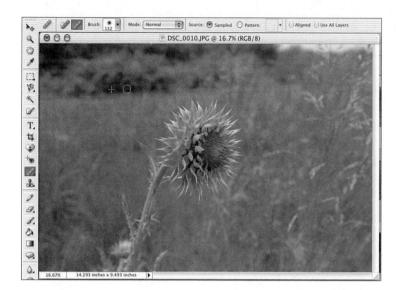

The Spot Healing Brush works best for repairing small blemishes and spots, thus its name.

(Copyright © 2005 Bob Shell)

The Red-Eye Tool

Although you can remove the dreaded red-eye from your photos using the Cloning Tool or the Spot Healing Brush, Photoshop Elements 3.0 gives you a much easier way with the new Red-eye tool. Just above the Spot Healing Brush on the toolbar you'll see an icon that looks like a little eye with a crosshair just to the left of it. That's the new Red-eye tool. Click it and you'll get a crosshair that you can move around on your image. Move it to the red area in someone's eye, or even reasonably close to that area, and click it. The red will immediately vanish. Visine is no longer the only thing that gets the red out!

Unfortunately, this remarkable tool that works so well on human eyes won't work on your cat's green-eye problem. Cats, and many other animals, have different retinal structure than humans and have a reflective layer on their retina, which throws back the camera's flash as a green or blue-green color. You must revert back to the Cloning tool, Spot Healing Brush, or other methods to deal with the dreaded green-eye!

Cloning Patterns with the Pattern Clone Tool

Sometimes you might want to fill in an area of an image with some texture. You can use the Pattern Clone tool to paint with texture. When you select this tool by clicking the stamp-shaped icon in the Toolbox and then selecting the right stamp icon on the

Options bar, you will see a new option, Pattern. Select a pattern and then you can paint on your image.

In the following figure, I used the Marquee tool to select the little girls. Then I used **Select, Inverse** on the **Menu** bar to actually highlight the area around the girls. I painted texture into this area using the Pattern Clone tool and to give it a nice effect, I then used **Filter, Sketch, Chalk & Charcoal** from the **Menu** bar to give it an interesting look. Finally, I used **Select, Inverse** to highlight the girls again and applied the **Recessed Frame** effect from the **Effects** palette in the Palette well. I think this creates a unique image that makes the girls jump right out at you. Try it on a photo you like.

Using the Pattern Stamp tool, you can generate some nice enhancements to your photos.

Fixing Minor Blemishes with the Dust and Scratches Filter

If you have some minor blemishes on a photo, leave your big gun (the Clone Stamp tool) in your Toolbox and turn instead to the Dust and Scratch Filter. A little bit of this tool applied consistently can go a long way to solving the problem. Open your

Say Cheese

Our experience says that it is best to select smaller parts of a photo for this type of correction and then repeat the process for another area needing correction. The reason is that what might be the perfect blend of Radius and Threshold adjustment for one blemish might actually create a new blemish elsewhere if the selection is too big.

image (this works great for your old black and whites you scan into your computer) and zoom in on the area you wish to repair. This tool often works best when you select just the area where the blemish exists. Follow these steps:

- 1. On the open image make a selection of the problem area using the **Marquee** tool, a **Lasso** tool, the **Magic Wand**, or the **Selection Brush** tool contained in the top part of the Toolbox.
- 2. Choose **Filter**, select **Noise**, and click **Dust** and **Scratch** to apply this filter. A dialog box will appear that lets you adjust the **Radius** and **Threshold** of your correction.

- 3. If you are correcting a large part of the image, move your cursor to different areas that you want to preview and click. This changes the portion of the image shown in the **Dust and Scratch** dialog box. You can also use the minus and plus icons in the dialog box to zoom in and out. You might also wish to check the preview box to see the changes reflected in the actual image. Previewing might slow down the process for larger selections.
- 4. Try different settings for the **Radius** and **Threshold** either by pulling the slider bars or by typing numbers directly into the text boxes. With trial and error you will get pretty good at estimating how much of each is required.
- 5. When you are satisfied with a correction, save a copy of the image, and then, if necessary, repeat this process after selecting another part of the image.

The Least You Need to Know

- ♦ You can use the Clone Stamp tool to cover up or move pixels in your image.
- You can clone with different opacities.
- You can clone from one image to another.
- Mix up the cloning tools and brush sizes to make a more-believable clone.
- Use the Pattern Stamp tool to paint with texture onto an image.
- For minor blemishes, use the Dust and Scratch filter.

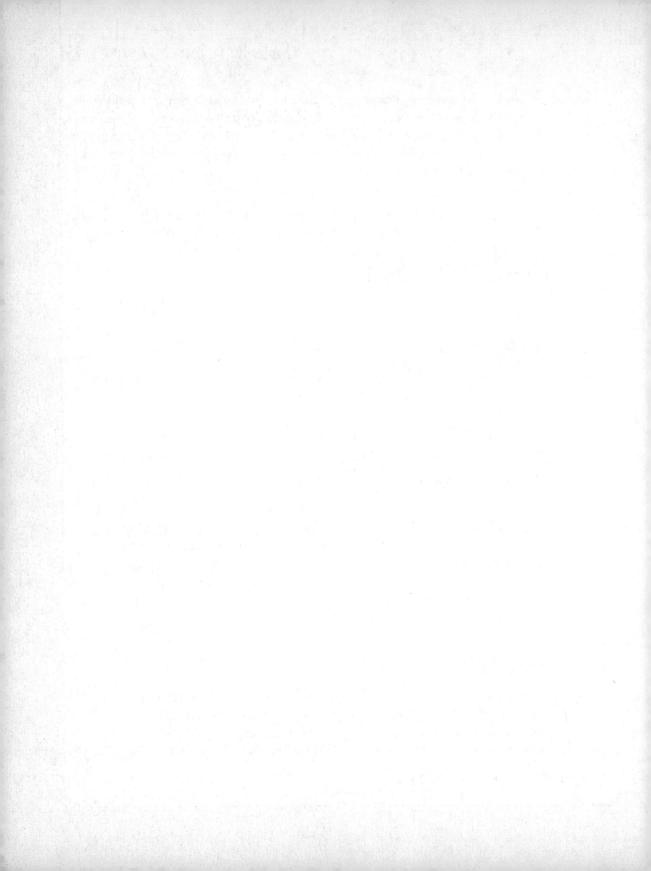

The Text Tool

In This Chapter

- Including text in your images
- Using secret type tricks
- Adding drop shadows
- Giving your type a new glow
- Changing the opacity of your type

You might want to include type or text in an image to produce a greeting card or calendar. Or maybe you are making a logo or web button, want to explain or caption your photo, or want to add a word bubble to the great picture of your aunt scratching her behind at last week's family reunion. Fortunately, Photoshop Elements 3.0 includes a Text tool, which you can use to add text to your images.

Adding Text

You can add text to an image in several ways, but no matter which way you use, begin by opening the image itself (if you want to practice on a solid white background, create a new image by pressing Ctrl+N/Command+N). Then, activate the Text tool by clicking the Text tool in

the Toolbox (the one that has a T on it) or by pressing T on the keyboard. An Options bar will open like the one in the following figure.

Say Cheese

Learning the keyboard shortcuts for the tools in the Toolbox is well worth the effort! After you're familiar with them you can easily toggle between tools while working in an area of your image without having to flutter your cursor around your screen.

There are four tools available on the Text tool button. You can toggle between them using the icons on the Options bar shown in the figure, or by clicking the T icon on the Toolbar and selecting the one you want to use. The choices are as follows:

- Horizontal Type tool
- Vertical Type tool
- Horizontal Type Mask tool
- Vertical Type Mask tool

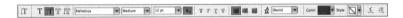

Use the Text Tool Option bar that contains four different Text tools and lays out the different options settings available when adding text to an image.

The horizontal or vertical variation is self-explanatory: do you want your text to run across the page or down it, as though you had hit the carriage return after each letter?

The difference between the Type tools and the Type Mask tools is a little harder to discern. The Type tools place text directly on the image, much like you were typing it there. By contrast, the Type Mask tools actually select type-shaped portions of the image. You can then apply effects and filters to the selected type-shaped portion of the image, or you can copy the mask of the selected type-shaped portion of the image and use it elsewhere. Now that was a mouthful, so while we chew, read on, and then I'll show you how to use the Type Mask tool later in the chapter.

To add text to your image ...

- 1. Choose the **Horizontal Type** tool on the **Options** bar and then select a type style such as regular, bold, or italic (note that the options available will vary depending on the font you select, because not every font is available in italic, for example), then choose a font and a point size from the three drop-down menu boxes on the **Options** bar.
- 2. Just to the right of the font size selection box is an icon with "aa" in it. This is the anti-alias toggle and your best friend in digital imaging of text. You will

almost always want to use anti-aliasing, so make sure it is white, meaning selected. To see the difference it makes, choose a very big font and toggle it on and off. With it off you will see jaggies around any diagonal or rounded portions of the letters. With it on, Photoshop Elements 3.0 gently blends your text into the background in a way that fools your eye into seeing smooth edges on the letters.

- 3. Choose the paragraph alignment you wish to use from the **Options** bar. Your choices are left-aligned, centered, or right-aligned. This really only matters if you plan to enter multiple lines of text.
- 4. Pick a color for the text you will be adding by clicking the color box on the **Options** bar. Use the **Color Picker** dialog box to select your choice; it works the same way as with the painting tools (see Chapter 17). If you are making the image for the web only, you might want to check the **Only Web Colors** choice in the lower-left corner.
- 5. Move your cursor over your image and notice that it now displays a fancy I-shaped cursor with a box around it (if you switch to the **Vertical Type** tool, the fancy I-shaped cursor rotates 90 degrees to indicate your tool choice). Click anywhere inside the image (or a selection, if one is active) and a bar cursor will appear with a height equal to the type size you selected. You can type in your text and it will appear on the image.
- 6. Select all or a portion of the text (you can use Ctrl+A or triple-click on the text itself or double-click on the T thumbnail in the Layer palette). Any text selected will be affected by the changes you make in the Text Options bar. Use the Font drop-down list to find a different font (type style) you like.
- 7. Click the **checkmark** button to the right of the **Options** bar, because even though most adjustments to formatting are shown instantly, they are not committed to the image until you confirm at this step. At this point, it's a good idea to open up the **Layers** palette, which is probably docked in the Palette well. Notice that the text you added is in its own layer. Generally, each time you click the checkmark the currently added text is committed to an automatically created layer. This is evident in the next figure, which shows two text layers. Check out Chapter 20 to find out more about layers.
- 8. After adding text, save a copy of your image using a progressive file name. Unless you are absolutely positive you will never want to edit it again, you will want to save it in a Photoshop Elements 3.0 format like Photoshop (.psd) to preserve layers and information about the text.

Say Cheese

Some true type fonts contain duplicate sets of letters; for example, one is normal face, another is italic, and another is bold. If the font you choose offers those choices, they will appear in the drop-down box. What if your chosen font lacks italics? Never fear, Photoshop Elements 3.0 is here: when you begin editing, the Options bar will display four icons to the right of the anti-alias icon that are faux bold, italics, underline, and strike-through. Even if your font lacks one of these choices, Photoshop Elements 3.0 will render your font the way you wanted it!

The text is contained on its own layer, allowing it to be modified and positioned independently of the rest of the image and other layers.

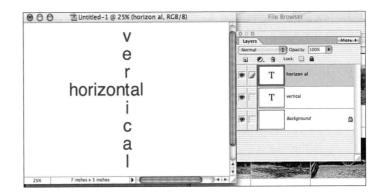

Notice that the text you highlight while in Type tool editing mode is not in a bounding box, a rectangular selection that defines the boundaries of the text that will be moved (read about selections in Chapter 16). You can place a bounding box around it by clicking the **Move** tool in the upper right of the Toolbox (or by typing **V** on the keyboard *after* committing your text to the layer with the checkmark). After the bounding box appears, you can resize, move, distort, and rotate the type by applying the same filters and tools that you would to other image elements. You also can use the **Change Text Orientation** button to the far right on the **Options** bar if you want to go from vertical to horizontal or vice versa (in fact, I usually create my text in horizontal fashion, and then convert it for convenience).

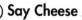

You can use the Layer Styles palette in the Styles and Effects palette as a way of applying some cool effects without touching the rest of the image. You click the Layer tab or, better yet, click and drag it out of the well, click the layer you want to affect, and then go to work with the Effects or Filters palette.

If you have more than one palette open at the same time, you can dock them to each other. With one palette already open, drag the other on top of it to get them in the same palette window.

Demo: Applying a Drop Shadow

A drop shadow is literally a shadow of an object, in this case text. They help define and add depth to the type and also make the type appear to float above the image. Graphic designers use drop shadows a lot to enhance the type quality, but like Brylcreem (for the old greasers out there), "a little dab will do ya!"

To add drop shadow to text in an image ...

- 1. Open any image or create a new one with **File**, **New**. Add any text you want with the **Text** tool found in the **Tool Bar**. Set the color, font, size, and other similar options as explained a minute ago.
- 2. Select all the text with either **Ctrl+A**, by triple-clicking on the text, or just by opening the **Layers** palette from the Palette well and clicking the text layer you want to drop-shadow. Text layers are shown in the **Layers** palette with a large capital **T** in the thumbnail window and the text that you entered to the right of the thumbnail.

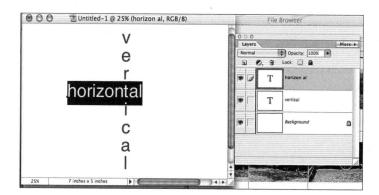

If you triple-click the text in any layer of your image, it will be highlighted and the layer will be selected in the layer menu. Notice that there is no f icon in the highlighted section of the Layers palette. In a minute there will be!

Say Cheese

Here's a really cool trick. Select all of the text on a layer and click the Warped Text button (the T with the curved line under it near the right end of the Options bar) and the Warped Text dialog box will appear. Fiddle around with the various gizmos and gadgets in here to make your text do some very interesting things. When you open the Warp Text dialog box it shows Style: None by default, which means if you click OK without changing the Style, you will apply no style. Who wants to be without style? Use the drop-down menu to change the style, and the dialog box comes to life with scads of options.

The Layer Styles palette dialog box enables you to select Drop Shadows from the drop-down menu and then pick from some predefined styles of drop shadows and related styles like Neon or Outline. You can toggle back and forth between these views of the Layer Styles using the toggle buttons in the lower-right corner of the palette window or by using the More button in the upper right and selecting either List View (not shown) or Thumbnail View (shown). The More button is only available if you drag a palette off the Palette well.

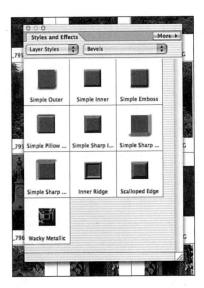

- 3. Click the Effects tab in the Styles and Effects Palette. Alternatively, you may select Window, Styles and Effects from the Menu bar. Select Drop Shadows from the pull-down menu.
- 4. Examine the drop shadows that are provided and select any one you prefer. Clicking it will apply it to all of the selected text, similar to the next figure.

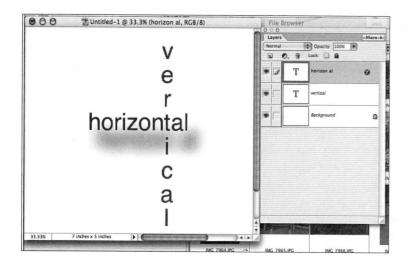

After you add a Layer style such as Drop Shadow to a layer, an f icon appears in the Layers palette to the right of the layer name or text contained on the layer (in this case, to the right of the word horizontal). Double-click the f to get available options for that Layer style.

5. Now you have a drop shadow; let's fine-tune it a bit to make it look good. Double-click the **f** icon (see the following figure) in the layer with the **Shadow**, which will bring up the Style Settings dialog box.

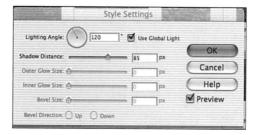

The options available for drop shadow are the lighting angle (Use Global Light will tie all drop shadow or similar effects to the same light source), shadow distance, and preview. Smaller numbers usually work best (say 2 to 7 pixels) for drop shadows.

6. Make adjustments until you like how it looks and save your changes in Photoshop format. Again we encourage the use of progressively numbered files.

Say Cheese

One of the best features of Photoshop Elements 3.0 is that any Layer Style added to your image is wed to the content. If you change the text in a layer, the drop shadow changes to match. One of the worst features of Photoshop Elements 3.0 is that the drop shadow is gray; you don't have the ability to modify it. You will have to later simplify the layer, which unweds it, and then use one of the color modification techniques if you want a different color drop shadow.

Changing the Opacity of Your Type in Photoshop Elements 3.0

Officially, there is no way to change the opacity of your type, but I'll show you a way to cheat (to be politically correct, we'll call it a workaround). Actually, I already have! If you followed the preceding demonstration, by changing the file into a Photoshop format, you will note that each text entry committed with the check icon on the Option bar appears in the layer stack as a normal layer. Well, that layer can have its opacity or blending mode changed. The Blending Mode options affect how the pixels of the current layer interact and mix with the layers below it. The Opacity setting determines how transparent the layer is; this enables you to see what is below it more clearly if the opacity has a lower number. Either will give a different look to your text.

On an image with a few layers, including one or more text layers, give this a try. Open the **Layer** palette and notice the drop-down Blending Mode menu and Opacity text box just below the Layers tab. Try changing the blending mode to **Soft Light** and see the change. Experiment with some other modes to see what you like. Now go ahead and decrease the opacity number and watch your type become transparent. Again, this procedure relies on layers, so you might want to come back to this after you read Chapter 20.

Demo: Making Your Type Glow

In this demo, you'll learn how to make a glow appear around your type. To begin, open the file you just worked on, or repeat steps 1 to 6 in the previous demo to generate a new image with type, then do the following:

- 1. Open the Layers palette.
- 2. Duplicate the shadow layer by dragging it over the **Page** icon at the bottom-right corner of the **Layer** palette.
- Rename this new layer by double-clicking it in the layer stack and typing glow in the dialog box that opens.
- 4. Deactivate the original drop-shadow layer by clicking the **Eye** icon—we'll keep this around for safekeeping, but leave it hidden from view.
- 5. Click the Glow layer in the Layer palette, if necessary, to select it.

- 6. Open the **Layer Styles** palette from the **Palette** well. There are really three ways to place this palette on your workspace:
 - ♦ You can click and drag it open independent of any other open palette.
 - ◆ You can click and drag it over a title bar of another open palette and continue to pull it downward until you see a line appear over the open palette (about where the More button is), which docks this palette in the same palette window under the open palette.
 - You can repeat the previous step but continue dragging downward even further until you see a faint dotted outline around the entire open palette window. Release the palette, which will place both palettes, one on top of the other, in a tabbed format.
- 7. Click the small slashed circle icon in the upper-left corner of the **Layer Styles** palette to remove the existing drop shadow from the glow layer. Then choose **Outer Glows** and choose **Simple** by double-clicking it (or you can drag it to the layer on the **Layer** palette if it is visible). Like drop shadow, you don't have much choice of color.
- 8. Save the image if you like the result.

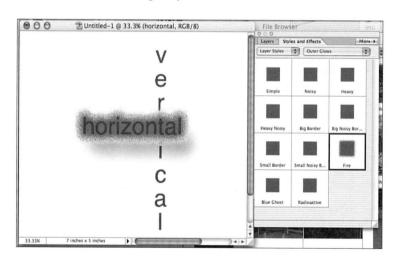

You can get some very nice results with the Styles and Effects palette Outer Glow choices. Notice how the two active palettes are joined in a tabbed format in one window.

There are some other ways to get outer-edge effects on your text layers. In fact, there is a whole host of effects on the Layer palette that work only for text, including Outline and Brushed Metal. They aren't too hard to find as they all say "ABC" clear

as day if they are special text effects. Unlike the Layer Styles, you can control the color of the Outlines when using the Effects palette, which works off of the current foreground color set at the bottom of the Toolbox.

Vectors to the Rescue

Photoshop Elements 3.0 renders text in a vector graphic format. Now unless it is after your bedtime and you want a reason to stay up late, you might be saying, "So?" Well, Adobe did a great favor for you when they decided to make text render in this format, because what it does is make a geometric formula to describe the text. You can therefore resize a text layer, rotate it, and otherwise mess around with it, and the program will redo the math and render the text error-free for you. Some programs render text in a raster format where color is mapped to bits; if you make significant modifications to such images it will degrade the quality of the image.

There are certain functions you might perform with text that will require that the text be converted from vector to raster format. If so, the Photoshop Elements 3.0 will prompt you and ask if it may simplify the layer, meaning make the conversion in format for the layer. If you expect you will have to resize or make other significant modifications to the text layer, you should rethink your order of attack to complete those modifications before simplification occurs.

The Least You Need to Know

- Text can be put onto a photograph.
- Text will create a new layer.
- Text can be manipulated to change its size, position, and color.
- With a little bit of workaround you can adjust the opacity of text.
- Drop shadow, outer glow, and other effects can really dress up text.
- Text is typically rendered in a vector format, but it might need to be converted to a raster format for certain functions.

Chapter

Using Layers to Add Images and Elements

In This Chapter

- Using layers
- Understanding layer hierarchy
- Adding and deleting layers
- Adding transparency
- Creating panoramas

The biggest advance in digital imaging came about when Adobe brought out Photoshop 3.0, which introduced layers. Many other companies soon followed Adobe's lead. Layers make imaging fun, spontaneous, and artistic. Before the advent of layers, every image brought into a Photoshop document had to be pasted onto the background layer. Every time you brought an element into an image, you had to save and rename the image to avoid overwriting earlier versions. If you forgot to save and rename and then made a mistake, you had to start all over.

What's a "Layer"?

Think of a *layer* as a plate of glass with an image on it. For example, one layer might have text, another might have the original photograph, and another might have a selection from a second photograph. (Usually, it is best to keep each image element on its own layer so that the element can be moved and manipulated without affecting the rest of the composition.) Each plate can be opaque, semitransparent, or fully transparent.

These layers are stacked one on top of another to create a single image, and all layers can be reshuffled in the stack to alter the image's composition. A layer can also be turned on or off, making its contents visible or invisible.

Lemme See One

With an image open in Photoshop Elements 3.0, open the Layers palette docked in the Palette well. By default, every image in Photoshop Elements starts with the background layer like the one shown in the next figure. When image pixels are erased from the background layer, a checkerboard pattern shows through indicating that you can see through the layer—which is called "transparency." The background layer itself cannot be erased, but it can be duplicated or converted into a regular layer.

The Layer palette shows the background layer.

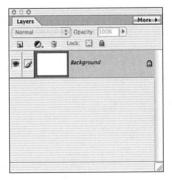

Using Layers: The Basics

The easiest way to learn about layers is to experience them yourself. To begin, let's create a new image:

1. Create a new image by pressing Ctrl+N/Command+N.

- 2. Because the image will be for onscreen viewing only, keep the resolution at 72 pixels/inch (commonly called 72dpi), size it at 5×4 inches (or 360×288 pixels), and set the mode to RGB and Contents either White or Transparent, using the options available on the New dialog box.
- 3. Select the entire image with **Ctrl+A** or choose **All** from the **Select** menu on the Menu bar.
- 4. Notice that the initial layer has been labeled the background layer, but it is actually Layer 0, as you will see in a minute. In the **Layers** palette, select the **background** layer and open the **Effects** palette docked in the Palette well. Then select **Sandpaper** under the heading **All** in the drop-down box and click the **Apply** button in the upper-right corner of the **Effects palette**. Now, if you look at the Layers palette, you will see that a new layer that contains a Sandpaper texture, Layer 1, has been added to the image. Some Photoshop Elements functions automatically add a layer to your image like this one did.

Adding Layers

If you want to bring new elements into your image and keep them separate from your original image, you will need to put them on their own layers when Photoshop Elements doesn't do it automatically. To add new layers manually ...

- With the image you just created open on the desktop, click the new layer creation icon in the lower-right corner of the Layers palette. We will be using this image a little later on in the chapter for a continued demonstration. Alternatively, you can use the Menu bar Layer, New Layer, or Shift+Ctrl/Command+N.
- 2. Look at the Layers palette and observe that a new layer appears, already named "Layer 2" (Layer 1 was created earlier and now contains a Sandpaper texture). You will notice that Photoshop Elements automatically shows Layer 0 as the background layer, but it is not actually numbered. You can name your layers to help you keep track of them, and I want to give you a little practice naming layers.
- 3. Repeat steps 1 and 2 to create Layer 2.

The Layer palette contains a plethora of great features to manage and manipulate layers.

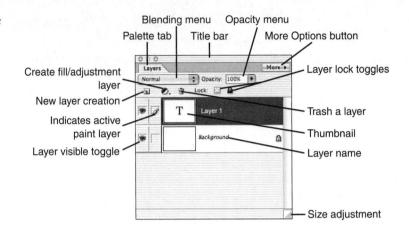

Flash

If you are trying to paint or delete on a layer and nothing is happening, be sure that you have activated that layer. If you have indeed forgotten to activate your target layer, check the other layers to be sure you didn't end up painting over or deleting something on them! (I can't tell you how many times I've done this.)

- 4. Double-click the **Background** layer, which is on the bottom in the **Layers** palette, and the **Layers Option** box will open where you can type in the new name of the layer (it says Background in the layer, but when you open the dialog box, it will say Layer 0).
- 5. Double-click the words **Layer 1** in the **Sand-paper** layer and you will see that a text box forms around the words. You can then type in the word **Sandpaper** to rename that layer.
- 6. Save your image in .psd or another Photoshop Elements format to preserve your layers for later editing.

Activating a Layer

No operation—a color change, fill, or movement—can be done to a layer until that layer has been *activated*. Conversely, when a layer has been activated, operations on it will not affect any other layers. Activating a layer is simple. Click the layer in the **Layer** palette to highlight it; that's all there is to it.

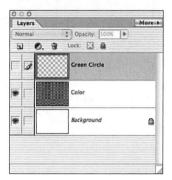

Layer 2 is activated, as indicated by the highlight box.

Showing and Hiding Layers

On the left side of each layer in the Layers palette is a small Eye icon. The contents of the layer are made visible by clicking on the box on the left of the eye. Clicking the Eye icon "closes" the layer so it becomes invisible. Notice in the following figure that the circle is no longer visible in the image; not surprisingly, that layer does not have an Eye icon next to it in the Layers palette. Note: a layer can be active and yet invisible.

Remember the text layer cannot be activated unless the file is in a Photoshop file format. To save in Photoshop Elements format use File, Save As from the Menu bar and click Photoshop for file format.

The Circle layer titled "Green Circle" has visibility turned off.

Deleting Layers

This can't get much simpler. If you want to delete a layer, grab it in the **Layers** palette and drag it onto the **Trash Can** icon at the bottom of the palette. If you goof up and drag the wrong layer—or change your mind—you can undo the action. (Remember, however, that you may undo only a limited number of actions, only 50 by default unless you have increased your undo preference using **Photoshop**

Elements, Preferences, General, modify History States from the Menu bar). If you are not quite sure you want to delete a layer, try hiding it instead (see the preceding section to learn how).

Understanding Layer Hierarchy

The only thing that is better than having layers is the ability to shuffle the layers up and down the layer pile or stack. A layer on top of the stack will always cover whatever layers are below it. But you can take this top layer and move it lower within the stack, closer to the background. This enables you to change how the layers, and the elements on the layers, relate to one another. You cannot move a background layer without first converting it to a normal layer.

Before we delve into layer hierarchies, let's draw on the layers of the image we created in the section titled "Using Layers: The Basics":

1. If you did it right, there will be a Background layer and a Sandpaper layer. Any extra layers can be deleted from the layer stack by highlighting them, right-clicking and selecting delete, or by dragging them to the trash icon. Make sure the Eye icon is visible on the Sandpaper layer.

Say Cheese

More than one layer can be made invisible at the same time, but at least one layer in the image must always be visible or you won't see anything in the image. Duh!

- 2. Using the **Rectangle** tool from the **Toolbox**, draw a fairly large red rectangle. If you don't remember how to draw shapes, back up and review Chapter 17. You will notice that doing this creates a new layer in the Layer palette stack.
- Hide the Background and Sandpaper layers by toggling the Eye icon in the Layers palette to the left side of each layer.
- 4. Activate the Red Rectangle layer by clicking it in the layer stack in the **Layer** palette, and be sure its Eye icon is visible.
- 5. Draw a large green oval using the Elliptical Shape tool from the Toolbox.
- 6. Hide the red rectangle layer by toggling the **Eye** icon off for that layer in the layer stack.
- 7. Activate the green oval layer by highlighting it in the layer stack in the Layer palette, and be sure its Eye icon is visible.

- 8. Use the **Polygon Shape** tool to draw a blue triangle and again make sure it is visible by toggling the **Eye** icon.
- 9. Save the file in .PSD format. You've come too far to lose it now! It should look like the following figure.

Only two layers are visible. Notice how layers cover one another, with the shape in the layer on the top of the stack in the Layer palette covering any visible layer below where they overlap.

To demonstrate the hierarchy of the layers, note the following:

- 1. The green sun is setting behind the blue mountain, but the Sandpaper and Red Rectangle layers are not visible. Even though they are not visible, if you saved in Photoshop format, they are still in the image and can be restored to visibility.
- 2. Toggle the **Eye** icon for the Sandpaper and Red Rectangle layers and note that you now have a sun setting against a red sky near a blue mountain in a desert—this *is* a creativity exercise for heavens sake.
- 3. Let's shuffle the deck a bit. With your cursor, which should look like a little hand, grab the green oval layer in the Layers palette and click and hold while you pull it down below the red rectangle. The blue triangle will be the top layer, covering the layers below it, but the red rectangle now also covers the green oval where they overlap. This is a great way to hide an element behind another element, as shown in the next figure.
- 4. Try adjusting the opacity of the red rectangle layer by highlighting it in the layer stack and using the opacity slider. It should fade toward pink as it becomes partially transparent, and your green oval will probably reappear, but in a brownish or olive shade, because you are now seeing it through the red.

Because the green circle is completely overlapped by the other two shapes, it disappears. Note the darker circle in the image, which shows where the circle is, even though it won't be visible.

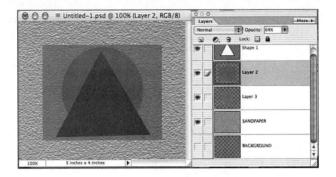

Working with Layers

After you've got the basics of using layers down, you can get into the nitty-gritty of really making them work for you.

Rotating, Distorting, and Resizing Layers

While you have a layer activated, select the **Move** tool from the upper-right corner of the **Toolbox.** As soon as the layer is selected, the selection handles appear. As before, you can resize, distort, and rotate the layer. Remember, all the objects on the layer are going to be affected. If you want to rotate just one part of the layer, you must first select that area using the **Rectangle** or **Selection Brush** tool.

Say Cheese

When you make a selection, it floats between the layers, which means that you can apply that selection to any layer. However, it is effective on the active layer only.

Moving Layers

To move a layer within an image, do the following:

- 1. Click to activate any layer in the Layers palette.
- 2. Select the **Move** tool from the **Toolbox.** Your cursor should change into a solid black triangle.
- 3. Place the cursor over the image itself, and then press and hold the **mouse button** down.
- 4. Move your mouse to move the layer.

To move a layer from one image to another ...

1. With one image open, open up any other image using either the **File**, **Open** or **Window**, **Browse** method from the **Menu** bar.

- 2. Position the images so that both are visible onscreen (if you need to make the images smaller, go ahead, using **View**, **Zoom Out** from the **Menu** bar).
- 3. Click the title bar of the second image you just opened and highlight any layer with content in that image. Then with the **Move** tool click and drag a layer to your originally open image.
- 4. As you drag the selected layer onto the first image with the **Move** tool, the first image will automatically become focused as the active window. Release it there.
- 5. Take a look at the **Layers** palette; the new element appears as a new layer. In some circumstances it might be shown as a floating layer.
- 6. To make this floating layer a new layer, drag the floating layer to the icon at the bottom of the **Layers** palette that resembles a piece of paper.
- 7. The new layer is automatically named the next number in the existing numerical order.

Say Cheese

If you don't feel like using the Layers palette to activate the layer you want to move, select the **Move** tool and click the object in your image that you want to move. After you move this object you will see its layer titled "floating selection." (Note that if you inadvertently pick the wrong spot, you might activate the wrong layer.)

Say Cheese

Often, when you copy a layer or selection from one image into another image, the pasted-in layer or area is too large or too small. After all, when you took the two different pictures, you probably weren't standing the same distance from each subject. To resize the pasted-in area or layer, select it using a **Selection** tool or the **Layer** palette, and resize as needed.

Erasing Layers

The Eraser tool allows you to erase pixels from one layer, and have pixels from the layer below show through. This can be quicker than making a selection and then deleting an area. To use the Eraser tool, open the **Eraser** tool from the **Toolbox**.

Choose a brush size from the Erasers Options bar, and then drag the Eraser tool over an active layer (use a large fuzzy brush and carefully erase around the edge of your image to achieve a nice, blended effect).

The Eraser tool allows you to erase pixels on one layer and have pixels from the layer(s) below show through. Turns out, this was a picture of Swiss cheese, not a mountain.

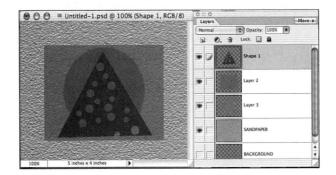

Transitioning from One Layer to Another

When you place one layer on top of another—especially if the top layer has been selected and copied or cut from one location to another—you sometimes end up with what I call a cookie cutter effect, where the edges look abnormally sharp. Follow these steps, and I'll show you what I mean!

- 1. Be sure the **Layers** palette is open on your screen.
- 2. Open any image that has a few independent objects that have flat color.
- 3. Zoom in on a flat-colored object.
- 4. Choose the **Magic Wand** tool from the **Toolbox**.
- 5. Choose the object. You might need to use the **Selection Brush** tool to trim your selection if you grab some of the color around the object.
- 6. Open the Edit menu and choose Copy (or press Ctrl+C/Command+C, the same keys used in almost all programs, word processing and spreadsheets alike, to perform copy-and-paste operations), which copies the object to the Clipboard.
- 7. Open another image, this time with darker colors.
- 8. Paste the object into the new image (open the **Edit** menu and choose **Paste** or press Ctrl+V/Command+V). The object appears in the center.

9. Zoom in to the object. You will notice that the edges look very sharp—what I call a cookie-cutter appearance—like that shown in the following figure of a flower placed atop a head.

To correct this cookie-cutter appearance, try Feathering.

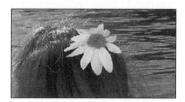

The flower is pasted onto the girl's hair, creating a new layer. It has a hard edge on it.

Feathering

Many imaging software programs let you feather a selection, which makes the elements on one layer "flow" nicely to the layer below. Using the previous example,

you can soften the edges of the flower and make it blend a little better into the image by doing the following:

- Be sure the pasted object's layer is active and the object is selected, and then open the **Select** menu on the **Menu** bar and choose **Feather.**
- 2. The **Feather** dialog box opens as shown in the next figure. The default number of pixels used to feather is 20.

Say Cheese

Remember, you can undo the feather and play around until you get the effect you like. Experiment with all the options to get the hang of how feathering works. Mastering this part of cutting and pasting really makes your images come together and look untouched (of course, we know better).

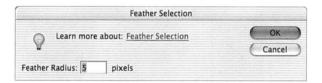

Use the Feather dialog box to blend your images together.

3. Use the **Feather Radius** field to set the amount of feathering (that is, how much of the object's edge will be deleted to soften the image). The number you enter varies depending on the size of the floating image and your image resolution. You'll have to experiment with it until you get the hang of it, but for now, try 5 or 10.

- 4. Click OK.
- 5. Cut and then paste your object back into the image.

When you have finished working on your image and you are delighted with it, you can flatten it before you save it. This reduces the file's size. Click the **More** menu in the upper-right corner of the **Layers** palette and choose **Flatten Image** from the menu that appears. The layers all merge together. Save your image, and you're done!

Soft Edges Make Pleasing Pictures

For a nice effect on images, try the following:

- 1. Pick a selection tool, usually the **Elliptical** or **Rectangle Marquee** tool from the **Toolbox**.
- 2. Set feathering to a number between 5 and 25, a higher number makes for a softer edge.
- 3. Select the main part of your photo and choose **Image**, **Crop** from the **Menu** bar. This trims the photo to just larger than the selection.
- 4. Finally choose **Select, Inverse** on the **Menu** bar and press the **Delete** key on the keyboard.

You should get a nice, soft-edged picture that fades out to the background color specified in the color swatch on the Toolbar, like the one in the next figure. Use of the Elliptical tool for this purpose makes an image you would commonly call a "cameo."

You can get away from same ol', same ol' square pictures with the soft-edge technique.

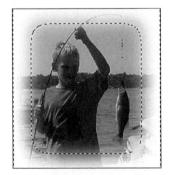

Putting It All Together: Panoramas

Sometimes a great scene presents itself, but your camera just won't let you capture it in one shot. Perhaps you don't have a wide-angle lens, or maybe using a wide-angle lens will cause undesired distortion or loss of detail. If you can take a series of slightly overlapping shots, Photoshop Elements 3.0 will reassemble them for you later.

Putting Images Together as One

Panoramic photographs can be visually stunning, but most of the time we just don't think about making them. In the old days, making panoramic shots required special, expensive cameras, and this prevented many from exploring their possibilities.

Now, through the magic of Photoshop Elements 3.0, anyone can make magnificent, sweeping panoramic images with just about any camera. You need not feel frustrated because your widest lens just isn't wide enough for the scene. For the example shown

in the color insert (Plates 1.24a, 1.24b, and 1.24c), I've combined some images of a broad vista seen from a Virginia mountain overlook. Even though I had a zoom lens on the Nikon D2x that went all the way to 12mm at the wide end, it still was not nearly wide enough to produce the image I wanted.

To take the photos I wanted to assemble I pivoted my body while standing in one place, making sure that each of the images overlapped the next one slightly. Photoshop Elements 3.0 needs this overlap to line up the images properly. Once you have the images in your camera it is time to load them into your computer and open Photoshop Elements 3.0 to begin the process.

Flash

Before taking pictures for this purpose, read this entire section. It will save you some of the trouble I go through here. Color insert Plates 1.24a, 1.24b, and 1.24c show three versions of the panorama I made. The top version shows the image immediately after it was combined, the middle one shows the panorama partway complete, and the bottom one shows the finished product.

Assembling the Panorama

From the **Menu** bar, select **File** and choose **Create Photomerge.** A dialog box like the one shown here will appear. It will contain each image that was already open in Photoshop Elements 3.0, but you can add more images if you need to at this time.

The Photomerge dialog box.

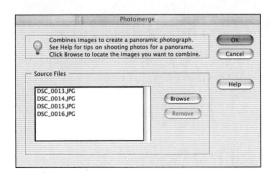

Say Cheese

If you don't have any documents open, you will get the Photomerge dialog box and will have to manually add images. If you are sure your images are similarly balanced for color, you don't need to take the time to open them individually.

After you have the correct images, click **OK** to create the merged photo. Depending on the number of pictures, you might have time to go say hello to your family while the program chugs away. It compares similar pictures' common elements and then makes an educated guess about how to lay the pictures atop one another to create the resulting image. It always astonishes me in how accurately it lines up the images by examining the areas where they overlap. I very rarely have to second-guess Photoshop Elements 3.0 to get things perfectly aligned.

Moving Images to the Proper Location

Miracle of miracles, the assembled image appears in a window that is also called a Photomerge dialog box (funny how two windows can have the same name, but some programmer decided it was okay), but for clarity we will call this second window the Photomerge workspace (see Plate 1.24a in the color insert). If a picture is misplaced, you can use the **Select Image Tool** (the **arrow button**—keyboard shortcut **A**) in the upper-left-hand corner of the workspace to drag it where it belongs. You will notice it becomes semi-transparent so you can easily align it. As you drop it back into the picture, if you have the **Snap to Image** option checked on the right side of the workspace, the picture should automatically align itself with the surrounding image and blend into it. If it doesn't quite align, try moving it ever so slightly again with the **Select Image** tool. If it still isn't quite right, you can make a minor rotation of it using the **Rotate Image Tool** (the **circle arrow** button—keyboard shortcut **R**) in the upper-left corner.

Removing Images

If you included an extra image by accident or just have too many images on the work-space to allow you to think, you can remove/dock the images by dragging them to the Photo Bin under the workspace. Images stored in this area may later be retrieved if you drag them back to the workspace.

Blending Your Images Together

If you are lucky, your images will blend together perfectly. I seldom have such luck! Fear not, however, because if you read this book carefully, you have the tools to solve the problem. Photoshop Elements 3.0 will try to blend the pictures together using common points it finds. I find that it is much better at matching them for alignment than it is for matching exposure or saturation settings. Once you've finished this step your results should be lined up perfectly, just as mine are in the second image (Plate 1.24b). You will notice, though, that there are some bands visible because the images vary slightly in density where they are overlapped. Checking the **Advanced Blending** box on the right will automatically correct for this. Select **Preview** using the button and see how it does. If you're happy with how Photoshop Elements 3.0 handled everything, as I am with the third and final image (Plate 1.24c), then your job is done and you can print and display your finished panoramic picture. If you are not completely pleased with how the automation handled your panorama, there are a number of tricks in the Photoshop Elements 3.0 collection that will let you fine-tune your project.

Using an Adjustment Layer

You might need to select the oversaturated section and apply an adjustment layer by choosing a Marquee or Lasso tool from the Toolbox for selection and then from the Menu bar choosing Layer, New Adjustment Layer, Brightness/Contrast. You might also try Enhance, Adjust Brightness/Contrast and select Brightness/Contrast. Use the sliders to adjust only the selected portion to make it blend better. Sometimes setting some feather to your selection will help soften any edges between the adjusted portion and the surrounding parts of the image.

Using the Smudge Tool

After applying some **Brightness/Contrast** correction, you might have a bit of an edge between the adjusted area and the surrounding image. Use the **Smudge** tool

from the **Toolbox** and use both the **Normal** and **Color** settings from the drop-down **Mode** menu on the **Options** bar (trial and error will usually help you find the right mix of these). Using the **Color** setting will drag a little color from one place to another to create continuity of color over any edge. Using the **Normal** setting will soften any edge in the image where contrast stood out. Lower the **opacity** on the **Smudge** tool, probably to the 7 to 25 percent range. Soft adjustments are best. Remember, if it has improved, save an intermediate copy every few adjustments. Also, you might want to increase the **Undo History States** (**Edit, Preferences, General, History States**) for this type of correction as the default is 50 undos. Because you are making many little corrections, you will quickly exceed that number.

Using the Clone Stamp Tool

If your picture doesn't quite match at the blend line you can use the **Clone** tool (covered in Chapter 18) to move a little of the scene back and forth over the blend line to create a better line and mask the smudge.

Restoring Color

In the blending process, you can adjust the color of the three photos to get a better blend. But be sure to restore the color to what my eye saw (or if that isn't good enough to make you happy, why stop at that). Using an unadjusted image as a reference, you can apply one or more adjustment layers (as explained in Chapter 20) to restore the saturation and brightness.

Perspective with Panoramas

Sometimes you will get a perspective distortion when using Photomerge that will make the horizon look as if it is warped. If this occurs, use the **Perspective** radio button on the left side of the workspace. This will allow you to specify one image in the mix as the center or vanishing point of the merged photo, and all other images will become linked to it. Use the **Vanishing Point** tool (keyboard shortcut **V**—the option is only available if **Perspective** is selected on the right) to pick which photo is the focal point. Sometimes this correction will create a bow tie effect, where the focal point image is squished and the surrounding images are stretched in height (this is how the correction was made). To correct this situation, use the **Cylindrical Mapping** option. Adobe's help section contains an example of this correction.

Fix Problems Before They Exist

One of the best things you can do is take good, consistent pictures to use for panoramas. If you have a tripod available, preferably with a panning head, use it. You want to pan side to side (or straight up—Photomerge works vertically as well as horizontally) without deviating from horizontal. Often people will try to keep the horizon or shoreline at a fixed point in the viewfinder, but as you pan, this will distort your picture when you merge it. Instead, make the images in a straight line. Try to keep the exposure and focus settings fixed, using manual settings instead of automatic aperture and f-stops. Finally, you should shoot for about 15 to 30 percent overlap between pictures. Less will make it more difficult for the program to find common points, and more might create bad blending.

Other Photoshop Elements Goodies

After you master the Photomerge technique, you should explore the program further. There are many other great features, such as animation and three-dimensional imaging and manipulation by rotating. Take your time, and you will find a lot to play with.

The Least You Need to Know

- Elements can rest on their own layers.
- Layers can be rearranged in their hierarchy.
- ♦ An element on a layer will cover the element on a layer below it.
- A layer can have opacity.
- Selections can be feathered.
- You can create beautiful panoramas using the Photomerge feature of Photoshop Elements 3.0.

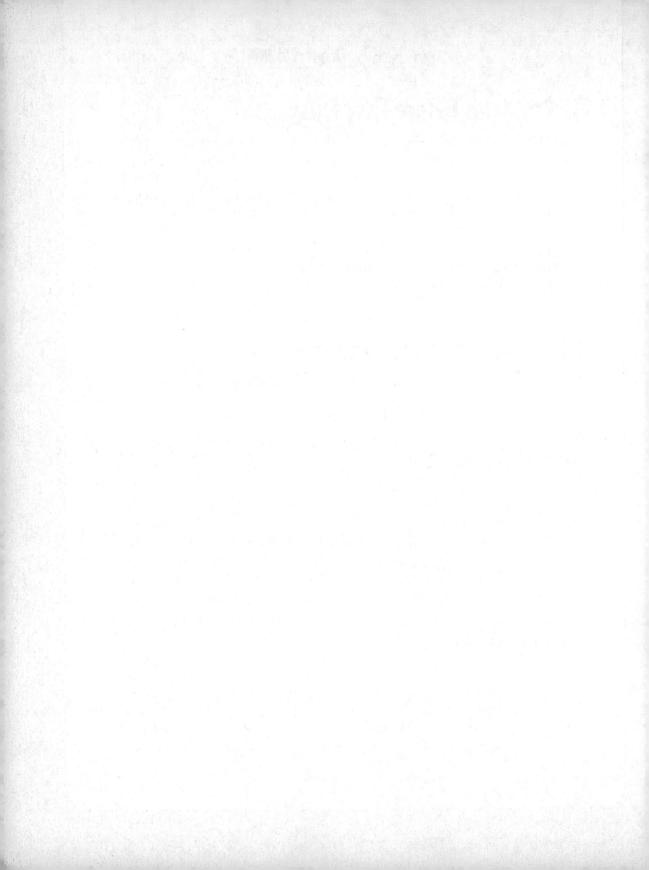

Filters and Effects

In This Chapter

- Learning about the many varieties of filters
- Applying filters to your image for the effects you want
- Applying multiple filters that can give you some unique results
- Making quick work of photo transformations

You can use filters to improve or add visual effects to your photos. Sharpening filters make your images look crisp and clear. Blur filters help you create effects such as depth of field and can help blend areas of your image together. Artistic filters can add texture, color, brush strokes, and a whole range of visual effects to your images. A whole range of filters is available to help you make your imaging experience fun and enjoyable.

Daddy, What's a Filter?

Filters are magical! Well, okay—to be honest, filters are simply mathematical formulas (called *algorithms*) that, when applied to an image, perform a specific task. That task can be as simple as finding every green pixel and changing it to red, or as complex as finding every pixel that has a neighboring pixel darker than it and darkening it. Some filters are easy to apply

to an image and take effect very quickly, whereas others cause your computer to grind away for many minutes. If you maxed out the possible RAM when buying your computer, you will be glad you did so when using filters. The more RAM you have, the faster filters will work their magic. If you find that the filters you like take too much time to run, consider adding more RAM.

Behind the Shutter

The most amazing—and most used—filters are the sharpening filters, which we covered way back in Chapter 14. These filters, and in fact much of digital photography, owe their existence to scientific and military research. The ability to single out a specific star amongst a cluster of constellations or to determine the crop yield of a Nebraska farm from space is all due to digital photography and the filtering, or sharpening, of digital information.

Whoa, There!

Filters can be a lot of fun to play with; making and applying special effects to your images can keep you busy for hours on end. You can create new "looks" for your images, and change their mood and intent. But before I let loose and describe all the wonders of filters, I must warn you that filters can be harmful to your images if you use them excessively or apply them too strongly.

Use filters sparingly. Let them add a sparkle or a subtle hint to your photos. Don't apply a filter just because you can. If you find that you need to apply filter after filter to make your image look better, you probably don't have a good image to start with. Leave your image alone, retake the image if you can, or go on to another image. When I teach digital photography or electronic imaging, I don't let my students anywhere near filters until they demonstrate creative composition and basic photographic skills. Filters should be used to enhance an already-sound image; they won't turn digital junk into image treasures.

Obtaining Filters

Photoshop Elements 3.0 includes a host of filters. If you are using a program that came bundled with your camera, it might also offer filters.

Most imaging programs, including Photoshop Elements, let you add additional filters. In fact, Photoshop Elements accepts any Photoshop plug-in. Many companies

offer specialized filters, or plug-ins, for your imaging software. For a pretty good list see www.thepluginsite.com/resources. (Filters are often called plug-ins because of the way they are added onto the original program code. Most programs have a folder called Plug-ins, where the filters are stored.) Some of these filters can be had for free, whereas others might cost \$150 or more. It is very common that popular filters offered by third parties are incorporated directly into the software in later versions.

Say Cheese

Some of the best Photoshop plug-ins come from Kodak. Kodak's Austin Development Center specializes in the development of plug-ins for photographers. You can download trial versions of their plug-ins from their website at www.asf.com. The most interesting recent plug-in from Kodak is Digital Gem Airbrush Professional, a plug-in that smoothes skin tones and reduces the appearance of facial blemishes without softening detail. It is really an amazing filter, and many portrait photographers wonder how they ever did without it. For those who make the move to Photoshop CS2, Kodak also offers some very useful Actions that are absolutely free. Actions will not run on Photoshop Elements. Hey, Photoshop CS2 has to do some things Photoshop Elements 3.0 won't do to justify its higher price!

Most third-party filter companies have websites from which you can get information and descriptions about their filters, so you might also try your favorite search engine. Many also offer a demo version of their product for you to download. In most cases, demo filters are limited in their functionality or durability—but you can be sure that there will be more than enough to whet your appetite. Note: before you buy a filter, try that filter's demo version so you can be sure that it will be able to run on your platform and with your specific version of software. It would be a shame to find out that the \$100 filter you just purchased won't work with your software unless you upgrade or spend money on hardware or operating system upgrades.

Let's Go

We could explore every filter ever made, but that would take a lot of time—and it would also take all the fun out of it for you. Instead, we will look at one or two filters in a few of the filter families or groups.

Adobe made using filters a lot easier when they introduced the Filter Gallery as part of Photoshop Elements 3.0. If you go to the Filters menu, you'll find the Filter Gallery as the first option. Selecting it opens the Filter Gallery, in which you can see all of the filters that came with Photoshop Elements 3.0 and a small sample showing what each one does. Selecting filters from this gallery is so much easier than trying to figure out from sometimes confusing names just what each one does. You must have an image open to access the Filter Gallery. When you click the thumbnail showing the effect, you will see the effect of that filter on your image in an image window within the Filter Gallery window.

The Filter Gallery makes it much easier to pick out just the right filter for the effect you want, since it shows you pictorially what each filter does, and lets you preview the effect on your image.

Here are some of the filters you will find in the Filter Gallery. You can create unlimited variations in your images with these filters.

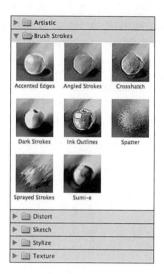

More of the filters in the Filter Gallery. There are so many filters that you can really go wild working with them. Just remember not to overdo it when applying filters to an image.

When working with filters, keep the following in mind:

- Most filters in Photoshop Elements 3.0 can be found in the Filter Gallery.
- ♦ You can apply filters to an entire image or you can isolate an area of an image and apply your filter only to the selected area.
- If you don't like the result of a filter, immediately undo it by pressing Ctrl+Z/Command+Z.
- If you play with the settings of a filter and then want to revert back to the
 defaults for the filter, hold the Alt key down and click the reset button that
 appears.

Say Cheese

You can zoom in or out of the preview box by clicking the + or - button below the box. If you put your cursor on the image inside the preview box, you can drag the preview to view a different section of your image. This comes in handy when you want to check an effect on a specific part of your image. Left-clicking in the preview window will toggle you back to the pre-filtered image so you can compare, and releasing will toggle back to the preview of the post-filter result.

The filters are grouped in the Filter Gallery by type. Any plug-in filters you add are generally placed at the bottom of the list. Only specially designed plug-ins will

display a preview thumbnail in the Filter Gallery. Without further adieu, the categories as listed in the following figure are: Artistic, Brush, Distort, Sketch, Stylize, and Texture.

Other filters that are not included in the Filter Gallery can be accessed directly on the drop-down menu when you click on **Filters**. There you'll find the following filters: Adjustment, Artistic, Blur, Brush Strokes, Distort, Noise, Pixelate, Render, Sharpen, Sketch, Stylize, Texture, Video, Other, and *Digimarc*.

These are pretty much self-explanatory except for Digimarc, which isn't a filter in the usual sense.

In Plain Black & White

Digimarc is a system used by photographers and others to embed invisible copyright information in their images. If you have an image you downloaded from the Internet, got from someone else, or got in some other way, clicking on Digimarc in the Filters menu will run a check on the image and look for any embedded Digimarc information, and display it in a window if any is found. You can also join Digimarc (www.digimarc.com) and get software to embed your own copyright information in your image to prevent theft.

The best way to access your filters is by looking in the Filter Gallery. Under each category of filter there are filter choices. Notice that whatever filter you last used appears at the top of the menu (Ctrl+F or Command+F) but if you click on it there, it will only be applied with the same settings used last time.

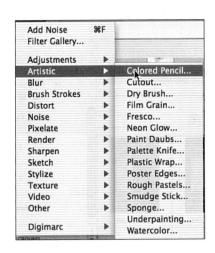

Artistic Filters

Artistic filters add effects over the top of images, such as colored pencil strokes or glowing colors. Photoshop Elements 3.0 has many different artistic filters; here, we'll take a look at the Colored Pencil filter.

- 1. Open an image that you think would look nice as a pencil drawing; one with some contrast and color usually makes for a good choice.
- 2. In the Filter Gallery choose Artistic, and select Colored Pencil.
- 3. The **Colored Pencil** dialog box opens as shown in the following figure; click and drag the three different sliders to vary the filter effect. The preview area lets you see how the filter effect will look before you apply it to the entire image.
- 4. Click **OK** when you like what you see in the preview box.
- 5. Open the **File** menu, choose **Save As**, and rename the image to preserve the original.

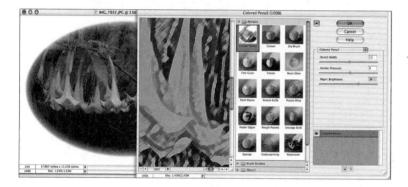

Many filters use dialog boxes with preview areas to help you visualize the filter's effect before you apply it.

Blurs

Usually, blur filters are used to improve image quality. However, in some cases, such as with the Motion blurs or Circular blurs, very nice effects can be rendered:

- 1. Open an image whose foreground object could use a little acceleration.
- 2. Open the Layers palette by selecting it in the Filter Gallery.
- Duplicate the background layer by clicking and holding while pulling the background layer thumbnail down over the Page icon at the bottom of the Layers palette.

- 4. Click the duplicate layer in the stack in the Layers palette to activate it.
- 5. Although you can apply this filter to the whole image, it is often best if you select some portion of the image (see instructions in the following activity) that you want to keep unaffected and then open the **Filter** menu or **Filter** palette, choose **Blur**, and select **Motion Blur** to apply the filter to the balance of the active layer.
- 6. Adjust the settings however you like, and click **OK**. It is usually best if you can keep the motion in the direction of travel for moving objects like we did with the runner in the following figure, but if you are simply seeking depth of field, direction of motion blur is discretionary.

You can leave a portion of your image unaffected by a filter. Try selecting only a portion of your image and applying the filter.

Everything outside the selection area remains unmodified. You can make something look like it is really moving. In this case I used the Magnetic Lasso tool several times to select the subject and turned an overly busy background into a canvas to show speed.

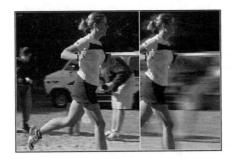

To capture only your subject, you need to select the correct selection tools, keeping these points in mind:

- 1. For a square, rectangle, oval, or circular object, try the **Marquee** tools from the **Toolbox.**
- 2. For a solid color object, use the Magic Wand tool from the Toolbox.
- 3. For a person, car, plane, train, tree, etc., use the **Magnetic Lasso** tool from the **Toolbox**, clicking where you need to hold a hard point, and trusting the magic for the rest. You can also try the **Lasso** or **Polygonal Lasso** tool. Remember, you can add and delete from the selection by using the middle two of the four icons on the **Options** bar between the tool selection icons and the Feather option.

- 4. After selection, invert the selection with Select, Inverse on the Menu bar.
- 5. Apply the blur filter and get amazing results.

Smudge Tool

Similar to blurring, the **Smudge** tool, which is located on the **Toolbar** and looks like a pointing finger, allows you to smudge and smear areas of your image (see the following figure). The **Smudge** tool grabs either the pixels under the brush (regular mode) when you first click, or uses the foreground color in the Toolbox color swatch (in finger paint mode—when the checkbox in the **Options** bar is selected) and drags the color through the image after the cursor. (You can re-click to grab more color and go over an area a few times to enhance the effect.) The **Options** bar lets you pick the smudge's size and fuzziness; no color selection need be made unless you have finger painting selected. I have the best luck with this tool when I create a duplicate copy of a layer to smudge and then turn down the duplicate layer's opacity after smudging in the Layer palette.

Using the Smudge tool gives images an artsy, windblown effect.

Texture Filters

Okay, before we move on from filters, let's dig in to one more category, Textures. Texture filters can be a lot of fun and can be used to create many wonderful backgrounds or interesting effects. Don't be afraid to experiment. The Texture filters that come in Photoshop Elements 3.0 are Craquelure, Grain, Mosaic Tiles, Patchwork, Stained Glass, and Texturizer.

Say Cheese

You don't have to use the filters I have chosen for this demo; use any ones you want. By all means, experiment!

- Open an image using File, Open or Window, Browse from the Menu bar.
- Either open the Filter Gallery, the Filter palette from the Palette well, or use Filter, Texture from the Menu bar.
- 3. For the next figure, I tried two different Texture filters, the Mosaic Tile and Patchwork filters.

The Texture filters can give many different looks to one image. The one on the right, Mosaic Tile, looks as if it was printed on a textured surface. The one on the left, Patchwork, looks as if it was created by needlepoint.

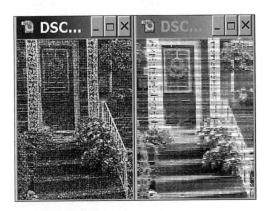

Demo: Applying Multiple Filters

You can use more than one filter on an image. By applying one filter on top of another you can build some interesting effects:

- 1. Open the **File** menu from the **Menu** bar, choose **New**, and create a new image that is 4 inches wide, 5 inches tall, and 72dpi.
- 2. Select the entire image using Ctrl+A/Command+A or the Selection, All choice on the Menu bar.
- 3. Set the foreground color by setting the toolbar color swatch to a primary color; then go up to the **Edit** menu on the **Menu** bar, select **Fill**, and fill the entire image with the solid color.
- 4. Look in the Filter Gallery and select Add Noise.
- In the Add Noise filter dialog box, click the Gaussian Blur option button, and type 155 in the Amount field.
- 6. Click OK. Either shag carpet or a nice background!

Start with a solid color back-ground.

- 7. Using the **Rectangle** selection tool, select about two thirds of the center of the image.
- 8. Open the Filters menu on the Menu bar, choose Blur, and select Motion Blur.

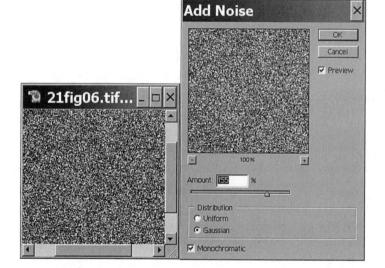

Noise filter applied to solid color background.

- 9. Adjust the settings however you like in the **Motion Blur** dialog box, and click **OK** to get something like the previous figure.
- 10. Again using the Rectangle selection tool, select an area inside the blur area.
- 11. Open the **Effects** menu, choose **Distort**, and select **Ripple** to apply the Ripple filter to the image. Your results, which are subtle, should look like the following image.

After applying a motion blur to the selection, go for a ripple.

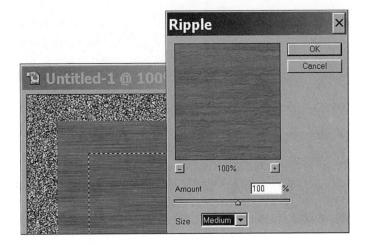

Create Your Own Filter

If you don't find quite what you want for a filter, or find yourself doing things manually over and over, consider making a custom filter. On the **Menu** bar choose **Filter**, **Other**, **Custom**. A **Custom** dialog box will appear, which at best is obtuse as to what it does. In quick form, there is a column and row matrix containing 25 text boxes. The center box represents a pixel in the image that is being evaluated by the filter. The filter will step through the entire image using the matrix and mathematically adjust the brightness of the pixels. The surrounding boxes adjust brightness relative to the evaluated pixel. There is a range for the brightness multiplier of –999 to +999. Less significant numbers are usually in order. Adobe suggests that you try to keep the sum of all numbers at or near 1 to avoid a completely black or white result. I find that most sets that I like have a scale number that equals the sum of the array set. As you increase the sum in the array boxes, you get a lighter image, and as you decrease it, you should get ... you guessed right, darker. You don't have to include a multiplier in every box. Those left blank will be unaffected.

This is big-time trial and error, but when you figure it out, you can do some very cool things. When you get one you like, you can save it and reload it later. An example matrix of values I found on the Internet suggests this to give a slight blur:

0	1	2	1	0
1	-1	-2	-1	1
2	-2	4	-2	2
1	-1	-2	-1	1
1	1	2	1	0

Play with the Scale number and you will get a smoother blur as you increase the number. You can also play with the offset, which will tend to lighten/darken the image. Both are mathematical formulas being applied. The folks at Adobe say, "for scale, enter the value by which to divide the sum of the brightness values of the pixels included in the calculation." Now there is plain English—not! Suffice it to say that there are whole books on this stuff, but the beauty is you can fiddle and learn as you go like I did in the following image. I used 8 for Scale and 0 for Offset. Save it and you will see it is saved as an .ACF file. I created a special folder to keep these in.

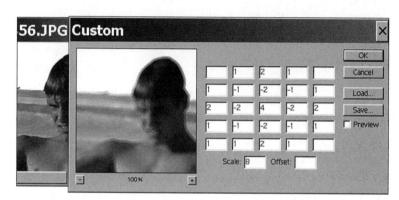

Use the Custom Filter dialog box to adjust your images. This shows the before (left) and after (right) because the preview box has been unchecked.

If you look on the Internet you will find recipes for these types of custom filter settings to achieve looks you want. Let's try one more; this one is for smoothing:

0	1	2	1	0
1	3	4	3	1
2	4	9	4	2
1	3	4	3	1
0	1	2	1	0

The sum of these numbers is 53, enter that into the Scale box and leave Offset at 0. This is actually an approximation of a Gaussian blur. See what it does, and save it if you like it.

Effects Make Quick Work of Photo Transformations

Photoshop Elements has a whole other bag of tricks up its sleeve called Effects. Many effects are just filters with specified settings, or even a combination of filters. Others

Flash

If you are working on a vector image (such as shapes, type, or layers containing one or the other) with the Effects, you will first need to simplify, meaning convert to raster, before the Effect will take hold. Photoshop Elements will ask if you want to, but understand that after you convert to raster, you cannot convert back.

are new tricks you haven't seen before. No matter what form they take, they bring power to your image processing. There are really three types of Effects:

- Selection
- Layer
- Type

Selection Effects work on any selection you have made in your image, which can, of course, include the selection of the entire image. Layer Effects work only on the active layer or layers. Type Effects work on text.

Let's Have an Effect!

One of my favorite things to do is to take a nice image and put a border around it. The Styles and Effects palette offers many good framing choices for those who prefer not to make their own. To open the Styles and Effects palette, drag it from the Palette well. Click the left drop-down menu and choose Effects, then click the right drop-down menu, and choose Frames. I particularly like foreground color and brushed aluminum. However, take a look at them all.

Let's try one more. The Fluorescent Chalk filter can make some interesting photo effects, as shown in the next image. Note that the Effects work without any options at all. They just do their thing and you either like what you get, or not. If you don't like it, you can just undo it.

You can make some interesting photos with Effects, such as this one created with the Fluorescent Chalk Effect filter from the Filter palette.

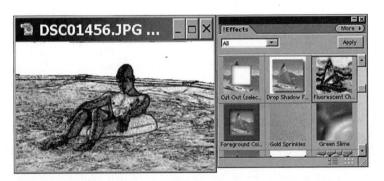

The Least You Need to Know

- A filter is a mathematical algorithm that is applied to the image.
- ♦ You can purchase third-party filters or even make your own using the Custom Filter dialog box.
- ♦ You can select areas of your image to filter and also protect areas from being filtered.
- ♦ You can use multiple filters together on the same image.
- ♦ You can use Effects to whip up some great image enhancements.

Chapter

What You See Is What You Get: Calibration

In This Chapter

- Taking the frustration out of color calibration
- Calibrating your monitor, not your eyes
- Calibrating your printer
- Making an educated guess
- Tagging images for color management

The next time you are in an appliance store, take a good look at all the televisions lined up next to one another. You will notice that every screen in the store looks different! Some are dark, some are light, one is too green, and another has too much contrast. But which one has the right color? Which one do you prefer? Is the one you prefer the right one?

You have run smack into one of the most aggravating problems of digital photography: color management. How do you know that what you see on your monitor is correct? If the image looks good on your screen, will it look good on someone else's? Will it be too dark, or too green? Will the contrast look right?

Color management doesn't end at the monitor; printers can also wreak havoc. Every printer reproduces an image differently. You can go to a computer store and print the same image on three different brands of printers, and get three totally different results. In fact, you can take three printers of the same model and get three differentlooking prints. This problem with color varying from one device to another is called device-dependent color. If left untouched, each monitor will do as it pleases and printers will follow. Soon we will have color anarchy! But have no fear. Color can be successfully and easily managed so it becomes device-independent. With a little bit of testing and careful planning, you can get consistent and predictable results every time, regardless of the monitor or printer you are using.

How the Pros Do It

To get a good idea of how color management can be achieved, I am going to talk you through a system that professional photographers and printers use. I will then explain how you can use it without too much trouble. This system not only provides consistent color, but also allows for different devices (monitors and printers) to be swapped in and out and have the color results remain the same. We're going to get a little technical here for a while, so don't worry if you get confused. Just sit back and relax. It will all make sense in the end.

(IE

Suppose you took all the colors that the human eye can perceive and globbed them all together in a three-dimensional space, such as a cube, sphere, or even a pyramid.

To describe where a color exists in that space, you can use a system based on three axes: Luminance (or lightness), A (green-red), and B (blue-yellow). In this manner, you can accurately describe where a specific color is in the color space. For example, suppose that the color Fire Engine Red exists at 44-L, 25-Y, and 100-Z. (I made these numbers up; don't go looking for them!) As long as this color world stays consistent from person to person, the coordinates used to describe the location for the color Fire Engine Red will be the same for each person. Because this point in the threedimensional color world exists, it can be accurately described and it is deviceindependent.

Well, in 1931, the folks in the Commission Internationale de l'Eclairage (CIE) made up a color world like we just did, and in 1976, that model for color was updated. They call the model CIE LAB color system. It theoretically displays every color perceived by the human eye and allows us to specifically describe each color. As long as everybody uses the CIE LAB space and its numerical description for finding colors,

everybody will be looking at the exact same color when given its description. That is, when we are told to look at 65-L, 62-A, 64-B (orange), we will all be looking at the same color. This consistent approach to describing color is the key to color management, in that you can use this color model as a constant, or control, to compare other colors and color devices.

Behind the Shutter

All through this book, I have been talking about RGB color spaces. So, why all of a sudden am I hawking CIE LAB? Here's the deal: RGB color spaces describe how much color is present because it is an additive method. The RGB color space describes how much red, green, and blue light is present—in the case of a monitor, how many pixels are illuminated and at what intensity. We have not talked much about the CMYK color system, which is used in printing, but it describes how much cyan, magenta, yellow, or black ink is on the paper, so it is additive.

The problem is that different monitors use more or fewer phosphors to produce the same color. On monitor A, you might need 235R, 28G, 28B to produce Fire Engine Red. On monitor B, 235R, 25G, 31B will produce the exact same color. In a like manner, for CMYK, different quantities of ink are used by individual printers to reproduce the same color.

Because the RGB and CMYK color worlds measure how much phosphor or ink is needed to reproduce a color, both systems are considered device-dependent. Depending on the device, a color's description changes according to what is needed to reproduce the color. Because the CIE LAB space describes where a color is in its color world and not how much ink or how many phosphors are needed to render the color, the color space is considered device-independent. No matter what device is used, Fire Engine Red will look the same—although different devices will use differing amounts of inks or phosphors to reproduce it.

So now what? The answer is simple—we calibrate your monitor and printer to the device-independent CIE Lab color system and your monitor and printer will then render colors to perfection. Think of it as cross-indexing. This chapter tells you how to do it.

ICC Profiles

Using the CIE LAB color space, you know how to describe every color we want, including Fire Engine Red. Now that you have a target to aim at, you need a method to tell you how far you are from that target. The International Color Consortium (ICC), which is made up of a group of eight industry leaders—four of which are Kodak, Adobe, Apple Computing, and Agfa—developed a method to do just that. When we know how far off we are, we can make a correction and index it so that the color is perfectly rendered.

The ICC system is simple. With it, you can calibrate every device that handles color. To begin, you display series of colors for which you know CIE LAB coordinates on your monitor or printer (I'm using a monitor for this example). After a color is displayed (say, for example, that you're displaying color L-100 A-80 B-60), you could use a monitor calibrator to measure it. The calibrator reads the color displayed by the monitor, and describes it in CIE LAB space. So suppose the L-100 A-80 B-60 color you sent to your monitor measures up on your screen as L-98 A-80 B-60. What do you do, panic? Nope, you're a professional. You take note that your monitor is -2 from your CIE LAB space. This notation is called an ICC profile.

Of course, you probably don't have a monitor calibrator handy, so what next? The answer lies in pre-defined ICC profiles that manufacturers now develop for each device, or by creating a custom profile using your eyes. By using the standard profile for your device (you might need to get it from your manufacturer if it is not in the documentation), you can make the correct adjustments with almost as much precision as the pro downtown who bought a fancy schmancy calibrator. You will come pretty close using just your eye.

Calibrating Monitors and Printers

If you really want to spend the serious money, you can buy a professional grade monitor with a calibration package and monitor calibrator included. You may also purchase calibrators and software separately. These devices and software might range in price from \$100 to \$1,000. Unless you are very serious about your color, or are a professional photographer, a low- to midrange calibrator will do.

Fortunately, with standard profiles now widely available and monitor calibration software included with Photoshop Elements 3.0 for Windows and standard on a Macintosh, the average person can do just fine without any of that!

Calibrating a Monitor with Macintosh/Windows

A rose is a rose is a rose, but let's be sure a red rose is red and a yellow rose is yellow. Let's get to work. Macs have a Color Sync control panel, which coordinates, keeps track of, and implements all the profiles you have. (A similar tool is found on Windows systems.) The ColorSync control panel reads the profile you have for your monitor. "Ah hah," it says, "according to its ICC profile, this monitor is -2. I'm going to add 2 to everything that the computer sends to the monitor. That way, the color #100 will look like it is supposed to." Pretty smart little control panel!

Every calibration system is going to go about the calibration task a bit differently, but here is the basic procedure:

- 1. Warm up your CRT monitor by using it for about a half-hour. You do not need to warm up LCD monitors.
- 2. Start your calibration software. For a Mac, use your Color Sync control panel, accessed via Color Sync in your System Preferences; for a Windows machine look in your Program Files/Common Files/Adobe/_Calibration folder on your hard drive. It might also have been placed in your control panel. Click Adobe Gamma as is shown highlighted in the following figure. On a Mac you will probably want to select Adobe RGB (1998), as this is pretty much the industry standard.

Because Apple computers incorporate sophisticated color management, Mac users can skip ahead to the section on calibrating printers.

- 3. In Windows choose **wizard** and click **Next**, but if you select control panel by mistake there is a chance at any time to go to the wizard for instructions.
- 4. Follow through the wizard screens, which will ask you to choose a profile for a starting point. If you are unsure of your ICC profile, use the one that appears; otherwise, click the **Load** button and find your profile.
- 5. Click **Next** and you will be presented with brightness and contrast settings as shown in the following figure. Do as it asks and click **Next**.

Start the Adobe Gamma utility, which comes packed with Photoshop Elements, to begin calibration on a Windows system. Use the wizard to find a setting that makes the center square nearly black while keeping the outside ring white.

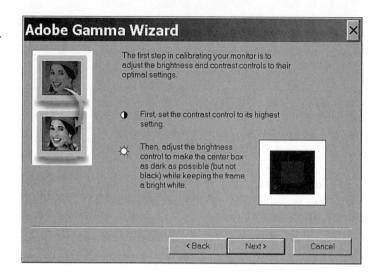

- 6. Pick your phosphor settings if known (you should be able to find this in your monitor documentation or get it from the manufacturer, but if not, use custom) and click **Next.**
- 7. Uncheck **View Single Gamma Only** and you will get the red, green, and blue channels. Use the sliders to make the center boxes match as nearly as possible the surrounding ring of striped color as shown in the following figure. When you have it set, click **Next**.

Make the three color channels match the outer rings with the sliders in this step. For the gamma you can use a number between 1.0 and 3.0, but you should probably best use the Windows default.

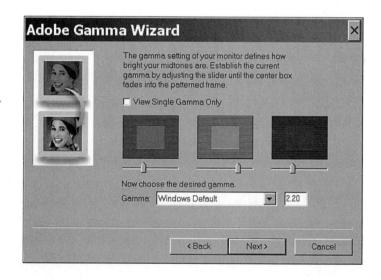

- 8. Measure the Hardware White Point (with the lights out) by selecting the most neutral gray square, and read the instructions carefully as you progress through this step.
- 9. You will also be asked at this point if you prefer to work at a different white point than the calibrated point. It is best to say no in most cases. Click Next to get to the last step!
- 10. You now can toggle back and forth before the adjusted and pre-adjusted settings using the toggle buttons as shown in the following figure. If the adjustment looks good, click **Finish.** Otherwise, you can click **Back** to redo a step or click **Cancel** to leave all well enough alone.

Behind the Shutter

It is important to note that the ColorSync control panel does not change the original file. It changes only how it is reproduced on the screen or the printer. When the file is sent to someone else's printer or monitor, and that person has calibrated to ICC profiles for his or her devices, the file will reproduce just the way it did on your system.

After you calibrate, don't rest on your laurels. Monitors slip further with age, so periodically recalibrate. As you begin to understand calibration more clearly, you can use the Control Panel method.

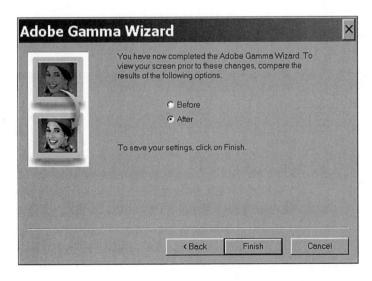

You get a chance to see the changes before confirming them. Toggle back and forth between the current and proposed calibrated state before accepting it.

Experienced calibrators can skip the wizard and work their own magic.

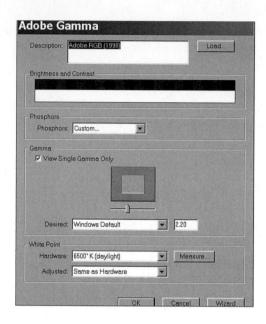

Calibrating a Printer with Macintosh/Windows

Some printers now come with calibration tests included with the bundled software. It usually involves diagnostics where you print a test page and then pick a set of color swatches that match with established colors/patterns.

The pros can do it the fancy way using printer calibration equipment to index to CIE LAB values. You make a printout and measure the printout with a printer calibrator, such as the one shown here. The calibrator, with a little help from some software, develops an ICC profile for the printer. For example, my printer reproduces the color #100 as #110, which means it has an ICC profile of +10. So when my system sends color to be printed, it subtracts 10 from the color as it is shipped to the printer.

Say Cheese

You can embed an ICC Profile
(Windows) or Color Profile
(Mac) in an image using File,
Save As from the Menu bar by
checking the correct box. This
will force the correct color as
your printer is calibrated.

Fortunately for the rest of us, it is no longer that tough! Photoshop Elements 3.0 now includes color management. Follow these steps:

- 1. Choose **File**, **Print Preview** from the **Menu** bar.
- 2. Select **Show More Options** below the image preview by checking the box.

- 3. Choose **Color Management** from the pop-up menu and make a selection as is appropriate for the type of printer you have.
- 4. Finally select a rendering intent, usually **Perceptual** for photographs.

Manual Labor: Printer Calibration Made Hard

If you can't use a recent Photoshop program or ICC profiles, you're going to have to calibrate by hand:

- 1. Calibrate your monitor as explained previously.
- 2. Cut and paste the Monitor calibration file into the image you opened; name the file **Original Image.**
- 3. Print the Original Image file.
- 4. Compare the print to the onscreen image. If it is an acceptable match, you are done. If, however, you feel the print is bluer and, say, darker than your onscreen image, you have some more work to do.
- 5. Copy the onscreen image and save it. Name the copy Test #1.
- 6. Adjust the color of the Test #1 image (refer to Chapter 14) so that it is less blue (more yellow) and lighter. The idea is to drive the onscreen image the opposite color of your print. (If your image is too red and too light, drive the test image toward green and make it darker.) You might have to adjust the contrast, also.
- 7. Keep track of the amount of color you added or subtracted from the test image, and how dark or light you made it. Jot this information down on a piece of paper—better yet, tape it to your monitor. Call these changes your "calibration set," which you will be applying manually as follows.
- 8. Print out the Test #1 image.
- 9. Open the Original Image file; close the Test #1 image or hide it from view. Does your new print look closer to the Original Image? You might have to go through this test a few times until you get a good result (remember to keep track of your color changes).

Applying this system is easy:

- 1. Adjust and manipulate any image you want to print, so that it looks best on your screen.
- 2. Save the image.

- 3. Before you print the image, apply the color, brightness, and contrast calibration adjustments you made previously. (Refer to your calibration set.)
- 4. Print the image.
- Your printed image should look like the image you had on the screen before you made your calibration changes.

I realize that this is a contrived and weird way to print out an image, but it works. You might find that your calibration set varies with different images, but it's a good starting point.

Tag Your Images with Color Calibration Information

Remember playing tag as a child? Maybe you haven't grown up yet and just played last week. If you are good at tag, you usually choose in advance the target of your strike. You then chase that target with purpose until you can tag it. Image color management is much like this. If you know in advance the purpose of your image, web or print, you can embed information in it which makes it more likely to be reproduced device independently if you send it forth into the world for someone else to work on.

With an image open, choose **Edit, Color Settings** from the **Menu** bar (or the shortcut **Shift+Ctrl/Command+K**). You then can choose **No color management** (seems silly, why did we open this dialog box?), **Limited color management** (which optimizes your image for onscreen viewing), or **Full color management** (which optimizes it for print). The difference is that onscreen uses the additive RGB color model and print uses CMYK subtractive color.

The Least You Need to Know

- Device-independent color can be achieved by using ColorSync or Adobe Gamma, both of which employ ICC profiles.
- If you have older printing equipment, you must calibrate your system and apply the color management manually.
- ♦ You can make ICC profiles for your monitor and printer using a color calibration meter if you are that serious, but for most people, available software now enables you to get it close enough using your eyes to calibrate.
- You can tag images with ICC profiles to optimize them for print.
- You can tag images with limited color management information to optimize them for onscreen display.

Part

Output

Seeing your image glowing on your screen is fun. Printing out your image is even more fun. Producing a beautiful print that is "suitable for framing" is a rewarding experience.

Printing is easy to do. By applying calibration techniques, you can make prints that look just like your monitor screen. What's more, you can repeat your results as many times as you like. Just think—you will never have to buy another greeting card again. Just flip on your printer and make your own!

Print It Out

In This Chapter

- Printing your images
- Making multiple copies
- Printing directly from the camera
- Making contact sheets

The only thing more exciting than seeing your image appear on your screen is seeing it emerge from your printer.

In Chapter 5, we reviewed printers and described the benefits of the various technologies. Now let's take a look at how to print out your images. Printing is fast, fun, and easy!

Get Connected

Before you spend a lot of time, paper, and ink, you should familiarize yourself with your printer. If your printer is not yet connected to your computer, connect it now—follow your printer's setup instructions and be sure to load all the printer drivers (computer-to-printer instructions) into your operating system. All printers should come with an installation

Behind the Shutter

Back when "real" printing presses were used, resolution (or dpi) was determined by how many dots could be resolved on the negatives from which the printing plates were burned. (Negatives were made and then contact printed, or burned, onto a metal plate. The metal plate was used to transfer ink to the blanket, which, in turn, transferred the ink to the paper.)

program that will automatically install the printer, or at the very least guide you through the installation process. Be sure to read the instructions before connecting your printer to your computer, because in many cases you need to install the printer driver software before connecting the printer to the computer.

It can be very frustrating to try to print out a photo from your imaging software only to have your printer sputter ink and spit out paper shreds. Try testing your printer out on familiar software, such as your word-processing software. That way, you will eliminate any questions about whether you have properly installed your imaging software. Chances are good that if your word-processing software prints correctly, your imaging software will, too.

Resolution: One More Time

I have talked about image resolution many times in the book; this is where it all pays off. If your image doesn't have enough resolution (that is, if your file isn't big enough), you are not going to have good printed results. Your images are going to look *pixilated*, or lack sharpness. Without enough digital information, you won't see much in the way of detail. To put it more simply, garbage in ... garbage out!

Printer Resolution Versus Image Resolution

You measure a printer's resolution by counting how many dots the printer can reproduce on a line one inch long. This is referred to as *dots per inch*, or *dpi*, and has pretty much been the standard of measure for a long time.

Put simply, ppi, or pixels per inch (image resolution), does *not* equal dots per inch (printer resolution). Many printers can resolve many dots for each pixel in the image. Your best bet is to read your printer's instruction book to find out the optimal pixel-per-dot ratio. Also note that you might find the info on the box as one of the listed selling points.

Behind the Shutter

Modern computer printers can resolve smaller and smaller dots than ever before. You might see printer manufacturers hawking Micro Dot, Tiny Dot, or even Teeny Weenie Dot technology. This differing terminology sometimes makes it hard to compare one printer with another. Unfortunately, the only real way to tell which printer makes the best prints is to test them and compare the results.

After you have found the optimal ppi for your printer, you can determine how large you can make your print. If you reverse the process, you can find out how big your file needs to be to make a specific-size image. For example, say your printer likes to see a 300ppi (remember, that's pixels per *inch*) file. If your file measures 675×1,200 pixels, your output print will measure 2.25×4 inches (675 pixels ÷ 300 pixels per inch = 2.5 inches; 1,200 pixels ÷ 300 pixels per inch = 4 inches). In the same manner, if you want to print out a 6-inch-long image on that same printer, you will need a file that is 1,800 pixels long. In most cases, or when in doubt, assume that your printer likes to see 300ppi file resolution.

If you lower this ratio, you will start asking your printer to print at a less-than-desirable resolution, and your prints will look the same: less than desirable. For example, if you took that same $675\times1,200$ file and printed it out to be 5 or 6 inches long instead of 4 inches, your prints would look less than optimal. You would start to see pixilation and fuzzy images.

In Plain Black & White

When you bring your file to a commercial printer, yet another standard is used to determine file size and resolution. Commercial printers establish the resolution of a printed piece by counting how many lines (of all those dots) per inch can be printed. In trade lingo, this is called **lpi**. Ask your printer (the human one) what lpi he will be using. The standard ratio between dpi and lpi is 2:1, so if the job will be printed at 150lpi, your file should be 300dpi. If this gets really confusing, ask your printer how big your file needs to be for him to print the job at the size you've specified.

Let's Print!

To print your image from within Photoshop Elements 3.0, do the following (note that you should read Chapter 22, if you haven't already; you will be glad you did):

- 1. Open your final, ready-to-print image. (That was easy.)
- 2. Use your selection tools to select the area of the image that you want to be printed. (If you want to print the entire image, don't select anything.)

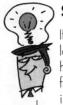

Say Cheese

If you haven't yet flattened the layers of your image, you can hide layers to prevent them from being printed. For more information about hiding layers, refer to Chapter 20.

- 3. Open the **File** menu and choose **Page Setup** to open the **Page Setup** dialog box (this dialog box might vary from printer to printer, and might look a little different depending on whether you're using a Mac or a PC).
- 4. Select which printer you will be printing to, and what paper size you will be using. Also select which way you want the image printed on the page, usually by clicking on a drawing.
- 5. If you have not yet done so, set your image size and resolution. Do this by entering the appropriate information in the **Photo Size** dialog box (to view this dialog box, open the **Size** menu and choose **Photo Size**).

Set your paper size and image orientation in the Page Setup dialog box. This box will look different depending on which printer and printer driver you are using. Relax, go with the flow!

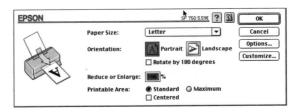

- 6. Preview the image to see how it will fit on your page. (This is a great way to avoid wasting paper!) Open the **File** menu and choose **Print Preview.** The choices you made in previous steps will affect how the page looks (if you need to, readjust your paper size or page orientation), and will become the default settings until you change them again.
- 7. Okay, let it rip. Open the **File** menu and choose **Print** (alternatively, press **Ctrl+P/Command+P**) to activate the printing process.

The print preview will help you avoid making costly printing mistakes.

8. The **Print** dialog box pops up on your screen. (This dialog box might differ depending on what type of printer you have; many of the options should be present, but arranged differently.) There are many options to play with here; you can choose paper quality, dpi, color inks, and the number of copies you want to print.

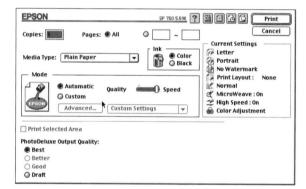

The Print dialog box will let you select the options for your printer.

Printing Multiple Copies on One Page

It is a shame to waste paper, especially the good, high-quality, expensive stuff. If your image is small, why not print up a few on the same page? It will take only a few

moments more to do, and you'll have copies to give out to all your friends. After all, everybody wants to see a picture of your kid's first bath (just as much as you wanted to see a picture of their kid's first haircut!).

If you have a copy of Photoshop Elements 3.0 installed, you are in luck. You can print multiple copies on a single sheet by opening the **File** menu, choosing **Print Layouts**, and selecting

Say Cheese

The paper size is important.

If you are printing on a smallerthan-normal sheet of paper or
on an envelope, you need to
fill in that information. Otherwise, you might find your printer
loses track of the page count and
is not feeding paper correctly.

either the **Contact Sheet** or **Picture Package** option. The Contact Sheet option takes a folder of images and prints them into small thumbnails with a number of them on a single page. The Picture Package option lets you print out one or a number of images in various finished formats, a lot like what you get from a photographer's studio or Sears's Picture Studio.

For those of you using Photoshop, I offer a simple solution:

- 1. With your image open, open the **Layers** palette (**View**, **Layers**). Make your canvas size the size of the paper that you will be printing on (**size**, **canvas size**). Label that layer **canvas size**. Determine how many of these precious images you can fit on one page by sizing them. Remember to leave a little room on the edges of the page and to include space between the images.
- 2. Make as many copies of the original layer as you need (if you can fit four images on the page, make four copies). See Chapter 20 if you need help with this.
- 3. Activate the bottom original layer (the one labeled "canvas size").

Say Cheese

If you haven't printed out your image before, I suggest that you make only one copy to start with. Then, if you like the way it printed, go ahead and make as many as you like.

Say Cheese

Need help aligning the

images? Turn on the rulers along the side of the print by pressing Ctrl+R/Command+R. If you look carefully, you will see a small indicator in the rulers that show your cursor's position; this can aid in the positioning of your copies.

- 4. Press **Ctrl+A/Command+A** to select the entire layer.
- 5. Fill the layer with white. This will serve as the base or background color for your page, and will ultimately be the border of your print. (See Chapter 17 if you need help with this.)
- 6. Activate each copied layer, moving each one into position on the page. Remember to leave space between each print for a border. (If you want a ¼-inch border around each print, leave a ½-inch space between the pictures because you will be cutting this border in half when you separate the prints.)
- 7. Save and rename your image (be sure you identify it as a "multiple").
- 8. Although you can now print the image as is, I suggest that you flatten the layers before you do so. The file size will be smaller, and your image(s) will print out much faster. If you need help flattening the layers, refer to Chapter 20.

9. Print the image, and use scissors, a razor blade, or a paper cutter to separate the prints.

Say Cheese

When aligning your images, you might even want to go one extra step: Add another layer just above the base (white) layer. Using the Line tool, draw a grid on this layer. You can use this grid as a guide for placing your images; just be sure you hide the grid layer before you print. Save a copy of this image with the grid to use as a guide for your next set of multiple prints.

Printing a Contact Sheet Directly from Your Camera

Believe it or not, many—if not most—cameras enable you to print directly from the camera. The camera is hooked up directly to the printer; no computer is needed. I frequently use this feature to get a *contact sheet*, which is a catalog of thumbnail-sized images currently in storage on the camera.

As each camera and each printer will handle it differently, I won't go into the nitty-gritty of how to accomplish this task. Suffice it to say that your camera and your printer must be connected. (In most cases, you'll use a cable to connect the port on your camera that you normally use to transfer data to your computer to the port on your printer designated for direct camera connection. On most newer printers this port is on the front.)

Depending on the specific camera and printer, you can also usually make prints in several sizes directly from the camera. Details on how to do this should be in your camera and printer instruction books.

Photo-Quality Papers: Suitable for Framing

Many printer manufacturers sell "photo-quality" paper for their printers (you might have gotten a little sample pack when you bought the printer). As these photo-grade papers are expensive, you might want to try a few alternatives. If you are using an inkjet or laser printer, you can substitute any type of paper that you would normally print on (be sure it will travel through your printer without jamming). For example, you might go to your local office-supply store and pick up some good-quality stationery or laser paper and try it out (you'll find that paper with a glossy surface works the best). You might also want to go to an art-supply store and try out some artist

papers. A thin, good-quality watercolor paper can make a very interesting surface for your images. Try using colored paper. Experiment and have fun!

Third-Party Inks

Third-party printing inks for inkjet printers can be found in professional photo stores or in photo magazines. These inks can yield even more beautiful colors

Say Cheese

Some types of paper have a very high acid content, which will cause the paper to yellow or discolor over time. To avoid this problem, ask your paper dealer for archival paper. You will have a good chance of getting this in an art-supply store. You might find the acid content of stationery paper written on the package.

than the inks supplied by the manufacturers. For example, some of the black-and-white ink sets yield startlingly beautiful quality—many let you print a four-color black-and-white image using subtly different colors of gray and black for the inks. I've seen prints made from inexpensive (under \$600) printers sit beside traditional (analog) black-and-white prints with no discernable differences. With all that power and technology at your fingertips, you can make a superb color or black-and-white print and never get your hands wet! That's why we're digital. Viva control!

The Least You Need to Know

- For a quick-and-easy print, use 200dpi as the printing resolution of your images.
- ♦ You can print multiple copies of your image when you send the first image to the printer. You can also gang up multiple copies of your image on one page.
- You can print multiple images or contact sheets in order to get a record of the images you've taken. This will also serve as a good hard-copy catalog.
- Better-quality paper for your printer will give great results. Try to use a glossy stock.

Chapter

E-mailing Your Pictures to Mom and Other Cool Tricks

In This Chapter

- Sending e-mail and attaching photos
- Building a website and including text and photos
- ♦ Putting your pictures on TV for all to see
- Converting your digital photographs into desktop wallpaper for your Windows and Macintosh systems
- Using AOL's You've Got Pictures and Apple's iPhoto Album service

It might not always be convenient to drag someone over to your computer screen to look at your new beautiful piece of art, and printing an image out on paper and mailing it off to someone seems so slow and antique. After all, we live in a world of high-speed Internet connections and e-mail. We can zip a message or file to someone anywhere in the world within minutes. So why not take advantage of this and send out your photos via the web?

Let's look at two ways of getting your images out in the world:

- ♦ Via e-mail. I won't go into great detail on how to use your specific e-mail program to send images to friends and family—there are so many programs out there that it would be impossible to cover them all. I will, however, show you the basics on how to prepare an image for transfer, and briefly discuss sending attachments via Microsoft Outlook and embedding images in messages in Apple Mail.
- Via a website. Most Internet providers will allow you some space on their server to post a website. Why not take advantage of this great technology?

So read on and let's get ready to go cyber!

Preparing Your Images

The first thing you need to do is determine what you want the receiver of your image to do with the file you are sending. Do you want her to be able to print the image out, or just admire it on her screen?

Remember, it can take a long time to push a big file down a phone line. You can make someone on the receiving end of your e-mail pretty mad if a huge file jams up her download, especially if she has a slow modem. If you want the user to be able to print out the image, you will need to send her the entire file. If you want her to just be able to view it on her screen, you should reduce the file size to speed up the download time.

Here are some guidelines:

- ◆ If your image is destined for a monitor only, reduce the resolution of the file to 72dpi. After all, many monitors reproduce an image at only 72dpi, so any more information will just be wasted. (Note: If you make your file size 5×7 inches at 72ppi, it will reproduce on the recipient's screen at 5×7 inches.)
- ◆ If color is not very important and if it's a monitor-only image, you can reduce the file size by changing the bit depth. When viewing an image onscreen, the difference between millions of colors and 256 colors is negligible. (See Chapter 15 for more information.)
- Compress your file. All files, whether for printing or screen display, should be compressed before being sent. The best compression format for photographs is JPEG (File, Save As, JPEG File). As far as settings go, I find that 6 works fine,

but you can experiment to find a setting that works best for you. (Note: The lower the setting, the more detail is lost.)

- You can reduce file size some by ditching information that won't be needed. If you use the Save For Web command under File, you will lose the thumbnail and all metadata, which will knock the file size down a bit.
- ♦ Watch your file size. Depending on your modem speed and the receiver's modem, a large file can really clog up the works. Files larger than 300KB can take forever to transfer. To test how long it will take to send a file, I sometimes start a transfer as a test. Most modem software will give you an estimate of how long it will take to upload a file. If you find that it will take longer than you are willing to have your phone line tied up, cancel the upload, reduce the image's file size, and resend it.
- ◆ If you have a broadband Internet connection and know the person you are sending to also has broadband, you can send larger files without too much concern. But even then, files the same size your digital camera makes might be much larger than anyone is likely to need. Generally speaking, I size my images to 5×7.5 or 8×12 (the exact dimensions will depend on the camera) at 72 dpi for e-mailing.

Sending Digital Photos via E-Mail: Attaching and Embedding

Just like any other type of file or document, you send digital photographs via e-mail as *attachments*. If you've ever attached a document to an e-mail message using your e-mail program, then you already know how to send photos! If you attach an image file to an e-mail message, the e-mail recipient must then save the attachment to her hard drive. Then, she can open and print the file using an imaging program.

Flash

I cannot stress enough that you should use a virus-checking program to check all files that are downloaded to your computer. If possible, set your virus-protection program to automatically check all downloads. If you are the recipient of an attached file, check it before you open it. If you are sending or forwarding files, take the responsibility to check your files before they go out. You never know when some little varmint has gotten into your machine.

Depending on what type of e-mail program you have, you might also be able to embed the image right into the body of an e-mail, which means that when the recipient opens the e-mail message, the image is visible (she need not download it and open it in an imaging program to view it). The downside to this is she might not be able to have access to the entire file. Also, although it can be printed out as part of the e-mail message, it most likely will not contain a lot of resolution.

Demo: Sending Attachments Using Microsoft Outlook

Attaching a photograph to a message sent via Microsoft Outlook, which is a popular e-mail program, is easy.

- 1. After you've compressed your image file, open Outlook Express, and click **New** in the top menu toolbar.
- 2. A new message opens. Type the recipient's e-mail address in the **To** field, and type the subject of the message in the **Subject** field.
- 3. Type your message. To attach a photograph (or any other type of file) to the message, click the little **Add Attachments** button (the one with the paper clip icon).
- 4. Navigate your file directory until you find the file you want to attach.
- 5. Select the file you want to attach, and click **Add** (or **Open**).
- 6. When all the files you want to attach have been added, click Done.
- 7. In the lower section of your message, you will see a thumbnail for the photo(s) you have chosen. This indicates that the photo will be delivered to your recipient with your message.
- 8. Click Send Now.

When the e-mail message arrives at its destination, the recipient will be able to see the image in the body of the message. Pretty cool!

Demo: Embedding Attachments Using Apple Mail

Sending an attached file in Apple Mail is similar to using Outlook Express:

- 1. After you've compressed your image file, open Apple Mail.
- 2. Open the File menu, select the New item, and choose Message.

- 3. A new message opens. Type the recipient's e-mail address in the **To** field, and type the subject of the message in the **Subject** field.
- 4. Type your message. To embed a photograph in the body of the message, open the **Insert** menu (paper clip icon).
- 5. Navigate your file directory until you find the file you want to attach.
- 6. Select the file you want to embed, and click Open.
- 7. Your photo will be added as an attachment and be visible in the body of the e-mail. Click **Send** to send the file.

What's Your URL?

Last weekend, I attended a family party. At the end of the party, I gave all my relatives my website address. When I got home, I quickly downloaded all the images from my camera and did a bit of editing. I then built a web page and posted it and the images to my Internet Service Provider (ISP). Everyone at the party was able to log on to the website and view my images!

What better way to show the world your photographs than posting them on your own website? There are many web page authoring programs available; many offer WYSIWYG (*What You See Is What You Get*) page building. Adobe's Photoshop Elements 3.0, which we used earlier in this book, can do great things with pictures and all automatically. Check out Chapters 14 through 21.

Hi, Mom! I'm on TV!

Many newer digital cameras have the capability to send out a video signal, which enables you to view the images stored in the camera's memory on your TV! Actually, the TV is not the only device that you can send a video signal to. The camera can be hooked up to a VCR, DVD recorder, LCD screen, or overhead projection system, which means that you can use your camera for a business presentation. Imagine you just spent the day touring your manufacturing plant and need to show the bosses how they can increase production. All you need to do is hook your camera to a projection system and give your show.

To do this, insert one end of a video cable in your camera's video out port, and the other end to the port on your television, VCR, projection system, etc. (And some people think torture via slideshow is a thing of the past!)

Sprucing Up Your Screen with Wallpaper

It is very easy to take your favorite photo and use it as a background, or "wallpaper," for your Windows or Macintosh screen.

Before you actually turn your image into wallpaper, you want to adjust its size so that it gives you the best look at all resolutions. To do so, you must first find out the pixel dimensions of the image. If the image you want as wallpaper is smaller than your resolution, it will have to be resized, and that can make it look bad.

If you run Windows and don't know what resolution your screen is set to, you can determine this by right-clicking on the desktop, selecting the **Properties** item, and looking up the resolution in the **Settings** tab. On Mac computers you will find your Monitor Control panel by opening **System Preferences** and clicking on **Displays**.

In general, anything at or above 1,280×1,024 will look good on both Macintosh and Windows computers. If the picture is larger, it will be reduced to fit, making the pixels finer-grain and clarifying the picture more. Of course, large images are just that: large. They can take up a lot of space, so be spare or archive them regularly on an external storage drive.

Say Cheese

Mac users need cool tools, too. Sadly, there are no free tools, but there is one that is about the most powerful tool on the planet and it's very inexpensive. That tool is Graphic Converter X from LemkeSoft. You can download a trial version at www.lemkesoft.com. As always, please pay your shareware fees. In this case, it's a mere \$30 for tools you will always use.

Using AOL's You've Got Pictures

America Online offers subscribers the option to send and develop their film with them, through a deal with Kodak. Although this really pertains to those who still use old-style film cameras, they do offer online picture albums that you can share with friends and family. Just log onto AOL and click the **You've Got Pictures** button on the Welcome screen (where it says, You've Got Mail!). From there you can upload images and save them to various albums of your making.

Flash

Because of the way AOL is structured, it is very difficult for someone to send photos to someone else unless both are using AOL accounts. When someone outside of AOL sends a photo to someone on AOL, AOL tries to convert the file to a mime file, and generally this just messes it up and makes it unreadable. I do not recommend AOL for serious photographers who might need to e-mail lots of photos.

Using iPhoto to Get Booked

iPhoto is one of the best applications that's come along in a while. Sadly, it's only available for an Apple Macintosh computer running Mac OS X.

After you have your images downloaded into iPhoto, it's a dream to examine, fix, and organize them in any way you see fit. iPhoto's simple yet powerful interface really makes it fun to work with even thousands of images. That's not all that iPhoto does, though. After you've collected a number of images that you'd like to retain for posterity, you can organize them into what Apple refers to as a Book. It's easy to do. Just click the Book button under the main display, select a Theme, organize your pages and pictures, add material, and then order it.

The results are breathtaking, though only as good as your pictures. Take the time to take really good pictures of treasured people and places and your book will come out beautiful.

Say Cheese

Speaking of books. If you would like to produce a professional-looking book of your photographs to give as a gift, there are now online companies that will do it for you. Sony runs one of them, but you do not have to use a Sony camera to use it. Sony's www.imagestation.com lets you upload your photos and have exceptionally nice books made. You can have just one made, or you can have many made. These books can be really exciting gifts for friends and family. At imagestation.com you

can also have your favorite photos made into regular prints, put on greeting cards, calendars, coffee mugs, tote bags, T-shirts, and even cookies, chocolates, and lollipops! You can become known for sending out really unique gifts for holidays, birthdays, and other occasions.

Other Cool Things You Can Do with a Digital Camera

In case you didn't know, some digital cameras can double as a webcam. What's a webcam, you ask? Simple, this type of camera connects directly to a port on the back of your computer and takes pictures of whatever happens to be in front of it. This kind of camera is really nothing more than a video sensor. The software on the host computer takes care of the rest.

What you do with a webcam is entirely up to you. The site on the web that started the whole idea of a webcam in the first place is the Trojan Room Coffee Machine cam, located in the computer laboratories of the University of Cambridge in England. Every 15 minutes, the software would snap a new picture of the coffee pot that the camera was pointed at. The cam was created so the people upstairs didn't have to walk downstairs just to find that the coffee pot was empty. A German company purchased the original coffee machine in an auction on eBay and it can now be seen here at www.spiegel.de/netzwelt/netzkultur/0,1518,174146,00.html.

Click the link near the top center of the page that is labeled Cam 1 and a new window will pop up with the picture. If you are located in the United States, you might want to visit the camera early in the morning (afternoon in Germany) or it will be dark.

The second oldest web cam on the Internet is Netscape's Fish Cam. Originally started by founding Netscape developer Lou Montulli, it soon became a popular stop on the early World Wide Web. Despite the fact that the Fish Cam came second and therefore was not original, it is still considered by most to be the epitome of uselessness. The fish are quite pretty to look at, though. Netscape, though now owned by AOL, still maintains the Fish Cam. You can see it at wp.netscape.com/fishcam.

Lastly, the most interesting feature of a number of digital cameras available today is the ability to record short bursts of video. With some cameras you are limited to 30 to 60 seconds, but many of the newer models are only limited by the size of the storage card. After you have your video masterpiece, you'll find out just how large these can be, and you will grow to deeply appreciate just how much DVD discs can hold.

Some Helpful Websites

America Online has many millions of subscribers. It stands to reason, then, that some of you reading this have an AOL account. For you, there's nothing less than entering

a keyword: Digital Cameras. Hosted by *PC Magazine*, this section of exclusive AOL content covers all manner of buying tips and a neat 27-tip section on printing digital photos so they look good.

The New York Institute of Photography is an honored educational facility that offers students the opportunity to learn how to take compelling pictures. Thankfully, they also offer a lot of free tips and tricks on the website (www.nyip.com). If you happen to live in the area, consider taking a course!

The Least You Need to Know

- You can send your images attached to your e-mail.
- You can also embed your images into your e-mail text.
- It's very easy to make a personal website, where you can post your photos for the world to see!
- ♦ You can use most digital cameras to show your captured images on a television.
- You can use your digital pictures as a Macintosh background or Windows wallpaper.
- A number of online companies can help you process your digital photos into real prints or put your images on a variety of things.

Speak Like a Geek: Digital Photography Words

access time The length of time a storage device requires to access data. Storage cards, hard drives, etc., all have access time in their specifications. Obviously, the faster the better.

acquire To bring digital data into a device (computer or other) or into a software application.

algorithm A set of mathematically defined rules that produces a specific set of actions.

aliasing Jagged edges around things in digital images. Programming that eliminates these jagged edges is called anti-aliasing.

aperture The opening in the lens that controls how much light passes through the lens. Refers to the diaphragm. In most cases this can be adjusted to let in more or less light as required.

artifact Erroneous information in an image, usually due to faults in compression, sensor noise, or poor-quality cables.

autofocus A camera or lens that focuses itself.

available light Light present in a room or environment, such as sunlight or existing room lighting, without the addition of flash or flood lamps.

beta A pre-release version of a software application. Sometimes you can download beta versions on company websites to try out. The companies want you to do this and give them feedback on any bugs you discover. This helps them fine-tune the release version. You might hear someone say that he is a "beta tester." Beta testers are people who have a formal relationship with the software company and get new products in beta form so they can test them and give the manufacturer their feedback.

bit Geek speak for a binary digit. The smallest amount of information a computer can work with.

bit depth The color capacity of a pixel. For every bit, a pixel can carry one color.

bitmap Sometimes called *raster*. A type of file that maps each discrete pixel (bit) in an image.

bleed When an image exceeds the size of a page. If an image needs to cover an entire page, it is bled off the page so no edges show after the printer trims the page.

bounce light Light that is reflected off a surface onto the photographic subject.

bug Sometimes *software bug*. Something in a software program that doesn't work correctly. Many software companies have places on their websites for you to report bugs. If you find one, please report it because this helps the company to improve its product.

byte Eight bits equal one byte.

CCD Charged couple device. A CCD converts light into electrical current. The amount of current varies with the brightness of the light. In your digital camera, this analog signal from the CCD is converted into digital data by an A/D converter.

CIE Color model developed by the Commission Internationale de l'Eclairage.

cloning To copy one part of an image over another part.

CMOS Complementary Metal-Oxide Semiconductor. Like a CCD, a CMOS converts light to electrical current. It is cheaper to manufacture and is becoming the most commonly used type of sensor in many pro and amateur cameras. CMOS works in a similar way as CCD, but often has the processor as part of the sensor chip.

CMYK Cyan, magenta, yellow, and black color used in printing. A four-color press uses cyan, magenta, yellow, and black inks. Many inkjet printers also use CMYK ink sets.

color balance The neutrality of an image. If an image is too blue, or out of color balance, yellow is added to bring the image back in balance or neutral in color.

color model (or color space) A method of defining color. RGB, CMYK, and HSB are examples of color models (spaces).

color temperature The color of light emitted by a black body as it is heated. The hotter the temperature, the bluer the light becomes. Color temperature is measured on a Kelvin scale. A household light bulb has a color temperature of 2,800° Kelvin. Daylight has the color temperature of 6,500° Kelvin. Although color temperatures used to always be expressed in degrees Kelvin, today the simpler term *Kelvins* is often used.

compression The process of shrinking or squeezing data in an image file. Most compression schemes throw away some data and are called "lossy." Some newer compression schemes retain all data and are called "lossless."

continuous tone Continuous and uninterrupted flow of light to dark tones in an image.

contrast The ratio of dark tones to light tones. An image with much contrast will lack mid or gray tones.

crop To remove unwanted portions of an image.

cyan A bluish/green color. One of the additive primary colors.

data Information.

default A preset setting programmed into software or firmware which is generally usable without change; a starting point.

depth of field The measure of the depth of the area of a photograph that is in focus.

digital Binary. That is, information which has been encoded in the form of 1's and 0's. All computers used today are binary in structure and store information in binary digital form.

DIMM Newer computers use DIMM (Dual In-line Memory Module, with memory chips mounted on both sides of the circuit board) memory. If you need to increase the amount of RAM in your computer, DIMM memory is what you will need to buy. Just check carefully as there are many different variations of DIMM and your computer most likely only accepts one type.

disk Generic term for round storage media. There are hard disks, floppy disks, "stiffie" disks, compact disks (CDs), digital video disks (DVDs), and so on.

download To receive digital data from an external source. Example: You would download from a website.

dpi Dots per inch. A measurement of linear resolution for a printer or scanner.

drift The changing from calibration of a device such as a printer or monitor.

driver Software that communicates between two devices and directs the operation of one of them, such as between a computer and a printer.

EPROM (Pronounced *eep-rom*) Erasable Programmable Read-Only Memory. A special type of chip that retains its programming without power, but can be reprogrammed. Many digital cameras now have EPROM chips that contain the firmware (operating system) of the camera. The advantage to this is that you can download firmware upgrades from the manufacturer's website to update your camera and even add new features.

EPS Encapsulated PostScript. A type of graphics file usually associated with printing.

export To change from one file format, usually the native format, into another. Example: exporting a native Photoshop format to a TIFF format. Also, moving data from one device to another.

exposure Light striking film or a digital chip. Also, the determination of how much light strikes the film and for how long.

exposure meter An instrument that measures light to determine which aperture setting and shutter speed to use.

f-stop The measurement of the diaphragm opening. The smaller the f-stop (higher the number), the greater the depth of field. Example: f/16 will have more depth of field than f/2.8.

file A collection of digital data such as an image or document.

file format The form or arrangement of information within a file. Many software programs have native file formats, which enable them to read the file. Some file formats are specific to a program.

filter A filter is a device that removes something from a medium. In the case of photographic filters, they attach to the front of the lens to remove some types of light and let other types pass through. Also, in digital imaging, an algorithm that is applied to an image to change it. Example: a sharpening filter.

filter surfing The less-than-suitable practice of covering up a poor image with filter effects that results in no noticeable improvement.

firewall A software program or hardware set to protect your computers from outsiders (read: hackers) reading or stealing your data. It will also protect your computer from viruses.

fisheye lens An extremely wide-angle lens with uncorrected barrel distortion. This causes lines to bow outward from the image center. Some software now enables you to correct fisheye images to produce rectilinear images without distortion.

fixed-focus lens A lens that cannot be focused. It is preset to one range of distance, usually from relatively close to infinity.

Flash Pix A multi-resolution file format used widely on the Internet.

focal length Distance from the rear nodal point (a virtual point) of the lens to the plane of focus. The focal length of a lens determines whether it is a telephoto, wide-angle, or normal lens.

freeware Software you can download from the Internet and use without paying a license fee. There are thousands of freeware programs available, and with a bit of searching you can probably find some of interest to you.

gamut Range of colors that a device (such as a monitor or printer) can accurately reproduce.

GIF (Pronounced jiff) Graphics Interchange Format. A file format developed by CompuServe to be completely platform-independent that is readable on Mac, Windows, and so on. A lossless file compression, using LZW compression algorithms.

Gigabyte One billion bytes, or, more accurately, 1,024 Megabytes.

grayscale Containing no color. Grayscale images contain white, gray, and black shades.

GUI (Pronounced *goo*-ee) Graphic User Interface. This helps the user control the computer or software by use of graphic images such as screen icons or pull-down menus.

half-stop Half of a full f-stop.

halftone An image produced on press. The image is converted by a RIP into tiny dots that give the illusion of continuous tones.

HSB A color model describing hue, saturation, and brightness.

HSL A color model describing hue, saturation, and lightness.

hue The specific shade or tint of a particular color.

index color Reducing the colors available to fit a smaller fixed gamut eight bits or less in depth. Usually used to reduce file size. Many colors used in images delivered on the web are indexed.

IEEE 1394 What Windows geeks call Apple's FireWire. IEEE is Institute of Electrical and Electronics Engineers.

ISO A numerical rating given a digital camera or film to express its sensitivity to light. The higher the ISO number, the more sensitive the film or sensor is to light. ISO is properly written as ISO 100/21 or ISO 400/23, but in most usages the second number is dropped.

jaggies Stair-stepped pixels usually found on diagonal or curved parts of an image that are caused by low resolution. Also called *aliasing*.

JPEG (Pronounced *jay-peg*) The Joint Photographic Experts Group (part of the ISO) developed this standard lossy compression file format.

key light Main light source.

kilobyte 1,024 bytes.

LCD Liquid Crystal Display. The type of display used on digital cameras, flat-panel computer screens, and some flat-screen TV sets. They use microscopic rod-shaped crystals that change polarization when exposed to an electrical field.

lossless compression File compression that does not lose any information.

lossy compression File compression that does lose information. Unnecessary information is thrown away.

lpi Lines per inch. A measure of resolution on a printing press. It comes from the days when images were rephotographed through lined screens to produce halftone dots.

LZW Compression Limpel-Ziv-Welch Compression. A lossless type of compression used in GIF and TIFF files. Named for the three originators.

mask A layer or selection in a file that is used to protect a portion of the image.

megapixel Literally, one million pixels, but camera chip measurements are generally rounded off to the nearest number of megapixels.

megabyte 1,024,000 bytes.

monitor calibrator A device, which attaches to the monitor screen, that is used to calibrate your monitor.

noise Unwanted artifacts in an image. Usually, noise appears in the dark areas of an image.

normal lens A lens that has approximately the same angular field of view as the human eye. On a 35mm camera, a lens from about 45mm to about 55mm in focal length is usually considered normal.

OS Operating system. This software is loaded into your computer's RAM at startup. It tells your computer how to deal with digital data.

PAL Phase Alternating Line. A European video standard. If you want to hook your digital camera up to a TV or video recorder, you will have to set the camera's video output to NTSC (USA, Japan, etc.) or PAL (most of Europe).

PDF Portable Document Format. A cross-platform file format created with Adobe Acrobat. PDF files can contain both text and images in files of compact size.

pixel Short for picture element.

pixilation Small squares or rectangles on an image, usually caused by enlarging too much. Also can be a result of low resolution.

platform Computer system, as in Windows, Unix, or Mac.

plug-in Add-on technology or computer code. Usually plug-ins are filters or special effects for imaging software applications.

ppi Pixels per inch. Measure of image resolution.

RAM Random Access Memory. The thinking capacity of a computer. The part of the computer where information is temporarily stored and processed.

Raster More often called bitmap. See Bitmap.

Red-eye A red appearance of your subject's eye caused by the camera flash bouncing off the retina of the eye. Red-eye can be avoided by moving your flash farther away from the lens, or it can easily be fixed in software like Photoshop Elements 3.0.

resolution The amount of fine detail that is rendered in an image.

RGB A color model with red, green, and blue.

ROM Read Only Memory, where the computer stores its operating instructions. Digital cameras today also have ROM to run their processors (see *EPROM*).

saturation Also called *chroma*. The amount of gray present in a color. The less gray, the higher the saturation, and vice versa.

shade A gradation of color.

shareware Software that can be downloaded from the Internet at no charge. Some shareware creators ask that you make a contribution if you like the software, and you should do so as an incentive for them to develop more. Some shareware creators don't want any payment, and their software is called freeware.

sharpness Refers to focus, the ability to display detail.

shutter Device that opens and closes to allow light to strike film or a chip. Shutter speed determines your ability to capture action. Some digital cameras turn the imaging chip on and off rather than employing an actual mechanical shutter, and some digital cameras use both systems.

SLR Single Lens Reflex. A type of camera that uses a mirror and prism to enable the user to see through the taking lens. At the time of exposure the viewfinder will black out because the mirror has to flip out of the way to allow light to reach the film or sensor.

speed The sensitivity of film or a chip to light. A slang term for ISO.

strobe Electronic flash. Slang used by some photographers. This usage is incorrect, because a strobe is a rapidly pulsing type of electronic flash.

telephoto lens A lens with greater magnification than a normal lens, and a narrower angle of view. Technically a lens is only a telephoto if the physical length of the lens is shorter than the focal length; for example, a 500mm lens that is only 350mm long. Lenses as long as the focal length, or longer, are properly called long focus lenses. But photographers typically call all of them telephoto lenses.

TIFF Tagged Image File Format. A cross-platform file format that can be saved uncompressed or reduced in size with LZW lossless compression to reduce file size.

tone Value, brightness, or lightness. The amount of light a color reflects.

TWAIN A standard of communications between digital devices such as cameras and scanners, and computer software. TWAIN drivers allow the import of data from cameras and scanners.

vignetting Darkening of the image toward the corners and edges.

virus An unwanted software program that hides in your computer and can take control of your computer or programs. A virus can severely damage your computer and corrupt your data.

wide-angle lens A lens that has a wide field of view. A typical wide-angle lens is 28mm (35mm camera equivalent).

WYSIWYG (Pronounced *wissy-wig*) What You See Is What You Get. A term that refers to what you see onscreen being what you get in print.

zoom lens A lens with continuously variable focal length. A zoom lens can zoom between 80mm to 250mm, for example. A true zoom will stay in focus as you change focal lengths. Lenses that do not maintain focus when "zoomed" are called "varifocal."

Index

AC adapters, 49 active autofocus lenses, 112 adding layers, 270-280 shadows, 263-265 additive primary colors, 20 Adobe Photoshop, 90 See also Photoshop Elements Adobe Photoshop Elements. See Photoshop Elements albums, 92 alkaline batteries, 46 angle of view (lenses), 116 AOL You've Got Pictures function, 328 aperture, 63 Apple Mail, e-mailing images, archiving programs, 170 arrays imaging, 25 linear, 27 stripped, 27 artistic filters, 293 aspherical lenses, 111 attaching images for e-mail, 325-326 autofocus lenses, 52, 112 focus lock, 113 automatic exposure controls, 106-108

auxiliary batteries, 47

B

backgrounds (composition), 136-138 backlighting, 144 balance (composition), 127 color, 206-207 batteries, 46 alkaline, 46 auxiliary, 47 chargers, 48 LCD monitor, 49 lithium, 46 lithium ion, 47 NiCd, 46 NiMH, 47 NMH, 48 preserving life, 49 bit depth, 213 black-and-white film, 24 blemishes, removing, 256 blur effects, 218 blur filters, 293 BMP files, 176 books (iPhoto), 329 bounce flashes, 147 brackets, flash, 149 brightness, 88 budgets, 32 built-in flashes, 146 built-in memory, 59 bulb settings, 146 burst modes, 62 bus (memory), requirements, 70

buying computers, 69 digital cameras, 35-46 filters, 288

(

cables. direct, 60 FireWire, 61, 73-74, 182-187 release cords, 64 USB, 61, 73, 182-187 calibrating colors, 303-305 printers, 310-311 monitors, 306-309 resolution, 160 camera obscuras, 4-6 cameras. See digital cameras card reader devices, 60 card readers, 187 CCDs (charged coupled devices), 25 CDs, 78 center-weighted exposure systems, 107 charged coupled devices. See CCDs, 25 chargers, battery, 48 NMH, 48 choosing Macintosh or Windows, 68-69 CIE LAB color system, 305 cleaning lenses, 114 clock speed, requirements, 71

balance, 127

colors, 131 contrast, 131 cropping, 129 diagrams, 125 horizon, 128 imaginary lines, 137 movement, 133 perspective, 135 point of view, 134 positive and negative space, 132 scale, 140 texture, 139 tips, 124-125 compression DropZip, 171 files, 168 lossless, 169 lossy, 169 StuffIt, 171 WinZip, 170 computers buying, 69 connecting camera, 182-187 downloading to, 60 connecting digital cameras to computers, 182-187 contact sheets, 321 contrast, 88 composition, 131 Corel Paint Shop Pro, 91 correcting distortion, 200 perspective, 199 CPU requirements, 70 cradles, 62 creating filters, 298 cropping, 88, 129 images, 198 cut and paste (images), 88

D

Daguerre, Louis, 6 daguerreotypes, 6 darkrooms, 11 DCS 2 camera, 9 depth of field, 104 designs, 44 balance, 45 grip, 45 pivot, 44 SLR cameras, 45 split, 44 desktop computers, downloading to, 60 despeckle, 219 diagrams, composition, 125 diaphragm, 98 Digimarcs, 292 digital backs, 39 digital cameras connecting to computer, 182-187 design facets, 44-45 Fuji Fine Pix F450, 36 megapixel ranges, 35-36, 38 Nikon Cool Pix 4500, 44 Olympus Stylus Verve, 45 Phase One P25, 40 PhotoPhase FX, 40 rangefinders, 34 single lens reflex, 33 software included, 89, 184 viewfinder, 33 direct cable (connection to computer), 60 distortion, correcting, 200 docks, 62 downloading files to computers, 182-187 to computers, 60

drawing on images, 239 quality, 88 downloading, 182-187 DropZip, 171 red-eye, 255 storage cards, 187 DVDs, 78 resizing, 88 e-mailing, 177 dye sublimation printers, 81 resolution, 159, 316-320 EPS, 174 FlashPIX, 175 calibrating, 160 retouching, 248-255 formats, 63 rotating, 196 GIF, 174 shaping, 243 JPEG, 172 Eastman, George, 8 sharpening, 214-217 PDF, 175 editing images, 222-226 sizing, 193-195, 324-325 resolution, 164 adding color, 234-245 software, 89 size, 324-325 adding opacity, 236 weather filtering, 236 adding text, 260-261 sizing, 163 websites, 327 TIFF, 174 blemishes, 256 effects, 300 fill flashes, 145-147 brightness, 88 e-mail, 11 fill lights, 155 cloning, 248-255 emailing images, 177, film, 10 colors, 88, 206-207 324-325 black and white, 24 calibrating, 303-305 attaching, 325-326 color, 25 partial removal, 226 embedding, 325-326 ISO, 102-103 compression, 168 embedding images for e-mail, film scanners, 83 contact sheets, 321 325-326 filters, 51, 88, 288, 293-295 contrast, 88 EPS files, 174 blur, 293 cropping, 88, 198 erasing on images, 242 creating, 298 cut and paste, 88 EXIF (Exchangeable Image neutral density, 108 drawing on, 239 Format), 173 FireWire cables, 61, 73-74, effects, 300 expenses, 12 182-187 e-mailing, 324-326 exposure, 106, 108 flare (lenses), 112 erasing areas, 242 external hard drives, 72 flash brackets, 149 feathering, 279 eyes, mimicking, 21 flash cards files BMP, 176 downloading files, 187 £ memory, 59 EPS, 174 sockets, 64 FlashPIX, 175 GIF, 174 flash meters, 53 f-stops, 52, 99 flashes, 53-54 JPEG, 172 depth of field, 104 PDF, 175 bounce, 147 half stops, 99 brackets, 149 TIFF, 174 shutter speed, 100 built-in, 146 filters, 288, 293, 295 field of view, 115 formats, 63 colors, 146 files fill, 145-147 improving, 189-201 BMP, 176 GN (guide numbers), 54 layers, 270-280 compression, 168 portable, 147 panoramas, 281-285 lossless, 169 recycle time, 56 printing, 316-320 lossy, 169 red-eye, 55 multiple, 319 studio, 153

344 The Complete Idiot's Guide to Digital Photography Like a Pro, Fourth Edition

FlashPIX files, 175 flatbed scanners, 83 focal length, 115 focus, depth of field, 104 focus lock (autofocus lenses), 113 fonts, adding text, 261 foreground (composition), 136

6

GIF files, 174 GN (Guide Number), 54 graphic cards, 75 grayscale, 212 Guide Numbers. See GN

H

half stops, 99 hard drives, 72 external, 72 heliography, 6 Herschel, Sir John, 7 history, photography, 4-6, 8 horizons (composition), 128 hot lights, 153 HSB colors, 212 hue, 207-209

I

ICC system, 305 images adding color, 234-245 adding opacity, 236 adding text, 260-261 blemishes, 256 brightness, 88 cloning, 248-255 colors, 88, 206-207 calibrating, 303-305 partial removal, 226 compression, 168 contact sheets, 321 contrast, 88 cropping, 88, 198 cut and paste, 88 downloading to computer, drawing on, 239 editing, 222-226 effects, 300 e-mailing, 324-326 erasing areas, 242 feathering, 279 files BMP, 176 EPS, 174 FlashPIX, 175 GIF, 174 JPEG, 172 PDF, 175 TIFF, 174 filters, 288-295 formats, 63 improving, 189-201 layers, 270-280 managing, 92 albums, 92 panoramas, 281-285 printing, 316-320 multiple, 319 quality, 88 red-eye, 255 resizing, 88 resolution, 159, 316-320 calibrating, 160 retouching, 248-255 rotating, 196 shaping, 243 sharpening, 214-217 sizing, 193, 195, 324-325

software, 89 wallpaper, 328 weather filtering, 236 websites, 327 imaginary lines (composition), 137 imaging arrays, 25, 34 improving images, 189-201 See also images increasing image size, 193 indexed colors, 213 ink (printers), 79, 322 inkjet printers, 80 resolution, 163 inter-lense shutters, 99 interpolation, 13, 35 iPhoto, 329 ISO, 102-103 ISO ratings, 63

J-K

JPEG files, 172

key lights, 154 Kodak, 8

LAB colors, 212 layers, 270-280 LCD screens (liquid crystal display), 56, 76 hoods, 56 selected delete, 59 lenses, 23, 50, 98, 110 angle of view, 116 aspherical, 111 autofocus, 52, 112 active, 112 focus lock, 113 passive, 112

cleaning, 114 diaphragms, 98 field of view, 115 filters, 51 flare, 112 maintaining, 114 sharpness, 51 shutters, 98 speed, 52 telephoto, 117-118 testing, 51 wide-angle, 119 zoom, 120 light backlighting, 144 colors, 144, 151 correcting, 201 f-stops, 100 fill, 155 flashes, 153 ISO, 102-103 key, 154 laws of, 22 night photography, 146 safety, 156 shutter speed, 100 weather, 144 light meters, 101, 144 linear arrays, 26 lines (composition), 137 lithium batteries, 46 lithium ion batteries, 47 long lenses, 117 lossless compression, 169 lossy compression, 169

M

Macintosh, 68-69
calibrating resolution, 161
comparing to Windows,
68-69
monitors, calibrating,
306-309

maintaining lenses, 114 managing images, 92 manual exposure, 106-108 matrix-based exposure systems, 107 Mavica (magnetic video camera), 8 medium format cameras, 39 megapixels, 35-38 memory flash cards, 59 hard drives, 72 external, 72 onboard storage, 59 metering, 63 Microsoft Outlook, e-mailing images, 326 midrange digital cameras, 38 modems, 74 monitors, 75-77 calibrating, 160, 306-309 CRT, 76 LCD, 76 resolution, 159 calibrating, 160 movement (composition), 133 multiple-purpose devices (printer/scanners), 84

N

negative space, 132 negatives, 210 neutral density filter, 108 NiCd batteries, 46 Niepce, Joseph, 6 night photography, 145-146 NiMH batteries, 47 NMH batteries, 48

0

onboard storage, 59 opening files, 177 optical viewfinders, 57 orienting images, 196 Outlook (Microsoft), e-mailing images, 326

P

Paint Shop Pro, 91 panoramas, 281-285 paper (printers), 79 photo quality, 322 parallax, 33 passive autofocus lenses, 112 PC sockets, 64 PCMCIA slots, 61 PDF files, 175 peripherals, 77 perspective (composition), 135 correcting, 199 photo-quality paper, 322 photos adding color, 234-245 adding opacity, 236 adding text, 260-261 blemishes, 256 brightness, 88 cloning, 248-255 color, 88, 206-207 calibrating, 303-305 partial removal, 226 compression, 168 contact sheets, 321 contrast, 88 cropping, 88, 198 cut and paste, 88 downloading to computer, 185

346 The Complete Idiot's Guide to Digital Photography Like a Pro, Fourth Edition

drawing on, 239	color balance, 206-207	Selection tools, 222-224
editing, 222-226	correcting photos, 199	deselect, 224
effects, 300	Crop feature, 198	inverse, 225
e-mailing, 324-326	despeckle, 219	reselect, 225
erasing areas, 242	distortion, 200	saving, 230
feathering, 279	Dust and Scratches filter,	Sharpen function, 215
files	256	Smart Fix function, 203
BMP, 176	effects, 192	Soften function, 218
EPS, 174	Effects tools, 300	Spot Healing Brush tool,
FlashPIX, 175	Elliptical Marquee tool,	254
GIF, 174	227	Text tool, 260-261
JPEG, 172	feathering, 279	drop shadows, 263-265
PDF, 175	Fill tools, 234-241	glow, 266
TIFF, 174	airbrush, 245	opacity, 266
filters, 288-295	blending, 236	vector graphic format,
formats, 63	eraser, 242	268
improving, 189-201	gradient, 236	Toolbox, 191
layers, 270-280	painting, 239	Unsharp Mask Filter, 217
managing, 92	pencil, 245	Variations feature, 209
albums, 92	shape, 243	Photoshop Images, Color
panoramas, 281-285	filters, 288	Calibration, 312
printing, 316-320	artistic, 293	Photoshop, Adobe, 90
multiple, 319	blur, 293	See also Photoshop
quality, 88	Filter Gallery, 290	Elements
red-eye, 255	smudge, 295	pictures. See images
resizing, 88	texture, 295	pivot designs, 44
resolution, 159, 316-320	Free Resize feature, 193	pixels, 26
calibrating, 160	Healing Brush tool, 254	pixilation, 13
retouching, 248-255	hue/saturation, 207-209	point of view (composition),
rotating, 196	Image Size feature, 195	134
shaping, 243	Lasso tool, 227	ports, 73
sharpening, 214-217	layers, 270-280	serial, 73
sizing, 193-195, 324-325	panoramas, 281-285	positive space, 132
software, 89	Magic Wand tool, 229	preserving
wallpaper, 328	Marquee Selection tools,	battery life, 49
weather filtering, 236	225-226	printers, 78
websites, 327	Menu bar, 191	calibrating, 310-311
Photoshop Elements, 90-91,	negatives, 210	color laser, 81
186, 190	Palette well, 191	dye sublimation, 81
Adobe Gamma utility, 307	Quick Fix function, 201	ink, 322
Blur function, 218	Red-eye tool, 255	inkjet, 80
Canvas Size feature, 196	removing color, 226	paper, 322
Clone Stamp tool, 248-252	rotating images, 196	resolution, 162, 316-320
		testing calibration, 311

Q-R

QTVR (Quick Time Virtual Reality), 15 Quick Time Virtual Reality. See QTVR QuickTake camera, 8

RAM (random access memory), 59 requirements, 70 rangefinder digital cameras, rechargeable batteries, 46 recycle time (flashes), 56 red-eye, 55 removing, 255 removing blemishes, 256 colors, 226 red-eye, 255 spots, 254 requirements bus, 70 clock speed, 71 CPU, 70 graphic cards, 75 hard drive, 72 modems, 74 monitors, 75-77 peripherals, 77 ports, 73 printers, 78 RAM, 70

scanners, 82

research, 32
resizing images, 88
resolution, 12, 63, 159
compression, 168
file size, 164
printers, 162-163, 316-320
retouching images, 248-255
reverse interpolation, 164
RGB colors (red, green, blue), 19, 210
rotating images, 196
run-length encoding. See loss-less compression

S

safety, lighting, 156 saturation, 207-209 saving files, 177 images for e-mail, 325 formats, 63 scale (composition), 140 scanners, 82 film, 83 flatbed, 83 software, 84 Schulze, Johann Heinrich, 5 secondary colors, 21 selected delete function, 59 self-timers, 64 semipro digital cameras, 38 sensitivity ratings. See ISO ratings serial ports, 73 setting budgets, 32 shadows, adding, 263-265 shaping images, 243 shareware programs, 170 sharpening images, 214-217 sharpness, lenses, 51

shutter lag, 12 shutter speed, 104 shutters, 98 inter-lense, 99 speed, 100 single lens reflex digital cameras. See SLR digital cameras sizing files, 163 images, 193-195, 324-325 slave sensors (flashes), 149 SLR digital cameras, 33 body-types, 45 smudge filters, 295 sodium thiosulphate, 7 software, 65, 89 Adobe Photoshop, 90 archiving, 170 downloading, 184 filters, 288 image editing, 185 Paint Shop Pro, 91 proprietary, 89 special effects, 88 speed clock, 71 ISO, 102-103 lenses, 52 modems, 74 shutters, 100 split designs, 44 spots, eliminating, 254 SRAM (static RAM), 59 stair-stepping, 13 storage cards, 187 stripped arrays, 27 studio flashes, 153 StuffIt, 171 subjects (composition), 124-125

T

talbotypes, 8 telephoto lenses, 117-118 temperatures (color), 151 testing flashes, 53-54 lenses, 51 printers, 311 viewfinders, 58 adding to images, 260-261 shadows, 263-265 texture (composition), 139 texture filters, 295 third-party software, 89, 91 TIFF files, 174 tri-linear arrays, 27 tripods, 157 mounts, 64 TWAIN drivers, 185

webcams, 330
websites, downloading
images, 327
white balance, 152
wide-angle lenses, 119
Windows (operating system),
68-69
calibrating resolution, 160
comparing to Macintosh,
68-69
monitors, 306-309
WinZip, 170

zoom, 121 zoom lenses, 120

U-V

upgrading RAM, 70 USB cables, 61, 73, 182-187 USB2 cables, 61

video modes, 56 videos, 327 viewfinder digital cameras, 33 viewfinders, 56 LCD screens, 56 optical, 57 testing, 58 visual compression, 118

W-X-Y-Z

wallpaper, 328 weather, 144 filtering, 236